"Richard Shultz should be commen[...] a thoroughly researched, highly analy[...] s- cinates. Special operations, especially [...]l- itary campaign or war strategy, are rarely subject to the kind of objective analysis and assessment offered in *The Secret War Against Hanoi*.

"The debates surrounding the conduct of the war against North Vietnam remain as contentious as when the war was fought: Shultz's study provides an invaluable contribution to the literature by not only describing the extent of covert operations carried out by the United States, but, more importantly, by also providing much needed context. In so doing, his study belongs on the shelves of all those seeking to further their understanding not just of the war in Southeast Asia, but of special operations in particular."

—Senator John McCain

"An intriguing recitation and analysis of a heretofore supersecret covert operation against the North Vietnamese. . . . Illuminating, *The Secret War Against Hanoi* reveals the dirty underside of the only war we lost."

—Lt. Gen. Bernard E. "Mick" Trainor, former SOG operative and military correspondent for *The New York Times*

"With impressive research, Richard Shultz has documented how a secret war, waged with the best of intentions, can be bungled from top to bottom. It's an eye-opener."

—Douglas Waller, author of *The Commandos*

"Well researched, well documented, well analyzed—the very best, most accurate story of what went on in the covert war against North Vietnam. The sharp eye of Shultz finds everything, misses nothing, among the unbelievable tales to be told. We haven't seen anything like this!"

—General John R. Galvin, dean, Fletcher School of Law and Diplomacy and former Supreme Allied Commander Europe

"Richard Shultz has written one of the most important books about the Vietnam War to be published. But *The Secret War Against Hanoi* is not just an outstanding interpretation of a key part of America's history; it also presents lessons directly relevant to the present day."

—James Adams, former bureau chief for the *Sunday Times* of London

THE SECRET WAR
AGAINST HANOI

ALSO BY RICHARD H. SHULTZ, JR.

The Soviet Union and Revolutionary Warfare

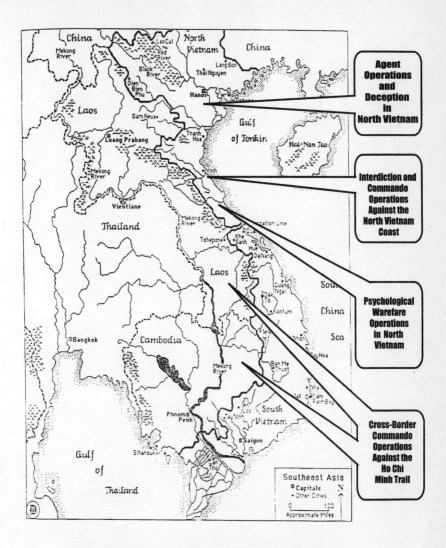

SOG's Instruments of Secret Warfare

THE SECRET WAR
AGAINST HANOI

**The Untold Story of Spies, Saboteurs,
and Covert Warriors in North Vietnam**

R I C H A R D H . S H U L T Z , J R .

Perennial

An Imprint of HarperCollinsPublishers

A hardcover edition of this book was published in 1999 by HarperCollins Publishers.

HarperCollins books may be purchased for educational, business, or sales promotional use. For information please write: Special Markets Department, HarperCollins Publishers Inc., 10 East 53rd Street, New York, NY 10022.

First Perennial edition published 2000.

Designed by William Ruoto

The Library of Congress has catalogued the hardcover edition as follows:
Shultz, Richard H.
 The secret war against Hanoi : Kennedy's and
Johnson's use of spies, saboteurs, and covert warriors
in North Vietnam / Richard H. Shultz, Jr. — 1st ed.
 p. cm.
 ISBN 0-06-019454-5
 Includes bibliographical references and index.
 1. Vietnamese Conflict, 1961–1975 — Military
intelligence — United States. 2. Subversive activities —
Vietnam (Democratic Republic). 3. United States —
Politics and government — 1961–1963. 4. United States —
Politics and government — 1963–1969. I. Title.
DS559.8. M44S58 1999
959.704'38—dc21 99-44524

ISBN 0-06-093253-8 (pbk.)

00 01 02 03 04 ❖/RRD 10 9 8 7 6 5 4 3 2 1

CONTENTS

❖

INTRODUCTION

❖

From the inception of the OSS (Office of Strategic Services) in World War II to the present, the U.S. government has employed special operations forces to execute covert missions in support of American foreign policy. However, because of the highly secretive and politically sensitive nature of many of these missions, little is known about them. To be sure, snippets of information slipped out over the years, but most of the documents and records of these covert operations remained locked in government vaults. They are among the deepest secrets of the Cold War.

With the end of the East-West conflict, we can now look behind the "shroud of secrecy" that has surrounded these activities for the last half-century. As the vaults are opened, it is becoming possible to examine the records of past covert-action successes and failures, and to derive lessons from them for future situations in which covert special operation forces may be needed.

The covert paramilitary campaign executed by Washington against Hanoi during the Vietnam War illustrates this new situation. Carried out by the Military Assistance Command Vietnam's Studies and Observation Group (MACVSOG or SOG), it was the largest and most complex covert operation initiated by the United States since the days of the OSS. MACVSOG waged its eight-year-long secret war against Hanoi from January 1964 to April 1972.

While a library full of books has been written on almost every other aspect of the Vietnam War, missing from those studies is a strategic and operational assessment of SOG. It has been argued that all World War II histories written before the revelations of Ultra—British code-breaking of secret German communications—were incomplete. The same can be said of studies of the Vietnam War. Without the full story of the covert paramilitary campaign waged by SOG there are important chapters missing from histories of the conflict. *The Secret War Against Hanoi* fills this gap, providing a complete account of a secret war that was never supposed to be revealed, unfolding new insights into America's Vietnam debacle.

THE EVIDENCE

This narrative draws on the experiences and accounts of those men who directed the covert war against North Vietnam and of the senior policy makers in Washington who commanded them. The author gained highly unusual access to the records and the individuals who ran a top secret covert organization known by the innocuous cover name, "Studies and Observation Group." This unique opportunity was afforded to the author by the then commanding general of the Army Special Operations Command, Lieutenant General Terry Scott, when he realized that SOG's lessons were being kept secret even from those charged with conducting similar operations today.

Thus, beginning in the summer of 1995, a comprehensive investigation of the covert war against North Vietnam was initiated. The research focused almost exclusively on primary sources, including in-depth interviews with more than sixty officers who ran SOG's covert programs. These included sessions with four of SOG's five commanding officers, as well as with those officers who directed or played a key role in each of the four divisions of SOG that planned and executed a wide array of covert operations against Hanoi.

They were responsible for SOG's four principal missions:

1. Inserting and running agent teams (spies) and creating a complex deception operation that included the manipulation of North Vietnamese POWs.

2. Psychological warfare (psywar)—establishing a fabricated resistance (guerrilla) movement in North Vietnam, kidnapping and indoctrinating North Vietnamese citizens, operating several falsely attributed "black" radio stations, distributing propaganda materials, forging letters and documents, and initiating other dirty tricks.

3. Covert maritime interdiction, capture, and destruction of North Vietnamese naval craft and fishing boats; bombardment of coastal targets; cross-beach commando sabotage raids against military and civilian coastal installations; and the insertion of psywar materials.

4. Cross-border covert reconnaissance operations against the Ho Chi Minh Trail by U.S.-led indigenous teams (Montagnards and Chinese Nungs) to disrupt the movement of North Vietnamese Army supplies and troops by identifying targets for air strikes, snatching or capturing enemy soldiers, wiretapping lines of communication, and distributing psywar materials.

Each of the more than sixty interviews was tailored specifically to the role each individual had played in SOG. Pre-interview questionnaires were based on information drawn from MACVSOG documents that dealt directly with those operations, programs, and activities that each interviewee had been responsible for. Consequently, the information gleaned from the SOG veterans was both detailed and in-depth. Because the author already knew the scope, operational details, and results of the operations executed by each individual, the interviews focused on nuances and subtleties often not found in highly classified records.

This interview technique was possible because of the extensive use made of two treasure troves of top secret documents. These included 2,000–3,000 pages of MACVSOG records that had been released by 1995. An additional 1,500 pages of even more sensitive SOG documents were declassified by the Defense Department and CIA for the author. These records provided a detailed and intimate view of MACVSOG's plans, programs, and operations. They also contained numerous studies, reports, and assessments of SOG's four operational divisions.

Those records were never supposed to see the light of day. In fact, many of the SOG officers interviewed were greatly surprised when

asked about matters they had taken an oath never to reveal. Several would agree to be interviewed only if they received a letter from or spoke directly to the commanding general of the Army Special Operations Command. Only after he confirmed that it was now permissible to discuss SOG, would they do so.

The book not only tells the story of the covert-operations campaign SOG waged against Hanoi but reveals the intimate involvement of the top leadership of the Kennedy and Johnson administrations in that campaign. When John F. Kennedy decided at the end of 1962 to take responsibility for covert operations against Hanoi away from CIA and assign it to the Department of Defense, a special unit in the Pentagon was tasked to supervise the mission authorization process. Known as the Office of Special Assistant for Counterinsurgency and Special Activities (SACSA) and reporting directly to the chairman of the Joint Chiefs of Staff, it was responsible for coordinating the approval procedures for all SOG operations. Action officers in SACSA's Special Operations Division walked these requests through the top echelons of the U.S. government.

When a proposed set of operations came to SACSA from MACVSOG, an action officer would hand-carry the request to the chairman of the Joint Chiefs of Staff for approval. Once he signed off, the action officer walked it to either Secretary of Defense Robert McNamara or his deputy, Cyrus Vance, for their consent. From there the action officer went to the State Department, where the proposal was reviewed by either Secretary Dean Rusk or the deputy undersecretary of state. The next stop was national security adviser McGeorge Bundy. However, even after he signed off on a request, the authorization process might not be completed. Bundy often told the action officers to return to the Pentagon but not to send an approval message to SOG until President Johnson reviewed the request.

Thus, an important part of this book focuses on the involvement of the most senior U.S. policy makers in SOG's covert operations. Interviews with the SACSA action officers unlocked the specifics of how the approval process worked inside the Pentagon, State Department, and White House. These action officers confirmed not only what the policy makers decided to do or not do, as also revealed in the declassified records, but provided clues about those factors that influenced Washington's decisions about its covert war against Hanoi.

The author also interviewed senior officials charged with the oversight and approval process. These included Robert McNamara, Walt Rostow, Roger Hilsman, William Sullivan, Richard Helms, William Colby, Victor Krulak, and William Westmoreland. When senior members of the Kennedy and Johnson administrations were not available for interviews, their oral histories in presidential libraries were used. Declassified records of the National Security Council, State Department, and Military Assistance Command Vietnam (MACV), where relevant, were also consulted.

In sum, *The Secret War Against Hanoi* is based on a unique evidentiary foundation of primary sources. Without access to these materials and individuals, it would have been impossible to develop the database necessary for this book. Having done so, the author takes the reader behind the "shroud of secrecy" that camouflaged SOG and deep into the vaults to learn about how the Kennedy and Johnson administrations sought to play the game using Hanoi's rules. The eight chapters and epilogue that follow reveal the intimate details of Washington's secret war against North Vietnam.

THE STORY

The story begins with President Kennedy's decision in January 1961, to task the CIA to initiate covert operations against North Vietnam. He wanted to turn up the heat on Hanoi and do to them what they were doing to the U.S. ally in South Vietnam. Two could play the game of subversion, dirty tricks, and covert war. By the summer of 1962, frustrated with the agency's inability to execute that mission, JFK ordered the military to take over and to greatly expand the covert war. The first part of Chapter One describes these events and explains why Kennedy chose this course of action.

The second part of the first chapter describes Operational Plan 34A (OPLAN 34A), the basis for MACVSOG. It outlines the planning process, delineates the different parts of 34A, and addresses the question of whether the plan identified vulnerable North Vietnamese pressure points that, if manipulated, could affect Hanoi's ability to conduct the war in South Vietnam. Consisting of a "total of 72 [categories of] actions ... [containing] a total of 2,062 separate operations," to be executed in 1964, OPLAN 34A constituted the basis for a major escalation of America's secret war.

It is one thing to develop a covert-action plan but quite another to assemble a clandestine organization to carry it out. There was no organizational blueprint for MACVSOG; it had to be created from the ground up in Saigon. Chapter Two discloses how difficult it was to get SOG up and running, especially as Washington demanded almost immediate results. SOG's leadership faced five challenges: (1) getting help from a reluctant CIA, (2) dealing with policy maker anxiety over specific covert operations proposed in OPLAN 34A, (3) creating a workable organization for SOG, (4) finding qualified people, and (5) establishing working relations between MACVSOG and its South Vietnamese counterpart.

Chapters three through six focus on the four operational divisions of SOG that carried out the covert war against Hanoi. These divisions targeted two "centers of gravity," as Clausewitz referred to an enemy's strategic pressure points. If they can be undermined or manipulated, it will throw an enemy off balance and affect his ability to conduct war.

One North Vietnamese "center of gravity" that MACVSOG sought to disrupt was rear area stability and security inside North Vietnam. Regimes like Hanoi place a high premium on internal security and population control even in peacetime. But Hanoi was at war with a superpower, and security of the home front was strategically essential. The second center of gravity MACVSOG targeted was the logistical supply network, command and control structure, and troop staging areas along the Ho Chi Minh Trail in Laos and Cambodia, one of Hanoi's most strategic assets for conducting the war.

To undermine Hanoi's home front security, MACVSOG directed an array of covert operations against North Vietnam, including the insertion of agent teams. The SOG division in charge of these activities is described in Chapter Three. Between April 1964 and October 1967, nearly 250 spies were inserted. When added to the CIA's insertions the number doubles to approximately 500. As with the agency, the percentage of successful SOG infiltrations was low.

In late 1967 SOG received mortifying news about its agent operations. Chapter Three explains what went wrong, taking the reader into the conspiratorial world of double agents, deception, and double-cross operations. Realizing it had been had, SOG set out to run a triple-cross deception operation back against Hanoi. It was a serious

effort aimed at capitalizing on a major catastrophe. The final part of the chapter presents the innermost details of this deception program.

Chapter Four describes SOG's psychological warfare campaign aimed at manipulating North Vietnam's leadership and population. The key element was an attempt to make Hanoi believe that a fabricated resistance (guerrilla) movement—the Sacred Sword of the Patriots League (SSPL)—was a "real" subversive outfit. To do so, SOG created an SSPL radio station that broadcast into North Vietnam and distributed SSPL propaganda materials. SOG also invented a fake SSPL liberated zone, purportedly inside North Vietnam, where kidnapped NVN citizens were taken to meet the SSPL and to be indoctrinated in a highly scripted ruse.

Additional psychological operations were undertaken—false radio stations, poison pen letters, forged documents, and similar dirty tricks—to magnify Hanoi's perception that it had a burgeoning security problem. It was an impressive array of psywar techniques. However, it was not the instruments employed but what they were supposed to achieve, and the policy maker limitations placed on them, that exposes major flaws in SOG's psywar campaign. The final part of the chapter explains why this was so.

SOG's third operational division conducted covert maritime operations (marops) against North Vietnam's coastline. Of the initial missions selected from OPLAN 34A, marops were seen by President Johnson and Secretary McNamara as likely to have the greatest immediate impact on Hanoi. These included shore bombardment, capture of prisoners, interdiction of enemy craft; cross-beach sabotage raids by commandos; delivery of psywar products; and the kidnapping of NVN citizens for indoctrination by the SSPL. Chapter Five describes these operations and assesses their impact. It concludes by analyzing why the expectations of McNamara and other policy makers were wholly unrealistic.

The final operational division of SOG consisted of U.S.-led covert reconnaissance team missions to disrupt Hanoi's use of the Ho Chi Minh Trail. The decision to do so was agonizing for the Johnson administration, given the president's innate caution and domestic political concerns. The first part of Chapter Six discusses the nearly two-year political battle between the State Department and Pentagon over whether to even allow SOG to operate against the trail.

Operations were finally authorized and the first U.S.-led covert team was inserted into Laos in October 1965. This division of SOG grew dramatically over the next three years and commanded most of its personnel, equipment, and missions. Starting in 1967, its operations were expanded to include Cambodia. The remainder of Chapter Six describes SOG's covert war against the North Vietnamese Army (NVA) on the Ho Chi Minh Trail. The purpose of those operations was to deny the NVA unencumbered use of the trail for moving forces quickly from sanctuaries in Laos and Cambodia to the battlefields of South Vietnam. As the chapter discloses, Hanoi took many steps to protect the trail against SOG operations.

In Chapter Seven the narrative shifts from SOG operations in the field to SOG's place in U.S. military strategy for fighting the Vietnam War. It begins by examining the extent to which U.S. military leaders responsible for conducting the war believed that covert paramilitary operations had a critical contribution to make and sought to integrate them into an overall war-fighting plan. The chapter reveals how the brass, and most importantly General Westmoreland, failed to view SOG operations in this way.

While senior military leaders did not see SOG as an integral part of their strategy, they nevertheless kept tight control over SOG operations because they worried about the political sensitivity of its missions. The second part of Chapter Seven discloses why this was so and details how military command-and-control arrangements worked to keep SOG on a short leash. It reveals the extent to which the senior military leadership opposed Kennedy's special warfare vision, fought to keep tight rein over covert operations, and failed to integrate SOG into the strategy for fighting the war.

The final chapter, Chapter Eight, turns to the theme of President Kennedy's and President Johnson's control over the secret war. Their employment of covert operations was characterized by both aggressiveness and trepidation. Starting with President Kennedy and including such senior figures as Robert McNamara, McGeorge Bundy, Walt Rostow, and Robert Kennedy, there was an eagerness to aggressively employ covert action as a means for convincing Hanoi to stop fomenting the war in South Vietnam. When the CIA proved unable to move fast enough, Kennedy ordered the Pentagon to take over and escalate the covert war against North Vietnam.

In spite of President Kennedy's aggressive approach, SOG operations came to be saddled with many constraints and restrictions under President Johnson. This chapter explains how and why this chasm developed between Kennedy's initial intentions and Johnson's actual execution of SOG operations. White House oversight came to be characterized not by a willingness to take risks but by the desire to avoid them. Beginning with President Johnson's review of OPLAN 34A in late December 1964 and throughout the entire SOG experience, senior policy makers rejected proposed operations deemed to carry political risk. They were timid and hardly hospitable to risk-taking, however eager President Kennedy had been to unleash covert operations against North Vietnam.

Nevertheless, despite White House timidity, Washington-imposed political constraints, and SOG's own operational failures and enemy countermeasures, by 1968 Hanoi was showing concern. Inside North Vietnam the regime evidenced growing fear of subversion and mounted a major counterespionage effort to deal with it. Likewise, SOG's operations against the Ho Chi Minh Trail had North Vietnam's attention. It instituted a number of measures to secure the trail's use. Finally, Hanoi placed its own spies inside the South Vietnamese organization that worked with SOG.

SOG was beginning to have the impact that Kennedy had envisioned in 1961. It had taken seven years to get to this point. Then U.S. domestic political reality struck. Chapter Eight provides the details of this evolution.

There is a great deal to learn from MACVSOG about the capacity of the United States to execute large-scale covert operations. This book identifies a number of obstacles that limited SOG's effectiveness. Playing by Hanoi's rules proved much easier said than done. However, the obstructions that plagued SOG can also be found in other Cold War examples where the United States has sought to use covert action. The epilogue highlights the MACVSOG findings and contrasts them with other covert actions initiated by the United States in which similar constraints hindered the implementation of these operations. This brief comparative survey elucidates the degree to which these impediments appear endemic to the use of covert operations by U.S. presidents.

The epilogue concludes by addressing one final question. In the aftermath of the Cold War, to what extent are the lessons from MACVSOG relevant for future presidents if they turn to covert operations in an effort to counter new threats to U.S. security interests?

1

IF THEY CAN DO IT, SO CAN WE

On Saturday morning, January 28, 1961, newly inaugurated President John F. Kennedy convened his first National Security Council meeting to discuss the situation in Vietnam. The news was not good, and it came from someone who knew Vietnam and was an expert on communist-instigated guerrilla warfare.

Edward Geary Lansdale was an unusual Air Force brigadier general. A veteran of the Office of Strategic Services (OSS) in World War II and an experienced clandestine operator for the Central Intelligence Agency, Lansdale had become a legend for his role in the successful counterinsurgency campaign in the Philippines in the early 1950s. He had been instrumental in Ramon Magsaysay's defeat of the communist Huk rebellion.

Fresh from that experience, he was dispatched by President Dwight D. Eisenhower to Vietnam as French colonial rule collapsed with France's surrender at Dien Bien Phu on May 7, 1954. Lansdale's initial assignment was to plan and execute a campaign of covert warfare against the new communist regime in Hanoi. Although this effort was unsuccessful, he stayed on through 1956 and became a close friend and confidant of Ngo Dinh Diem, the future president of South Vietnam.

Lansdale was just back from a two-week fact-finding visit to Vietnam in early January 1961 and had been invited to brief the National Security Council on what he had learned. Kennedy had already read Lansdale's memorandum on the trip and remarked to members of the NSC that "for the first time, [it] gave him a sense of the danger and urgency of the problem in Vietnam."[1]

Lansdale did not mince words. He told the NSC that "Beginning in December 1959 and continuing to the present, there was a mounting increase throughout South Vietnam of Viet Cong terrorist activities and guerrilla warfare." The Hanoi-backed VC employed "kidnaping and murder of village and hamlet officials, ambushes, and armed attacks." North Vietnam's goal was "to absorb South Vietnam into the communist bloc."[2] Lansdale saw little during his visit that gave him hope. Hanoi and the Viet Cong were closing in, and under current conditions, the Saigon government was unable to postpone, let alone prevent, its approaching demise.[3]

Lansdale endorsed the "Basic Counterinsurgency Plan for Vietnam," which had been submitted to Washington by the U.S. embassy in Saigon in early January 1961.[4] The report called for major changes in the ways in which the Diem government was responding to the insurgency. Counterguerrilla forces and civic reform programs were needed to defeat the VC and win the support and loyalty of the peasants. The United States could provide assistance for these programs, but Saigon had to cooperate. In many ways, the plan was consistent with the views of the president and several of his key advisers. They believed that winning a guerrilla war, a war without fronts or conventional battlefields, required new policies and strategies. Things had to change in South Vietnam.

The challenge was significantly more complicated and difficult than the Philippine insurgency that Lansdale had helped defeat. In the Philippines, the problem was Huk-led internal communist subversion and guerrilla warfare. The Viet Cong were carrying out similar activities in South Vietnam, but unlike the Huks, the VC received external help, support, and direction from Hanoi. This outside assistance was the difference between the two situations, and it was pivotal.

The Counterinsurgency Plan sought to neutralize and defeat the Viet Cong challenge inside South Vietnam, a task that would be greatly simplified if North Vietnamese assistance was eliminated.

What could be done to convince Hanoi that supporting the Viet Cong was not in its interest? At this point in the NSC meeting, the president asked whether guerrilla operations could be mounted inside North Vietnam. Allen Dulles, the holdover director of the CIA, explained that limited efforts were being made to organize South Vietnamese guerrillas capable of harassing North Vietnam. But he acknowledged that only four teams of eight men each had been established under CIA auspices and that they were not deployed and operating inside North Vietnam on a permanent basis. Their mission was harassment in the border region of North Vietnam. Kennedy was told that "These teams had been allocated to working on a series of guerrilla pockets in the South of the country" and "moved in over the Laos border."[5] It was a marginal effort and not likely to discourage Hanoi in its struggle to unify Vietnam.

Kennedy was not happy with the CIA efforts and stated that he "want[ed] guerrillas to operate in the North."[6] This was the beginning of what would turn into the largest and most complex covert-operations campaign carried out by the U.S. government during the Cold War. From 1964 until 1972 it would be executed by the military, not the CIA. It included agent networks, a notional (imaginary or invented) resistance movement, deception, psychological warfare, maritime activities, and cross-border clandestine reconnaissance operations.

That covert-action campaign began on a Saturday morning in January 1961 when a new president decided that he was going to put Hanoi on notice that there was a price to be paid for its attempt to subvert South Vietnam. I want to do to North Vietnam what they are doing to us in South Vietnam, said JFK in effect, and do it now!

COVERT OPERATIONS AND SPECIAL WARFARE: NEW TOOLS TO FIGHT THE COLD WAR

In the 1950s, John F. Kennedy was part of a growing chorus of political figures, military officers, and academics who believed the United States needed to develop new tools and tactics to fight the Cold War. In Southeast Asia, Latin America, and elsewhere in the Third World the emerging threat was communist guerrilla warfare. This would define the conflict between East and West, and the United States needed to prepare for it. When he was president, JFK's personal inter-

est in fighting guerrilla warfare received wide publicity. He came to see "special warfare" as the way to counter guerrillas. In the military vernacular, these new "tools and tactics" consisted of three elements, according to Army doctrine: counterinsurgency, unconventional warfare, and psychological operations.

A great deal has been written about the Kennedy administration's enthusiasm for counterinsurgency. Douglas Blaufarb, a former senior CIA clandestine operator who as chief of station ran the agency's secret war in Laos in the mid–1960s, refers to the Kennedy years as the Counterinsurgency Era.[7] It involved a systematic attempt to defeat guerrillas by adopting their tactics. An often-heard refrain in the early 1960s was that you must be able to "steal their thunder." A specialist in these operations put it more formally: "It is necessary to parry the revolutionary weapons, adopt them, improve them for one's own use, and then turn them against the revolutionaries."[8]

While counterinsurgency received all the public attention and notoriety, Kennedy was equally preoccupied with unconventional warfare. According to military jargon of the early 1960s, unconventional warfare (UW) was to be carried out "in enemy held or controlled territory." The objective was "to take advantage of or stimulate guerrilla resistance movements against hostile governments."[9] This is what the OSS did in Europe and Asia during World War II. It involved fostering covert paramilitary operations inside an enemy state by organizing and supporting a guerrilla resistance movement from among the indigenous population. Through these activities, UW sought to undermine a hostile government by reducing its military effectiveness, economic viability, stability, and morale.

An important element of unconventional warfare was psychological warfare, or psywar, as it was often called. It consisted of "activities and operations planned and conducted to influence the opinions, emotions, attitudes, and behavior of the enemy [and] the indigenous population."[10] It is easy to see Kennedy's attraction to UW. This is precisely what he wanted to carry out inside North Vietnam.

Kennedy's advocacy of special warfare was part of his broader condemnation of Eisenhower's national security policy in general, and, in particular, of the doctrine of "massive retaliation." The Eisenhower administration asserted that the United States could use its technological advantages to determine how to respond to enemy threats and

challenges. Technology could substitute for manpower, and superior nuclear weapons would deter any and all stratagems devised by the Soviet Union and the communist bloc.

John Foster Dulles, Eisenhower's secretary of state, and an enthusiastic advocate of massive retaliation, put it this way before the Council on Foreign Relations: "A potential aggressor must come to know that he will not be able to impose battlefield conditions that suit him." Rather, "We will take advantage of our superior nuclear strategic strike capability to deter both direct and indirect, local and general, efforts by the communists to achieve gains at America's expense."[11] In other words, the United States, and not its enemies, would determine how, when, and where to fight.

In military terminology, massive retaliation was an all-purpose strategy that proponents believed could be used against any type of military challenge. As President Eisenhower stated in 1955, "I see no reason why nuclear weapons shouldn't be used exactly as you would use a bullet or anything else."[12]

Kennedy did not buy it. He was skeptical that it would work against guerrilla warfare and believed there was an urgent need for a thorough strategic reappraisal of this policy. This asymmetrical strategy gave the United States few options in a complex world of indirect warfare and unconventional challenges. Kennedy argued that "Events in Indochina and elsewhere have already knocked the props out from the assumptions of massive retaliation; and our reduction of strength for resistance in brushfire or guerrilla wars, while threatening atomic retaliation, has in effect invited expansion by the communists in areas such as Indochina through those techniques which they deem not sufficiently offensive to induce us to risk atomic warfare."[13]

Massive retaliation lacked credibility. Did anyone really believe that the United States would respond to a guerrilla war with nuclear weapons? Kennedy remarked sardonically that he found it difficult to consider that America would "commence atomic retaliation against the communist insurgency in Burma."[14] It was a reasonable criticism. The United States needed more, not fewer, options to respond flexibly to diverse challenges. Options had to be symmetrical, Kennedy thought. Thus, he devoted considerable attention to strengthening the overt and covert elements of special warfare. Two months into his administration the criticisms of Eisenhower were central to his call for

a new approach. In an address to Congress in March 1961 the president observed that "nonnuclear and guerrilla warfare have since 1945 constituted the most active and constant threat to Free World security." We require "a greater ability to deal with guerrilla forces, insurrection, and subversion . . . We must now be ready to deal with any size of force, including small externally supported ones; and we must train local forces to be equally effective."[15] In June 1962 he told the graduating cadets at West Point that the United States needed "a whole new kind of strategy" to meet these challenges.[16]

Kennedy surrounded himself with senior advisers who also advocated special warfare and covert-action options. His choice of General Maxwell Taylor as his military adviser is illustrative. Taylor purportedly understood the issues both intellectually and through firsthand experience. He had operated behind enemy lines in Italy and parachuted into France during World War II. In Korea, he organized counterguerrilla operations in the Chiri-san mountains in 1953. As Army chief of staff in the late 1950s, he was an in-house critic of Eisenhower's strategy. His subsequent condemnation of that strategy appeared in a highly touted book that Kennedy read and liked.[17] In 1961, in an article in *Foreign Affairs*, Taylor called on the United States to develop the capacity to respond to guerrilla subversion in the Third World.[18] Maxwell Taylor was the kind of general the new president was looking for. He understood what had to be done.

McGeorge Bundy was Kennedy's special assistant for national security affairs, a position Bundy redefined in terms of its importance. Kennedy chose Bundy because he epitomized the tough and activist image Kennedy was seeking. Bundy was frequently characterized as aggressive, brilliant, and willing to use force. David Halberstam would write of Bundy that he was part of the "ultrarealist school. Its proponents believed that they were tough, that they knew what the world was really like, and that force must be accepted as a basic element of diplomacy." For Bundy, covert action was a part of the game, an instrument "of normal diplomatic-political maneuvering."[19] Bundy would chair the 303 Committee, whose jurisdiction came to include all U.S. covert operations, including those directed against North Vietnam by the CIA and the military. It was established in 1961 following the Bay of Pigs because Kennedy wanted tighter control of secret activities.

Kennedy's secretary of defense, Robert McNamara, is most frequently identified with the conventional escalation of the Vietnam War that began in 1965. However, he was also a principal proponent of symmetrical responses to communist use of guerrilla warfare and covert activities. During 1961, McNamara, at Kennedy's instigation, doubled the size of the Special Forces and helped orient them toward counterinsurgency and unconventional warfare missions. After the Bay of Pigs debacle, McNamara was instrumental in transferring responsibility for larger covert operations from the CIA to the Department of Defense. In 1963, he played the major role in drafting and authorizing a new program of covert operations to be directed by the military against Hanoi.

Next there was Walt Rostow, Bundy's deputy and eventual successor. An economist from the Massachusetts Institute of Technology, he was at the forefront of thinking about special warfare and covert operations. His book, *The Stages of Economic Growth,* proposed an all-inclusive assault on the roots of communist insurgency and subversion to stop trouble before it started.[20] Rostow asserted that the United States had to go on the offensive against these new Cold War challenges. His ideas on special warfare, foreign aid, and development strategies for the Third World influenced Kennedy before he became president. It was Rostow who first read the report from Lansdale's January 1961 visit to Vietnam, and it worried him. He made sure that Kennedy saw it. Rostow had definite views on Vietnam and pushed for covert operations against North Vietnam following the NSC meeting of January 28, 1961.

Taylor, Bundy, McNamara, and Rostow were not alone. The president's brother, Robert Kennedy, was a counterinsurgency enthusiast and also saw it as the solution to the problems in South Vietnam. Another key figure was Roger Hilsman, who as a member of the OSS had organized guerrilla units to prevent the Japanese from taking control of Burma in World War II. He knew about UW firsthand. Hilsman's practical experience and intellectual interests drew him to special warfare, and he became a major proponent of counterinsurgency as the way to halt guerrilla threats to the Third World. William Bundy, a CIA veteran and the older brother of the national security adviser, also believed in the importance of covert operations. There were others.

The new theater of Cold War operations was the Third World, and special warfare doctrine and forces could provide important instruments for executing U.S. policy in this environment. The senior players in the new Kennedy administration were unanimous on this matter. Most important, their views were consistent with and reinforced those of the president.

THE LEGACY OF CIA COVERT OPERATIONS

Before 1961, U.S. experience in covert paramilitary operations of the kind that Kennedy wanted to conduct inside North Vietnam had yielded very few successes. CIA operators called these denied areas; they were tough targets to penetrate, let alone subvert. The Soviet Union, the countries of Eastern Europe, Communist China, North Korea, Cuba, and North Vietnam were all denied areas. One highly experienced U.S. intelligence officer has labeled them "counterintelligence states" because of their overriding attention to internal security and population control.[21] Intelligence and police forces abounded, countering all security threats, whether real or imagined. Building resistance movements and agent networks inside these denied areas had proved to be a daunting and, all too often, fruitless task for the CIA.

This had not been true of the United States' first serious effort at covert paramilitary and resistance operations, which took place during World War II. On June 13, 1942, following considerable bureaucratic infighting between the Office of the Coordinator of Information, directed by William Donovan, and the Joint Chiefs of Staff, the Office of Strategic Services was established by presidential order and placed under the jurisdiction of the Joint Chiefs. This was a contentious matter for the chiefs, who were concerned about command and control of covert paramilitary operations. Such actions were not carried out along traditional or conventional military lines, which worried the senior military leadership. Donovan contended that wartime demanded that covert paramilitary activities be geared to and coordinated with conventional military operations and that the OSS should be integrated with the U.S. military.[22]

OSS unconventional warfare operations inside enemy-held territory included psychological warfare or morale operations, in the OSS

vernacular, and the promotion of partisan resistance movements employing guerrilla tactics. The former sought to encourage local resistance to the enemy and to demoralize its personnel. The measures employed included dropping propaganda leaflets, broadcasting from clandestine radios, and assisting resistance movements to produce propaganda for distribution in occupied territory. Psywar included dirty tricks. According to one account, "Postal links between neutral Sweden and Nazi Germany [were used] to [falsely] implicate a number of Germans regarded as particularly effective in pursuing the war against the allies, in the June 20, 1944, bomb plot to kill Hitler."[23] Apparently, the forged material resulted in many executions.

The OSS also provided material support to resistance movements and sought to organize and train guerrillas in occupied Europe and parts of Asia. For example, in 1942, bases were established in India, Burma, and Ceylon for conducting guerrilla and commando operations against the Japanese. This turned into a major unconventional warfare effort. Similar operations were carried out in occupied Europe. In northern Italy, the Special Operations Branch of the OSS helped establish a resistance movement that tied up German troops and resources. In France, OSS units worked with the Maquis, the French Resistance, before and after D-Day to divert and disrupt German occupation forces. There can be little doubt that these operations made important contributions to the Allied victory.

Following World War II, the OSS was dissolved. President Harry S. Truman sought to minimize U.S. involvement in secret activities. It was peacetime, he reasoned, and such measures were not needed. This expectation did not last long as the reality of the Cold War set in. The Central Intelligence Agency was established as a part of the National Security Act of 1947. In 1948, two directives—NSC 4 and 4A—formally assigned responsibility for covert operations to the CIA.

Another directive in 1948, NSC 10/2, established the Office of Policy Coordination at the CIA to develop and execute covert-action options against the USSR and its allies. According to the document, "The National Security Council, taking cognizance of the vicious covert activities of the USSR . . . to discredit and defeat the aims and activities of the U.S. and other Western powers, has determined that . . . the overt foreign activities of the U.S. government must be supplemented by covert operations."[24]

The NSC assigned all the tricks in the covert-operations bag to the CIA: "Specifically, such operations shall include any covert activities related to: propaganda; economic warfare; preventive direct action, including sabotage, anti-sabotage, demolition and evacuation; and subversion against hostile states, including assistance to underground resistance movements, guerrilla and refugee liberation groups, and support of indigenous anti-communist elements." Thus, the CIA became the instrument through which the United States would carry out unconventional warfare operations against the USSR and its allies and surrogates in situations short of "armed conflict by recognized [conventional] military forces."[25]

The late 1940s and 1950s are frequently referred to as the CIA's golden age of covert operations, a fair but misleading assessment. To be sure, there were success stories. These included American assistance to Europe following World War II. The foreign policy goal was to forestall communist political expansion and rebuild democracy. Political parties, trade unions, cultural organizations, and related groups needed help as they struggled against better-financed and better-organized communist counterparts. They received that assistance from the CIA. Together with the economic and diplomatic support of the Marshall Plan, covert action made an important contribution to the rebuilding of Europe.

In the Philippines, covert action played a critical role in the 1950s in defeating a communist insurgency. From a geostrategic perspective, it was in the United States' interest to keep the communists from power there. Covert paramilitary assistance was part of a larger program that sought to encourage political reform and economic development in the Philippines. It worked; with Edward Lansdale's help, the Huks were defeated by Ramon Magsaysay, who was elected president in 1953.[26]

The most widely discussed and controversial success stories from the period involved the 1953 coup against Mohammed Mossadegh in Iran and the 1954 overthrow of the Jacobo Guzman Arbenz government in Guatemala. At the time, each operation was seen as a spectacular accomplishment in the protracted war being waged against Moscow. Iran was of great geostrategic importance to the United States, and the government of Mossadegh had appeared to be moving in Moscow's direction in the early 1950s. With hindsight, the opera-

tion in Guatemala, where the geostrategic factors and Moscow linkages are less clear, seems more questionable. Over the years, both operations have generated great debates over whether U.S. actions were defensible, in terms of both their long-term practical effects and their ethical implications for U.S. democratic principles. At the time, however, Iran and Guatemala were seen as crucial, and CIA covert political, propaganda, and paramilitary operations proved decisive in accomplishing U.S. policy goals.

These "success stories" heightened the CIA's reputation as an organization that could act quickly and efficiently. Covert operations had been successful, according to a leading specialist on intelligence, for several reasons. First, in Washington, "There was clear-cut, consistent policy coordination and leadership at the top that seized opportunities" to use the covert-action instrument effectively. Next, "Creative planners knowledgeable about their regions identified allies who shared specific American objectives." Finally, case officers capable of developing and executing "effective projects . . . were able to realize their objectives."[27]

Against denied areas, however, there were no similar CIA successes. During the late 1940s and early 1950s, the agency initiated several covert paramilitary operations that sought to destabilize and overthrow communist regimes inside the Soviet bloc. These included the Baltic republics of Estonia, Latvia, and Lithuania, Poland, the Ukraine, and Albania. Many agents were trained, given false papers, and inserted into these denied areas to develop resistance networks and carry out paramilitary operations. Few were heard from again.

One senior Army officer, assigned to the CIA at that time and involved in agent operations, put it this way when asked how the individuals he trained had fared. "I went down to the airfield each time an agent team was about to be inserted into a target country," he recalled, "to do a final check of their equipment and to wish them good luck. I remember one piece of equipment in particular. We referred to it as the belt of freedom. It resembled a larger version of a money belt and contained all the propaganda literature that was to be used by the agents to attract followers to the resistance." When asked how many agents were able to establish themselves and initiate operations, the now-retired officer said, "At the time none of those I was responsible for made contact after being inserted."

Two decades later, while serving as a defense attaché in the Soviet bloc, he finally encountered one of his men. At a reception one evening a man came up behind him and whispered, "I still have the belt of freedom." As the attaché turned to look, all he saw was the man's back as he left the room. He had survived, but that was about it.[28]

This story is illustrative of what took place in denied-area operations. For example, in the late 1940s the CIA and British intelligence tried to stir things up in Albania. It is now known that hundreds of Albanian émigrés were trained and sent back to establish a resistance movement and conduct guerrilla warfare. The results were disastrous. Many of the agents were publicly tried, and the operation had to be shut down in 1953.[29]

A similar sequence of events occurred in Poland. Thousands of Poles stayed in the West after World War II. As communism overran Poland, nationalist émigré organizations sprang up and claimed to have substantial networks behind the Iron Curtain. The Freedom and Independence movement, or WIN (its Polish acronym), was one such organization. The CIA believed it was legitimate and backed it with money, training, and the air-dropping of agents, arms, and other equipment to WIN units in Poland. In reality, WIN had been penetrated by Polish intelligence in the late 1940s, and inside Poland all operations were compromised and run back against the CIA.[30] It was another failure and part of a similar pattern found elsewhere in the Soviet bloc in the late 1940s and 1950s.

Operations against denied targets outside the Soviet bloc proved equally difficult. During the Korean War, the CIA attempted to carry out an array of covert activities that mirrored those of its OSS predecessor. Under the cover of the Joint Advisory Commission, Korea (JACK), the agency was tasked with stepping up pressure on Communist China by supporting guerrilla movements there, especially along the supply lines of its forces in Korea. One of JACK's members and, over a decade later, the third chief of MACVSOG in Vietnam, was then-Major John K. Singlaub. He had experience in covert action, both as a member of the OSS during World War II and in the latter half of the 1940s in Manchuria. Singlaub found little evidence of an established program when he arrived and became CIA deputy chief of station in Korea.[31]

JACK was able to insert into North Korea a handful of teams, whose members had family connections there and were able to survive. Singlaub notes that the agents did "deliver reliable intelligence on enemy troop movements." However, JACK was "never able to establish anything approaching a true Maquis-type resistance network," like that organized in France during World War II.[32]

In the latter half of the 1950s, CIA covert paramilitary operations against denied areas included Tibet and North Vietnam. Of all the denied-area operations at that time, the Tibetan program was the most successful, at least in the short term. Tibetan resistance grew out of harsh Communist Chinese occupation and rule. By 1954, partisan elements were fighting, and in 1955, a three-regiment force of the People's Liberation Army (PLA) was destroyed. As the rebellion expanded into 1956, the CIA established contact and began cooperation with the partisans. This included the provision of extensive equipment and training. As the conflict progressed, the Tibetans raised a skilled partisan army of approximately 100,000. They had a substantial impact on the People's Republic of China, causing it to divert significant manpower and resources. However, by 1960, the Chinese military had established control and the resistance was reduced to a minor nuisance. There was never any chance of Tibet's being liberated from the Chinese communists. For the United States to attempt to do so would have risked nuclear war. This game was not worth the gamble. Washington's policy was one of harassment of Communist China, and that ended in the early 1960s when the Chinese military took charge in Tibet.

Operations against the North had begun in 1954, following the Geneva Accords that divided Vietnam at the 17th parallel into two countries: South Vietnam (Republic of Vietnam) and North Vietnam (Democratic Republic of Vietnam). The division was to be temporary, and provisions were made for free elections in 1956, with the goal of reunification. While the United States did not sign the Accords, it did publicly agree with them. Nevertheless, by not signing the agreement, Washington gave itself a loophole for avoiding compliance. Lansdale was sent to plan and execute a campaign of covert warfare against the new communist regime in Hanoi. Following the Geneva Accords there was a 300-day population resettlement period when Vietnamese in both the North and South were given the opportunity to relocate.

Before the period ended, Lansdale was able to train, equip, and infiltrate a handful of small paramilitary teams into North Vietnam. Caches of arms were smuggled in along the coastline by a secret U.S. Navy unit. Not much came of these efforts, as the new regime in North Vietnam mopped up Lansdale's stay-behind teams. Ho Chi Minh, on the other hand, ordered some 10,000 Vietminh agents to stay in place in South Vietnam and form an underground network. Their purpose was to "destabilize the fledgling South Vietnamese nation through political agitation and propaganda, and provide the seeds of an 'indigenous' southern insurgency should Ho order one."[33]

In 1956, the CIA helped establish the First Observation Group, a paramilitary organization operating outside the South Vietnamese Army chain of command. It was under the direct control of President Ngo Dinh Diem. Its initial mission was to organize guerrilla forces just below the 17th parallel as stay-behind units in the event of a North Vietnamese invasion. The CIA felt the First Observation Group had the potential to conduct unconventional warfare on the other side of the 17th parallel to disrupt North Vietnamese Army lines of communication and to gather intelligence. In 1958, there was a joint Diem-CIA agreement to conduct agent operations against Hanoi. Not much came of this arrangement, as CIA Director Dulles pointed out in response to President Kennedy's question at the January 28, 1961, NSC meeting. There were no U.S.-run resistance teams operating inside North Vietnam on a sustained basis.

The same was not true for Hanoi's efforts in the South. In 1957, Ho's stay-behind cadre began to carry out propaganda, armed attacks, and recruitment to build a clandestine organization. Former southern cadres that had relocated to the North in 1954 began to make the trip back by way of what would become known as the Ho Chi Minh Trail. In 1959, this reinvigorated network unleashed, on Hanoi's orders, a terror and assassination campaign against South Vietnamese officials and village chiefs. According to U.S. figures, "2,500 assassinations took place in 1959, more than double the previous year," and "sabotage, previously localized, became widespread."[34] Hanoi had authorized an armed struggle in the South, and as Lansdale told Kennedy and the members of the National Security Council at the January 28, 1961, meeting, it was putting the Diem government at risk. Lansdale implored the new administration to

"recognize that Vietnam is in a critical condition and should treat it as a combat area of the Cold War, as an area requiring emergency treatment."[35]

This was the legacy of CIA covert operations against denied areas that the Kennedy administration inherited. Since the days of the OSS, there were few success stories. For nearly fifteen years, operations against the denied areas of the Soviet Union, Eastern Europe, Communist China, North Korea, and North Vietnam bore little fruit. Consequently, when President Kennedy insisted on that January day in 1961 that he "want[ed] guerrillas to operate in the North," he was asking the CIA to undertake a mission it had had little success executing against other denied areas.

Furthermore, North Vietnam was, in the eyes of one of the CIA officers dispatched to Saigon to execute the mission, one of the toughest denied areas. Before his 1963 assignment to South Vietnam, Herbert Weisshart had conducted denied-area operations against "North Korea, mainland China, [and] even North Vietnam from a different base"[36] for over ten years. He knew Asia. Weisshart had studied both the Chinese and Japanese languages, as well as East Asian affairs, while at Harvard University in the late 1940s. He had been a student of professors John Fairbanks and Edwin Reischauer, two of the country's top experts on China and Japan. What Kennedy wanted us to do, Weisshart explained, was very difficult. "Of all of the denied area targets at the time to include the USSR, PRC [People's Republic of China], GDR [German Democratic Republic], North Korea . . . I believed North Vietnam was the most difficult target against which to run psywar and other covert operations."[37]

Weisshart believed this for six critical reasons. First, "Unlike occupied France . . . where the Maquis resistance had formed and welcomed support from the outside, no incipient or developed resistance existed in North Vietnam (NVN)." The United States would have to create it. Second, "The NVN rulers and people were still exulting and living in the aftermath of their having won independence from colonial oppression by militarily defeating the French in 1954." There was still popular support for "the Hanoi regime's effort to build a progressive and economically sound nation." This was the case, Weisshart claimed, even though North Vietnam had carried out a very harsh land-reform program in the latter 1950s. Third, "Controls over

personal movements in the urban, country, coastal, and border areas were exceptionally strong." Fourth, "Once the borders were closed there was no outward flow of Catholic, ethnic tribe or other disgruntled individuals who might be sought for recruitment purposes." Fifth, "There was little non-communist travel or commerce into NVN cities or ports. Thus, there was almost no opportunity of entry by recruited agents or casual informants who could bring out intelligence from NVN and be debriefed." Sixth, "The SVN political and economic situation in the early 1960s offered little in the way of an attractive alternative to the NVN target audience."[38]

To what extent did President Kennedy, Mac Bundy, Walt Rostow, Bob McNamara, Max Taylor, Bobby Kennedy, Bill Bundy, and the other special warfare and covert-action enthusiasts know this history of CIA denied-area operations? Did they understand the difficulty of initiating an unconventional warfare campaign inside North Vietnam? Were they aware of the requirements for successfully executing such an effort? As it turns out, they had little insight into how complicated carrying out a covert campaign inside North Vietnam was going to be.

KENNEDY AND VIETNAM: EARLY POLICY GAMBITS

John Kennedy's concern over Vietnam began long before he entered the White House. In 1953, he spoke out against French colonialism in Vietnam and asserted that the first requirement for U.S. involvement was "independence for Indochina."[39] He was critical of Eisenhower for being too cozy with the French.[40] Following the Geneva Accords of 1954, JFK came to be associated with the American Friends of Vietnam, an eclectic organization of former leftist-leaning intellectuals, conservative generals, and public officials of various political points of view. They hoped to find a "third way or independent nationalist alternative" for South Vietnam. Members included liberal intellectuals such as Max Lerner and Arthur Schlesinger, Jr., the socialist leader Norman Thomas, Leo Cherne of the International Rescue Committee, Cardinal John Spellman, Generals William "Wild Bill" Donovan and Michael "Iron Mike" O'Daniel, Supreme Court Justice William O. Douglas, conservative Governor J. Bracken Lee, liberal Senator Mike Mansfield, and Joseph P. Kennedy, the father of then-Senator Kennedy. Also involved was then-Colonel Ed Lansdale.

The Friends of Vietnam believed that Ngo Dinh Diem was the "independent nationalist alternative" needed to combat the communists. They were able to build support for him in the United States in the waning years of the Eisenhower administration. This translated into increasing foreign assistance. Unfortunately, inside South Vietnam, Diem was not proving to be a very successful alternative to the Viet Cong. In fact, as Kennedy moved into the White House the situation was marked by a rapid decline in the effectiveness of the Diem government, as well as the growing activism and power of the Viet Cong. U.S. intelligence estimates during 1960 "began to reflect the conviction that Diem's political base had been seriously eroded, and that the Democratic Republic of Vietnam (DRV)-supported Viet Cong posed a vital threat" to the survival of South Vietnam.[41]

On the heels of these reports came a very pessimistic end-of-year National Intelligence Estimate (NIE) on Vietnam. The NIE reports were regarded as the premier products of the U.S. intelligence community, and the report on Vietnam was a very significant document. The bad news it contained was soon compounded by Lansdale's trip report and the Counterinsurgency Plan for Vietnam, drafted by the U.S. Military Assistance Advisory Group in Saigon. Within the first days of his presidency, the situation confronting Kennedy was bleak and deteriorating. He wanted to take action quickly, but he was to learn that bureaucracy seldom moves at full throttle.

In early March, JFK inquired about his late-January request that the CIA commence covert operations inside North Vietnam. How were things progressing? Were we giving the North Vietnamese a taste of what they had been doing in the South? He discovered that little had transpired in a month and a half. In response to this bureaucratic lethargy, he quickly issued National Security Action Memorandum 28. Instead of requesting action, he now ordered the CIA to respond to the "President's instructions that we make every possible effort to launch guerrilla operations in North Vietnam territory."[42]

In April, Kennedy directed the deputy secretary of defense, Roswell Gilpatric, to head an interagency Presidential Task Force to draft a "Program of Action for Vietnam." Lansdale was appointed operations officer, and other key members included Rostow; U. Alexis Johnson, the deputy undersecretary of state; and Desmond Fitzgerald, chief of the Far Eastern Division of the CIA's Directorate of Plans.

The objective: "to counter the Communist influence and pressure upon the development and maintenance of a strong, free South Vietnam."[43]

The Task Force report was ready for the president in early May. It began with more bad news. Its "appraisal of the situation" was grim. "Despite greatly stepped up efforts by South Vietnamese forces . . . 58% of the country [of South Vietnam] is under some degree of communist control, ranging from harassment and night raids to almost complete administrative jurisdiction in the Communist secure areas."[44] The Task Force recommendations, while focusing primarily on internal security and development in South Vietnam, included covert action against North Vietnam.

On May 11, the president reviewed the report and approved the program's recommendations. It had a grandiose concept of operations: "The U.S. objective [was] . . . to prevent Communist domination of South Vietnam; to create in that country a viable democratic society, and to initiate, on an accelerated basis, a series of mutually supporting actions of a military, political, economic, psychological, and covert character designed to achieve this objective."[45] With it, recorded and issued as NSAM 52, the president ordered the bureaucracy to take action.

At this time, the CIA was in the midst of generating a program of covert operations against North Vietnam. It consisted of infiltrating agent teams and individual agents (singletons) for intelligence collection, psychological warfare (radio broadcasts, leaflets, and gift-kit air-drops), maritime operations against the NVN coast (intelligence collection, psywar, and sabotage), and creation of a notional resistance movement.

Herb Weisshart, the deputy chief of the Combined Studies Division (CSD) of the CIA's Saigon Station in the early 1960s, characterized "these operations as very modest. It was a small program . . . I'd say 90% of the CIA effort was in the South."[46] Why a modest program, given the president's demands? Weisshart asserted that William Colby, CIA's chief of station in South Vietnam at the time, was instrumental in constraining covert action against the North because he believed a large effort there would consume CIA resources needed for the operations inside South Vietnam. Constraining the North Vietnam operation "was not a bad idea because he [Colby] could see

where the future was going and that South Vietnam would be a greater challenge . . . in terms of the U.S. commitment."[47]

In the midst of this lethargic response to Kennedy's Vietnam directives, the Bay of Pigs fiasco unfolded. It was another CIA flop against a denied area and a huge political embarrassment for the president. During the 1960 election campaign, Kennedy had described Cuba as "the most glaring failure in American foreign policy . . . a communist menace that has been permitted to arise under our very noses."[48] Of course, what he was really saying was that it had been permitted to arise under the noses of the Eisenhower administration. The Castro regime was "a supply depot for communist arms and operations throughout South America—recruiting small bands of communist-directed revolutionaries to serve as the nucleus of future Latin revolutions." It was a "hostile and militant communist satellite," receiving "guidance, support and arms from Moscow and Peking."[49] Kennedy vowed that things would be different in his presidency. He offered strong rhetoric, real "red meat." However, in April 1961, Kennedy failed to back his campaign bravado with action. The result was the Bay of Pigs debacle.

Heads rolled and changes were made. First, CIA Director Allen Dulles and his deputy director for plans, Richard Bissell—architects of the invasion—were forced out. But Kennedy believed the problem ran deeper than Dulles and Bissell. It was institutional. The Bay of Pigs soured Kennedy on the CIA's ability to plan and execute covert paramilitary operations. Just two months after the fiasco on June 28, 1961, Kennedy approved three National Security Action Memoranda—numbers 55, 56, 57—to redefine and transfer executive branch responsibility for executing unconventional-warfare operations from the CIA to the Pentagon.

NSAM 55—Relations of the Joint Chiefs of Staff to the President in Cold War Operations—eliminated exclusive CIA authority over planning and executing covert paramilitary operations. Addressed to the JCS chairman, Kennedy's memorandum stated: "I look to the Chiefs to contribute dynamic and imaginative leadership in contributing to the success of the military and paramilitary aspects of the Cold War programs."[50] It was the first step by the president to reduce the CIA's authority over covert paramilitary operations.

The next gambit was NSAM 56—Evaluation of Paramilitary Requirements. It requested that the secretary of defense "inventory

the paramilitary assets we have in the U.S. armed forces, consider various areas of the world where the implementation of our policy may require indigenous paramilitary forces, and thus arrive at a determination of the goals we should set in this field." Having identified the assets required to meet possible policy requirements, "it would then become a matter of developing a plan to meet the deficit."[51] General Lansdale was assigned to compile the inventory, identify the deficits, and recommend those assets that would have to be generated so the Pentagon could execute covert paramilitary operations.

Lansdale produced several papers for Deputy Secretary of Defense Gilpatric. One addressed the challenge of how to "carry unconventional warfare to the enemy." Lansdale observed that "current plans for action against North Vietnam appear to be about as extensive as can be made under present U.S. policy." What he wanted to do was change that policy and expand Defense Department assets. "Consideration should be given to a long-range policy towards North Vietnam. If the Communists can wage subversive war to capture a country, then it is high time," declared Lansdale, "that we paid them in the same coin."

Lansdale proposed establishing an anticommunist resistance movement inside North Vietnam. Admittedly, this would not be easy. The operation would be "long and arduous." However, "if our objective was to create a situation akin to that in Hungary, and then be prepared to help, with the end objective of uniting Vietnam," this would necessitate that a "considerably larger program be planned for actions against North Vietnam."[52]

Lansdale's proposal was controversial, to say the least. "Creating a situation like Hungary" was highly provocative inside the U.S. government. For example, at the CIA such ideas were unwelcome after 1956. One of the most contentious operations proposed was the establishment of agent networks inside North Vietnam, with the objective of developing a resistance movement. The Washington bureaucracy, particularly the State Department and the CIA, resisted that proposal. Hungary had a whole different meaning for them. They drew the lesson from the Hungarian revolt in 1956 that such uprisings would not be supported by Washington and could lead to world war. Therefore, rebellions inside communist states were to be eschewed rather than encouraged.

Finally, and most important, NSAM 57 set the bureaucratic ground rules for planning and executing covert paramilitary operations by the CIA and the Defense Department. It stated that any proposed paramilitary operations that must be "wholly covert or disavowable, may be assigned to CIA, provided that it is within the normal capabilities of the agency." The key phrase here was "normal capabilities of the agency." NSAM 57 stated that "Any large paramilitary operation wholly or partially covert which requires significant numbers of militarily trained personnel, [and] amounts of military equipment" will be construed to "exceed normal CIA-controlled stocks and/or military experience of a kind or level" needed for such operations. These larger programs would become "the primary responsibility of the Department of Defense with CIA in a supporting role."[53]

NSAM 55, 56, and 57 illustrated Kennedy's dissatisfaction with the CIA and his determination to develop the operational means to conduct UW against North Vietnam and other denied areas. He was not about to concede the new battlefield to the other side. Beyond the operational level, this conviction was evident in other policy initiatives. For the counterinsurgency elements of special warfare, a Special Group (Counterinsurgency) was created in January 1962 by NSAM 124. Its purpose was to establish policy-level oversight to "insure proper recognition throughout the U.S. Government that subversive insurgency is a major form of politico-military conflict equal to conventional warfare," and "to insure the development of adequate interdepartmental programs aimed at preventing or defeating subversive insurgency and indirect aggression in countries and regions specifically assigned to the Special Group."[54]

Another top-level group—the 303 Committee—was assigned responsibility for White House control of covert action, including paramilitary operations.[55] Its jurisdiction came to include all important covert operations worldwide. The 303 Committee had responsibility for the CIA's 1961–1963 operations against North Vietnam. In 1964, military-directed covert action against North Vietnam would become one of its principal accounts. Members of the committee included McGeorge Bundy, the national security adviser; Roswell Gilpatric, the deputy secretary of defense; U. Alexis Johnson, the deputy undersecretary of state for political affairs; and Richard

Helms, the deputy director of central intelligence. Bundy chaired the committee. The Joint Chiefs of Staff also had a senior representative. According to Gilpatric, it was General Maxwell Taylor, the chairman. He also noted that on occasion, "McNamara would come into those meetings. Whenever there was any major program under consideration, I would alert him, and he would come."[56]

Given the Pentagon's increased role in counterinsurgency and covert warfare, the Joint Chiefs established the office of the Special Assistant for Counterinsurgency and Special Activities (SACSA), reporting directly to the chairman. The SACSA was to provide staff support to the secretary of defense and chairman of the JCS in carrying out the requests of the Special Group (Counterinsurgency) and the 303 Committee. At the Washington level, it was to help plan and direct those special warfare operations in which the Defense Department was participating. All defense components involved in these missions were to provide SACSA with the support it required. Established in February 1962, the first SACSA was Marine Corps Major General Victor H. "Brute" Krulak.

Krulak was an innovative thinker. As a young officer observing Japanese operations against China in the late 1930s, he came up with the hull design for a landing craft that solved the problem of rapidly unloading assault forces coming from the sea. The result was the LCVP, the standard landing craft used by the Marines in the Pacific during World War II. Krulak also distinguished himself in combat during the war by leading unorthodox and dangerous nighttime amphibious raids. On one of those missions a landing craft carrying about thirty of Krulak's raiders struck a reef and began sinking. They were saved by the courageous action of a torpedo-boat crew commanded by a young Navy lieutenant named John Kennedy. Lieutenant Colonel Krulak expressed his gratitude to him. In 1961, now Major General Krulak and President Kennedy became reacquainted when Krulak went to visit the new president in the White House. They sat together and reminisced about their World War II adventures. An old bond was reestablished. They hit it off, and Krulak quickly became one of the president's favorite generals. Consequently, when Kennedy needed a senior officer for the new position of SACSA, he picked Krulak.[57] It was another indication of how closely President Kennedy monitored his new special warfare policy.

Thus, as 1961 ended and 1962 began to unfold, President Kennedy

had made several bureaucratic and policy moves in order to be able to "make every possible effort to launch guerrilla operations in North Vietnam territory." Unfortunately for the president, little but disappointment lay ahead.

CIA OPERATIONS AGAINST NORTH VIETNAM: TOO LITTLE AND NOT FAST ENOUGH

The administration's perspective on Vietnam during 1962 was schizophrenic. It began with a pessimistic assessment of the situation. There were few signs of improvement. On January 15, 1962, Defense Secretary McNamara convened a conference to assess this deteriorating situation and develop options. He wanted to move fast to beef up the U.S. effort in Vietnam. McNamara concluded that a new command at the operational level was needed that could achieve unity of effort and get things moving in the right direction. On February 8, the administration established the U.S. Military Assistance Command, Vietnam. MACV, which was a unified subordinate command of the Commander in Chief, Pacific, was assigned responsibility for all American military activities in Vietnam. Advisers began to flow into South Vietnam to execute McNamara's new options and reverse the VC tide.

MACV's commanding general, Paul Harkins, was confident that this could be accomplished in 1962. Harkins was Max Taylor's choice for the job. They were close associates, going back to the late 1940s at West Point, when Taylor was the superintendent and Harkins his commandant of cadets. When Taylor commanded the Eighth Army in Korea, Harkins had been his chief of staff. But Harkins was an odd choice, given the type of conflict taking place in Vietnam. He had absolutely no experience with insurgency warfare, and the staff he assembled at MACV was equally devoid of counterinsurgency expertise.[58] Nevertheless, Kennedy and McNamara accepted Taylor's choice of Harkins.

For the administration, 1962 quickly came to be dominated by two other issues—the Cuban missile crisis and Laos. Vietnam was relegated to the back burner, although ultimately the Geneva settlement on Laos had a profound, if unintended, impact on the conflict in South Vietnam. For Hanoi, the Ho Chi Minh Trail in Laos would prove critical to its war in the South.

For North Vietnam, the trail was what the great Prussian philosopher of war Carl von Clausewitz called a "center of gravity." This refers to an enemy's "hub of all power and movement, on which everything depends." Clausewitz asserted that a commander able to identify and disrupt the "centers of gravity" could strategically impair the enemy's ability to wage war.[59]

The Ho Chi Minh Trail was a communication and transportation system that consisted of an NVA logistical supply network, command-and-control structure, and troop staging areas. Geographically, it was located along a complex network of paths and roads stretching from North Vietnam through Laos and into South Vietnam. There was also a Cambodian extension. The trail was one of Hanoi's strategic keys for fighting the war in the South. It provided a decisive logistical advantage, as well as the benefit of moving forces quickly from sanctuaries in Laos and Cambodia to battlefields in South Vietnam. The foremost authority on military geography, John Collins, has noted that "the Ho Chi Minh Trail . . . was nothing more than a skein of rustic traces through the wilderness when it opened in the late 1950s. Dedicated men, women, boys, and girls bent bandy-legged beneath heavy loads trudged down those paths, all but ignored by senior officials in the United States and the Republic of Vietnam (RVN) because the invoices were unimpressive: a little rice, a few pitted handguns captured from the French, homemade weapons pieced together like Rube Goldberg toys."[60] This depiction of the trail changed dramatically in the 1960s.

By 1962, NVA General Vo Bam and the 559th Transportation Unit were well into the third year of constructing infiltration routes into the South. They had begun work on the trail as a result of a May 1959 decision by North Vietnam's Central Committee to escalate the insurgency in the South. For General Bam, it was a great honor to be entrusted with the "task of organizing a special military communication line to send supplies to the revolution in the South." Twenty-five years later he would reflect that "never before in my soldier's life, so full of special assignments, had I felt so moved as I was then. I knew that a crucial task was awaiting me."[61]

Things were progressing nicely by 1962 for General Bam and the 559th. According to a CIA report from the previous summer, Hanoi had, in the month of June alone, infiltrated 1,500 troops into South Vietnam. While this would be considered only a trickle a few years

later, in June 1961 it constituted a doubling of what had occurred in the preceding months. The report added that Hanoi could easily increase infiltration down the trail should it choose to do so.[62]

Consequently, the situation in Laos was becoming a serious problem for Kennedy. Something had to be done to stem the flow. Rostow and Taylor recommended a joint Lao, Thai, and SVN military operation against a key part of the trail to disrupt infiltration. U.S. Special Forces would serve as advisers. Taylor and Rostow also called for a range of other actions against North Vietnam, including bombing.[63]

Kennedy was not ready for these alternatives. Military intervention into Laos and bombing North Vietnam were out of the question. He stated, "I want to have a negotiated settlement. I do not want to become militarily involved."[64]

Those negotiations were under way in Geneva and on July 23, 1962, resulted in the "neutralization" of Laos. How it came about is a complex story, and in hindsight, the results were lamentable. However, at the time the president praised the agreement for allowing the United States to avoid military intervention.

The key figure at Geneva was W. Averell Harriman. Born into one of America's most well-known and wealthiest families, Harriman amassed a fortune of his own during World War I through the Merchant Shipbuilding Company. By the mid–1920s, at the age of thirty-three, he owned the largest merchant fleet in the United States. During the 1930s, he branched out into his father's railroad empire and became chairman of the board of the Illinois Central in 1931 and of the Union Pacific in 1932.

World War II brought Harriman into the U.S. government, and he launched a four-decade career as a powerful and freewheeling diplomat. During the war, he represented the Lend Lease program to the British and the Russians, serving as President Franklin D. Roosevelt's special envoy to Winston Churchill and Joseph Stalin. In 1943, Harriman was appointed ambassador to Moscow. This was the beginning of a long-standing interest in U.S.-Soviet relations and his conviction that he knew how to deal with Moscow. Following World War II, Harriman helped shape American foreign policy in the early days of the Cold War. In 1948, Truman appointed him as the official U.S. representative in Europe for the Marshall Plan, and in 1951, U.S. representative to NATO.

Inside government, Harriman developed a reputation as a vicious and brutal bureaucratic infighter. Anyone who tangled with him could expect a blunt rebuke. His approach to bureaucratic negotiations was described by his staff as "water torture. He would make the same point over and over, until his adversaries gave in." After watching Harriman in action, Mac Bundy began calling him the Crocodile: "He just lies up there on the riverbank, his eyes half closed, looking sleepy. Then, whap, he bites." The nickname stuck. "Bobby Kennedy gave Harriman a gold crocodile, and Harriman's staff gave him a silver one," with the inscription, "from your victims."[65]

In spite of his diplomatic experience, Harriman was going nowhere in the new administration. At first he held the innocuous title of ambassador-at-large, a position without power in Washington. In October 1961, Kennedy appointed him assistant secretary of state for Far Eastern affairs. This was the bureau in State that had been most damaged by the McCarthy period. After all, it had lost China. Upon taking over, Harriman described the bureau as "A wasteland . . . It's a disaster filled with human wreckage."[66]

Harriman became involved in Laos almost by default. It was not an issue he viewed with particular interest. But he saw the assignment as his path back into power: the president wanted a "negotiated settlement," and Harriman got it for him. He was rewarded with an appointment as the undersecretary of state for political affairs.

Laos was a complicated, almost bizarre, situation.[67] It had gained political independence after the Geneva Conference of 1954 but quickly fell into a power struggle between the communist Pathet Lao, headed by Prince Souphanovong, and the Royal Lao Government, headed by Souphanovong's half-brother, Prince Souvanna Phouma. It soon became more than a family squabble. Hanoi backed Souphanovong, and the U.S. supported Souvanna Phouma. Between 1954 and 1959, the Pathet Lao, which held only two northeast provinces, sought to expand its power, while the government attempted to regain control of these areas. In 1959, mounting hostilities culminated in a communist offensive, supported by Hanoi, against Royal Lao Army outposts in northeast Laos.

During the years 1959 to 1962, the conflict deteriorated into a protracted internal war. The period was marked by coups and counter-coups in the Royal Lao Government that resulted in the emergence of

a neutralist faction led by Prince Souvanna Phouma and a right-wing element headed by General Phoumi Nosavan. The general seized power in December 1961, and Souvanna Phouma fled to Cambodia. During early 1962, he set up headquarters on the Plain of Jars in central Laos.

This split only strengthened the Pathet Lao and Hanoi's position in Laos. Neutralists found themselves in an alliance of convenience with the Pathet Lao. Moscow soon entered the picture, ostensibly on the side of Souvanna Phouma, who had first requested Soviet assistance after the United States had suspended aid to his government and threatened to withdraw advisers in the period just prior to Phoumi's seizure of power. The Soviets now used the invitation to supply NVA forces and their Pathet Lao clients in northern Laos. The neutralists received what was left, after the NVA and Pathet Lao took their cut. It wasn't very much.

This was the situation when Harriman entered the scene. He believed Souvanna Phouma was the key to a negotiated settlement. Harriman prodded the three factions to agree, in principle, to form a government of national unity, and by December 1961 the Geneva Conference had approved a provisional draft for a declaration of neutrality. The big problem for Harriman, reported David Halberstam in *The Best and the Brightest*, "was trying to convince the Soviets that they had little to lose" by agreeing to the neutrality settlement. Halberstam suggested that Harriman thought it was a tough sell.[68] In retrospect, one wonders if Moscow hadn't understood the ramifications of Laotian neutrality much more clearly than did Harriman and the administration in Washington. Two of the three parties to the settlement were Soviet allies. Equally important, while the agreement would ostensibly bring the immediate Laotian crisis to an end, it would not stop General Bam and the 559th from working on construction of the trail.

In June 1962, the Laotian factions met on the Plain of Jars to hammer out the agreement and to form a coalition government of national union. It took effect on June 23, and Laos was declared neutral on July 6. As a result, all foreign forces—U.S., Soviet, North Vietnamese—were to leave Laos. They all did—except for the NVA.

An International Control Commission, which was in charge of the checkpoints for departing foreign troops in Laos, recorded the with-

drawal of only forty members of the NVA. It was estimated that there were 10,000 NVA soldiers in northern Laos,[69] not even including General Bam's 559th Transportation Unit. In effect, the Kennedy administration had conceded Laos and unencumbered use of the Ho Chi Minh Trail to Hanoi. Intelligence estimates reported that by the spring of 1963, NVA troops had pushed General Phoumi's forces farther back from the expanding trail network, and truck convoys were moving supplies over a 100-kilometer stretch of road. In Saigon, General Harkins sought to downplay these facts as unconfirmed rumors.[70]

While Laos's "neutrality" was being negotiated in 1962, the CIA's program of covert operations against North Vietnam, such as it was, was in full swing. Headed by Gilbert Layton, the North Vietnam Operations Branch of the CIA's Saigon Station contained only a handful of operators. Some of them, like Lucius "Three Finger Luigi" Conein and Tucker Gougelmann, would become legends. The chief of the Saigon Station was Bill Colby, a rising star in the agency. A veteran of the OSS, he had worked with the French resistance during World War II. That experience had demonstrated to him the value of covert operations. Like those of many of his CIA contemporaries, Colby's academic pedigrees were all Ivy League. An undergraduate at Princeton, he received his law degree from Columbia after World War II. Colby was a practicing labor attorney before joining the CIA in 1950. By 1959 he was chief of station in Vietnam. This was followed by an assignment as chief of the Far Eastern Division of the CIA's Directorate of Plans. Colby explained that the purpose of the covert program was "to increase the insecurity in North Vietnam to match the insecurity that they were producing in South Vietnam." Kennedy was receptive to the idea, Colby would recall.[71]

What did these operations entail? How extensive were they? Was Hanoi feeling more apprehensive about its internal security in 1962? According to Colby, the covert-action program during the 1961–1963 period had been a modest effort. It included "agent teams [that] were infiltrated into North Vietnam." When asked for what purpose, Colby responded that his initial thinking had been "to establish a base for resistance guerrilla operations." This was not, however, the mission that he actually assigned to the teams that he sent North. At first, they were to collect intelligence. In 1962 this changed to sabo-

tage and harassment. The next year the agent teams were told to carry out psychological warfare.

Whatever the mission, the result was almost always the same. It was a debacle. North Vietnam was not wartime France, as Colby came to learn. More than thirty agent teams and several singletons were dispatched from South Vietnam to North Vietnam by land, sea, and air during the 1961–1963 period. Many of the agents were former residents of the North who moved South under the clause in the 1954 Geneva Accords permitting population relocation. All too often, the CIA's official chronology had remarks like the following next to a team's code name: "captured soon after landing"; "doubled, played [back], terminated"; "no contact; lost contact."[72] In fact, by the end of 1963, only four teams and one singleton were thought still to be operating inside North Vietnam. The rest were dead, in prison, or acting under enemy control.

It was all too reminiscent of past denied-area operations, as Colby would lament: "You know that we got involved in supporting a Polish resistance organization that turned out to be totally manipulated. The East Germans have said that many of our so-called agents were really being run by them. The Cubans more recently have said the same. So, [North Vietnam] isn't a novel situation."[73]

Several factors accounted for the CIA's misfortunes in North Vietnam, most of them due to CIA ineptitude. First, the CIA was not the one recruiting and vetting the agents selected for the teams. Its South Vietnamese counterpart was in charge of selecting former NVN residents who were living in the South. Quality control was a problem. Second, inserted teams were spread out in the North, and there was no attempt to focus on a given location and then expand. There were no friendly elements in the areas where the teams were infiltrated. These insertions were known as "blind drops," because, as Colby noted, "There was nothing to drop to. There were no intelligence networks [in place in North Vietnam]."[74] Furthermore, some teams were parachuted into very remote areas that were of little importance and where survival was a highly demanding task. Third, teams depended on resupply by air, but this was difficult given the CIA's limited air assets. Fourth, teams were given little in the way of false identification and documentation to survive in the controlled-security environment of North Vietnam. Finally, there were serious questions regarding the

security of the operation. Some wondered if it had been penetrated by North Vietnamese intelligence.

These were not the results President Kennedy wanted. Herb Weisshart, reflecting on the operation, explained that the outcome was not surprising: the teams "were never invited in, there was no resistance up there . . . The main problem was the operational climate . . . It did not allow for the easy insertion of agents. There was no one to hook up with and start a resistance operation. Certainly it was not possible in terms of the way we were trying to do it."[75] North Vietnam was not France during World War II, said Weisshart, but more like the denied areas of the Baltic Republics, Poland, Albania, and the Ukraine. However, there was one big difference between North Vietnam and the communist bloc countries in the 1950s. Hanoi was at war with a superpower, a fact overlooked by Weisshart.

In addition to agent teams, the CIA's Saigon Station carried out small-scale maritime operations (marops) against the North Vietnamese coast. Here also, the mission of Tucker Gougelmann's NVN operations branch was changing. It began as reconnaissance and intelligence collection. Shortly thereafter, agent team insertion by sea was added. In 1962, the mission became harassment and sabotage raids. Gougelmann, in charge of these marops, was a tough former Marine who had been severely wounded in the Pacific during World War II. As a CIA officer, Gougelmann had run denied-area operations against Eastern Europe in the 1950s before moving on to Vietnam.[76] But his maritime operations against the North were modest and accomplished little, according to Admiral Harry D. Felt, the head of Pacific Command in 1962. At that time, Felt believed that covert action could have worked against Hanoi, causing it to stop supporting the insurgency in the South. However, much more had to be done than these "forays into northern waters, since they were neither fast enough nor sufficiently armed" to have any impact. "CIA's planners were not suitably trained to mount naval missions of this type," in his view.[77] By the end of 1962, the marops component of the CIA's program received motor torpedo boats for the runs up North. The next year, Norwegian patrol boats (PTFs), or "Nasties" arrived. Still, the operation remained small-scale, and at most a minor nuisance for Hanoi.

By the end of 1962, Colby had seen enough. He planned to change the focus of the CIA's covert operations against North Vietnam to one

that emphasized psychological warfare, which up to that point had been negligible. He had concluded, "The agent operation did not work. It was my thesis that if we worked reasonably hard on psychological operations, which included radios and things like that, you could have an impact because the communists are so hyper about the danger of resistance that if you suggest that there was any opposition group within their ranks, it would drive them crazy."[78]

Herb Weisshart was sent to Saigon to head CIA's psywar effort. He had done it all before against other targets. "Almost everything we did against NVN we had carried out elsewhere." When he arrived, Weisshart found that "there was no psywar effort to speak of . . . They sent me out to develop the program." This entailed "increased leaflet drops, accelerated [clandestine] radio programs," and the creation of a notional resistance movement known as the Sacred Sword of the Patriots League. According to Weisshart, the purpose of the psywar program was "to see what we could do to force North Vietnam to take some of their assets and divert them to worrying about what we were doing in their backyard."[79]

Thus, as 1962 came to a close, the CIA program of covert operations against North Vietnam was limping along, hardly what President Kennedy had in mind. It was doubtful that these efforts had caused Hanoi to feel more apprehensive about its internal security. This fact was not lost on the CIA. The agency prepared a reinvigorated covert-action plan for North Vietnam and submitted it to the president in January 1963, but Mac Bundy had his doubts about implementation. He told Kennedy that there was "every reason to believe that the execution of this plan will encounter all the difficulties of [CIA] operations in denied areas."[80]

The Pentagon Takes Over: OPLAN 34A and the Origins of MACVSOG

In July 1962, McNamara held a meeting in Hawaii with officials from the Defense Department, Pacific Command, CIA, State Department, and MACV to consider the military's takeover, consistent with NSAM 57, of the CIA's paramilitary programs in Vietnam. The process for transferring these covert paramilitary programs was named Operation Switchback.

At the meeting, General Harkins confidently told McNamara, "We are on the winning side. If our programs continue, we can expect VC actions to decline."[81] He went on to summarize all the progress that had been made in the strategic hamlet program, ARVN operations against the VC, training of the Civil Guard (CG) and Self Defense Corps (SDC), and so on. McNamara was delighted and observed that "six months ago we had practically nothing [positive to report but since then] we have made tremendous progress." He asked General Harkins "how long" before "the VC could be eliminated as a disturbing force." The head of MACV replied that he "estimated about one year from the time that we are able to get ARVN . . . fully operational and really pressing the VC in all areas." It was good news and a remarkable turnaround. However, McNamara was more cautious than Harkins, estimating that it would probably take three years for the Vietnamese armed forces to become "fully operational" and finish off the VC.[82] Still, the United States was moving in the right direction, as all the statistics demonstrated.

Harkins's wishful thinking and misplaced optimism was contagious. It was soon reflected in a report of the president's military representative, Max Taylor. Just back from a September 1962 visit to South Vietnam, Taylor presented a litany of achievements and then declared that "much progress has been accomplished since my visit in October 1961."[83] While there was evidence to the contrary, especially from U.S. Army officers serving as advisers to ARVN units in the South Vietnamese countryside, as well as in the CIA's intelligence reports, 1962 came to an end with McNamara, Harkins, Taylor and others all encouraged about progress in Vietnam.[84] They had deluded themselves—the United States wasn't winning.

This was apparent to American military advisers who observed the situation up close. The Viet Cong showed no fear of the ARVN. This was exemplified by the battle of Ap Bac, which began in December 1962. In the Mekong Delta, forty miles southwest of Saigon, three VC companies dug in along a one-mile stretch between the villages of Ap Bac and Ap Tan Thoi. ARVN's Seventh Division, equipped with automatic weapons and armored personnel carriers, and supported by bombers and helicopters, attacked the VC defensive positions but was effectively repulsed by what amounted to 300 guerrillas. The battle ended on January 2, 1963, with the VC slipping away in good order. Ap Bac was humiliating. It revealed the extent to which ARVN

was rife with poor leadership and terrible morale. An ARVN division of troops could not cope with the strategy or fighting spirit of 300 Viet Cong. Ap Bac cast doubt on the claim that the United States and South Vietnamese were winning the war.

Next came the battle over intelligence estimates. On January 11, the CIA's Office of Current Intelligence declared in a "Status on the War in South Vietnam" report that "The tide has not yet turned. South Vietnam has made some military progress with the VC due largely to extensive U.S. support. The Viet Cong, however, continue to expand the size and effectiveness of their forces, and are increasingly bold in their attacks." While the report concluded that the current situation was a stalemate, it was hardly a ringing endorsement for the United States ally. The estimate presented a picture of an escalating VC challenge that the Government of Vietnam (GVN) was having a difficult time fending off.[85]

NSC staff member Forrestal painted a much gloomier picture for the president. The son of the first secretary of defense, he had been an aide to Harriman, working on the Marshall Plan. A graduate of Harvard Law School, Forrestal had come to the NSC staff from Wall Street to work on Vietnam. JFK sent him to South Vietnam in late December 1962 for a fresh look at the situation. On February 11, 1963, Forrestal told Kennedy to expect a costly and long war. He challenged the MACV statistics on VC casualties that were being used to assert that the United States side was winning. He pointed out that no one really knew how many of the 20,000 Viet Cong killed last year were only innocent or at least persuadable villagers. Furthermore, the VC could easily recruit replacements for their actual casualties. Forrestal also raised questions about the number of successfully constructed strategic hamlets. This program was central to the U.S. effort in South Vietnam. It sought to physically resettle the rural population into centralized and fortified hamlets, protecting them from Viet Cong influence, recruitment, or attack. There were several weaknesses in this program, according to Forrestal. He was right. It created animosity among those who were forcibly displaced, it provided inadequate security from the VC, and there was plenty of mismanagement and corruption on the part of South Vietnamese officials.[86]

Two months later, the CIA took issue with Forrestal's appraisal in revised National Intelligence Estimate (NIE) 53–63, "Prospects for

Vietnam." Released on April 17, it declared that "communist progress has been blunted and that the situation is improving."[87] Because the original draft of the NIE was pessimistic, CIA Director John McCone "remanded the estimate, meaning he sent it back to the drawing board."[88] It came back optimistic. Taylor, Harkins, Rostow, Krulak, and other members of the administration were all optimists, and McCone made sure the NIE was consistent with their favorable view of the situation. Below the senior level, those involved with reality "on the ground" in South Vietnam had a very different perspective. The inconsistencies within the CIA's estimates and the differences in Forrestal's appraisal compared to McNamara's and Taylor's, illustrate the divergent views that were emerging at various levels of the government in early 1963.

Shortly after NIE 53–63's optimistic assessment was released, political turmoil erupted in South Vietnam. Twenty thousand Buddhists celebrating the birthday of Gautama Siddhartha Buddha in Hue were fired upon on the order of the Catholic Deputy Province Chief, who had decided to enforce an old French decree forbidding Buddhists from flying their multicolored flag. Nine Buddhists died and about twenty were wounded. Hue revealed yet another defect in the Saigon government. Diem and his family were Catholics. South Vietnam was predominately Buddhist, yet Catholics had come to fill most of the key posts in the civil service, military, and police organizations. Religion had become an avenue for economic advancement and political influence. In response to this pro-Catholic stance, Buddhists began organizing political opposition to the Diem government in the late 1950s. By 1963, it had grown into a significant political movement.

Diem transparently sought to cover up the incident at Hue by blaming it on the Viet Cong. It did not wash. The Buddhist leaders demurred and demanded justice from the government. They did not get it, and more Buddhist protests turned into a referendum on the legitimacy of the Diem regime. Hue was followed by larger demonstrations, with Buddhist monks immolating themselves in protest to the actions of the regime. Images of these monks burning themselves to death in the streets of Saigon stunned President Kennedy.

It was a nasty scene that escalated into an orgy of outrageous statements by Diem's sister-in-law, Madame Nhu. She callously referred to

the immolations as "barbecues" and offered to provide the gasoline for any future cookouts. During the summer, her husband, Diem's younger brother and head of the secret police, ordered assaults on Buddhist temples and sanctuaries. By July, South Vietnamese generals were planning a coup, as they told CIA officer Lucius Conein.

As the situation in South Vietnam continued to come apart, decimating the "good news" of 1962, the administration looked for options to address a rapidly disintegrating situation. At the May 6, 1963, Secretary of Defense conference held at Pacific Command headquarters, escalation of the covert war against Hanoi became a major agenda item. The decision was made to turn up the pressure on the North. Later in May, as part of Operation Switchback, the JCS directed Pacific Command to develop a program of U.S. paramilitary support for the government of Vietnam to escalate covert action against North Vietnam. Admiral Felt had his staff begin to plan these operations.

In sum, the crisis in South Vietnam in the first half of 1963, in conjunction with the president's dissatisfaction with the CIA's capacity to execute larger paramilitary operations against North Vietnam, set in motion a planning process that led to a major expansion of Washington's covert war in Southeast Asia. The Pacific Command draft was sent to the JCS on June 17, 1963. It recommended an array of covert operations to be directed against Hanoi, all under the rubric Operational Plan 34A, or OPLAN 34A as it came to be known. These actions were aimed at causing the leadership of North Vietnam to divert resources from, and in time stop supporting, its insurgency in the South.

Maxwell Taylor, who had moved to the Pentagon from the White House in 1962 to become chairman of the Joint Chiefs of Staff, did not approve the plan for two months. Why he sat on it until September 9 is difficult to discern. More than likely, some combination of the following reasons was at play: (1) The situation in South Vietnam had reached crisis proportions, and this dominated the executive branch's time. (2) There was no MACV paramilitary organization in place to carry out Pacific Command's recommendations, even if Taylor wanted to move quickly. (3) Taylor did not believe covert action could accomplish much and he did not see such operations as a job for soldiers. Contrary to what the Kennedy administration

thought, the assets were not readily available in the Department of Defense. (4) Diem was not particularly interested in the proposal, given his preoccupation with political survival.

Taylor finally approved the plan on September 9, but the Pacific Command's proposal fell into limbo for another two months. This was due to the political drama being played out inside the South Vietnamese government, which culminated in the November 2 assassination of President Diem, as well as to Taylor's lack of belief in the usefulness of special warfare measures. Pacific Command's OPLAN 34A was put on the agenda for a special meeting on Vietnam convened in Honolulu by Defense Secretary McNamara on November 20, 1963, two days before Kennedy was assassinated. Given events of the preceding eleven months, the atmosphere was gloomy. In addition to exploring ways to prosecute the war more effectively with the Military Revolutionary Council of South Vietnamese generals that replaced Diem, the meeting discussed ways to strengthen CIA-MACV cooperation and to expand covert operations against North Vietnam.

CIA-MACV relations hardened around Operation Switchback. The Kennedy administration concluded once more that the CIA had again proved unable to operate against denied areas and that it was time for a change. It was now the Defense Department's turn. McNamara was confident that they could attain better results. What was needed was a massive effort, not the modest one that the CIA had engaged in. Colby, who was at the meeting, attempted to dispel the notion that simply adding more assets would significantly alter the situation. He had concluded that covert operations against North Vietnam could not succeed, regardless of the size of the effort. It led him as the head of CIA's Far Eastern Division to limit covert action against North Vietnam to psychological warfare.

Colby recalled that at the meeting "the general attitude of the military was that the CIA was doing too little, too slowly. A few agents, a few flights over the North, but no U.S. muscle. The CIA style was one of supporting and supplying the Vietnamese to actually do the job." It was McNamara's view that the CIA was "only playing at it, but not really getting a critical mass into NVN that could have an impact." It was classic McNamara. Numbers were the answer to everything. Colby stood up at that conference and said that "We in CIA had come to the conclusion the agent operation in North Vietnam just

wasn't going to work. My Deputy Chief of the Far East Division bugged me on the subject, saying, 'Look, this is just nonsense.' We went back and took a look at our experience in North Korea, in the Soviet Union in the late 1940s-early 1950s, in China, and in none of these cases had any of these operations really proved successful." In each of those operations, Colby pointed out, "we were up against communist-disciplined totalitarian systems."[89]

McNamara saw it differently. To him, it was a numbers problem. The military had what was needed—resources, assets, special warfare doctrine—to put a full-court press on Hanoi. The secretary of defense was confident that a massive covert effort could wreak havoc inside North Vietnam and cause Ho Chi Minh to stop supporting the insurgency in the South. Colby countered: "Mr. Secretary, I hear what you are saying, but it's not going to work. It won't work in this kind of society."[90] He was throwing in the towel. Denied areas were too difficult to penetrate. It was a staggering concession.

National Security Action Memorandum (NSAM) 273 grew out of the Honolulu Conference.[91] It authorized the escalation of covert operations against North Vietnam. President Lyndon Johnson approved it on November 26, within four days of John F. Kennedy's death. It set in motion the following actions, according to a December 5 memorandum by Roger Hilsman, the assistant secretary of state for Far Eastern affairs. A joint MACV-CIA plan for intensified covert operations against North Vietnam was to be finalized in Saigon and due in Washington on December 20. Paramilitary operations in southern Laos against the Ho Chi Minh Trail were to be included in the planning.[92]

In Saigon, Herb Weisshart was assigned by the CIA's deputy chief of station to assist in finalizing the CIA-MACV plan. He explained, "We took everything that was being done by CIA against NVN . . . and we constructed a plan to go from the existing level of intensity to increasingly more intensive stages." The plan was developed at a time when "the situation [in South Vietnam] was critical." Their task was to set out how the existing program of actions "could be accelerated, given the need to progress into more intensive actions."[93] What came out of the Honolulu meeting was a big push at the policy level for OPLAN 34A, which the Pentagon Papers would describe as "an elaborate program of covert military operations against the state of North Vietnam." It was not, they noted, a modest set of pinpricks similar to

CIA's indifferent 1961–1963 effort.[94] This is an accurate appraisal. OPLAN 34A was provocative on paper. It could have resulted in a wide-ranging and diverse set of covert actions aimed at harassing, subverting, and punishing North Vietnam.

The plan's objective was ambitious: through "progressively escalating pressures to inflict increasing punishment upon North Vietnam and to create pressures, which may convince the North Vietnamese leadership, in its own self interest, to desist from its aggressive policies."[95] The CIA-MACV planners proposed five broad categories of operations to accomplish these goals.

The first involved collecting intelligence on North Vietnam. This would be gathered through the insertion of agents or spies, as well as by communications, signals, and electronic intelligence.

Second, psychological operations were to be aimed at both the North Vietnamese leadership and the populace to maximize harassment and create divisions. At Colby's direction, the CIA had begun doing some of this in 1963, and OPLAN 34A called for a "continuation of the already approved . . . [CIA] programs" with "an expansion of that effort" to "include a buildup to support resistance movement operations (both real and notional)."[96]

The third category involved political pressure. This included highly specialized paramilitary actions designed to impress Hanoi with the seriousness and cost of its continued involvement in Laos and South Vietnam. This would entail sabotage of facilities or installations critical to the economy and security of North Vietnam. If Hanoi was not impressed, that "would result in further and more damaging retaliatory actions."[97]

The fourth category returned to the issue of fostering the development of a resistance movement. This was seen as a critical aspect of the proposed covert project: "It was recognized that successful development of resistance movements in NVN, as an integral part of OPLAN 34A, could help bring sufficient pressure to bear on the Democratic Republic of Vietnam to cause its leadership to reevaluate and cease its aggressive policy."[98] The CIA-MACV planners believed this was the key to the overall covert endeavor. Fostering resistance was the way to raise the heat on Hanoi.

Finally, other destruction operations, to include airborne and seaborne raids as well as clandestine reconnaissance coordinated with aerial attack, would be directed at the North.

OPLAN 34A was to begin as a one-year program of operations divided into three escalating, four-month phases. An executing organization would have to be designated, although what kind was not specified. In retrospect, it was an important oversight.

The idea of putting direct pressure on Hanoi appealed to Lyndon Johnson, but he decided to move cautiously. On December 21, 1963, the president assigned an interdepartmental committee to study OPLAN 34A to "select from it those actions of least risk."[99] The chair of the committee was Major General Krulak, the Pentagon's Special Assistant for Counterinsurgency and Special Activities (SACSA). On January 2, 1964, the committee report reflected Johnson's caution. It selected from 34A the least risky operations for execution and recommended that the first four-month phase of covert operations against North Vietnam begin on February 1, 1964.

The plan was also reviewed by McCone, McNamara, Rusk, and Mac Bundy, under the auspices of the 303 Committee, and their recommendations were forwarded to the president in a January 3 memorandum. They were, said Mac Bundy, "united in recommending that you approve it."[100]

However, as is frequently the case, the devil was in the details. First, not everyone was united in what they thought the results would be. McNamara was "highly enthusiastic," while CIA Director McCone asserted that "no great results are likely from this kind of effort." Secretary of State Rusk felt it was important because it "will help to persuade Hanoi that we have no intention of quitting," although he pointed out that "98% of the problem is in South Vietnam," not up North. Finally, Bundy was supportive and wanted the operators "in the field" to get started. However, he also insisted that the entire program be closely watched "within the Government by the Special Group [303 Committee] which monitors all covert programs."[101]

The results of these high-level policy deliberations also revealed that the senior players had reservations about some critical aspects of OPLAN 34A. All references to development of a resistance movement, which was seen as a central component of OPLAN 34A, are missing from the memorandum. There was concern that if the United States was too aggressive with the use of covert operations inside North Vietnam, Hanoi might escalate the war in the South.

Additionally, Washington needed to be careful that it did not get involved with actions that were not deniable. Then there was the fear of how China would react if U.S. covert action actually began to destabilize North Vietnam. Would it come to Hanoi's aid, leading to a replay of the Korean War?

Likewise absent is any reference to covert operations in Laos against the Ho Chi Minh Trail. There was fear about upsetting Harriman's accords. The United States had brokered the agreement, and if caught violating it, the administration would suffer a major embarrassment.

In mid-January of 1964, Lyndon Johnson approved the McCone, McNamara, Rusk, and Bundy recommendations, which reflected the Krulak committee report. OPLAN 34A's "Program of Actions contained a total of 72 [categories of] actions which if implemented over a 12-month period, would produce a total of 2,062 separate operations. Out of the 72 [categories of] actions proposed . . . 33 were ultimately approved for implementation during Phase I."[102]

Three years after Kennedy had called for a serious program of covert action against North Vietnam, the operational plan to execute the president's wishes was finally authorized by order of Lyndon Johnson. MACV was tasked by Washington with responsibility for executing OPLAN 34A but had no clandestine apparatus in place for doing so. It would have to be assembled almost from scratch.

On January 24, 1964, MACV headquarters in Saigon issued General Order 6, creating a highly secret new organization to execute these operations. It was euphemistically called MACV's "Studies and Observation Group," known as MACVSOG or simply SOG.

2

STANDING UP MACVSOG

It was one thing to plan covert action against North Vietnam, but quite another to establish a secret organization to carry it out. There was no blueprint for MACVSOG or roster of special warfare experts in OPLAN 34A or General Order 6. All of that had to be created from the ground up. It would take time to establish.

This was the situation Lieutenant Colonel Edward Partain found when he arrived in Saigon in 1964. As he was chief of MACVSOG's Airborne Operations, his section took over the CIA's agent program against North Vietnam, such as it was.

Partain was a 1951 graduate of West Point, and his formative years as an Army officer were spent in the infantry, including a tour with the 25th Division during the Korean War. In the latter half of the 1950s, then-Major Partain served a two-year tour with the 10th Special Forces Group in Germany. His mission in the 10th, in the event of a war, was to infiltrate Estonia "by air, land, or sea to organize resistance [guerrilla forces] to the rear of the Soviet armed forces." Partain recalled that various elements of the 10th "were designated to [specific] countries, we studied the area, we studied the language. It was basically guerrilla leadership." This was modeled on the OSS in World War II. The purpose of the 10th was not, Partain stressed, to create agent networks in Soviet rear areas: "We were told

by CIA types that there would be agents in place in an ongoing resis-
tance before we were inserted." The 10th was not in the business of
building and running agent networks.[1]

The secret organization Lieutenant Colonel Partain reported to
was, on the one hand, just being organized, and, on the other hand,
"under considerable pressure to become operational like yesterday."
McNamara, Mac Bundy, Rostow—the "big boys" in Washington—
wanted the squeeze put on Hanoi. As a result, military personnel, on
very short notice, were being "pulled out of various MACV agencies,
and . . . [even] directly from the field, and thrown together, some of
them without any significant experience in the entire subject area, and
told to get to work." It was a helter-skelter approach. Partain, in
hindsight, asserted that "there should [have been] an organization
approved and personnel designated who would set up and complete
their plans before attempting to start operating."[2] This was not the
case in 1964.

COLONEL CLYDE RUSSELL ARRIVES IN SAIGON

Partain served under Colonel Clyde Russell, the first of five chiefs of
MACVSOG. Russell had arrived with a small advance party in
January and, for the next six months, had to fly by the seat of his
pants. He had been hand-picked for SOG, as MACVSOG came to be
called. Russell joined Special Forces in the 1950s, following a main-
stream Army career as a paratrooper and infantry officer. During
World War II, he had parachuted into France and Holland. After the
war, his assignments were all in the infantry branch, including chief of
staff of the Infantry School at Fort Benning. Why he moved over to
Special Forces is not clear.

Russell was an experienced special operator, having commanded
the First Battalion of the 10th Special Forces Group in Germany, and
the Seventh Special Forces Group at Fort Bragg. The latter's area
focus was Latin America. Thus, while Russell was one of the senior
officers in Special Forces, Asia was new to him. Furthermore,
Russell's unconventional warfare experience with the 10th did not
prepare him for covert operations against North Vietnam.

Upon arrival, Colonel Russell met with a CIA contingent from the
Saigon Station's NVN Operations Branch. It included Herb Weisshart,

who became Russell's deputy. Weisshart remembered the early days of MACVSOG as chaotic. It was not an organization prepared to hit the ground running: "It was almost a by-guess-and-by-golly, step-by-step type of situation. First of all, Russell had no previous experience in covert action against denied targets." This was also true of the others in his advance party. According to Weisshart, "These other officers were all thrown into a brand new situation that they had never been involved in before. By this I mean [they had no experience] operating against denied areas. And it did take time to learn about this kind of non-permissive environment."[3]

A lack of experience was not Russell's only problem in 1964, as he attempted to get MACVSOG off the ground. Several other serious challenges had to be addressed.

Russell had been told that the assets from the CIA's covert operations against North Vietnam would be transferred to MACVSOG. They would serve as the leaven for OPLAN 34A's expanded program. Additionally, several CIA officers who had run those operations would serve under Russell's new command. This had all been authorized by NSAM 57. But at CIA headquarters, the agency's leadership could hardly envision itself playing second fiddle to the Pentagon when it came to covert operations. It intended to turn over the assets involved in its covert operations against North Vietnam to SOG and be done with the whole affair. CIA had no interest in providing SOG with a large number of skilled officers and taking orders from the military.

The CIA program against North Vietnam had been a modest endeavor, and the assets handed off to MACVSOG were minimal. They consisted of four agent teams and one singleton agent supposedly in place in North Vietnam; a handful of Chinese Nationalist pilots, who flew the agent insertion and resupply missions; meager maritime operations capabilities at Da Nang; some secure communications; and a psywar program that had only recently been accelerated. It was not much to build on, as Russell quickly discovered. One of his biggest misconceptions upon assuming command, Russell observed, was "the assumption that we would take over [significant] assets in being."[4] In other words, that SOG would inherit a full-blown operation. Where he ever got this idea is not clear. He had been briefed at CIA headquarters prior to arriving in Saigon. Did the CIA

overstate what it had going against North Vietnam, or did Russell not understand the paucity of what he inherited? Given his lack of any experience in covert operations, the latter seems more likely.

Russell also expected that approximately three dozen "first string" intelligence officers from the CIA's Saigon Station would be assigned to MACVSOG. He received thirteen in 1964, and this was cut to nine in 1965. NSAM 57 may have called for the CIA to play a "supporting role" in larger covert paramilitary operations run by the military, but Colonel Russell found the agency reluctant to do so. In June 1964, CIA Director John McCone sent a letter to Deputy Secretary of Defense Cyrus Vance that outlined this coming "reduction of CIA participation" in SOG. Furthermore, McCone explained that agency involvement would be limited both in the number of officers assigned, as well as in their professional expertise. "CIA would limit its support to psychological warfare operations," the letter said. Vance's response to McCone argued for "no changes in the CIA support to MACVSOG."[5] The CIA went forward with the reductions. There is no evidence that Vance tried to get McNamara to weigh in with the White House to compel the CIA to reverse itself.

Furthermore, with few exceptions, Weisshart being one of them, the CIA did not assign "first string" officers from its Directorate of Plans to MACVSOG. Instead, they were garnered by the CIA's Saigon Station to work in the agency's expanding operations against the Viet Cong inside South Vietnam. The CIA had passed the baton to the military for operations against North Vietnam, concentrating its efforts in the South. The one exception was psywar. Here, the CIA was willing to assist SOG. However, in reality, this also reflected agency indifference. In the Directorate of Plans, psywar specialists were not considered "first string officers." The fast movers were in human-intelligence collection (i.e., recruiting spies) or aspects of covert action other than psywar (e.g., political and paramilitary operations). So much for NSAM 57 and the CIA's designated "supporting role."

As Russell strove to establish his new organization, policy maker uncertainty about the scope of MACVSOG's mission came into play. On paper, OPLAN 34A was an ambitious, even provocative, plan. Its objective was, in Clausewitz's terms, to weaken two of North Vietnam's "centers of gravity." The first was Hanoi's internal security system and control of the population. Totalitarian or dictatorial polit-

ical regimes always place a high premium on these matters. However, for Hanoi this was even more essential because it was at war with a superpower. To undermine Hanoi's internal control, Russell believed that establishing a resistance movement was essential. The second "center of gravity" targeted by MACVSOG was the Ho Chi Minh Trail in Laos. Cross-border covert reconnaissance operations to disrupt this strategic logistical network were likewise indispensable, thought Russell.

However, starting a resistance network inside North Vietnam engendered considerable policy maker trepidation. Although it was an integral part of OPLAN 34A, Washington had already waffled over the issue. This was a bizarre situation for Russell. On the one hand, Washington was telling him to escalate covert operations against Hanoi. On the other hand, it was constraining what he could do by denying SOG the authority to foster a resistance movement. In 1970, Russell recalled that "one of my big disappointments was that we could not start a guerrilla movement in North Vietnam. . . . Looking back, had we started in 1964, I am quite confident we could have quite a guerrilla effort going in NVN today."[6] In 1964, Washington also blocked SOG from initiating covert operations against the Ho Chi Minh Trail in Laos. This was equally perplexing to Russell.

As Russell struggled to establish MACVSOG and begin operations, General Bam, whom the leadership in Hanoi had hand-picked, and the 559th were in their fifth year of constructing the Ho Chi Minh Trail. In December 1963, North Vietnam's Politburo sent Colonel Bui Tin and a dozen military specialists and civilian cadres on a factfinding mission down the trail. They were to determine if the Viet Cong could win the war on their own or whether NVA regular units were required. Hanoi needed to know because the collapse of the Diem government and parade of coups that followed were an opportunity not to be missed.

Bui Tin's report was unequivocal, as he recalled to Stanley Karnow in a 1981 interview. The only choice was to send a sizable NVA contingent into South Vietnam. It was time to "move from the guerrilla phase into conventional war." In early 1964, Hanoi decided to follow Bui Tin's recommendation and escalate the war in the South. As a result, construction of the trail became a much larger project. Karnow

reports that its architect, Colonel Dong Si Nguyen, was told to "spare no expense." He brought in engineer battalions equipped with up-to-date Soviet and Chinese machinery to build roads and bridges that could handle heavy trucks and other vehicles.[7] Within a few years, the trail became a major network that could transport 10,000–20,000 NVA soldiers and equipment from the North into South Vietnam every month, a five- to tenfold increase over the early 1960s.

While Hanoi had decided to dramatically expand the trail in order to escalate the war in South Vietnam, Colonel Russell was told that MACVSOG could not conduct any operations against the trail. He recalled that "during my time, we were restricted from going into Laos at all."[8] It was not until the fall of 1965, almost two years after it was established, that SOG was given permission to operate there. It was difficult enough for Russell to set up a secret organization from scratch. Now, Washington began to fret over every mission, further complicating Russell's task.

Russell also found that the Pentagon had not settled on the organizational framework for MACVSOG. Initially, he planned to organize a Joint Unconventional Warfare Task Force (JUWTF), following the Pentagon's unconventional warfare doctrine. There were, in Russell's mind, practical benefits to such an approach. First, it included a joint table of distribution that would provide SOG with direct multiservice personnel and participation. Unconventional warfare doctrine called for personnel drawn from all branches of the military's operational sections to efficiently plan and execute land, air, and naval covert paramilitary operations. This would prevent the mainstream conventional military from ignoring SOG. Second, the JUWTF was to come under the direction of the theater commander, in this case General William Westmoreland, and the lines of support between the services and the forces assigned to the JUWTF were to be clearly designated. This would integrate SOG into the larger military strategy of MACV. It would become an integral part of the overall war effort, and not some ancillary outfit to be kept on a short leash. To Russell, this seemed like the way to go.

However, there was a downside to the JUWTF, as the third chief of MACVSOG, Jack Singlaub, explained: "The part I object to is the effort to retain service components within the JUWTF concept. It is my feeling that unconventional warfare [operations] should lose the

identities of the services doing it."[9] This is important, and points to the enduring problem of parochialism among the armed services. The armed services, even in organizations like SOG, seek to retain their identity. What Singlaub proposed made sense for SOG-type units but runs counter to the organizational culture of the services. However, there is a downside to Singlaub's argument. By submerging the identity of each service, the lines of support between the services and the forces supporting an organization like MACVSOG could become blurred. This would cause a serious problem in terms of receiving the right personnel from the services, as we will see.

Russell learned that the JUWTF concept was not accepted at the higher echelons of the Pentagon. He was never told the reason for this opposition; he knew only that he would have to organize SOG along task lines. This meant establishing specific elements or sections connected like building blocks to form an organization that would suit the operational requirements assigned by higher authorities. Despite his support for the JUWTF concept, Russell was not opposed to this approach because it gave him an important degree of flexibility. Even so, there were real costs to it, as became apparent when MACVSOG attempted to find qualified military personnel for covert operations.

Russell discovered that such individuals were at a premium in the U.S. armed services. Moreover, those that did exist were difficult to locate through the personnel system of each service. To carry out OPLAN 34A, MACVSOG needed individuals with a mindset quite apart from that of conventionally trained officers and enlisted men. It required personnel with a background and experience in special warfare. The more unorthodox and sneaky the job, the more specialized experience needed. This certainly was the case with respect to covert psywar operations, as well as running agent networks in denied areas.

What Russell and those who followed him received, all too often, were individuals who came from the mainstream military. Especially in the early days, many had no experience relevant to the operational section in SOG to which they were assigned. For example, Ed Partain, who was in charge of agent operations in 1964, had no experience in such activities. "I was familiar with the terminology," he noted, "but as far as [actual] agent handling or covert-type operations experience, I had nothing." His deputy had been involved in unconventional war-

fare activities during the Korean War, but not directly in agent opera-
tions. Partain characterized the young officers assigned to him as
"dedicated, hard-working and willing to learn, but as to agent han-
dling they were not trained at all."[10] Likewise, military personnel
assigned to the psychological operations section of SOG knew little
about black psywar techniques.

Even when Special Forces personnel were assigned to MACVSOG,
they tended to be more familiar with counterinsurgency, rather than
unconventional warfare. This is not surprising, since counterinsurgency
was given much higher visibility in the Kennedy administration. The
president frequently expressed concern over the threat of communist
wars of national liberation. The possibility of "losing" whole countries
to insurgencies was not a prospect he was willing to entertain.
Counterinsurgency was intended to head off communist subversion.
Kennedy made strong efforts to get the Army, in particular, moving in
this area. He instructed the secretary of defense to increase counterin-
surgency resources.[11] Consequently, when Jack Singlaub took over as the
third chief of MACVSOG in May 1966, he found that "Special Forces
personnel were coming to Vietnam with their training oriented primar-
ily to the counterinsurgency role rather than to the unconventional
warfare role."[12]

To counteract this problem, Russell tried to get the personnel sys-
tem of each military service to identify individuals who had experi-
ence in unconventional warfare. They were not able to deliver, not
being programmed for such requests. There were no personnel proce-
dures that permitted the chiefs of SOG to identify and request quali-
fied and experienced personnel in covert unconventional warfare. At
the end of his tour as chief, Singlaub lamented: "The services must
have some system established where the names of those who have had
covert operational experience can be retrieved and the individuals
assigned to this type of operation."[13] As if this was not bad enough,
many of those initially assigned to SOG were on temporary orders for
only six months. Russell eventually had this changed. Still, the normal
tour of duty in MACVSOG was one year, as it was for other military
personnel sent to Vietnam. However, it took an initially inexperienced
officer assigned to SOG one year to learn the ropes. At this point,
instead of benefiting from what he had learned, SOG would start over
with another inexperienced man.

The final complication confronting Russell in 1964 was his relationship with SOG's South Vietnamese counterpart. According to OPLAN 34A, he was to provide the South Vietnamese Strategic Technical Directorate (STD) with advice, assistance, training, and material to enable it to carry out a graduated program of covert paramilitary operations against North Vietnam. In other words, SOG was to be in an advisory role. This arrangement never materialized. Within a short period of time, SOG took charge not just of planning but of executing covert operations against North Vietnam. The STD's role became one of providing indigenous personnel for SOG activities, and their access to sensitive operations was restricted. SOG's overriding concern was the STD's glaring lack of security and its vulnerability to enemy penetration.

EVOLUTION OF SOG

By the time Clyde Russell relinquished command of MACVSOG in May 1965, most of its core elements had been established along task lines, based on operational requirements set in Washington. As SOG grew rapidly over the next few years, its organizational structure became increasingly complex, with four operational sections at its core. Each section had planning and execution responsibility for one of the following covert missions: agent networks and a deception program, covert maritime raids, psychological warfare, and cross-border operations against the Ho Chi Minh Trail.

Each of these four covert missions was assigned a code name and tightly "compartmented." In intelligence jargon, compartmentation is concerned with secrecy. Operations in one section or compartment of SOG were not known to personnel working in another section. Compartmentation was very tight and adversely affected the principles of unity and coordination of effort.

The code name for the entire covert operation waged against Hanoi by SOG was Footboy. Each of its four covert-operational programs was also assigned a code name. For example, the insertion and control of long-term agent teams was known as Timberwork. However, Timberwork also came to encompass short-term agent teams and, in late 1967, authority for executing a complex deception program against North Vietnam, code-named Forae. This was an

attempt to convince Hanoi that the threat of subversion inside its borders was much more serious than what it already knew about.

Maritime operations, or marops, were code-named Plowman. They consisted of an array of psychological and paramilitary operations. Humidor was the code name for SOG's psywar against North Vietnam. It was composed of a mélange of different techniques.

Not until late 1965 was SOG's mission expanded to include covert cross-border operations into Laos. The objective was twofold: to learn precisely what the Ho Chi Minh Trail entailed, and to develop a set of operations to deny Hanoi easy access to Laos as a base from which to launch operations inside South Vietnam. Initially code-named Shining Brass, the program involved teams composed of tribal minorities that were led by U.S. Special Forces sergeants. In 1967, these covert cross-border operations were extended into Cambodia. They were code-named Daniel Boone.

MACVSOG had one other operational section, whose role was to provide air support for all covert operations directed against North Vietnam proper, as well as for those focused on the Ho Chi Minh Trail. The code name for air operations was Midriff. This section maintained SOG's airplanes and helicopters.

SOG was always commanded by a U.S. Army colonel. Known as the chief of MACVSOG, he was to have a background in special warfare activities. If SOG was to be integrated into overall U.S. strategy for fighting the Vietnam War, its chief also had to be adept at operating among senior leadership at MACV and JCS. He needed access to the brass and had to be seen as a member of their club. Otherwise, SOG could easily become peripheral and unrelated to the main war effort.

The selection of the chief of MACVSOG was critical. This was especially true in light of the fact that the position was not assigned to a general officer, with the authority and access that would have entailed. While the senior civilian leadership in Washington may have been enthusiastic about special warfare, the same was not true of their Pentagon counterparts. The armed services in general, and the Army in particular, did not share the Kennedy administration's fervor for it—just the opposite. The military's lack of interest, even disdain, could be seen in how the Army's senior leadership resisted Kennedy's charge to develop counterinsurgency capabilities, as Andrew Krepinevich's clas-

sic study—*The Army and Vietnam*—documents. "Attitudes within the Army hierarchy bore out both the service's disinterest in Kennedy's proposals and its conviction that the Army could handle any problems that might crop up at the lower end of the conflict spectrum. For instance, General Lemnitzer, chairman of the JCS from 1960 to 1962, stated that the new administration was 'oversold' on the importance of guerrilla warfare." Likewise, General George Decker, Army chief of staff from 1960 to 1962, "countered a presidential lecture to the JCS on counterinsurgency with the reply, 'Any good soldier can handle guerrillas.' General Earl Wheeler, Army chief of staff from 1962 to 1964, stated that 'the essence of the problem in Vietnam was military.'" Finally, General Maxwell Taylor felt that "counterinsurgency was 'just a form of small war' and that 'all this cloud of dust that's coming out of the White House really isn't necessary.'"[14]

Their attitude toward unconventional warfare was similar. Consequently, a general officer's slot was not to be squandered on an organization like MACVSOG. Limiting the chief of SOG's rank to colonel imposed significant hurdles on the organization's effectiveness. Russell highlighted one obstacle in his criticism of the mission authorization process: "It was a tremendous operational handicap to have to get these missions cleared all the way, in some instances, to the White House. The restraints were numerous. For example, we had a plan to mine Haiphong harbor with dummy mines. It was a good operation but we never got it off the ground; papers and [more] papers [were submitted], and it was always disapproved and we never knew who or why except the mission was disapproved."[15] Colonels do not have the authority to press for such explanations, but generals do.

For MACVSOG to make a significant contribution to U.S. strategy, access to the MACV and Joint Chiefs of Staff planning process was essential. Otherwise, the senior military leadership would have little or no understanding or interest in the potential value of covert operations against North Vietnam.

Clyde Russell had no such entree with the senior Army leadership in MACV or the Joint Staff. When he entered Special Forces in the 1950s, he became part of what was, at that time, seen as a home for misfits. Reflecting on those days, retired Major General Ed Partain recalled: "In the early fifties . . . Special Forces groups were not a recognized part of the Army. They were seen as outsiders . . . great warriors . . . but they

could not live comfortably within the peacetime regimental system. Well, you had people of the sort that you wished you could deep freeze on the last battlefield and thaw out on the next battlefield of the next war. So, it was a rough group. . . . When I got to the 10th Special Forces Group in 1957 . . . I did not want to go, I was just detailed to go."[16] As chief of SOG, Russell was far removed from the mainstream Army. Consequently, when the commanding general of MACV, William Westmoreland, planned U.S. escalation of the war in 1964, Russell was not included in the process. He was not invited to the discussions.

Russell's replacement was a legend from World War II. Don Blackburn's unconventional exploits in the Philippines were turned into a Hollywood film in the mid–1950s entitled *Surrender—Hell!* When the Japanese captured the islands, he fled to the bush and organized partisan guerrilla units from among hill tribesmen, mostly Igorot headhunters. They came to be known as Blackburn's Headhunters and played a pivotal role when General MacArthur returned to take the Philippines back from the Japanese. In 1944, as a result of these heroic exploits, Blackburn became the youngest full colonel in the U.S. Army at the age of twenty-nine. However, the Army was unsure of what to do with this expert in unconventional warfare once World War II ended. At first, it tried to turn him into a respectable Army officer, sending him to the infantry school. Through this reeducation, it was intended that Blackburn would go mainstream. In 1950, he was sent to teach at West Point. However, according to one account of those days, he took every opportunity to "pepper his courses with grains of his own theories of combat, challenging his cadets to come up with ways of holding their casualties down, urging them to think unconventionally."[17] Apparently, joining the mainstream came hard to the former leader of Blackburn's Headhunters.

Following a stint in Vietnam as an adviser, Blackburn returned to special warfare in the late 1950s. He was assigned to command the 77th Special Forces Group at Fort Bragg. So much for turning the Headhunter into a respectable officer. In 1961, President Kennedy declared that special warfare was important, and Blackburn found himself organizing a covert paramilitary group that was to be a part of the new administration's response to the crisis in Laos. Then, in May 1965, he became chief of MACVSOG. Blackburn seemed ideal

for the job; he certainly had considerable experience in special warfare. However, he was still a colonel, but now the one with the longest service at that rank in the U.S. Army.

It is said that officers with Blackburn's special warfare experience were valued by General Westmoreland. In his memoir, the former commander of MACV declared that the "SOG commanders were an ingenious group."[18] Jack Singlaub, the third chief of SOG, believed that Westmoreland thought SOG important. He asserted: "My impression is that you see the difference in outlook towards this type of activity between General Westmoreland and [his replacement] General Abrams. General Abrams was very anti–Special Forces; he was anti–special operations. I've heard him say he just didn't think that it was in the Army's interest to take all of the best soldiers and put them in special units, thereby degrading the regular units. . . . Now, I had fantastic relations with General Westmoreland. . . . I never missed a Monday meeting at the appointed time to brief General Westmoreland [on SOG operations] in over two years. Abrams would often postpone or change the time of the meeting, Westy would never do that."[19]

Westmoreland has written that "SOG played an important role during our operations against the enemy in Vietnam."[20] However, his memoirs acknowledge that he "had serious reservations about how much the covert operations accomplished."[21]

During his one-year tour as chief of SOG, Don Blackburn briefed Westmoreland only once. According to Blackburn, Westmoreland was a "conventional commander of conventional units and was not interested in an outfit like SOG."[22] Blackburn may have had legendary credentials as an unconventional warrior, but he found that "special operations were never highlighted in MACV's considerations. It was a conventional operation over there. . . . It stands as an accepted fact that special operations was a sideshow, or a stepchild."[23]

Thus, SOG's first two chiefs, Russell and Blackburn, faced difficult hurdles. Senior policy makers in Washington wanted to use covert operations to pressure Hanoi to stop supporting the war in the South but at the same time worried about doing too much. In the military, SOG was an afterthought as the brass planned a conventional war.

The deputy chief in MACVSOG's chain of command was always an Air Force officer, but not a "fast burner"—not on the fast track for promotion to general officer. The number three ranking position at SOG headquarters was held by a CIA officer. The SOG-CIA relationship was always a tenuous one. Regardless of what NSAM 57 stipulated, the agency was not about to become subordinate to a Pentagon-led covert paramilitary operation. If the policy makers gave the mission to MACV, so be it. The CIA would focus its attention elsewhere.

Before assuming command, Blackburn "went out to the Agency to see Bill Colby to ask if he could get a more senior CIA officer to be the deputy for SOG." Colby listened but never changed the assignment. When asked if the CIA played an active supporting role in MACVSOG, Blackburn's response was an emphatic "No. Not when I was there. . . . The thing that bugged me is that I didn't have an adequate CIA type. The deputy was weak."[24] Later chiefs had reasonable working relationships with the senior CIA officer, but agency involvement remained limited and the quality of officers assigned was uneven at best.

Notwithstanding these hurdles, MACVSOG grew as fast as (or even faster than) America's conventional force commitment to Vietnam, and it became an increasingly complex organization. By 1967, it was responsible for covert programs in North Vietnam, Laos, and Cambodia. This expansion can be seen in SOG's organizational charts for 1965 and 1969, shown on pages 55 and 56. The first shows its composition one year after Clyde Russell's advance party arrived in January 1964, when SOG had only 128 people assigned. By 1969, the organization had over a thousand Americans; several thousand South Vietnamese, Laotian, Cambodian, and Thai personnel; and even pilots from Nationalist China.

Despite SOG's sizable growth, at its core were the following four missions that, taken together, constituted a covert paramilitary campaign.

Agent Networks and Deception

The insertion of long-term agent teams into North Vietnam was the responsibility of SOG's Airborne Operations Group. From 1964

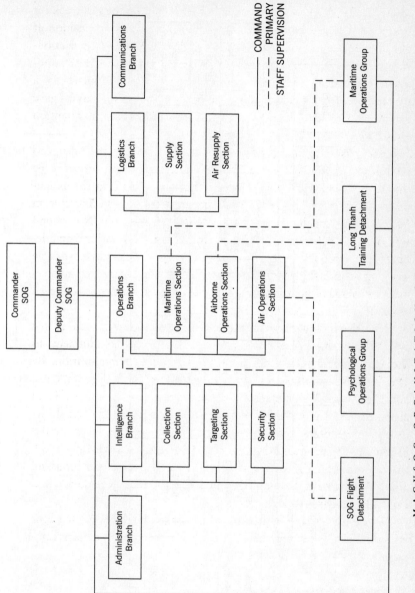

Commander SOG

Deputy Commander SOG

Administration Branch

Intelligence Branch
- Collection Section
- Targeting Section
- Security Section

Operations Branch
- Maritime Operations Section
- Airborne Operations Section
- Air Operations Section

Logistics Branch
- Supply Section
- Air Resupply Section

Communications Branch

SOG Flight Detachment

Psychological Operations Group

Long Thanh Training Detachment

Maritime Operations Group

——— COMMAND
— — — PRIMARY
STAFF SUPERVISION

MACVSOG ORGANIZATION CHART — JANUARY 1965

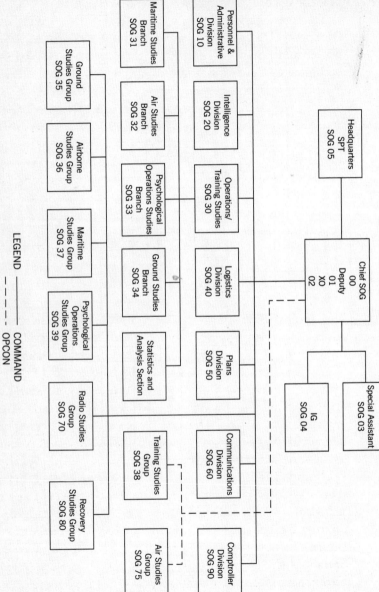

MACVSOG ORGANIZATION CHART — DECEMBER 1969

Headquarters
SPT
SOG 05

Chief SOG
00
Deputy
01
XO
02

Special Assistant
SOG 03

IG
SOG 04

Personnel &
Administrative
Division
SOG 10

Intelligence
Division
SOG 20

Operations/
Training Studies
SOG 30

Logistics
Division
SOG 40

Plans
Division
SOG 50

Communications
Division
SOG 60

Comptroller
Division
SOG 90

Maritime Studies
Branch
SOG 31

Air Studies
Branch
SOG 32

Psychological
Operations Studies
Branch
SOG 33

Ground Studies
Branch
SOG 34

Statistics and
Analysis Section

Radio Studies
Group
SOG 70

Training Studies
Group
SOG 38

Air Studies
Group
SOG 75

Ground
Studies Group
SOG 35

Airborne
Studies Group
SOG 36

Maritime
Studies Group
SOG 37

Psychological
Operations
Studies Group
SOG 39

Recovery
Studies Group
SOG 80

LEGEND ————— COMMAND
 - - - - - OPCON

to 1969 this section was known as OP 34. In late 1967, two new missions—short-term reconnaissance and target acquisition teams, or strata, and a complex deception program—were added.

The insertion of long-term agent teams into the North was extremely difficult and largely unsuccessful under the CIA. Washington could not decide on the objectives of these teams. According to OPLAN 34A, the agents were to establish a resistance movement in North Vietnam. Since this was never officially authorized by Washington, the mission was changed to intelligence collection, sabotage, and psychological warfare. Oddly, the agent teams were instructed to avoid contact with the population even as they attempted to carry out these missions. Under such conditions, one wonders how realistic it was to expect the teams to accomplish anything. In 1966, the mission was changed again. Emphasis was now placed on intelligence collection and establishment of civilian contacts, with secondary attention to psywar and sabotage. This change in mission was to be accomplished through a fifteen-month plan, and entailed inserting or relocating agent teams to watch every major road leading out of North Vietnam to the Ho Chi Minh Trail in Laos.

Not only was the mission of long-term agent teams in constant flux, due to Washington's dithering, but the operation itself came under close scrutiny. There was concern that the teams had been compromised by Hanoi's Ministry of the Interior, but no thorough counterintelligence assessment took place until late 1967.

By 1967, there was dissatisfaction up the chain of command with agent operations. The accomplishments were meager at best. Moreover, mounting concern about whether the teams had been compromised heightened skepticism about their possible effectiveness. As a result, OP 34's mission was revised again.

The rationale for this revision was as follows: "It was believed that short stay-times and mobility of strata teams would enable them to survive and to be successfully exfiltrated."[25] In fact, getting the strata teams in and out came to be seen as the principal measure of success. During 1968, then-Major George "Speedy" Gaspard ran the strata operations into North Vietnam. Prior to this assignment, Speedy had been in South Korea, on loan to the CIA, helping to develop a counterinfiltration program with the South Korean National Police. It was a challenging mission, a time when North Korea was attempting to

infiltrate significant numbers of agents into the South. According to Gaspard: "We killed 119 [North Korean agents]. . . . This was in 1967. . . . [We] didn't take any prisoners, that was very difficult to do. . . . They [the North Korean agents] just wouldn't surrender."[26]

When Gaspard joined SOG, he switched from countering agent-infiltration teams to running strata operations into North Vietnam. His goal for the teams was "to get them in, get them out and get some information from them."[27] This was meaningful given that not one of more than 500 long-term agents inserted into North Vietnam by CIA and SOG was ever successfully exfiltrated back to South Vietnam.

At the end of 1967, OP 34 added a diversionary or deception program. The idea for it grew out of the suspicion that many of the long-term agents had been compromised and that Hanoi was conducting counterespionage against SOG using captured team members as double agents. If true, this would enable North Vietnam not only to know SOG's operational methods and objectives, but to feed it false information or disinformation through the doubled agents' radio transmissions. The diversionary program, code-named Forae, hoped to convince Hanoi that the threat of subversion inside its borders was much greater than suggested by any agent teams they might have uncovered. Forae "consisted of six [compartmented] projects, approved verbally by COMUSMACV [General Westmoreland] on 14 March 1968."[28]

Thus, by 1968, OP 34 was divided into three branches: OP 34A, agent team operations; OP 34B, strata operations; and OP 34C, diversionary operations.[29]

Covert Maritime Operations

Covert maritime operations, or marops, constituted MACVSOG's second core mission. Also inherited from the CIA, responsibility for it was assigned to the Maritime Operations Group, or OP 37. In January 1964, Naval Advisory Detachment (NAD), the cover name for OP 37, was set up in Da Nang. In 1965, SOG headquarters established a small marops staff called the Maritime Studies Branch. Essentially, this branch functioned as a staff element, while NAD was the action arm for covert maritime operations.

The chief of the NAD was always a Navy commander. However, with a few exceptions, those assigned by the Navy to command OP 37

had no experience in unconventional warfare. Jack Owens, for example, the first chief, was a destroyer commander who knew nothing about covert marops. His career in the Navy had been spent at sea on large surface ships, not running covert small-boat operations against the coastline of denied areas like North Vietnam. An officer did not get promoted to higher ranks in the Navy by operating in the shadows. The way up the ladder was to go to sea, either on surface ships or submarines. Consequently, there were few officers with the rank of commander who had experience in covert operations in 1964. In the Navy, special warfare was not considered an important mission. So, when the Navy selected Jack Owens, it was a clear signal that he was not considered material likely to make admiral.

The deputy chief for operations and training of the NAD was always a Marine Corps officer, who was much more likely to know something about special operations. This was true of Lieutenant Colonel James Munson, who was assigned to the post in 1964. As he said later, he had "worked with CIA . . . and was deemed acceptable by Langley. . . . I also had been with the United Nations, which was most unconventional for a straight military officer because we were trying to do cease-fire and peacekeeping operations and I had to work with host nationals and learn or try to achieve UN and, covertly, U.S. objectives using host national methods and approaches. So, that was considered special operations."[30] However, Munson had no direct experience in the kinds of covert paramilitary operations assigned to OP 37. He was chosen because he had high language aptitude and experience in intelligence, both in the Marine Corps and at the CIA.

The choice of both Owens and Munson illustrates the continuing difficulty SOG had finding the right personnel. When asked whether any of his Navy superiors in the NAD had had a special operations background, Munson recalled, "I didn't find any of the Navy officers to have had anything in their background that suited them for MACVSOG." He noted that Jack Owens once said to him, "Hell, I'm a destroyer skipper, I don't know anything about this kind of operation." Owens was honest enough to say, "I really don't know the details of this but we're responsible, so you do what you can."[31]

As with OP 34, the mission of the NAD was also in flux between 1964 and 1969. At various times during this period, a number of different kinds of operations were conducted. Covert marops included:

cross-beach seaborne raids to include small-scale demolition operations and capture of NVN officials; mortar bombardment of shore targets from special fast boats; interdiction of NVN craft moving supplies South by sea; delivery of psychological warfare materials; the capture of NVN citizens, primarily fishermen, as part of a larger psychological operation; the insertion of agents and pseudo-agents into North Vietnam from the sea; and the collection of coastal intelligence.

The missions performed during a particular period depended on the whims of Washington. At the policy level there was frequent rethinking and change in the types of maritime missions initiated. Policy maker apprehension over covert marops arose in the early days of SOG, primarily because OP 37's fast boats were involved in the famous August 1964 incident in the Gulf of Tonkin.

Within NAD, an Operations/Training section planned and executed all covert maritime operations against North Vietnam, but only after authorization from Washington. A SEAL/Recon section, which consisted of a U.S. Navy SEAL Team One detachment and Marine reconnaissance personnel, trained Vietnamese commando teams for cross-beach operations along the North Vietnamese coast. A Mobile Support Team trained and advised Vietnamese crews in the tactics, gunnery, navigation, and operation of the fast patrol boats or "Nasties," as they were called. These crews were responsible for carrying out the actual operations in North Vietnamese waters.

No U.S. personnel were permitted to take part in any of the OP 37 missions in North Vietnam. Only South Vietnamese personnel, under the authority of the Strategic Technical Directorate's Coastal Security Service, were authorized to go North. The CSS was the Vietnamese counterpart to the NAD and subordinate to South Vietnam's STD.

Black Psychological Warfare

SOG's third core mission was its "black" psychological warfare program against North Vietnam. It was called "black" (or covert) because the communications or actions emanated from falsely attributed or nonattributed sources. In other words, the target audience, in this case the leadership and populace of North Vietnam, was not supposed to see the source as the United States, but as someone else.

There is a great deal of fantasy that surrounds psywar—what it entails and what it can accomplish. Psychological warfare is a classic aspect of intelligence skullduggery. Sun Tzu, the ancient Chinese strategist, placed a high premium on its contribution to the attainment of victory with no violence or a minimum of violence. This is easier said than done. Psywar has much in common with deception and is one of those Cold War terms that conjures up images of skillful manipulation of an adversary. There are those who believe that it can be an effective substitute for combat.

A closer look at psywar reveals that it is not so magical. The communists were said to be psywar masters, and in fact, there is some truth to this assertion. The classic study on psywar from the late 1950s—*A Psychological Warfare Casebook*—points out that "The Soviet concept of psychological warfare is anything but mysterious. It is conceived more as an organizational weapon than just as a word weapon. With the communists there is no sharp distinction between words and deeds."[32]

Psywar was an important element of the overall strategy employed by the Vietnamese Communist Party against both France and the United States, formidable outside powers that it fought between 1946 and 1973. Consequently, Ho and his comrades conducted extensive psychological warfare campaigns, both internationally and on the domestic territory of France and the United States. Psywar was used to isolate France and then the United States internationally and to undermine their political cohesion at home.

The United States only dabbled at psywar during the Cold War and never really mastered it. The CIA directed propaganda campaigns against the denied areas of the Soviet bloc, but the strategic objective of these efforts was not very easy to discern, if one existed at all. A case in point was Radio Free Europe and Radio Liberty, both CIA-directed enterprises until the early 1970s, when they were taken away from the agency by the U.S. Congress. The purpose of the radios was to communicate with the populations trapped behind the Iron Curtain. According to former CIA officer Cord Meyer, who had responsibility for the radios in the 1950s, "their success was due to the early decision to make the news reports as objective and accurate as possible and to concentrate coverage on those internal developments within the bloc which neither the Voice of America nor BBC was able to cover."[33]

According to those lucky enough to escape from these denied areas, the CIA accomplished this objective. The radios were seen as an accurate source of information by those behind the Iron Curtain. However, one wonders what U.S. policy makers expected the populace to do with the knowledge gained from these broadcasts. What they were not expected or encouraged to do, at least according to official American policy, was to take violent action against their repressive governments. In other words, through the radios they could come to know the truth, but the truth was not intended to instigate them to take action to set themselves free through revolt. Rather, according to Meyer, the radios were to contribute "incrementally over time [to] improv[ing] the chances for gradual change toward more open societies."[34] American policy makers were drawing a fine line between political evolution and revolution. It was a line that the Hungarians could not see or were unwilling to heed in 1956, when they sought to set themselves free. The United States, taken by surprise, proved unwilling to help and stood by as the Hungarian revolution was crushed.

While the CIA dabbled in psywar, the mainstream U.S. military had little regard for what it called psychological operations or psyops. After all, what could they really accomplish? Specialists in military psyops were seen as boondogglers by conventional warriors. Throwing words at the enemy accomplished little. It was best to junk psyops and reinvest the resources in a new battleship or armored division. Unlike the communists, the Pentagon did not see psywar as a significant part of overall strategy for the conduct of war.

SOG inherited its psywar program from the CIA. The architect of the agency program was Herb Weisshart. He drew on his experiences against North Korea and Communist China in developing a program of "leaflet and gift kit airdrops, black radio broadcasts, the initial development of a notional [fabricated] resistance movement . . . [and] maritime operations using small boats for psywar." He characterized the effort as "a small-budget operation," an accurate appraisal.[35]

According to Weisshart, the CIA program targeted the North Vietnamese leadership and population. MACVSOG's psychological warfare targeting mirrored the CIA's. How did it seek to influence Ho Chi Minh and the senior leadership in Hanoi? What did it want them to worry about? How did Weisshart and his SOG counterparts hope to deceive Hanoi, and to what end? According to the former

CIA specialist in psywar, the objective was to make the leadership believe it had a festering internal security threat. It was to think the population was becoming dissatisfied with a war that wasted the lives of its children, and, as a result, was secretly organizing opposition groups. As this perception spread, according to Weisshart, "the hoped for result was that Hanoi would have to divert, in increasing measure, intelligence, counterintelligence, internal security, and constabulary personnel and NVA forces to deal with this potential [internal security] problem."[36] In theory, these were perfectly reasonable psywar goals.

What about the population of North Vietnam? How did it fit into this effort? Here the CIA drew the same fine lines it had done in Eastern Europe during the 1950s. The purpose was to provide accurate information to the Democratic Republic of Vietnam's population about their government and the war in the hopes it would lead them to express distrust, disaffection, and even mild forms of dissent. However, once again, the obvious question arises: once the NVN people became disaffected and distrustful, what did Washington hope they would do? According to Weisshart, there was no desire for them "to take executive action, which means trying to blow up installations or things like that. . . . My feeling was that you wanted the population to go to the point where the NVN government must take measures of some kind in the internal security realm. . . . [Y]ou're hoping to tie them up to some degree and divert resources that they might otherwise apply to the war in the South."[37] CIA and SOG were not to encourage the North Vietnamese population to attempt to kill members of the Hanoi government. Why not? According to Weisshart, "You don't want them [i.e., the population of North Vietnam] to get themselves killed because of what you're asking them to do."[38] It was a telling distinction and one that Hanoi never drew in its promotion of the war in the South. The more South Vietnamese and American soldiers and officials killed by the Viet Cong and their sympathizers, Hanoi reasoned, the better.

Although the CIA handed off its psywar program in 1964, this was the one section in SOG where it remained engaged. Weisshart noted that "our people (CIA) just kept running the subsections of what became known as OP 39 at the beginning. Then the military took over as they were able to."[39]

Weisshart and Lieutenant Colonel Norbert Richardson directed the psywar program in the early days of SOG. Richardson had been assigned to the CIA and worked in its psywar section in Saigon. In the late spring of 1964, Lieutenant Colonel Martin Marden became the chief of MACVSOG's psywar operations. He had little experience in it. The same was true of those who followed Marden in command. While they may have had a Special Forces background, black psywar was not part of their experience. Joining Marden, recalled Weisshart, were twenty-five bright, enthusiastic, young, and inexperienced Army lieutenants and captains.

Captain John Harrell was one of those young officers. A 1959 graduate of the Infantry Officers Candidate School, Harrell was assigned to the Special Warfare Center at Fort Bragg to be trained "to go into psywar units." However, as he recalled, "There was absolutely no training that came down from Special Warfare Center directed to us as unit training . . . We had absolutely no mission training. We didn't get any real practical experience in propaganda." Nor was he trained in psywar: "We never got into that. We knew what it was, we knew a lot of the techniques from the schooling. We were told what it was, told how it's done and were given some examples, but we never trained for it."[40]

When Harrell arrived in Vietnam, he was assigned to head the Research and Analysis Branch of OP 39. "I had no idea what that was going to involve, [and] didn't even know what kind of documents or anything else I was going to be handling other than classified. I didn't know what they pertained to."[41] Harrell found himself heading a branch he knew little about. In the early days of MACVSOG he was not alone.

The psywar that SOG carried out against North Vietnam included the following operations: the creation of a notional or fabricated resistance movement, known as the Sacred Sword of the Patriots League (SSPL), whose purpose was to foster the impression that a well-organized resistance was active in North Vietnam; and the indoctrination of NVN detainees at Paradise Island. Started in 1965, the latter operation sought to convince kidnapped North Vietnamese fishermen that the SSPL was real and that they had been taken to a liberated part of North Vietnam. Other activities included a variety of black radio operations; insertion of leaflets and gift kits; fraudulent

letters mailed to NVN officials and citizens from third countries; the contamination of enemy ammunition; forged NVN currency; and booby-trapped items planted in Laos.

Covert Operations Against the Ho Chi Minh Trail

SOG's final mission involved American-led covert reconnaissance team operations against the Ho Chi Minh Trail in Laos. The decision to execute this mission was an agonizing one for the Johnson administration. It took nearly two years to decide to "cross the fence," as SOG men called operations in Laos. Although the trail had been discussed during the formulation of OPLAN 34A, it was deleted from the final product. The reason stemmed from the 1962 Geneva Accords' prohibition against foreign forces entering Laos. Anxiety over violating the Accords prompted Washington to assign in February 1964 the following restrictions on covert operations in Laos: "No Government of Vietnam forces are authorized to operate across the Laos border. . . . No U.S. personnel are authorized to accompany any covert GVN [ground] elements into Laos."[42]

In March 1964, the Joint Chiefs of Staff pressed Secretary McNamara to lift the restrictions, "which were limiting the effectiveness of the military operations in Vietnam."[43] In May, as a result of intelligence reports indicating "extensive [enemy] military logistics activities in Laos," the JCS was authorized "to initiate joint planning with the South Vietnamese Government for cross-border operations and to proceed with limited covert intelligence collection patrols into Laos."[44] What this actually meant was that GVN teams could cross the Laotian border, but "no U.S. advisors would be allowed to accompany the teams."[45]

Clyde Russell, MACVSOG's chief at the time, learned of this decision when he "was called to Saigon during one of Secretary of Defense McNamara's visits and without warning was brought into the conference where he was consulting with General Westmoreland, Ambassador Lodge [United States ambassador to South Vietnam], and General Taylor." McNamara had one question for Russell: "How soon could I launch operations into Laos. . . . [He] wanted an eyeball-type observation of the road nets that were generally astride Highway 9." The teams were to be ready to launch "in 30 days." It was classic

McNamara. Russell tried to explain that while he could train South Vietnamese reconnaissance teams, "I didn't feel that we could assure any tangible results unless our own people participated." McNamara told Russell, "I agree with you; however, Mr. Rusk does not at this time feel that we should risk the exposure of American forces in an area that they're not supposed to be in."[46]

Russell developed an ambitious plan called Leaping Lena, and trained the Vietnamese teams. However, they proved unable to handle what they encountered "over the fence" in Laos, and few came back alive. It was a tragic disaster, although the operation did reveal interesting information about NVA activity on the trail. It was not just a handful of barefoot guerrillas traipsing through the jungle, but NVA regulars. Hanoi took protection of the trail quite seriously. It was of strategic importance to their conduct of the war in the South.

By early 1965, MACV was clamoring that something had to be done about the trail in Laos. However, Washington still worried about the political sensitivity of U.S. covert military involvement in Laos. This was the situation Don Blackburn inherited when he took command of MACVSOG in May 1965. He quickly realized that if SOG were going to operate against the trail, the covert teams had to be U.S.-led. He explained: "Because of the failure of the indigenous operation in Laos, Leaping Lena . . . I felt it had to be conducted with American direction and leadership."[47] This required authorization at the highest levels in Washington. Blackburn ended up making a special trip to Washington to argue his case. "I knew I had to go," he said, "to get authority to go cross-border into Laos and I did it."[48]

While Blackburn was fighting the political battle, SOG developed an operational plan for Laos. It called for "three phases beginning with short-stay, tactical intelligence missions progressing to longer-stay sabotage missions and culminating in long duration missions to develop resistance cadre."[49] Phase one operations were finally authorized for execution in September 1965. The first U.S.-led recon team was inserted into Laos in October. Yet before this could take place, a complex set of restrictions had to be negotiated and agreed to by representatives from the departments of Defense and State, the CIA, Pacific Command, the United States embassies in Vientiane and Saigon, and the U.S. Military Assistance Command, Vietnam (MACV). Like its other operational counterparts, this section of SOG

likewise experienced micromanagement, intense political scrutiny, and exacting restraints.

Organizationally, operations against the trail were assigned to a new section of MACVSOG. On the 1969 diagram, it is designated as OP 35, the Ground Studies Group. To build it, Blackburn recruited a legendary Army officer, Colonel Arthur D. Simons. Characterized as "a gruff, barrel-chested, mean-looking rock of a soldier," Simons was said to be simply "fearless."[50] He was both a soldier and a leader and had demonstrated excellence in many combat situations. Men wanted to follow him and believed in his capacity to take them through dangerous situations. The following comment by one who served with him is illustrative: "I would follow Bull Simons to hell and back for the sheer joy of being with him for the visit."[51]

Nicknamed "Bull," Simons had worked with Blackburn in the past. The Headhunter had picked him to organize and train indigenous units in Laos in the early 1960s. He took 107 men to Laos for an operation code-named White Star. Its initial objective was to train the Laotian Army. However, Simons's mission changed to helping hill tribesmen organize into guerrilla bands to harass North Vietnamese traffic along the Ho Chi Minh Trail. By the time he finished, he had established a substantial indigenous force of unconventional soldiers. The area of operations for the White Star teams was the Bolovens Plateau.

The results were predictable for an operation run by Bull Simons. Blackburn recounted: "We took the Bolovens Plateau and held it until the Geneva Agreement in 1962. . . . We put the cork in the bottle during White Star and it was to our advantage to have it. . . . Simons set things up. The Bolovens always was referred to as the cork in the bottle, the key area for North-South movement. Simons recognized this and wanted to take advantage of it . . . At that time the Pathet Lao were controlling the Bolovens. Simons developed an operation that ran the Pathet Lao off the plateau and held control over the Bolovens until that Geneva Agreement cleaned us out of there."[52]

In 1965, Simons received a call from Blackburn. He needed someone to organize U.S.-led recon teams for clandestine operations in Laos. The objective, Simons was told, would be "to develop a capability of interdicting the movement of those supplies down that Ho Chi Minh Trail, and we realized we were starting from scratch and

it was going to take time to do it."[53] Simons was on his way to
MACVSOG.

The organization Simons established in 1965 grew dramatically
over the next three years. OP 35 became SOG's largest operational
section. In 1966, a total of 137 recon teams were launched into Laos.
Starting in 1967, OP 35's area of operation expanded to include
Cambodia. By 1969, its three command-and-control groups each
maintained one or more forward launch sites from which teams were
inserted. Furthermore, the number of operations had risen to over
400 each in Laos and Cambodia. Most consisted of small U.S.-led
teams to identify targets to be hit by air strikes. Secondary missions
included capturing enemy personnel, bomb-damage assessment,
ground photography, wiretapping, and implacing of electronic sen-
sors.

SOG's Support Sections

SOG had three unique groups supporting its four core missions.
One was the Air Studies Branch and Air Studies Group, known as OP 32
and OP 75. The Air Studies Branch planned air support. OP 75 was
the operational arm and included all the aircraft elements—heli-
copters, tactical aircraft, transports, and forward air controllers—
assigned or available to support SOG missions. Its forward elements
were located at air bases in Vietnam and Thailand.

Helicopter support, which was essential for OP 35 missions in
Laos and Cambodia, was provided by one unit of the South
Vietnamese Air Force, the 219th Helicopter Squadron, and two USAF
Special Operations Squadrons that operated out of Udorn and
Nakhon Phanom in Thailand. Tactical air support and forward air
controllers were mainly from the U.S. Air Force, although the
Vietnamese did assign one squadron of fighter aircraft to SOG.
Finally, SOG had third-country personnel—pilots from Nationalist
China—flying unmarked aircraft on missions into North Vietnam.

A second element of note was MACVSOG's Logistics Division—
OP 40. While the activities of a logistics divisions are generally rou-
tine, OP 40 was an exception because of its work with the U.S. Army
Counterinsurgency Support Office and the CIA's top secret Far East
logistics office, both located on Okinawa. These two organizations

provided SOG with a wide variety of exotic unconventional warfare devices, such as specialized weaponry, duplicated NVA uniforms for recon teams, tainted AK–47 ammunition, booby-trapped items, special wiretap devices, and rice contaminants.

Such unusual and, in some instances, diabolical devices were not always appreciated in Washington. Singlaub would recount one example that had to do with contaminating NVA rice caches found along the Ho Chi Minh Trail. "We did have some trouble with rice. I wanted to use a contaminant called Bitrex, which would have been an easy way of ruining the rice since we couldn't haul it out, and it was essential to the conduct of NVA operations. You find 100 tons of rice, that's a hell of a lot. If we had been able to take in Bitrex and just spread it on the rice, it would render it unsuitable for eating. . . . The State Department blocked my use of Bitrex. But, in fact, this rice was strictly for military consumption and to destroy it would place an added burden on their supply system."[54] But the State Department saw the use of Bitrex as chemical warfare, even though it poisoned no one; Bitrex simply made the rice so bitter that it was enough to gag a maggot. After a good deal of wrangling between the State Department and the Joint Chiefs of Staff, Singlaub eventually received permission to use the contaminant.

The third SOG group whose support proved critical to all its missions was its Communications Division, OP 60. Its advanced cryptographic equipment maintained secure traffic with MACVSOG operatives in the field. One of its more extraordinary forward-deployed transmission-relay sites was on a peak in southern Laos that was so steep, it proved secure from the NVA. It became a lifesaver for recon teams that faced serious communications problems in Laos. From this peak, according to one recent account, "relayed radio messages from recon teams" could solve a "deadly problem" facing them. "The NVA had figured out SOG's modus operandi and had begun allowing teams to land unmolested, then waited for the helicopters to fly well east so intervening mountains cut off the teams' radio transmissions. Then the NVA hit them."[55] Code-named Leghorn, this radio relay site proved invaluable. The site also became a repository for state-of-the-art National Security Agency technical intelligence systems that intercepted and manipulated NVA communications, both in support of SOG and other unrelated intelligence operations.

SOG's Paramilitary Campaign

MACVSOG's four core missions—insertion of agent teams and deception program, psychological warfare, operations against the NVN coast, disruption of the Ho Chi Minh Trail—constituted a covert paramilitary campaign. It was essential that SOG operations take the form of an integrated campaign, if they were to play a role in the larger U.S. military strategy in Vietnam.

Military campaign planning is an element of policy and strategy formulation for war. Military strategy generally consists of one or more campaigns. These take place at what the military calls the operational level of war, whose end purpose is the accomplishment of the established strategic aim.

MACVSOG's four core operational missions constituted the basis for a covert paramilitary campaign, aimed at two targets of strategic importance—Hanoi's internal security and control of the population, and its use of the Ho Chi Minh Trail.

Strategy sets the focus for all campaigns, and in turn all campaigns should support the aims of strategy. As the military frames the issue, strategy translates policy into military terms by establishing military strategic aims. These military aims, in turn, generally are but one component of a broader grand strategy for conducting war.

Thus, there has to be an interrelationship and integration of policy, strategy, and operational campaigns. Policy sets the aims that strategy seeks to accomplish. Campaigns are meaningful when they support and are integrated into strategy, and when they are coordinated, harmony among the various levels will reinforce success, while disharmony will undermine success. In the case of MACVSOG, coordination and integration proved difficult, sometimes nonexistent. Disharmony was at play. SOG did develop and carry out a covert paramilitary campaign that focused on two strategic concerns of the enemy. However, efforts to integrate that campaign into an overarching U.S. military strategy for the war in Vietnam were never evident.

COMMAND AND CONTROL OF MACVSOG

The operations MACVSOG carried out were considered highly sensitive and raised concerns over their control and oversight among both

senior military officers and civilian policy makers, although for different reasons. Actually, there was an element of schizophrenia in the behavior of Washington. At first the Kennedy administration was highly enthusiastic about covert operations against North Vietnam and wanted to manage the process at the operational level. Senior officials, unaware of the difficulties of initiating a complex covert action against a denied area, expected immediate results. Furthermore, they insisted on knowing every detail. What was the impact? Was Hanoi feeling the pressure? Washington wanted to know all the particulars.

When the results were not to their liking, recriminations quickly followed. JFK was not happy with the CIA's performance against North Vietnam and assigned the operations to the Pentagon. Then, in the late spring of 1964, the Johnson administration expressed disappointment over SOG's slow start and McNamara called for an immediate increase in the number of operations. Later, as the war focused on conventional operations, the third chief of SOG, Jack Singlaub, noted that senior policy makers lost interest in what covert operations could contribute. "I definitely feel that took place at that time because there was a lack of education of how covert special operations could assist conventional operations. Prior to the commitment of U.S. ground forces, the only action or possibility of action was covert operations. Once conventional forces were introduced, the assumption was that they could achieve our objectives. Everybody was very optimistic: 'All it takes is a few U.S. divisions in there and we'll whip their tail.' It didn't happen, and those of us who had studied this knew that it wouldn't happen that way."[56]

The policy makers' schizophrenic behavior stemmed from the fact that paralleling the enthusiasm for covert operations was apprehension over possible unintended consequences. In particular, policy makers feared public exposure, referred to as "blowback" in the lexicon of the CIA. Civilian policy makers worried over upsetting the situation in Laos and instigating international criticism if U.S. covert missions against the Ho Chi Minh Trail became public. With respect to North Vietnam, they fretted that its destabilization might prompt intervention by Communist China, creating a second Korea. Even if this did not occur, too much covert action against Hanoi might instigate the North Vietnamese to escalate the war in the South, fueling

that crisis. This anxiety resulted in a series of constraints on every SOG mission. While the policy makers' enthusiasm for SOG faded, as Jack Singlaub noted, their trepidation and the resulting operational restraints remained to the end. Consequently, White House oversight of MACVSOG was stringent.

Senior military officers also agonized over SOG operations, but for reasons different from those that troubled civilian policy makers. Their concerns had more to do with the mainstream military's attitude toward special operations in general, be they counterinsurgency or unconventional warfare. The generals did not believe special warfare could contribute very much to the prosecution of the war in South Vietnam. Blackburn put it this way: "Why didn't they use special operations forces more effectively? Westmoreland was a conventional commander. . . . Westy, he was having meetings all the time with the corps commanders and getting a run down of what the corps were doing. . . . He never worried about that with us."[57]

The Pentagon generals had another reason for opposing special operations. The allure of these "derring-do" kinds of missions, encouraged by JFK's enthusiasm for the Green Berets, was attracting highly promising young officers. For the senior military leadership that was a problem. Jack Singlaub understood this attitude well. His own career reflected that awareness. One of the Army's most talented special operators, Singlaub rose to the rank of major general because of his assignments and achievements in the conventional mainstream Army. In fact, when first told he had been selected to head SOG, then-Colonel Singlaub tried to get out of the assignment. He implored Army chief of staff Harold K. Johnson to allow him to take a conventional command in Vietnam. Singlaub recounted that "Johnson's face was set in an expression of tempered impatience" over his request. He told me, "Jack . . . General Westmoreland specifically requested you as the new MACVSOG commander. That will be your assignment."[58] This seems like a contradiction. Why would the mainstream Army worry about losing its best young officers to Special Forces and then assign a first-rate colonel to be chief of SOG? Perhaps the reason Westmoreland insisted on Singlaub had to do with Singlaub's success in mainstream assignments and not his special operations background. He was not an iconoclast like Blackburn, a special operator that Westmoreland had little time for. Westy felt comfortable with Singlaub.

All of this senior-level civilian and military angst resulted in a Byzantine approval process for all MACVSOG operations. On a monthly basis, each of the four operational sections of MACVSOG would draw up a schedule of missions to be executed in the next thirty-day period. This would be submitted by the chief of SOG directly to General Westmoreland. MACVSOG purposely bypassed its South Vietnamese counterpart, the Strategic Technical Directorate, even though OPLAN 34A had specified that coordinating with and supporting GVN covert operations was an essential. The STD was excluded almost immediately, however, because SOG chiefs believed the STD had been penetrated. COMUSMACV then sent the SOG package up the chain of command. The schedule of proposed missions would next pass through the Pacific Command for comments and then be sent to the Joint Chiefs of Staff—specifically to the Special Assistant for Counterinsurgency and Special Activities. Within the Pentagon, the SACSA would submit the proposed schedule of missions to the office of the secretary of defense and the chairman of the Joint Chiefs for review and approval. From there SACSA action officers would take SOG's mission package to the State Department, the CIA, and the White House for authorization.

At any point in this review process, proposed missions could be altered or rejected. It was not unusual for this to take place, according to the first two chiefs of MACVSOG. As Clyde Russell noted: "By the time we got a program out of country, it had been whittled quite a bit. That program would then go to Pacific Command and they would whittle it some more, then it would go to the JCS where it would be further sniped at." Following the Joint Chiefs, the civilian agencies took their turn.

Russell believed that this mission approval process resulted in restraints that were "too many and too frequent."[59] Don Blackburn saw it the same way: "Tight control from Washington hamstrung the operation. I can appreciate the problems faced in Washington. However, this stringent control affected timeliness. It seemed strange that the authority to conduct some operations had to come directly from the White House. Sometimes it took three to four weeks for decisions."[60]

A good example of this "whittling process" can be seen in how the State Department fought to keep SOG out of Laos. State was opposed

to covert operations in Laos because of the 1962 Geneva Accords. Laos was neutral, and SOG's desire to send U.S.-led recon teams to operate against the Ho Chi Minh Trail there was verboten, at least until the fall of 1965. When the U.S. ambassador to Laos, William Sullivan, could no longer keep SOG off the trail, he successfully fought to impose a stringent set of restrictions on all covert operations. According to Blackburn, "Sullivan wanted us to confine our operations to 20-by-10-mile area grids. He also didn't want us to go in by helicopter. . . . I explained it to him and he saw the logic because he said you can take [your men] out by helicopter, but don't put them in that way. I said this doesn't make sense. . . . It was a crawling process to get some of these restrictions eased."[61]

The CIA likewise wanted to keep SOG out of Laos, but hardly because of its commitment to the Geneva Accords. CIA was running its own covert war in northern Laos. It had organized and armed Hmong tribesmen, headed by Vang Pao, and did not want SOG mucking around in its area of operations. Again, Blackburn recalled that "The CIA was damn near all-powerful over there in Laos. They ran the show over there."[62]

Even after a schedule of SOG missions had been authorized through the chain of command, the oversight process was still not complete. The same chain of command had to approve executing each specific operation that had already been authorized. Twenty-four hours prior to launching an operation, MACVSOG, through MACV, had to notify each agency that had already authorized it.

3

GOING NORTH

When President Kennedy declared at his first National Security Council meeting on January 28, 1961, that he wanted to mount guerrilla operations inside North Vietnam, what he had in mind originated in his long-standing preoccupation with guerrilla warfare. On April 27, 1961, he told NSC members, "We are opposed around the world by a monolithic and ruthless conspiracy that relies primarily on covert means for expanding its sphere of influence—on infiltration instead of invasion, on subversion instead of elections, on intimidation instead of free choice, on guerrillas by night instead of armies by day." The bureaucracy had to come to understand what the United States was up against, he said—"a struggle in many ways more difficult than war"—and they should begin by reading the writings of Mao Tse-tung and Che Guevara on guerrilla warfare.[1] He had.

When General Lansdale briefed the NSC at that meeting, he reported that the Viet Cong, or VC, were mounting a rapidly expanding and increasingly successful campaign of terrorism and guerrilla warfare against South Vietnam. The Hanoi-backed VC strategy was a sophisticated one that had as its ultimate objective the overthrow of the Diem regime. According to Lansdale, Saigon's demise was on the horizon.

Why were the Viet Cong so successful, and could their accomplishments be replicated "up North"? At least two factors accounted for

the Viet Cong's rapid progress. One had to do with experience. Ho
and the senior leadership of the Vietnamese Communist Party (VCP)
had mastered the principles of revolutionary warfare, as their defeat
of France in 1954 had demonstrated. When Hanoi decided in January
1959 to change its strategy toward South Vietnam from "political
struggle" to "armed struggle," those sent South to execute the policy
were schooled and experienced in the principles of revolutionary war-
fare. So were the cadres who had remained in South Vietnam after
1954 and were now instructed to resume armed activities.

By December 1960, this experience was paying dividends and Hanoi
decided the time was right to formally establish a National Liberation
Front (NLF). The purpose of the Front, or as the U.S. referred to it, the
Viet Cong, was to foment a general armed uprising in South Vietnam
and bring about a revolution. Although controlled by Hanoi, the NLF
promulgated national independence and not ideological class warfare.
This broadened its recruitment base and played well internationally.
Class warfare would have to wait until after the revolution. The NLF
was simply a new version of the Vietminh organization, which had been
established by Ho Chi Minh in 1941 to mobilize and mold anti-French
and anti-Japanese sentiments into a revolutionary warfare movement.
However, the NLF had two critical advantages over the Vietminh: (1) it
could draw on all that experience and the lessons that Hanoi had surely
gleaned from the Vietminh's victory over the French in 1954;[2] (2) North
Vietnam provided the NLF with supplies and eventually soldiers.

In the 1960s, a great deal of fiction clouded the understanding of the
Viet Cong, among both its detractors and its defenders. On the one
hand, Washington portrayed the VC as a terrorist organization that
flourished almost exclusively through coercion. For example, a
December 1961 Kennedy administration white paper on the Vietnam
situation asserted that the movement "relies on every technique for
spreading disorder and confusion. . . . No tactic, whether brutal terror,
armed action, or persuasion, is ignored."[3] On the other hand, the anti-
war movement in the United States romanticized the Viet Cong as bare-
foot guerrillas and claimed they were successful because, according to
journalist Frances Fitzgerald, the Vietnamese peasants believed the "lib-
eration cadre were nicer."[4]

There was a grain of truth in each view. The VC did go to great
lengths to recruit peasants, and this included demonstrating respectful

behavior toward them. However, they also cut off the heads of land-lords and government officials following stage-managed village show trials. In reality, the Viet Cong constituted a highly sophisticated movement that combined ideology, organization, reformist policies and programs, nationalist propaganda, and violence, including terror-ism, into a political-military strategy of revolutionary warfare. One leading expert concluded, "What the NLF produced was a major, if not necessarily beneficial, contribution to the sociology of revolu-tion."[5]

The second reason the VC were advancing rapidly had to do with the Diem government. Diem has been described as a "brilliant incom-petent who beat the odds longer than anyone thought possible. . . . Reclusive and paranoid, he depended almost exclusively on his family, refused to delegate authority, and did little to build a broadly based, popular government."[6] Corruption, incompetence, repression, intrigue, and remoteness from the population were the hallmarks of the Diem regime by the early 1960s. Clearly, the odds favored the Viet Cong.

Neither of these two conditions existed in North Vietnam in 1961. First of all, there was no legacy of anticommunist resistance to build on. Stay-behind agent teams that Lansdale had organized in the North in 1954 had long since been mopped up by Hanoi's Ministry of the Interior. There were no cadres waiting for the signal to activate armed opposition up North, as there had been in the South in 1959. Second, Ho and his followers established a highly regimented coun-terintelligence state structure. While the communist regime in North Vietnam may not have been loved, its security forces were efficient and feared. Former CIA director William Colby explained it this way: ". . . that total permeation of society with local block wardens . . . It leaves no one free. . . . That is the way you run a communist society, total discipline. That's what we ran into in the operations we tried [against North Vietnam]."[7]

Did Secretary of Defense McNamara realize this when he pushed in 1963 for the Pentagon to take over CIA operations against North Vietnam? Apparently not. McNamara attributed the failure of the CIA's program against the North not to the toughness of the target but to the timidity of the agency's efforts. What was needed was a larger endeavor. Think bigger and send more agent teams North—

that was the answer. The military could put more horsepower into the operation. In his memoir, McNamara acknowledged that "it was an absurdly ambitious objective."[8] Maybe! But in the early 1960s, he reflected the enthusiasm for covert operations that mesmerized the Kennedy administration.

Richard Helms, at the time the CIA's deputy director for plans, attended the 303 Committee meetings that reviewed all covert operations. He had worked his way up through the operational side of the agency and in 1966 would become CIA director. Helms was the consummate clandestine operator. He knew the business and had no illusions that covert action was a magic bullet. It took expertise, time, and hard work to be successful. Recalling the Kennedy administration, and in particular the president and his brother, Robert, the former head of the CIA declared that they had great enthusiasm for covert operations but little understanding of the complexities of carrying them out. With respect to McNamara's rationale for taking covert operations against North Vietnam away from the CIA and assigning them to the Pentagon, Helms explained it this way: "If the Kennedy brothers were for it, McNamara was for it." Did McNamara know what it was going to take to succeed up North? Helms doubted it: "McNamara knew nothing about such operations."[9]

SOG TAKES OVER AGENT OPERATIONS

Once in Saigon in early 1964, Colonel Clyde Russell, the first chief of MACVSOG, quickly found out that he had to address several major issues if he were going to make any improvements on what little the CIA's agent program had accomplished. To start, Russell had to find qualified and skilled military officers who could recruit, train, insert, and run agent teams in denied areas. Additionally, he was going to need to draw on appropriate unconventional warfare operational concepts and doctrine that could serve as the basis for expanding the agent operations inside North Vietnam, as demanded by the senior policy makers. What Russell found was a dearth of both.

Locating the necessary U.S. military personnel with experience in agent operations proved exceedingly difficult for all the chiefs of MACVSOG. Why? Because little expertise existed. This reality became quickly apparent to Russell when Lieutenant Colonel Ed Partain arrived

in Saigon in June 1964 to take over OP 34. What did he know about the insertion and control of long-term agent teams in North Vietnam? How much experience did he have in executing these operations against other denied areas? Was he at least trained in the intelligence tradecraft of agent handling? There was no evidence of any of the above in Partain's record. Although he was a West Point graduate and a fine officer, Partain was not prepared to command OP 34.

Why was he selected? Purely by happenstance. "I was on orders to go to MACV to work in the J–3 section [operational planning] for then Brigadier General Richard Stilwell," Partain recalled. "Clyde Russell had taken over as the first Army commander of SOG, and he went to Stilwell and said, 'I have got to have someone in this organization who is capable and honest' . . . So, Stilwell did the dirty on me and sent me over to SOG."[10] Did Partain know what he was getting into as the chief of OP 34? It was all new to him.

Few of those assigned to work for him had training or experience in agent operations. Partain recalled, "There wasn't anyone I knew after the CIA types left [OP 34] who had any agent-handling experience." When asked why the selection process failed to identify the appropriate officers, the now-retired Major General Partain observed it was because such officers generally "did not exist within the Army."[11] Here was a major example of how unfamiliar senior policy makers were with the military's capacity to take over specific types of covert operations. Because of dissatisfaction with the CIA's efforts up North, McNamara asserted that the military had more capabilities, and therefore could do a better job of escalating agent operations against North Vietnam. In reality, this was just not true. The military had little such expertise. When asked how the secretary of defense could make such a blunder, Partain sighed: "I think we both realize that this was yet another of his errors in judgment with regard to Vietnam."[12]

Ed Partain was not the only chief of OP 34 to lack experience in the operations he was charged with executing. The same was true of the next two lieutenant colonels who commanded this section of SOG. Neither Reginald Woolard nor Robert McLane had any knowledge of the business. Like Partain, they were fine officers with Special Forces experience. However, as Pete Hayes, a deputy to both Partain and Woolard, noted: Special Forces training at Fort Bragg "was not oriented on agent operations at all."[13]

Partain, Woolard, and McLane were all fish out of water. For each, the SOG assignment turned out to be a frustrating and disheartening experience. McLane's deputy in 1966, John Hada, remembered that toward the end of his tour "Bob McLane was pretty disenchanted with the whole operation. . . . I know when I got there he was very disillusioned . . . he just wanted his watch to end and go home."[14] This was because McLane found himself commanding officers who knew little about the operations they were to carry out. Consequently, as Hada noted, "Lieutenant Colonel McLane was not getting the results that he expected. I know he was not happy."[15] Partain expressed the same sentiments. His experience in MACVSOG was not considered a career high point by him—just the opposite. He was happy when the year was over so he could forget it and move back to the mainstream Army.

Russell also found that the Army's unconventional warfare doctrine had little relevance to the agent mission assigned to OP 34. The Army's focus was on organizing guerrilla forces in support of general war operations like those in World War II.[16] The doctrine outlined requirements for U.S. Army and indigenous guerrilla operations in Eastern Europe during a conventional war with the Soviet Union and envisioned considerable guerrilla and other behind-the-lines operations. The doctrine assumed that agent networks organized by the CIA could be activated in time of general war and would be in place when the Special Forces units arrived. Given what is now known, it is likely that the SF units going behind enemy lines in a hot war would have found themselves on their own.

Unconventional warfare doctrine was geared for hot war, while its role in cold war was ignored. There was a serious mismatch between how officers were trained at the Special Warfare School at Fort Bragg and what they were asked to do against North Vietnam. Before becoming the deputy chief of OP 34, John Hada was at the School in the Unconventional Warfare Department. At that time, he noted, "the Unconventional Warfare Department taught a fifteen-week UW course to selected officers. They had to go through that course in order to be qualified as Special Forces officers." When asked if it included long-term agent operations, Hada replied, "No. None of that was taught, there was no specificity involved. Some operations conducted in World War II, in the Philippines, were mentioned . . . [also] the Maquis in France."[17]

Pete Hayes, Partain's deputy, told the same story. The UW course he took at Fort Bragg "was introductory level. It was mainly on the development of resistance groups in a wartime setting. . . . I don't [believe] at that time that the Special Warfare Center had the charter for agent operations. That all fell within the intelligence field." He noted that the UW concepts were modeled on the World War II experience, so that Special Forces "would be introduced into an area where there were already friendly contacts. The infrastructure had been established." What about doctrine on how to develop that infrastructure and set up those networks? According to Hayes, "It wasn't there."[18]

In charge of a mission for which neither he nor his subordinates had training or experience and for which there was no appropriate doctrine, Partain simply adopted techniques employed by the CIA. After all, at the agency's core was the Directorate of Plans, and its raison d'être was the recruitment and running of agents. It seemed logical to Ed Partain, and so that is what he did. Reg Woolard and Bob McLane agreed, and likewise employed the same CIA agent methodology when they headed OP 34.

What method did the CIA use in its agent operations up North? The program's architect, Bill Colby, referred to the agent-insertion technique as a "blind drop." It entailed putting agent teams into North Vietnam on their own. Well, not completely. Colby pointed out that "we did find some people willing to go back into the area from which they had come. So they were familiar with the geography, and some of the people in the area in which they were to be inserted."[19]

The CIA did not actually recruit the agents who were sent North but left that to the South Vietnamese. Colby conceded that this had its drawbacks: "Remember, we were dealing with the South Vietnamese. They were running the operations, it wasn't CIA hiring these agents individually. . . . [I]t could be there were some [double] agents in there, but obviously that was their business. I can't say there weren't, I can't say there were. You assume they're agents. Then you compartmentalize things. That is the way you do your business."[20] It was a matter of quality control, and shortcomings in the CIA's agent operations against North Vietnam were much more serious than Colby either knew or let on.

Colby explained that once inserted, the agents were "to go back and be fairly quiet, just get there, establish yourself somehow, legitimize yourself, and then gradually, over time, extend and develop a

little network of friends." It was a long-term process and "takes time. In France," he explained, "it took from 1940 to 1944."[21]

The blind-drop concept proved quite unsuccessful during the 1961–1963 period. The CIA inserted well over forty agent teams and several individual agents (singletons) into North Vietnam by land, sea, and air. For most of them, the insertion proved not to be a blind drop at all. There were people to meet them on the ground, but they were not members of a friendly resistance network. All too often, the agents were met by North Vietnamese security forces and either killed or captured.

It was a catastrophe of substantial proportions. Of the roughly 250 agents the CIA inserted, only four teams and one singleton were considered to be operating inside North Vietnam at the time MACVSOG took over.[22] This amounted to less than 15 percent of the total number of agents inserted.

What went wrong? Colby attributed the low success rate to the NVN internal security system. By 1963, he was convinced that "the agent operation did not work," and it was better to focus on psywar. "It was my thesis that if you worked reasonably hard on the psychological, which included the radios and things like that, you could have an impact because the communists are so hyper about the danger of resistance that if you suggest that there was any opposition group within their ranks, it would drive them crazy."[23]

This was the state of the CIA's agent-operations program in January 1964. The blind-drop concept had resulted in only a small number of successful insertions. However, rather than wonder why this was so, MACVSOG adopted the CIA approach as the basis for its own agent program, and on orders from Washington, prepared to put more agents into NVN. These were the marching orders the secretary of defense gave to MACVSOG. As Colby explained, the heat was on to escalate the effort: "They were under pressure to keep going. You know, from the top. See, I could stand up and say, 'Mr. McNamara, it won't work.' A colonel can't. You don't have colonels that say it won't work; they say, 'Let me do it, boss.'"[24]

OP 34's AGENT OPERATIONS

In the early months of 1964, the CIA completed the transfer of its agent operations in North Vietnam to MACVSOG. This consisted of

four agent teams, code-named Bell, Remus, Tourbillon, and Easy, that were believed to be operating from inside enemy territory. The teams consisted of roughly thirty individuals. A fifth team, which the CIA had inserted in February 1962 and assumed was operational—Europa—stopped all radio contact as the CIA assets were being transferred. It was considered lost to the enemy. Finally, the CIA handed off its one successful singleton, known by the code name Ares.[25] The CIA also turned over to SOG its Camp Long Thanh facility with approximately 169 agents in training, and several safe houses in Saigon.[26]

McNamara and the senior policy makers in Washington expected action. They wanted SOG to escalate the agent program and to do so quickly. Between April 1964 and October 1967, close to thirty agent teams and a handful of singletons were inserted into North Vietnam—approximately 250 agents.[27] When added to the CIA insertions, the number sent North doubled to close to 500. As with the CIA, the percentage of successful insertions by OP 34 was low. By late 1967, it was believed that only seven teams—Remus, Tourbillon, Easy, Eagle, Hadley, Red Dragon, and Romeo—and the singleton agent, Ares, were still operating inside North Vietnam. These were hardly the results Washington expected.

In the latter half of 1967, the new chief of OP 34, Bob Kingston, decided to reassess the agents program. His findings led to a comprehensive review in 1968 conducted by a team of CIA and Defense Intelligence Agency (DIA) counterintelligence specialists. They evaluated every team's message traffic, intelligence reports, and movements, all case officer reports, and related materials. The process took one month to complete. The conclusions were devastating. Nothing had worked. All the teams that OP 34 thought were legitimate were actually under enemy control and being run back against MACVSOG. It was a complete double cross, a seven-year spoof that had seen nearly 500 agents inserted into NVN but none brought back out, or exfiltrated, in SOG jargon.

What went wrong? The answer is not easy: it involves the world of counterespionage, double and triple agents, disinformation and deception. CIA's longtime chief of counterintelligence, James Angleton, once described this cryptic world as a "wilderness of mirrors." John Masterson, the head of Britain's security service, MI 5,

referred to it as the "double-cross system."[28] However, it was not just the cleverness of North Vietnam's specialists in the "double-cross" that explained the debacle. The blame has to be shared by others, including policy makers in Washington who wanted to go North and the operators in SOG who executed the mission.

Long-Term Agent Operations: The Results

The long-term agent program, as seen in once highly classified SOG reports, was a fiasco. Of the seven teams and singleton agent believed to still be operating inside North Vietnam in 1967 (see the following map for their purported locations), three teams and the singleton had been inherited from the CIA.[29] Therefore, after four years of trying, SOG had only four teams—Eagle, Hadley, Red Dragon, and Romeo—to show for its efforts.

It was a very low success rate, no matter how you cut it. When taken together with the earlier CIA program, it can only be portrayed as a real debacle. However, the numbers tell just a part of the story. It is also necessary to look at those teams that were considered successful insertions and evaluate what they actually accomplished—which was little.

The CIA inserted Team Tourbillon on May 16, 1962. Subsequently, it was reinforced with two additional agent insertions. Located in the northwest region of North Vietnam, Tourbillon was ordered to conduct sabotage and harassment operations. Later, this was changed to intelligence collection. In none of its activities did Tourbillon accomplish anything of note. According to one report: "No significant intelligence was reported."[30] Each time SOG attempted an exfiltration, the team failed to arrive at the designated landing zone.

In August 1963 the CIA infiltrated Team Easy into Son La Province to "contact selected Meo and Thai settlements to establish safe areas for other teams operating in the area." It was also to "determine resistance potential, selectively arm tribesmen for harassing attacks on NVA lines of communications and road traffic," and recruit tribal leaders for "exfiltration and training."[31] After January 1964 this mission was not continued because SOG never received authorization to carry out the resistance operations. Easy was now tasked for "intelli-

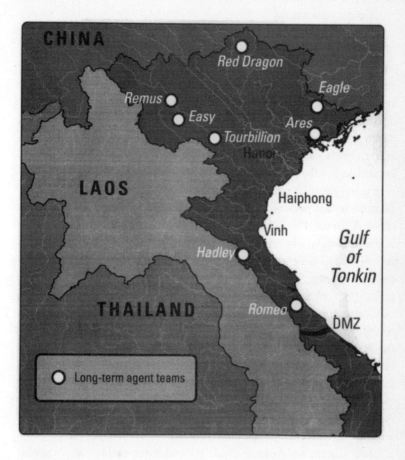

gence collection by observation and exploitation of locally recruited subsources." Nothing remarkable was ever reported, according to SOG documents. Nevertheless, Easy was reinforced four times with a total of twenty-three men. When alerted that some of the team members were to be exfiltrated, Easy "went off the air" and stopped all radio communications.[32]

The six-man Team Remus parachuted in April 16, 1962, near Dien Bien Phu to "establish a base area from which intelligence collection activities could be launched." It was to gather "enemy military, political, and economic information; locate resupply drop zones and safe areas for possible infiltration of additional agents; collect available documents; and recruit subsources and support personnel."[33] In 1964, Remus reported that it had sabotaged a couple of bridges. McNamara was elated. Colby recalled that the secretary of defense "was just as excited as a baby" over such reports. "I remember him thinking this was a big deal, like that's going to change the course of the war."[34] Because it was believed to be successful, Remus was reinforced five times. With the 1966 change in the agents' mission, the team began to make excuses about why it had provided so little useful information. In 1967, SOG ordered the team to exfiltrate two agents. They claimed it was too dangerous.

In 1968, all radio contact with the team ceased. At the same time, the "interrogation of a recently captured NVA prisoner of war revealed he had knowledge of the capture of a SVN ranger team in the Remus area of operation in June, 1962." On May 13, 1968, Hanoi "confirmed this by announcing capture of a SVN ranger team. . . . All facts presented left no doubt this was Team Remus."[35]

Ares was the CIA's only singleton agent to survive. Those sent into North Vietnam after him were never heard from. According to the records, a "case officer encountered Ares at the Refugee Debriefing Center, Saigon, on August 29, 1960 and assessed him as a capable man motivated by desire to revenge himself on the authorities of NVN. He was subsequently recruited."[36] Ares was inserted into North Vietnam by sea in early 1961, up near the Chinese border. At first, he was considered very productive, providing "information on NVN documentation, the Uong Bi Power Plant, highways, bridges, Haiphong Harbor and other miscellaneous items which he was able to observe or gain information on through debriefing of his sub-

sources."[37] However, by 1966, SOG began to wonder about his reporting and resupply requests. When told to find a suitable drop zone for resupply, Ares proposed alternative ways to resupply that suggested he was trying to get SOG "to expose additional assets." When SOG attempted to exfiltrate Ares, he "failed to comply."[38] Nevertheless, Ares stayed in radio contact until 1968, as Hanoi continued to play the game.

Team Eagle was inserted near the border with China on June 27, 1964. Its "mission was to conduct sabotage operations on NVN routes 1 and 4, the Muc Nam Quan rail line and the Mai Pha air base." There was no evidence that Team Eagle ever carried out any of these operations.[39] It was also supposed to produce intelligence reports on these targets. According to a SOG assessment, "The information received was of little or no value." In 1966, Eagle was tasked with the road watch mission. The results, according to SOG, were the same: "The mission was not completed."[40] In 1968, the team was instructed to move south for exfiltration. Eagle reported it was not able to get itself in position to be exfiltrated. Contact with the team stopped shortly thereafter.

In November 1965, SOG inserted by helicopter the ten-man Team Romeo "into an area immediately north of the DMZ. Its mission was "to conduct area reconnaissance for collection of intelligence information; perform the road watch mission, and conduct harassing and sabotage activities." Its major target was "NVN Route 103, which was believed to be a major route for infiltration of men and supplies to the South."[41] How well did Romeo do? According to SOG documents, after mid–1966 its accomplishments were insignificant. "The team has not furnished any reportable information during 1967 and 1968."[42]

Team Hadley was also infiltrated just north of the DMZ to conduct the road watch mission against NVN Route 8, which connected Route 15 to Routes 81, 12, and 121 in Laos. These routes were "considered major troop and supply infiltration routes to the South." Hadley was also tasked to watch "the Ngan Pho River . . . a principal water supply route."[43] The team had initial problems because of enemy detection. However, after that its response to messages from SOG was almost immediate. Still, there is no evidence that Hadley reported useful intelligence or identified potential air-strike targets.

The final team considered operational in late 1967 was Red Dragon. Inserted on September 21, 1967, this seven-man team was located in the northern provinces of Lao Cai and Yen Bai. These provinces were situated in the Red River Valley along the Chinese-NVN border. Major rail, road, and water routes ran through these provinces. Team Red Dragon was to "conduct sabotage and intelligence missions."[44] According to the documents, it "was largely unproductive" and its "security status was a matter of question since its initial radio contact." Apparently, there was a serious disagreement over whether the team had been captured and forced to work for the North Vietnamese as a double agent: "U.S. personnel were convinced the team was under NVN control, [while] the SVN counterpart case officer felt otherwise."[45] Contact was maintained in 1968, but Red Dragon went off the air in 1969.

Whether their mission was sabotage and harassment or intelligence collection and reporting, the long-term agent teams produced very little. When asked to what extent they carried out successful sabotage operations during his year as chief of OP 34, Ed Partain observed that with the exception of "one incident," he "was not aware of any successful effort by a team to sabotage anything."[46] What was that successful operation? "One of the teams radioed in that they had destroyed a bridge and gave us the location. Well, that was the best thing that happened on my tour. So, we asked for a photo recon. . . . What they had done is they had blown one leg off of a footbridge leading from a village."[47] The intelligence collected by the teams was of little use as well. It is not surprising that Partain had real doubts about the productivity and effectiveness of the long-term agent teams. It was his "recollection that this view was shared by Russell [the first chief of SOG] . . . and was also Blackburn's [SOG's second chief] initial reaction" upon being briefed on the program.[48]

During Reg Woolard's tenure as chief of OP 34 from June 1965 to May 1966, the assessment of agent team productivity was the same. His deputy, John Hada, was "very critical" of the results, adding that "We had no way of verifying whether the teams were operational or whether they were doing what they were supposed to be doing."[49] Likewise, Pete Hayes, who briefly worked for Woolard, found "little real intelligence and practically no concrete evidence of successful operations on the part of the agent teams that were in place."[50]

Bob McLane replaced Woolard in May 1966, but agent productivity remained dubious. Hada, who also served as McLane's deputy, remembered that toward the end of 1966, the chief of MACVSOG had seen enough of the agent operations run by McLane. "Jack Singlaub . . . knew that things had to be tightened up both on our part and the part of the South Vietnamese Strategic Technical Directorate [STD]. . . . In fact, Singlaub was so distressed about the way things were going in OP 34 that he talked to General Westmoreland [about it]."[51]

Singlaub decided to address the problem by bringing in Lieutenant Colonel Robert Kingston to head OP 34. A no-nonsense, tough soldier, Kingston, who was known as "Barbed Wire" Bob, would finish his career as a four-star general. Like Singlaub, he was a talented special operator who rose to the rank of general because of his service in the conventional, mainstream Army. Kingston was the first chief of OP 34 to have case officer training and operational experience in agent operations. It did not take him long to size up the situation.

A quick review of communications traffic told Kingston that the accomplishments of the agent teams were inconsequential. The longer he examined the data, the more he realized that OP 34 had a much bigger problem than just unproductive agents. The whole operation smelled bad to him. McLane had been biding his time and wanted out. Having reviewed the personnel in OP 34, Kingston recalled that he "was dissatisfied with some of the case officers that I had [inherited from McLane]. . . . I called them in and said, 'Brief me on your teams.' Even though they only had one or two teams each, they had to go get folders in order to brief me. They couldn't tell me what the composition was, what the mission was, where they went in, how they went in, what the communications were with their teams. So, I got rid of them." Still, he found that the rot ran deeper as he read "all the teams' communications."[52]

After a few more weeks of intense study, Kingston had seen enough and was ready to brief the chief of MACVSOG. Singlaub did not know that he was in for a big shock. Kingston gave it to the chief his way: "I went to Singlaub and said, 'What do you want to tell Ho Chi Minh?'" Singlaub was not amused. What did he mean? he growled. Kingston then informed him that "your [agent] teams are doubled and I can send Ho the message through them." Well, "Singlaub went

right through the roof." It was classic Bob Kingston: no nonsense, no pulled punches, only unvarnished facts. After he cooled down, Singlaub told Kingston to initiate a thorough review of the whole mess.[53]

The Counterintelligence Review and the Double-Cross System

The more Kingston looked, the more he was drawn to conclude that "most of them [agent teams] were either captured or doubled sometime shortly after they got there."[54] Several factors drew him to that conclusion. First was the pattern that emerged from the large number of failed insertions. According to Kingston, "We were losing too many teams" and the losses followed the same pattern. About one team a year made it in successfully, while all the others were either never heard from or quickly went off the air. The success-failure rates were just the opposite for agents sent by SOG to reinforce those teams that were believed to have been successfully inserted. Most made it in. Too much consistency, thought Kingston.

A second indicator was the radio traffic with the agent teams. According to Kingston, "in communications, the radio operator has a signature; they called it a fist. If this did not match up with a communicator, you knew you had a problem. Also, in this traffic, if they had doubled a radio operator, he might include certain misspelled or odd words that he normally would not use, in order to tip SOG off that he had been captured. Finally, through following the direction of the message back to the geographical location you might be able to determine credibility."[55] These factors had been missed by the case officers Kingston fired because "they didn't really know what they were seeing."[56]

Third, sometimes Hanoi was clumsy and tipped its hand. For example, it would send a doubled team's message from an area other than where that team was supposed to be located. Kingston recalled the following instance: "We had a team that was supposed to be in a certain area. However, when we checked the directions of their communications to us, it was coming not from the location where the team was supposed to be operating but from Hanoi."[57]

Fourth, the fact that MACVSOG was never able to exfiltrate one agent, let alone a team, was another obvious indicator to Kingston. He recalled that he tried twice to get Team Easy to move to a pickup

point for exfiltration, but in both instances they radioed that they could not get there. Finally, the chief of OP 34 believed that security lapses contributed to the debacle. For example, some of the agents in training actually went AWOL from the camp at Long Thanh and then showed up later and said they wanted back in the program. Neither OP 34 nor the STD had any idea where they had been while AWOL.

Had all the agents been doubled? Kingston would not go that far: "I wouldn't say all of them, but most of them were either captured or doubled sometime shortly after they got there."[58] The findings were unnerving to Jack Singlaub. Still, he was not ready to close the books on the program, but decided on one more review, this time by an outside audit by counterintelligence specialists from the CIA and the DIA.

In the midst of this horrendous situation, Lieutenant Colonel Robert McKnight took over as the chief of OP 34 in January 1968. He had gained unconventional warfare experience in Laos in the early 1960s as part of Bull Simons's White Star operation. McKnight also served with the First Special Forces Group, which focused on Asia, and had studied Lao. What about long-term agent operations? Like most previous chiefs of OP 34, he had no knowledge of what they entailed. However, he did have the advantage of drawing on Bob Kingston's assessment. What he learned was not good. OP 34 was a troubled command. With the exception of Kingston, those running the operation had been deluding themselves about what was being accomplished. They "really didn't think that the operation was a failure. They wanted to believe that their teams were operating effectively and we were getting some useful intelligence from them."[59]

McKnight wanted to know just how bad it really was. The new chief of OP 34 decided to conduct his own assessment of the entire operation. He collected all the agent team information and started to read. When he finished, McKnight concluded that he had a real mess on his hands. How bad was it? He recalled: "When I took over, the first thing I did was ask to see all the files. I sat there and read and read for two or three weeks. I came to the same conclusion [as Kingston] that all the teams had been compromised shortly after they were inserted."[60] Could it be that Hanoi had run a complete double cross against SOG for seven years? McKnight wondered. That was up to the counterintelligence boys from the CIA and the DIA to determine.

Finally, they were ready to report. The news was as bad as it could get. It was a complete double cross. All the teams that OP 34 assumed were legitimate were actually under the control of Hanoi's Ministry of the Interior. Some of them had been run back against first the CIA, and then SOG.

The CI team compounded its bad news: Hanoi had instituted what England's John Masterman had described as a "double-cross system." During World War II, he ran such an operation against Nazi Germany for MI 5, Britain's security service. In his account of that exploit, Masterman explained that the double-cross system was much more than simply "a number of isolated cases" of doubled agents and "did much more than [just] practice a large-scale deception." Through "the double agent system [MI 5] actively ran and controlled the *entire* German espionage system in this country."[61]

A double-cross system is an intricate operation. Masterman described its seven interrelated activities. First, establish control over all enemy espionage activities in one's country; in other words, gain control of the enemy's agent system and manipulate it in such a way that the enemy "will not expend a great deal of time and effort to establish another system."[62] They must believe they are having some success, as MI 5 led the Germans to believe of their agents in Britain. The North Vietnamese did the same thing against OP 34's long-term agent operations until 1968.

Second, use controlled agents to "contact and apprehend new agents and spies." The OP 34 teams that were considered legitimate were frequently reinforced. For example, Team Tourbillon received new agents once in 1962, twice in 1964, and again in 1965, 1966, and 1967. Team Remus was reinforced four times and Team Easy five times. All of these reinforcements were either captured or killed by the North Vietnamese.

Third, the double-cross system enables one to "obtain information about the personalities and working methods" of the enemy's security service.[63] From the agents it captured, MI 5 was able to learn all about German tradecraft. This permitted it "to trip up and expose other agents" when they were inserted. The CIA-DIA counterintelligence team noted that Hanoi's Ministry of the Interior gained such knowledge of OP 34's methods and practices. They also learned its codes and ciphers, the fourth element of the double-cross system.

Fifth, through its double-cross operations, MI 5 was able to discover a great deal about German intentions, especially the planned invasion of Britain. Likewise, Hanoi learned much about how far Washington was willing to go in its use of the agent teams against North Vietnam. Such knowledge can then be manipulated, according to Masterman, to "influence and perhaps change the operational intentions of the enemy."[64] This is the sixth element. By controlling all of SOG's teams, Hanoi had the opportunity and exploited it. SOG was allowed just enough success to keep the operation intact but not to escalate it. It was a very clever maneuver and revealed Hanoi's understanding of the double cross.

Finally, the double-cross system provides the opportunity to send the enemy disinformation. The CIA-DIA team found plenty of it in the message traffic, and some of it was quite clever. For example, after the first air strikes against the North, Ares enthusiastically called for more. It fit perfectly into Hanoi's international propaganda campaign of portraying the United States as a bloodthirsty aggressor.

The CI team told Singlaub and McKnight that the agent program was a total "blowout." After reviewing the report, the SOG leadership had two questions: (1) What went wrong and why did it turn out so badly? (2) Might Hanoi's double cross be run back against them? Could SOG create a triple-cross system to convince Hanoi that, in fact, it had uncovered only part of a much larger and more intricate subversion operation inside its borders? It was a Machiavellian thought, devious and shrewd.

EXPLAINING THE DOUBLE CROSS: IT TAKES TWO

Experts in deception operations argue that both the deceiver and the deceived must contribute to the operation if it is going to succeed. Neither the cleverness of the deceiver nor the receptivity of the target of the deception is sufficient by itself. It takes two for a major deception operation to work.[65] Certainly, this was true of the operation run by North Vietnam against SOG. Hanoi succeeded because of SOG's mission uncertainty, inept operational concepts, a lack of expertise, and inadequate procedures for agent recruitment, motivation, and training, plus Hanoi's own skill in running a double cross.

SOG's Mission Uncertainty and Inept Operational Concepts

What were the agents supposed to do once they were inserted into North Vietnam? The answer from Washington was neither consistent nor resolute; rather, it was just the opposite. The mission of the long-term agent teams was in a state of continuous reevaluation. Washington could not make up its mind about what it wanted the agents to do. Instead, it worried more about the downside of such operations than about how they might undermine Hanoi's internal security.

OPLAN 34A had called for the development of a resistance movement inside North Vietnam. This was seen as central to the overall plan, a critical element, if covert operations were to have the desired impact on Hanoi's leadership and its aggressive policies in the South. Establishing a resistance movement up North was the key to success. It's exactly what President Kennedy had in mind in 1961.

In spite of this, Washington was never willing to authorize SOG to execute the mission. According to one previously top secret document: "As originally conceived, airborne operations were intended to build a resistance movement in NVN which would exert pressure against the NVN Government, divert resources, and make continuous support of the war in the RVN less attractive." However, the document reported that "the implementation of the resistance movement was never authorized at the Washington level and, therefore, airborne operations were conducted under ambiguously worded mission statements."[66]

One can only imagine Clyde Russell's astonishment and disbelief in 1964 when he learned that the resistance mission had been rejected. He had expected to be running a guerrilla operation inside North Vietnam. He was supposed to do to Hanoi what it was doing in the South. Reflecting on his disappointment upon learning of Washington's decision, the first chief of SOG said: "I cannot understand why, as a nation, we take such a dim view of guerrilla warfare that we run, and yet it is one of the best operations that the communists have been running against us."[67] Russell believed the United States should have pressed forward with the resistance mission but Washington was not willing to entertain such recommendations.

Russell believed that Hanoi was vulnerable and a resistance operation could work. As for the blind-drop concept, he believed it should be scrapped because it had accomplished little. He proposed, instead,

focusing on the minority tribal elements along North Vietnam's borders. Russell had looked at an ethnic-linguistic map and concluded that North Vietnam could be divided geographically into two distinct regions. One area encompassed the mountains of the western and northwestern sections of the country. This region was made up of ethnic tribal minorities that were, by tradition and experience, hardly amicable to the Vietnamese. They constituted roughly 15 percent of the population in the North in the mid–1960s. Most of these tribal minorities are related to peoples in Laos and China, not the Vietnamese, and most of them believed that all Vietnamese were the enemy.[68] The other part of North Vietnam is the Vietnamese-inhabited lowlands, which includes the coastal plain. It was among these ethnic tribal minorities that Russell proposed beginning his resistance movement. Hanoi did not exercise such tight control over them and they did not like the Vietnamese. Russell proposed playing the tribal card. It was not the only card in his deck. The Catholic communities centered in two Red River Delta coastal provinces (Nam Ha and Ninh Binh) and in two provinces further South (Nghe An and Ha Tinh) also were not friendly to the communists. There was evidence of dissent and even sabotage in these provinces. In fact, in 1956 there had been an uprising in some of these areas. Finally, there was North Vietnam's small Chinese population, yet another possible wild card. What Russell had in mind was playing on Vietnamese hostility toward the indigenous Chinese. In North Vietnam they can be divided into two dissimilar categories. In the highlands along the PRC border there are pockets of Chinese tribal elements. There also is an urban Chinese population centered in Haiphong.

Ed Partain recalled that in 1964 he and Russell "recommended that we [OP 34] establish a resistance" along ethnic tribal lines. "That is my recollection. I know that Clyde Russell and I talked about it. . . . It was as much in his mind as mine, that if these agent teams were to be effective in any meaningful way, they had to establish a resistance."[69] The two officers sent a request up the chain of command. A few weeks later, Russell reported that the proposal had "been turned down. That would have had to be a decision that had come out of Washington," Partain reflected.[70]

If not a resistance movement, what were the agent teams for? Russell and Partain could hardly believe their ears. According to

Russell, they were "told to tell the teams that they were not to make contact with the populace in the North and at that time [their mission] became strictly psychological operations as well as intelligence collection." For the chief of SOG, this made little sense. He wondered how you "collect much intelligence when you're hiding in the hills and trying to protect your life." What good did it do "running around the woods dropping a few hand-printed leaflets?"[71] As strange as it seems, this was the mission assigned to OP 34. It was real "dumb stuff," but there was little Russell or Partain could do to change it.

When Don Blackburn replaced Russell in May 1965, it did not take him long to see the folly of the agent program. He quickly surmised that it made no sense. After all, Blackburn knew something about running guerrilla operations behind enemy lines. He was one of the Army's few specialists in that art, and he set out to get OP 34 on the right track. Blackburn reviewed Russell's proposal and expanded it. What "was needed were bases inside Laos contiguous to the NVN border from which the teams could be inserted, reinforced, resupplied and withdrawn as necessary by helicopter or land means." The Headhunter wanted to set up a "front organization" that could "establish cells in the North and develop a system to extract people for training and reinsertion as well as inserting people from South Vietnam who were northerners. Indigenous assets from areas contiguous to North Vietnam would have been useful in such operations."[72]

Blackburn was on a roll. It was like the good old days of operating out on the edge of the envelope. Not only did he develop the concept, he started looking for former northerners in South Vietnam who wanted to go back and operate against the communists. Blackburn recalled that such individuals with "tribal contacts in the northwest area of NVN and [from] other oppressed elements of the population [e.g., Catholics] were available." Blackburn cited, as an example, "a chief from northwest NVN [living in South Vietnam since 1954] who was willing to lend his support in recruiting and establishing contacts locally available in SVN as well as in NVN." This was how you began, according to the former leader of Blackburn's Headhunters. Start by "establishing cells and contacts" and turn these into a front organization and then "a real resistance effort."[73]

Blackburn prepared a briefing of his plan to refocus the agent program back to the original resistance concept. He knew from Russell's

experience that "a resistance movement could not be organized without higher authority." Still he was confident. After all, the existing effort made no sense and had accomplished nothing. Surely Washington would see that "the modus operandi that prevailed [blind drops] amounted to a one-way street for the team personnel with no hope of return."[74]

The 1965 proposal went all the way up the chain of command to the NSC's 303 Committee. The answer was the same: OP 34 was not authorized to attempt to establish a resistance movement up North. Blackburn was shocked at the response from Washington. "This was unfortunate," he noted, "because it could have been a parallel to the NLF [VC] and could have provided something more credible . . . to tie operations to."[75] Again, Washington was unwilling to challenge NVN using Hanoi's rules. Blackburn learned that the policy makers feared going this far. Such moves would violate the stated U.S. policy of not seeking to overthrow the Hanoi government. It all seemed preposterous to Blackburn. What kind of war was this? he wondered.

Blackburn also found out that the CIA opposed his proposal because it would infringe on the agency's area of operations in Laos. The CIA had its own tribal guerrilla operations under way, having raised a Hmong army led by Vang Pao. It was attempting to prevent Hanoi's takeover of Laos, as well as to inflict losses on NVA men and resources operating in northern Laos. The Hmong was one of the hill tribes that Blackburn had identified in his resistance proposal.

The Headhunter went to see the CIA's chief of station in Laos to cut a deal. "I wanted [Douglas] Blaufarb to let us take these teams into the North from Laos. In other words, take former North Vietnamese and work from bases in Laos and push to a point to see what they could do about establishing something in NVN and then push on further. This is what we did in the Philippines."[76] The CIA was not about to agree to his proposal. Northern Laos was *its* area of operations. Blackburn was not only up against the CIA but also the U.S. ambassador to Laos, William Sullivan. He wanted to keep SOG completely out of Laos and opposed Blackburn's proposal. He likewise objected to his plans for covert operations against the Ho Chi Minh Trail. SOG was persona non grata in Laos.

When an Army colonel who is not part of the conventional, mainstream military goes up against the CIA and the State Department, he

will lose. SOG was not given the authority to establish a resistance movement working out of bases in northern Laos. The 303 Committee would permit only the CIA to operate there. Blackburn was disgusted with the whole business and "was for stopping it . . . I think that they had a misdirected purpose because you go and take a team of South Vietnamese and drop them in an area that they knew nothing about or very little about and where they weren't able to gather the support of the people, and they were going to be captured right away. This is what happened."[77] The operational concept and mission focus were preposterous.

At the time Washington rejected the Blackburn proposal, there was a modification in the agent mission. In October 1965, a new operations order was issued to SOG through Pacific Command. It stated that the mission of the teams was now to "conduct intelligence, sabotage, psychological, and escape and evasion operations." This was almost the same as the existing operations order. However, the teams were now allowed to make some contact with the local population to "recruit and support local agents in NVN for intelligence and evasion nets."[78] It was a distinction without a meaning and was going to make little difference. Blackburn just shook his head and reflected: if you could not organize the population into a resistance movement, "why put them in there? This thing always stuck in my mind out there, and that is why I was never very enthusiastic about the agent teams; that's why I was trying to turn in this other direction."[79]

Blackburn relinquished command of MACVSOG to Jack Singlaub in May 1966. The agent teams had continued to go North on his watch, with the same results that Russell had experienced. Blackburn had inserted six teams, composed of forty-six members. They accomplished nothing to speak of.

Jack Singlaub had his doubts about OP 34 operations even before he arrived in Saigon to take command. "I must say that, in my SACSA briefings [in the Pentagon], I was surprised they thought that they could get away with parachuting agents into that territory. The territory of Vietnam, as I found earlier in Korea, was not like parachuting agents into occupied France or Yugoslavia, or any other place where, during World War II, the OSS conducted operations. I expressed some negative views about this way of getting them in, but I saw right away they didn't appreciate my insights, so I didn't make

an issue of it in the briefing. You know, I'm the new guy and should first go out and see what was taking place and what could be done."[80]

Once in command, it did not take Singlaub long to see that the operation was going nowhere, at least the way it was being executed. Having reviewed the files, he learned that all too often a blind drop turned into a dead drop. The Blackburn proposal of developing a resistance by first setting up a front and then working into North Vietnam through Laos was the way to go, according to the new chief of SOG. However, he soon learned that OP 34 "had a specific prohibition against establishing a guerrilla organization in North Vietnam. . . . We were proscribed from establishing an anti-Ho Chi Minh or anti-North Vietnamese government resistance movement."[81]

Singlaub decided to send up a trial balloon to see how the policy makers would react. Didn't they know there were tribal personnel from the North, living in South Vietnam, who could be recruited for the resistance mission? Singlaub learned that "many of the leaders of northern hill tribes [who] took the opportunity in 1954 to move South . . . were in contact with the Vietnamese counterpart of MACSOG." Were they interested in going back? According to Singlaub, "They [had] expressed a willingness to return . . . to recontact their people whom they felt were still loyal to them." But for what purpose were they willing to take such a risk? Only if "given some assurance that they would be permitted to organize a resistance movement and to use it [for] . . . the creation of an autonomous area in North Vietnam."[82] If the United States would support that objective, they were ready to go North.

Singlaub quickly found out that there was no change in Washington's attitude. U.S. national policy was, according to one declassified SOG document, "to refrain from advocating or inciting any activity which might lead to an internal uprising against the current government of North Vietnam."[83] Singlaub recalled: "They [Washington] would just never approve things that we wanted to do in the area of guerrilla warfare and resistance operations."[84]

Instead, MACVSOG was told by the Joint Chiefs that the agents should place "maximum emphasis . . . upon intelligence collection and the establishment of civilian contacts." New teams were to be inserted and teams in place moved to "areas astride every major line of communications [LOC] leading from NVN into Laos." The pri-

mary mission was "intelligence collection by road watch, rail watch, and river watch."[85] To begin implementing the new concept, twenty-five agents were to be trained in the next few months and inserted along North Vietnam's main access routes leading to the Ho Chi Minh Trail.[86] It was only the beginning.

It was to be a big effort that could, over the next fifteen months, purportedly involve hundreds of new agents. The program was a tall order, thought Singlaub, and presented some serious challenges for SOG. First of all, it was still a blind-drop insertion, with all the problems that approach had already encountered. Next, where was he going to find hundreds of highly motivated indigenous tribal elements from these regions of North Vietnam, now living in the South, who were willing to go back and execute this mission? Recruitment was not going to be easy: "The personnel who would have made good resistance leaders ... were not only not willing to return as road watchers themselves but would not recommend to MACSOG any of their better personnel to do this type of mission."[87] They might be willing to go back and fight and die to liberate their traditional lands, but not to count trucks.

Nevertheless, Singlaub had his instructions, and OP 34 executed them under the command of Lieutenant Colonel Bob McLane. During his year tour, McLane inserted over fifty new agents and attempted to relocate those already in place. One year of this folly was all that Jack Singlaub could take. Agent operations were not working and he knew it. OP 34 was in disarray. John Hada, McLane's deputy, recalled that "Bob McLane was under a great deal of pressure from Jack Singlaub to straighten that section out." To address the problem, Singlaub brought in Bob Kingston in May 1967 to replace McLane. "Singlaub knew Kingston," recalled Hada, and he "wanted to replace Bob McLane with someone who understood agent operations."[88]

Bob Kingston was the right man for the job. He quickly realized that the operational concept for agent team insertion—the blind drop—was seriously flawed. The policy objective was likewise screwed up. He discovered that these were not the only problems in OP 34. Several factors account for the failure of the long-term agent program. Still, there was little doubt that flawed policy objectives were at the top of the list. Kingston thought it just plain stupid.

Why was Washington so resistant to giving SOG the authority to establish a resistance movement inside North Vietnam? On what grounds did Washington reject this keystone element of 34A?

Among the reasons learned by the chiefs of SOG was the belief by Washington policy makers that covertly fostering a resistance movement contradicted official U.S. foreign policy, which did not call for the destabilization or attempted overthrow of the Hanoi regime. In other words, the policy makers were of the opinion that covert operations should be consistent with official policy. Consequently, every time SOG "requested authority to develop a resistance movement," it was "told from Washington that this was against U.S. objectives and aims in Vietnam. A resistance movement [was] counter to overt national objectives."[89]

According to Singlaub, this was one of "at least two reasons given for [opposition to the resistance concept]. Singlaub saw little sense in this unwillingness on the part of Washington "to separate overt from covert policies."[90] After all, one of the motives for employing covert action was that overt alternatives were not likely to achieve the intended results. Furthermore, covert action gave you the flexibility to get around overt policy limitations. The policy makers' logic seemed bizarre to SOG's operators. If covert action was to be consistent with overt policy, why was it necessary to operate covertly?

The second reason Singlaub cited "was fear that a resistance movement might get out of hand" and actually accomplish something.[91] Things were really getting strange, he thought. The U.S. ambassador to South Vietnam, Henry Cabot Lodge, put it this way in 1964: "I welcome exerting increased pressure on North Vietnam with the double aim of bringing about a cease-fire by the VC and Pathet Lao and neutralizing North Vietnam. . . . I do not think it profitable to try to overthrow Ho Chi Minh, as his successor would undoubtedly be worse."[92] One can only wonder whom Lodge had in mind. How could things get worse with someone other than Ho? Did Lodge have any understanding of the enemy? Convoluted reasoning, thought the chief of SOG.

Policy makers likewise worried that destabilizing North Vietnam might "provoke large-scale retaliation from the North Vietnamese." They might decide to escalate the war in the South if the United States made things too uncomfortable for them up North. Didn't

Washington understand that Hanoi had already made the decision to intensify operations in the South when it decided to introduce NVA regulars in late 1963?

Finally, if the Hanoi regime started to come apart, Washington fretted, this could "cause the Communist Chinese to get into the act," as in the Korean War.[93] At the very time policy makers worried about Communist Chinese involvement, Mao was leading the Cultural Revolution in China. For the next several years, the PRC would undergo a massive internal purge that would have a paralyzing impact on all government activity, including foreign policy. Did Washington understand the implications of the Cultural Revolution?

For the double-cross system to be successful, both the deceived and the deceiver have important parts to play. The United States certainly lived up to its part.

Lack of Expertise in OP 34

With the exception of Bob Kingston, none of the OP 34 chiefs had any background running agent teams in denied areas. Contrary to what the policy makers assumed, this was not part of the special warfare capabilities of the Pentagon. The curriculum at the Special Warfare School at Fort Bragg did not cover it and it was not to be found in doctrine.

Ed Partain, the chief of OP 34 from mid–1964 to mid–1965, was a case in point. He was not a specialist in the mission he was expected to escalate inside North Vietnam. Halfway through the year, Partain came to see that there were serious problems with how the mission was defined, with the insertion procedures, and with the Vietnamese personnel being trained for the operation. He also knew that he had very little understanding of the North Vietnamese target. So why did he continue to infiltrate agents along the same lines that had achieved little for the CIA? In part, inexperience, according to Partain, led to an "unwillingness to face reality."[94] In other words, wishful thinking.

Actually, there was very little Partain could do to change things. He was far down the chain of command and possessed little knowledge of how to "fix these problems." Partain realized this when he "went to Clyde [Russell] and talked to him" about the whole situation. "I guess I'd been there five or six months. I said we're wasting time,

money and lives. Why don't we do something else? Russell said, 'You don't understand, there's high-level interest in continuing this.' . . . I gathered that it came from Washington."[95]

The U.S. personnel assigned to Partain were in the same boat. They included enthusiastic young Army majors like Pete Hayes. A graduate of West Point, he was bright and eager but not prepared to execute OP 34 operations. He had worked with the CIA in Korea running clandestine maritime teams into the North to attack coastal targets and rescue downed pilots. To be sure, this was an aspect of UW, but it did not involve training and running agent networks in denied areas. Still, at least it seemed as though Army personnel were trying to find qualified officers. In reality, this was not the case. Hayes was selected for OP 34 through a mistake. "I think that Colonel Clyde Russell was chief, MACVSOG, at that time. He had me confused with John Hayes, who also spent quite a bit of time in MACVSOG. He had been in the 10th Special Forces Group with Russell. So, when I reported in, I became aware that he had me confused with John Hayes." Because of his prior work with the agency, Pete Hayes got to stay on.[96]

During his tour, Hayes also realized there were serious problems with the operation. He recounts how the following incidents, which involved Team Bell and Ares, greatly contributed to this awareness. "We almost had our aircraft shot down on a resupply of Team Bell. What the crew said was that a helicopter ambushed them and so they recovered to an alternate airfield in Thailand." Likewise, there were some indicators in attempts to resupply Ares that led Hayes to conclude that "he was already under control . . . and this was just the guys up North playing with us."[97]

The personnel problems continued when Reg Woolard and Bob McLane commanded OP 34. John Hada, who served as the latter's deputy in 1966, remembered that several of the case officers were very detached and not at all enthusiastic about the mission. He characterized them as "abysmally poor. . . . They didn't know how to deal with other peoples and other cultures. . . . [T]he average officer that was in OP 34 did not have a college degree . . . They could not sit down and assess what was going wrong. They couldn't evaluate what was going on because they didn't really understand."[98] Hada concluded: "I think the best way to describe it is, we were flying blind. We had really no control at all."[99]

This was exactly what Bob Kingston encountered when he took over in May 1967. He inherited subordinates who were either enthusiastic and inexperienced or lackadaisical and inexperienced. Kingston fired the latter and sought to develop those he kept in agent operations.

OP 34 was up against a regime in North Vietnam that paid great attention to internal security and population control. The intelligence and security forces were highly professional and skilled at countering internal threats and challenges. Developing agent networks inside such denied areas as in the 1950s had proved a daunting task for the CIA. And the CIA had knowledge, training, and experience in running agent operations: for OP 34, it was a real mismatch, and it showed.

Agent Recruitment, Motivation, and Training

An agent operating inside North Vietnam had to be highly motivated and highly trained. It was a difficult environment, given the nature of the Hanoi regime. However, agent recruitment, motivation, and training were endemic problems that plagued OP 34 from its inception in 1964 until the Diversionary Program was established in late 1967.

The quality of the individuals recruited for the long-term agent program was at best uneven. While some were patriotic and zealous, the OP 34 leadership believed they were more the exception than the rule. There were many difficulties with the recruits, motivation being at the top of the list. Low agent commitment was a direct result of the recruitment process.

The trouble Clyde Russell would face in recruiting suitable personnel became immediately apparent when he took charge of those agents-in-training who were turned over to SOG from the CIA in January 1964. "When we took over, we found we had a number of so-called agents who were not qualified for anything. They had been on the payroll and they liked the pay, but when we got ready to commit them, they were not eager to go," said Russell. It was a pathetic situation, and taking over these CIA "assets" presented the chief of SOG with a serious dilemma. He did not believe that if inserted, they would accomplish anything of substance. "The original assets we had [inherited from the CIA] for this effort were not capable of going any-

where." Still, Russell observed, "We couldn't turn them loose in South Vietnam because they had been briefed and rebriefed on the operations in North Vietnam."[100] They knew too much and were so unreliable that, thought Russell, for a price they would reveal the whole operation to the enemy or anyone else who might want to know about it.

As strange as it may seem, Russell's solution to the problem was to send them up North. He "didn't expect them to come up on the air" and communicate but to "surrender immediately upon landing, which they did." There was only one reason for sending them, according to the chief of SOG: "We had to get rid of them. . . . Our solution was to put them up North."[101] To be sure, it kept the story of agent operations from ending up in the *New York Times*. However, one can imagine that Hanoi had little trouble getting those agents it captured to reveal the details about the whole operation.

The recruitment process did not improve during 1964, or thereafter, because SOG had to rely on its STD counterpart to recruit personnel. The South Vietnamese did not come through: the "inability of STD to recruit high quality individuals for agent training has forced the deployment of mediocre teams," SOG's 1964 annual report admitted.[102]

Herein was one of the major issues facing Ed Partain when he took over OP 34. According to Partain: this "is one of the primary problems you have when you're dealing with a third party who is providing you with the recruits. . . . They are the ones who are telling us that these recruits are committed; they're telling us they're well educated. We had no way of validating that."[103] He adds, "As near as we could tell," these recruits "were not of the educated middle class. If you recall, many or most of our agents in World War II were educated, committed, knowledgeable risk-takers. These people were not." Furthermore, "MACSOG 34 did not have the language skills and could not question them." It was "not able to rely on background checks that we did."[104]

Once the agents were trained, Partain discovered that "most of these people didn't want to go. It was almost bribery to get them on the plane." You had to give them "an extra gun, give them an extra 10,000 piasters . . . and in one case we actually had to push this one guy onto the plane—and off of it."[105]

Pete Hayes had a similar experience. "I can recall one situation [in 1965] where we got them all ready to get on the airplane and one individual, and in this case he may have been one of the radio operators, said, 'I can't go. I don't have a wristwatch.' I said, 'We just solved your problem.' I took off my watch and gave it to him. He said, 'I forgot my signal plan, my recognition signal.' And I said, 'Don't worry about it, this is your recognition signal,' and I gave it to him. . . . Generally, the radio operators were a cut above the normal agent but they would get contaminated by these other guys and would figure out reasons why they couldn't go. . . . We finally got them on the plane."[106]

Ed Partain finished his tour and was replaced by Reg Woolard, who was replaced by Bob McLane, but the low quality of the personnel recruited for agent training remained the same. SOG's 1966 end-of-year report spelled out the depth of the problem: "During the year, it became increasingly difficult to recruit quality agents." Furthermore, "Desertion among agent trainees continued to be a big problem and has had an adverse effect on the ability to maintain team unity. The [annual] AWOL/desertion rate among agent trainees increased from eight percent during March to 21 percent in May." Recruits deserted because they "became disenchanted with the prospect of operating as an intelligence agent in North Vietnam." Apparently, STD never told its recruits what they were expected to do. When they learned "the hard facts" about the mission and "that none of the attempts to bring . . . teams out of North Vietnam had been successful," their disenchantment grew dramatically.[107]

John Hada recalls that OP 34 never knew what the STD might bring them. "In several cases it was difficult to calibrate their background, their education, their socioeconomic status. They were all eager because of the salary. But I would say, based on my observations, that they did not manifest any great patriotism for the Republic of Vietnam." Their eagerness quickly dissipated when it was time to be inserted. Hada believes the recruits "were in it mainly as a way of getting some money."[108] Because OP 34 did not control the recruitment process, he concluded, "the careful selection of agents was very wanton, [and] left much to be desired."[109]

The solution to this problem was straightforward, as Hada notes: "If we could control selection we would probably be much better

off."[110] But no one in OP 34 had the language skills or expertise in agent recruitment.

It was painfully apparent to Bob Kingston in 1967 that the South Vietnamese were recruiting young kids by selling them a bill of goods. "You're going to work with the Americans," they probably told them. "It will be an exciting adventure and you will be paid handsomely for taking part in it." Kingston was never really sure what the STD told them. "We didn't know how they recruited them, what they promised them."[111] Kingston set out to take control of the recruitment process. It was a small effort but clearly in the right direction. However, it barely got off the ground, and then became irrelevant when OP 34 initiated the Diversionary Program.

Recruits were sent to be trained as long-term agents at Camp Long Thanh but the training was uneven. U.S. advisers instructed the recruits in the use of weapons, combat tactics, demolition, air insertion, communications, and related military specialties. However, the recruits also required professional-level training in intelligence tradecraft. It is highly doubtful that they received much instruction at a sophisticated level. Ed Partain stated emphatically, "We tried to teach them weaponry, first aid, demolitions, communications . . . but there was no tradecraft training as such . . . we did not do that."[112] It was left to the STD. How well did it do? OP 34's leadership had no way of knowing.

Training was not the only problem at Camp Long Thanh. There were security improprieties as well. Agents were not kept in isolation after they had received their mission briefs, violating one of the basic rules for such operations. Instead, the agents were allowed to go on leave. This is mind-boggling, given the fact that the VC had a "large intelligence network" in the Long Thanh area and "had spies among the agents, cadre, security battalion, and civilian workers."[113]

Given the quality of the recruits, it is not surprising that discipline among the trainees suffered at Long Thanh. Many of the recruits "had questionable reputations . . . and brought known discipline problems to Camp Long Thanh."[114] Other factors contributed to the situation: the STD often used false recruiting promises and once recruits became aware of the real mission they were to carry out, the "belief that the agents were all going to die anyway caused the agents and some of the [training] cadre to believe that the agents should

enjoy themselves while they had the opportunity."[115] All of this contributed to the high desertion rates.

Hanoi's Skill at Running the Double-Cross System

The double-cross system that North Vietnam ran against MACV-SOG fit the tradition of similar operations run against Western intelligence organizations by their communist counterparts throughout the Cold War. Like other totalitarian communist states, North Vietnam placed a high premium on internal security, counterintelligence, and control of the population. It was a "counterintelligence state."[116] In such regimes, there is overriding concern with domestic security matters. Intelligence and police forces abound, and their mission is to counter any and all internal security threats. In the intelligence lexicon, this is referred to as defensive counterintelligence. It involves identifying, apprehending, and neutralizing saboteurs, subversives, counterrevolutionaries, spies, commandos, and any ordinary citizen who might express even minor opposition to the party's authority. Regimes like Hanoi take all these matters quite seriously. In fact, they tend to be paranoid about the whole business of conspiracy, espionage, and subversion.

To ensure internal stability and control, totalitarian regimes establish and maintain massive police, security, and intelligence services. Organizational redundancy is their hallmark. This was certainly true of the former Soviet Union, which served as the model for other communist states. From its inception, the "search for enemies, their discovery, and elimination was an overriding state objective."[117]

North Vietnam adopted this approach to counterintelligence and internal security. Like its Soviet counterpart, it was fixated on these matters. According to John Dziak, a former senior Defense Intelligence Agency officer who, for three decades, worked to help the United States counter the KGB and its surrogate services in other communist states, such totalitarian political systems "display an overarching concern with enemies, both internal and external. Security and the extirpation of real or presumed threats becomes the premier enterprise of such systems." To defeat these enemies, counterintelligence states make a "very heavy commitment of state resources." As Dziak notes, "This fixation demands the creation of a state security service that penetrates and permeates all [of the country's] institutions."[118]

Hanoi maintained such an apparatus. Its sine qua non was organizational redundancy, tight control of the population, and total vigilance. The apparatus extended from Hanoi down through each of North Vietnam's administrative levels to the lowest units, the villages. The People's Police Force (PPF) was at the base of Hanoi's internal security system. Under the authority of the Ministry of Public Security, the PPF was to discover, prevent, and repress all sabotage and subversive activities, and to control, neutralize, and reeducate all counterrevolutionary elements. To this end, it was accorded broad powers to search, detain, arrest, seize evidence, apply coercion, and use weapons to exterminate spies, counter saboteurs, and unearth plots of subversion.

At the village and at higher administrative levels, the PPF maintained a close liaison with its counterparts in the local militia, military, and intelligence agencies. Here is where organizational redundancy came into play. Each of these other agencies had internal security responsibilities and powers that overlapped those of the PPF. So did the Armed Public Security Force. Under the auspices of the Ministry of National Defense, it had among its duties the protection of all key facilities against sabotage; security of the border areas to thwart or detect infiltration by commandos; and surveillance, detection, and suppression of counterrevolutionary activities by ethnic minorities in the mountainous region along the Laotian border. These were the groups that the first three chiefs of SOG proposed to employ to establish a resistance movement up North. Although Washington did not see their potential, Hanoi apparently did.

As one moved up the state administrative structure through the districts, provinces, and cities, one found parallel representatives of each of these village agencies. This was redundancy with a vengeance. Finally, at the ministry level, in addition to public security and national defense, the Ministry of the Interior had a major responsibility for combating subversion, espionage, and sabotage by spies and commandos infiltrated into North Vietnam. More redundancy.

This apparatus allowed Hanoi to conduct a massive defensive counterintelligence campaign. It was, as William Colby explained: "total permeation of the society. . . . It leaves nobody free."[119] SOG's long-term agent teams were pitted against an imposing security apparatus. The agent teams, given all the problems that plagued OP 34, hardly stood a chance. It was a total mismatch.

Hanoi was not satisfied with identifying, apprehending, and neutralizing SOG's agent teams. Like other communist regimes, it proved to be proficient at offensive counterintelligence. Actually, its double-cross operation against MACVSOG was one of several similar successful operations run against Western intelligence organizations by their communist counterparts throughout the Cold War. Hanoi had been able to draw on this tradition of success through liaison arrangements that existed among the communist intelligence services. The KGB was well represented in North Vietnam, and North Vietnam's intelligence officers studied at all of Moscow's intelligence schools, where the curriculum was replete with case studies of double-cross operations.

However, at least three other factors contributed importantly to Hanoi's development of a security and intelligence apparatus that was skilled in both offensive and defensive counterintelligence operations. The first had to do with its conspiratorial mentality. The NVN leadership was worried greatly about enemies and made the search, discovery, neutralization, and manipulation of them a top priority. Second, North Vietnam devoted considerable resources to the internal security and counterintelligence missions. This was reflected in the size, training, and professionalism of its security apparatus.

The third factor, which was especially critical, had to do with experience in the art of subversion, deception, conspiracy, and clandestine operations. For decades the Vietnamese Communist Party had operated in the shadows, employing all these techniques. Hanoi's surrogate in the South, the Viet Cong, was making good use of this expertise. Consequently, this knowledge and experience contributed directly to Hanoi's ability to counter similar measures when directed against it. The masters of subversion and conspiracy knew what to look for and what steps to take to neutralize such operations when they became the targets.

THE DIVERSIONARY PROGRAM AND THE ART OF THE TRIPLE CROSS

As Singlaub and McKnight surveyed the damage in early 1968, they pondered what to do with OP 34. Maybe it would be best to shut OP 34 down. Why continue to do more of the same? they wondered more than once. However, in reviewing both the counterintelligence report on the

agent program and Kingston's earlier assessment, Singlaub and McKnight kept coming across a rather curious, indeed bizarre, detail. At first, it made little sense to them.

Counterintelligence experts found in going through the files that Hanoi claimed to have identified a much larger number of long-term agents than SOG had inserted. If these accounts had appeared only in the NVN press or public radio broadcasts, SOG's leadership would have written them off as just more North Vietnamese propaganda. However, this contention was also showing up in internal party documents, directives, and special decrees. For example, the chief prosecutor of the People's Supreme Organ of Control warned the DRV's National Assembly in March 1966 that during the previous year, spies had actively gathered military, economic, and political information, and enemy agents had sowed dissension among various religious organizations and ethnic minorities. The message sounded alarmist.[120]

The more the SOG leadership pored over the data, the more they found that Hanoi seemed overly worried about spy commandos and enemy agents that, in reality, did not exist. Police and counterintelligence investigations, and arrests, were on the rise. During 1967, the NVN government intensified its internal security measures and appeared to be employing all available communications to warn the population of "spy rangers" in their midst.[121] In 1968, decrees were issued establishing harsher penalties for counterrevolutionary activities. At the same time, the official party paper reported that plotting and conspiracy, aided and abetted by enemy agents, "runs very deep and their activities are dangerous."[122]

Hanoi seemed to have a growing case of spy mania, Singlaub thought: things were finally getting interesting. So the North Vietnamese were worried about agents infiltrating by land, sea, or parachute. The more Singlaub delved into the intelligence data, the more intrigued he became. He noted that Hanoi's internal security operatives were spending a great deal of time and energy searching different geographical locations for agent teams that existed only in their imaginations. He found that these searches were real "dragnet" operations. "They interrogated villagers and reinterrogated them." They rounded up all the likely suspects. Anyone "who had ever been suspected of supporting anti-communist activities in the past" was brought in for questioning.[123] Distrust and conspiracy seemed to be

spreading through the minds of North Vietnamese officials. Perhaps it would not be long, Singlaub mused, before the party and cadres started to eat their own.

A fixation on subversion, deception, and conspiracy can take its toll. Such regimes often launch witch hunts against perceived enemies and spies. Sometimes they become real paranoid affairs where the blood flows freely. Stalin's great purges were an example. They not only devoured the ranks of the Bolshevik Party, but destroyed the Red Army's officer corps on the eve of World War II. During an eighteen-month period beginning in 1937, Stalin removed 3 of 5 marshals, 14 of 16 army commanders, 60 of 67 corps commanders, and 136 of 199 divisional commanders. Many were executed, the others sent to the gulag. This was eating your own with a vengeance. The Soviet Union was not alone. In 1965, Mao unleashed his Great Cultural Revolution, a bloodbath that reached deep and high into party ranks.

Hanoi was no exception, as the evidence unearthed in the counter-intelligence review revealed. It was fanatical about internal security and population control. If this was the case, Singlaub reasoned, then now was not the time to shut OP 34 down; just the opposite. It should be cranked up and expanded, but with a very different purpose. Hanoi was vulnerable to being deceived about the extent to which it actually controlled all of OP 34's agent operations. Perhaps it could be made to believe that many more teams than it knew about were operating inside its borders. In the jargon of the intelligence world, this is the *triple cross*. It was not going to be easy, but here was an opening. It was time to exploit Hanoi's paranoia. To this end, SOG created the Diversionary Program. It was SOG's turn to play hardball.

The Diversionary Program

The Diversionary Program, code-named Forae, was approved by COMUSMACV on March 14, 1968.[124] General Westmoreland's approval of Forae was done "verbally."[125] This is not surprising in light of the kinds of operations carried out.

Forae "initially consisted of six projects," three of which "were transferred to SOG's psywar section for implementation."[126] The three remaining projects, which were assigned to OP 34, became the core of the triple cross.

Forae was elegant in its simplicity and complex in the operations required to carry it out. It sought to convince Hanoi that it had uncovered only the tip of the iceberg and that, in fact, plotting and conspiracy, aided and abetted by enemy agents, really did "run very deep." It planned to "convince the enemy that there were more teams inside NVN than actually existed."[127] It was hoped that Forae would "divert NVN to defense and internal security . . . increase strain on control of the populace, create opportunities for friendly psychological operations, and exploit and harass the enemy in his rear."[128]

The roots of Forae lie in the deception operations initiated by Bob Kingston. Kingston decided to "put radios in [NVN], some with teams, some just air dropped that were set to transmit two black radio programs [Voice of the SSPL and Radio Red Flag]. What we wanted to do was have the NVA use their security forces to go after what they thought were teams but were really just radios."[129] His operation was "mainly radio deception." Another aspect of it was to send radio messages to "existing teams to link up with other teams that did not exist. We would tell a team to relocate in order to link up with another notional team. Here's your sign, here's your countersign, here's the way to link up."[130] It was a very modest effort and not likely to cause Hanoi any great concern.

Forae's Three Core Projects

A program as ambitious as Forae required a sophisticated array of deception techniques to make it work. More than radio deception was needed. The task of developing related operations in 1968 fell to the chief of OP 34, Bob McKnight. He had a small cell of officers who developed the different operational components of Forae. They proved to be creative. These officers and their chief came to "understand [NVN's] internal security concerns and the extent to which they worried about these matters."[131] With this knowledge, OP 34 set out to create a complex triple-cross system.

McKnight revealed that in addition to deceiving Hanoi, Forae also aimed at misleading MACVSOG's counterpart, the Strategic Technical Directorate (STD). They were to be told only part of the story and were led to believe that Forae was just a new version of OP 34's long-term agent operations. According to McKnight, the STD was to think that

everything "was on the up and up. I don't believe that they ever knew what we were really doing in terms of deception." The triple cross was not just against Hanoi but also "against our counterparts," noted the chief of OP 34,[132] who was convinced that the STD was infiltrated by enemy intelligence.

Forae had three key projects—Borden, Urgency, and Oodles—at the heart of its effort. It was time to exploit Hanoi's paranoia.

Project Borden

Project Borden recruited NVA prisoners of war as SOG agents. Once enlisted, the POWs were unwittingly manipulated to serve the objectives of the Diversionary Program.

Then-Captain Bert Spivy, a West Point graduate, was "one of seventeen" members of the class of 1960 "who took seriously President John F. Kennedy's belief in the mission of special forces." Spivy recalled, "At the time, we were told that this was not good for our careers. However, the president emphasized the challenge of communist revolutionary insurgency and of the need for the United States to develop an effective means of response. A key element of this response was assigned to special forces and therefore we took the president's challenge."[133] Early in 1968, Spivy found himself in OP 34's Diversionary Program helping to run Project Borden.

Spivy's first task was to acquire NVA prisoners of war who would cooperate, recruiting them through U.S. division-level POW holding areas. OP 34 wanted to steer clear of any NVA held by ARVN. Spivy described the selection process in the following terms: "We identified likely candidates through discussions with those who ran the POW facilities. Next, we would interview a select number of these to determine whether they were interested in being recruited as agents."[134]

What the POWs who were chosen did not realize was that those running Borden couldn't care less whether or not the NVA volunteers were sincere about becoming agents. In fact, according to Borden records, "It was fully expected and intended that many of the recruited agents would reveal their assigned mission to the NVA of their own volition or under interrogation."[135] Spivy emphasized, "We wanted them [the NVA POWs] to believe that this was a legitimate attempt to recruit them. In other words, we wanted them to believe

that we were seriously attempting to have them switch sides and become part of a large agent network and resistance movement inside North Vietnam."[136] Of course, the real concern was not whether they were trustworthy or untrustworthy, but whether OP 34 could recruit them for a deception purpose they knew nothing about.

Once back inside North Vietnam, Project Borden's prisoners of war would serve OP 34's objectives without realizing it. The chief of MACV-SOG who replaced Jack Singlaub in September 1968, Colonel Steve Cavanaugh, explained: "During training we would give these alleged or ringer agents the specific mission of making contact with an alleged team in North Vietnam to give them some sort of information. . . . Of course, we were setting these guys up because there was no team to contact. We expected that they would be captured and that they would be interrogated, and because we didn't believe that these people were truly wanting to work for us in the first place, we assumed they'd spill their guts. They were ringers. We wanted them to be captured, we wanted them [to be interrogated] to reveal everything we had told them about all these teams working up in the North."[137] It was only part of the charade that OP 34 was spinning in Project Borden.

Next came the training of the recruited POWs as SOG agents. It was a completely scripted and controlled affair, as Spivy related: "We used [manipulated] members of the STD as part of a group of agents being trained. Their purpose was to informally [and unwittingly] feed these North Vietnamese POWs information about others who had gone North or rumors about resistance organizations up North. It was this sort of thing that reinforced the formal [false] information that we were feeding them during this so-called training process."[138] This formal feeding might include providing the POWs with "contacts or dead drops or ways of communicating with other agent cells. We might also provide information about corrupt government officials who we claimed we learned about from messages sent back from agent teams inserted by us."[139]

Borden was "designed to divert NVN military resources to counter this penetration." It was hoped that Hanoi would start a witch hunt within the ranks of the NVA, resulting in the "harassment and alienation of NVA troops from their leaders, strained NVN ideological control, and inducement of defection."[140] Once the training charade was completed, the false agent was ready to be inserted back into

North Vietnam or NVA-held territory in Laos or Cambodia. However, even during the infiltration the spoof continued as the Borden agent was given "the ultimate paratrooper compliment: in honor of his training performance, he would be the 'man-in-the-door,' the first to exit the aircraft." The rest of the team would follow his lead. Of course, "He did not know that as he leapt into the blackness his teammates unhooked [their parachutes] and sat down." They were all part of the game. When NVN security policed up the area of the insertion they would find parachutes "dangling in trees." These had been carrying not agents but "ice blocks." By the time the enemy found them, the other agents had melted away.[141]

Even those NVA POWs who were not selected for training and insertion had a part to play in the game. According to Borden records, they were "returned to normal detention facilities to spread specific project information to other detainees for eventual transmission to NVA intelligence analysts."[142]

This added another twist to the Borden Project that was aimed at the general POW population from which these ringer agents were selected. It was devised by a young Air Force officer assigned to SOG during 1967–1968. Clem Tamaraz was unusual for his service. The Air Force rarely produces officers with such a keen interest in the arts of deception and counterintelligence. Many of his ideas became operational elements of the Diversionary Program.

Tamaraz related the following ploy: "Prisoners who were not recruited would nevertheless be exposed to the recruitment in such a way that they would believe that we were welcoming back an agent who had been among them all this time." Here is how the spoof worked. "The way we did that was using fluorescent powder. What we did was [to pretend we were conducting] a study of hypertension among North Vietnamese prisoners. We had a Navy doctor who would go up to a prisoner location and examine the prisoners for hypertension. Actually, he would mark the forehead of one with this invisible powder. Then the next day I would arrive to interrogate the prisoners . . . and would shine the light so the mark would show up on the head of one; then we'd quickly grab him, welcome him, all smiles, shake his hand, hug him and take him out. The rest of the POWs would see the mark when we shine the light [on him]. . . . So, they know this guy is different."

It did not take a genius to draw the conclusion that he was an agent. This message was reinforced by POWs who washed out of Borden's training charade. "So, North Vietnamese intelligence is getting word through the prisoner of war camps that we have people planted. Then they're getting word . . . that we're sending people back in. It reinforces the concept that we're training people to go North."[143] Finally, the POW marked with the fluorescent powder was given the choice of becoming an agent for OP 34 or being returned to the POW facility from which he was taken. It was not a difficult decision. OP 34 had one more POW to put back up North.

According to Spivy, Borden's initial goal was to put in a few hundred agents each year.[144] During 1968, records show that as the project was being developed, "98 detainees had been collected for this project. Fifty of them were returned to detention facilities, 44 were inserted as agents into NVN and NVN-controlled territory. . . . Four were scheduled for insertion in January 1969."[145] For those running Borden, 1968 was considered a good start. They planned to do much more in 1969, when Washington intervened at the end of 1968 to shut down all SOG operations against North Vietnam that involved physically crossing its borders.

Project Urgency

Project Urgency, the second core element of Forae, encompassed two operations. The first had to do with North Vietnamese soldiers, militia, or party cadres who were uncooperative types, real true believers who had been captured or kidnapped. OP 34 would gain access to these individuals in one of two ways. They could be selected from the same division-level POW holding areas from which Project Borden collected POWs. They were also picked up during Plowman, SOG's maritime operations that kidnapped North Vietnam citizens. Once captured or selected, these detainees were taken to Paradise Island, where they were indoctrinated in the fabricated resistance movement, the Sacred Sword of the Patriots League, run by SOG's Psychological Operations Group. Detainees or POWs picked for Urgency were those who would not cooperate. They were real hard cases and made no bones about it. Clearly, they were not sympathetic to the fabricated resistance movement. But Project Urgency knew just

how to make use of them. According to Bob McKnight, the chief of OP 34 in 1968, it was decided to frame these zealots as spies and put them back into North Vietnam.

This was real hardball. First, incriminating espionage items were sewn into the seams of the detainee's clothing without his knowledge. It was a professional job. Next, according to McKnight, "We gave them some training and showed them how to get on and off helicopters [or use a parachute] and then put them back into areas where we figured they would be an easy day's walk to a populated area."[146]

It was intended by those running Project Urgency that the NVN security police would pick up the detainee and find the planted material that identified other agents and related espionage activities. When the framed cadre, militia member, fisherman, or soldier denied any knowledge of the planted material, it was highly likely that the interrogation process would turn ugly. The more he tried to explain the matter away, the harsher the means of interrogation would become. According to McKnight, "We attempted to manipulate them by making it appear they were agents. . . . We were hoping they'd all be killed or give false information that we planted."[147]

The second Urgency operation involved Paradise Island detainees who wanted to cooperate—or at least pretended to. Either way, those running Urgency were interested. These detainees could serve as either pseudo- or actual agents. In most instances it really did not matter because Urgency was mainly a deception operation. However, during their indoctrination, a handful of the more intelligent were recruited and trained as low-level agents, then returned to NVN to be contacted at a later date. Actually, OP 34 had carried out a similar program with selected detainees at Paradise Island in 1967. According to the records, "The concept of operations was to utilize two Plowman detainees . . . for low-level intelligence collection in their home areas." The two agents—Goldfish and Pergola—were returned to NVN in September 1967. Neither was ever heard from again.[148] However, the main purpose of this part of Urgency was to manipulate detainees as pseudo-agents. Their sole purpose was to tell all to NVN security officials during interrogation.

The objective here was not intelligence collection, but deception. These detainees were trained as agents in the same way as those selected for Borden. In fact, according to Bert Spivy, "I went out to

Paradise Island and was able to observe the fishermen operation. The purpose for me was to learn these different techniques because I was to carry out a somewhat similar operation with NVA prisoners of war."[149] What he learned was that Urgency was managing a completely scripted affair, where the detainees were surrounded by role players and fed disinformation about other agents and networks. The training process was an elaborate affair ending in a special ceremony where the "new agent" was inducted into a secret brotherhood. This was quickly followed by his insertion back into North Vietnam.

As with Borden, Urgency was just getting under way when in late 1968 Washington put a hold on all operations that involved crossing the NVN border.

Project Oodles

The third core element of Forae was Project Oodles. It was a sophisticated elaboration of Bob Kingston's efforts at radio deception. According to SOG records, Project Oodles was "designed to portray an apparently extensive and successful agent network in selected areas of North Vietnam. To this end, fourteen phantom teams [were] activated."[150] They were intended to convey a more sophisticated network parallel to the one the North Vietnamese had uncovered and were running back against SOG. It was an elaborate spoof devised by Dave Thoenen, a mid-level CIA officer attached to OP 34.

To make Project Oodles believable, different false radio messages were sent from OP 34 to each phantom team. These included operational instructions about intelligence collection targets, the activities of other teams, and upcoming resupply and reinforcement missions. Additionally, individual team members were sent messages from their families, especially at the time of important holidays. For example, on his birthday an agent would receive personal messages from his parents, wife, and children. On his wedding anniversary a very personalized greeting came from his wife, recalling special past events.

Actual resupply bundles were also parachuted into the area where a notional team supposedly was operating. Of course, what NVN security would find was the remains of the bundle, not the actual supplies. The impression OP 34 hoped to foster was that NVN security was too late: the agent team had already been there and removed the bundle's contents.

According to project records, "To add credibility, personnel presence is implied by the paradropping of ice block–weighted personnel parachutes to be found after the ice melts, hanging in trees."[151] Again, the message to Hanoi's People's Police Force or whoever else found the parachutes was, "You're too late; you just missed them."

Another ploy: Pseudo-agents being inserted from both the Borden and Urgency projects were led to believe they would be met at their designated drop zone by members from one of Oodles' phantom teams. While these pseudo-agents may have believed they were actually going to meet up with an established team, OP 34 intended simply that they would corroborate other evidence that the phantom teams were real.

Finally, radios that sent messages out from these fake teams were air-dropped into North Vietnam. This completed the communications loop. Messages were coming in and answers were being sent out. Additionally, devices known in the trade as agent-harassing devices were air-dropped into NVN to cause their security forces to react. The objective was for the enemy to search and find the device but not the agents using it.

Like Borden and Urgency, those aspects of Oodles that involved actually crossing the NVN border, such as fake resupply missions and insertion of radios, were halted in late 1968. Oodles continued into 1969 but was "limited to sending radio messages to 14 notional teams. An average of two messages per week were transmitted."[152]

Other Projects Supporting Forae

While Borden, Urgency, and Oodles were the core elements of OP 34's Diversionary Program, other operations run by MACVSOG served to support the efforts aimed at convincing Hanoi that it had a serious internal security problem. One of these, the strata (Short Term Roadwatch and Target Acquisition) team program, which was also run by OP 34, did not have this as its primary mission, but reinforcing Forae was a by-product of its operations.

The original authority for the strata project can be traced to a May 1967 Pacific Command message. The first two strata teams were inserted into North Vietnam at the end of the year. The area of operations for strata was south of the 20th parallel, approximately 150

miles north of the DMZ, where the teams were to collect intelligence on the road network leading to the three major passes feeding into the Ho Chi Minh Trail in Laos. While the long-term agent teams had been retasked in 1966 to collect intelligence on these, the few that had survived in place had accomplished very little. Therefore, "it was believed that the emphasis on short stay-time and mobility in strata team training would enable them to survive and to be successfully exfiltrated."[153]

Strata teams were composed of "5–15 indigenous personnel transported by USAF/RVNAF helicopters. . . . Missions were to be for 15–30 days."[154] Twenty-four such teams were sent north in 1968. The strata team targets can be seen in the map on page 122.[155] Major George "Speedy" Gaspard, who supervised the project then, related that their primary mission was "road watch and reconnaissance . . . to watch a road, a path, or whatever and the ability to find the exfiltration site. It was very difficult for the people on the ground because of the terrain; don't let me make it sound easy."[156]

Speedy Gaspard was an experienced Special Forces officer who during the Korean War ran reconnaissance-team operations cross-border into North Korea. He "commanded a detachment called TLO (Tactical Liaison Office), which usually consisted of one lieutenant or a captain, and three or four NCOs and anywhere from forty to sixty South Korean team agents. As an infantry division went on line, a TLO team would attach to the division and run patrols, working on a low-level intelligence mission. . . . I ran some ninety-seven missions across the DMZ into the North and received some pretty high marks for those activities."[157] Later on, in the mid–1960s, Speedy was back in South Korea, this time "to develop a counterinfiltration program." At that time, North Korea was attempting to infiltrate a significant number of agents into the South. On the basis of these experiences, Speedy Gaspard seemed like the right man to head strata.

Strata teams were assigned secondary missions that included planting mines, capturing prisoners, and distributing psyop materials. But the program's records show that strata team accomplishments were minimal against these targets. The agents were said to have rarely gotten close enough to a road to actually observe a truck or identify a target worthy of an air strike. None of the strata teams ever captured a prisoner, and they planted very few mines. They did, however, leave

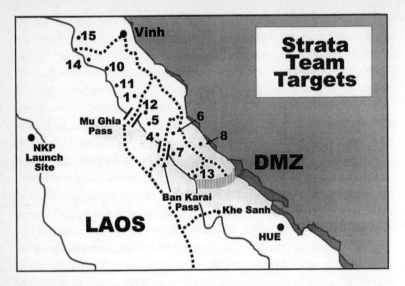

TEAM LOCATIONS

psyop materials in areas where they were inserted.[158] These materials had to do with the phantom resistance operation, the Secret Sword of the Patriots League. Typically, this involved leaving a leaflet that denigrated a particular cadre in the area. The idea was, according to Gaspard, "either to run him down or to convince NVN security that notional groups were real and operating in this area."[159]

In light of this, what use were strata operations? Gaspard puts a unique spin on how to measure success. "My measure is, if you're running the program, and we were, and your mission is to get them there, well, that's my mission. If they achieve something on top of that, that's gravy as far as I'm concerned. I know that's kind of a callous way of looking at it, but I have to measure it."[160] How did this affect Hanoi? Gaspard believed that it told the North Vietnamese, "We can come into your country at will . . . we can put flags and leaflets on the trees at will."[161]

While the strata teams were not accomplishing all their intended missions, the fact that they penetrated North Vietnam 24 times in 1968 obviously had a reinforcing effect in terms of the Diversionary Program, as Gaspard suggested. In effect, it was real evidence of spy

commandos, as Hanoi referred to them. As with other MACVSOG operations that involved physically crossing into North Vietnam, however, the strata program came to an abrupt halt at the end of 1968. In 1969, strata was refocused on Laos and Cambodia. The objective remained intelligence collection, not deception.

There was still more to Forae. SOG's psywar section (OP 39) developed three other projects. The first, Project Uranolite, "was to be the insertion of agent-alluding and harassing devices into North Vietnam to divert NVN security to locate and examine the devices, search for the using agents, expand the apparent range of activities, and strain the population controls." These items were to be distributed by air into selected areas. Examples included "Boxes with characteristic imprints of agent equipment such as assassination weapons or explosives, with actual electronic [deception devices] (low powered beacons, weather sensors, cheap radio receivers, or devices with no other purpose than to require technical analysis)." This project "was ready for initiation when the bombing halt [1968] stopped all such action against NVN."[162]

Next was Project Pollack, which "was to be incrimination of NVN officials as anti-NVN agents with the specific objectives of diverting NVN security to apprehend, detain, interrogate, and investigate innocent officials and their agencies." This was to be achieved "through letters with easily discovered secret writing." These letters were to be "sent through doubled contacts in NVN or through pseudo-agents inserted into NVN." In the intelligence trade these are called "black letters." This project "was initiated" in 1968.[163]

Project Sanitaries "was to be an expansion of SSPL [Sacred Sword of the Patriots League notional resistance movement] activities through the use of a redemption coupon leaflet. . . . They were designed to convince the NVN security elements and people that the SSPL efforts were extensive, have popular support, and to entice the people to conceal the coupon for possible reward." This project was also stopped in November 1968.[164]

The SSPL, begun in 1965, also contributed to the Diversionary Program. Its two operations were both directly linked to and supported the OP 34's triple cross.

Finally, OP 39 also mailed a wide variety of fraudulent letters to NVN officials and citizens. Some of these letters were intended to bring the recipient under suspicion for espionage activities or to actu-

ally incriminate him as an agent. An added twist was to tie the information in the letter to false information about agents and espionage fed to the NVN personnel being manipulated by Projects Borden and Urgency.

SHUT IT DOWN

OP 34 was finally on the right track, and by the fall of 1968 the Diversionary Program was under way. The chief of OP 34 and a handful of officers had proved creative at establishing the architecture of a complex triple-cross system. It was a serious effort aimed at capitalizing on a major debacle. OP 34 was back in the wilderness of mirrors, but this time as the deceiver and not the deceived.

Early indications were that the Diversionary Program caught Hanoi's attention. North Vietnamese newspapers and radio broadcasts from 1968 revealed a great deal of worry over agents, spies, espionage, and subversion. This was a marked change from previous years. The articles and radio commentary had become much more alarmist and far more extensive. Even in its formative stages, the Diversionary Program clearly was having the intended effect. Hanoi was feeling the heat and becoming increasingly sensitive to the threat of subversion.

Then an incredible message arrived. In November 1968 MACVSOG received an urgent communiqué from Washington. It was told to stop all operations that involved crossing the North Vietnamese border. For the Diversionary Program, this amounted to an almost-total shutdown— just as it was getting off the ground. Why was this happening? wondered an astounded chief of SOG, Colonel Steve Cavanaugh. He recalled, "Not long after I'd been there, I was called from Washington and the question was, 'Do you have any teams north of the parallel?' I had three strata teams on the ground, and they said, 'You have to get them out immediately because we're instituting a bombing halt and we are going to publicly say that we have no activities north of the parallel.' I remember this caused all sorts of consternation because there's no way that you get a team out overnight. So, that was about the last effort to put our people in the North because we were reaching a point in the war where we were pulling back."[165]

The Diversionary Program fell casualty to Johnson's post-Tet pol-

icy review. At the end of January the Viet Cong initiated a country-wide offensive that startled Washington. In addition to attacking thirty-six of forty-four provincial capitals and five of South Vietnam's major cities, the VC carried out assaults against the U.S. embassy in Saigon, South Vietnam's presidential palace, and ARVN headquarters. Even though the VC and NVA forces suffered as many as 40,000 battlefield deaths and quickly lost control of any areas seized, the Tet offensive was a colossal strategic shock for the Johnson administration. It shattered all the optimistic Pentagon estimates from 1967 about progress in the war and predictions that it would soon be over. Tet demoralized LBJ.

On March 31, 1968, LBJ told the nation he had unilaterally ordered the bombing of North Vietnam stopped—except for the area just north of the DMZ, where the continuing NVA buildup directly threatened U.S. and SVN forward positions—and that he would not seek reelection. The Tet offensive radically changed American policy toward Vietnam. The goal was no longer winning the war but getting out of it.

The bombing halt was supposed to be an act of good faith signaling the administration's desire for serious negotiations, a new peace initiative. It was a profound change. North Vietnam, which was going through its own Tet assessment, declared its readiness to let talks begin.

Haggling for a month over where to meet, Hanoi and Washington finally agreed on Paris and the talks began on May 13, 1968. Once there, North Vietnamese negotiators quickly laid out their conditions or "price" to start peace talks. It amounted to a demand for U.S. capitulation. For the American negotiating team, headed by Averell Harriman, it was a difficult and frustrating situation. Hanoi stipulated that the peace talks would only move forward with the "unconditional cessation of the U.S. bombing raids and all other acts of war" directed against NVN. In other words, turn off MACVSOG. Hanoi rejected all U.S. demands for reciprocity, which might affect its ability to support the war in the South. They were not about to turn off the VC or remove NVA forces. Hanoi also refused to recognize the government of South Vietnam, and the United States did the same with respect to the Viet Cong.

By July, LBJ had had enough. He resumed B–52 bombing raids north of the DMZ. However, Hanoi had dug in over the issue of reciprocity and Harriman could not get it to budge. By the early fall, he

was able to convince LBJ to agree to halt the bombing again, if he could extract some concession from the North Vietnamese. Eventually, the Crocodile was able to negotiate an "understanding." It was hardly a concession. He could not budge North Vietnam to accept reciprocity, and told its Paris delegation that the United States would halt the bombing without any quid pro quo. Hanoi, said Harriman, presumably would stop rocket and mortar attacks on South Vietnamese cities and cut back infiltration of NVA across the DMZ. North Vietnam refused to make any formal commitment to do so, but Harriman believed it had given him a "wink and a nod."

This was all he could get. Hanoi did not even have to acknowledge that it had troops in the South, let alone remove them. Also, no order to turn the VC off was forthcoming from the North Vietnamese. It was another Laos 1962-type deal, again brokered by Harriman. On October 31, Johnson announced that on the basis of "progress" at Paris, all bombing raids over North Vietnam would stop. However, as a once highly classified document reveals, the administration also agreed to halt all MACVSOG covert operations that involved physically crossing the North Vietnamese border, whether by land, sea, or air. According to a 1970 top secret report: "During the initial stages of the Paris peace talks, the representatives of Hanoi presented a 'price for peace' proposal. Included in this proposal were . . . demands that were a direct reaction to the Footboy program [the code name for the entire covert operation waged against Hanoi by SOG was Footboy]."[166]

If SOG ever wondered about the extent to which its Diversionary Program was getting to Hanoi, here was proof positive. SOG could only wonder why LBJ caved in to the DRV's demand to turn off the covert war.

For the operators in OP 34, it made no sense. Why would you concede everything before beginning to negotiate? Why give up on operations that could serve as valuable assets once the actual negotiation process started? Just deny that you're engaged in MACVSOG operations and then crank them up. This was the way the operators saw things.

There was no need to make covert action consistent with overt policy, thought SOG men in the field. But the senior policy makers were following a very different calculation forged in the aftermath of its

shock over Hanoi's Tet offensive. Also influencing the decision to accept Hanoi's demands was the 1968 presidential election. According to the most exhaustive study yet on this turn of events, Harriman, Cyrus Vance, and Clark Clifford "all feared that if something dramatic were not done soon, Hubert Humphrey's faltering campaign would collapse, resulting in the election of the despised Richard Nixon." They persuaded LBJ, who "feared being accused of a cheap political trick" if he accepted Hanoi's "price for peace" proposal, to go along.[167]

For OP 34 and the Diversionary Program, the Johnson administration peace offensive meant the endgame for operations up North. Covert activities were shut down. The triple cross was turned off.

As late as 1995, the United States would learn, Hanoi was still drawing lessons from "the wartime experience of combating spies and infiltrators." Officially, the DRV's Interior Ministry claims that "Lessons learned from countering the very first infiltrations were gradually transformed into general operating procedures that eventually resulted in an unbroken string of successes against infiltrators."[168] But a DRV security officer revealed in March 1997 that Hanoi had believed that the total number of agents sent North during SOG's heyday was between 1,000 and 2,000, rather than the 500 that the CIA and SOG actually infiltrated.[169] His not-for-attribution remarks show how significantly Hanoi had miscalculated and how effective the Diversionary Program had become before it was axed.

4

DRIVE THEM CRAZY
WITH PSYWAR

By late 1962, as his tour as the CIA's station chief in Saigon came to an end, Bill Colby concluded that the agency's operations against North Vietnam were a bust. In particular, his agent teams just were not producing results.

Colby returned to Washington to head the Far East Division in the agency's Directorate of Plans, which was responsible for all clandestine operations. One of his first actions was to have his new staff assess Saigon Station's operations up North. Their report confirmed what he had already decided. Colby would later recall that "My deputy chief of the Far East Division bugged me on the subject, saying, 'Look, this [sending agents into North Vietnam] is just nonsense.' He went back and took a look at our experience in North Korea, in the Soviet Union in the late 1940s–early 1950s, in China, and in none of these cases had any of these operations really proved successful." The report bluntly stated that these "kind of agent operations in North Vietnam just were not going to work."[1]

This created a conundrum for Colby. It was clear that CIA operations against Hanoi were going nowhere, but President Kennedy, according to Colby, continued to insist that he wanted to "increase the insecurity in North Vietnam to match the insecurity they were

producing in South Vietnam."[2] Was there something else the CIA could do? Colby decided the answer was *psywar* in the CIA's parlance—psychological warfare. He believed that communist regimes were naturally paranoid, something all police states suffered from. If you could manipulate that psychosis, Colby reasoned, "it would drive them crazy."[3] As station chief in South Vietnam, he had initiated a modest psywar program against Hanoi. Now Colby wanted to escalate it. It was a long shot but all he could come up with.

Actually, there was logic in what Colby proposed. He wanted to play on Hanoi's obsession with counterintelligence—to take advantage of its excessive fear of subversion, deception, and conspiracy; to manipulate its fixation with perceived internal enemies and spies.

In reality, there is no black magic in covert psychological warfare operations, contrary to what some of its enthusiasts profess. It is a standard instrument of statecraft and a part of CIA's "bag of tricks" during the Cold War.

While a covert psywar campaign is not magical, it is complicated, if executed in a sophisticated manner. It entails the planned use of propaganda (e.g., radios, leaflets, other printed items) and other psychological techniques (e.g., fronts and notional or imaginary organizations) to influence and manipulate the opinions, emotions, attitudes, motives, and behavior of the leadership and population of a hostile nation. Psywar campaigns are complex and hard work.

In 1948, OSS veteran Frank Wisner had been placed in charge of covert operations. The organization he headed, (euphemistically called the Office of Policy Coordination) was housed at the CIA but operated under direct National Security Council control. A covert operation was an intricate undertaking, he knew, be it political, psychological, paramilitary, or economic in focus. Wisner, it is said, postulated that all such operations had to be mounted by an organization that performed like a "mighty Wurlitzer: it could play military and diplomatic tunes; it could mount operations, control newspapers, influence opinion."[4] The analogy pointed to the complexities involved in all covert actions especially psywar.

To succeed, psywar operations had to be managed as complex campaigns that integrated a variety of different instruments. But this is not what Colby had in mind for operations against North Vietnam when he picked Herb Weisshart in 1963 to be the deputy chief of the

North Vietnam Operations Branch of CIA's station in Saigon. Weisshart soon learned that he was not expected to mount a Wurlitzer-type psywar campaign against Hanoi. A modest effort would do, Colby's guidance made clear.

Weisshart arrived in Saigon in March 1963 to develop the covert psywar program. He recalled that it was almost like starting from scratch: "There was no large psywar effort to speak of against the North at this time."[5] Weisshart had conducted similar operations in northeast Asia and would rely heavily on those experiences. He had no choice in the matter because he knew very little about Vietnam.

What was the goal of this new psywar effort? According to Weisshart, "It was only for one reason. That was to see what we could do to force North Vietnam to take some of their assets and divert them to worrying about what we were doing in their backyard. You couldn't expect much more."[6] It was hardly an ambitious under-taking and not a "mighty Wurlitzer."

Nevertheless, Weisshart got to work and began developing a psywar program. This included more broadcasts from covert radios into North Vietnam, more leaflet and gift kits by air and sea, and creating the fake resistance organization that came to be called the Sacred Sword of the Patriots League (SSPL). In the midst of his labors, Weisshart learned how impatient Washington had become with CIA's meek efforts and that it had decided to turn covert operations over to the Pentagon under Operation Switchback. It was time to put the heat on Hanoi, and as he recalled, the view of the policymakers was that "the military had the money, manpower, and materiel to do so."[7]

As Switchback was implemented in 1963, Herb Weisshart not only worked on preparing OPLAN 34A, but learned that he and several of his CIA colleagues were going to be assigned to MACVSOG and work for an Army colonel by the name of Clyde Russell. Given the ambitious scope of 34A, Weisshart hoped that now he would have the opportunity to expand the psywar program into a real Wurlitzer per-formance.

GETTING STARTED: SOG'S PSYWAR PROGRAM

Colonel Clyde Russell, the first chief of SOG, faced the following four immediate challenges in 1964 in terms of the psywar section of this

embryonic black organization: finding the right personnel; establishing the organizational divisions of the psywar section; developing an operational plan; and initiating operations. Furthermore, he had to accomplish each of these tasks more or less simultaneously. It was a tall order.

The first item on Russell's agenda was personnel. Weisshart moved over to SOG at the time of Russell's arrival in January 1964 and became his deputy. He was the senior CIA officer among a small number of agency psywar specialists. Russell told Weisshart to expect a large contingent of Army psywar specialists. Things sounded promising. The new chief of SOG assumed that because the Special Warfare Center at Fort Bragg specialized, in part, in psychological operations, the officers assigned to SOG would know the business. They should at least have had classroom and operational-level training in psywar methods at Bragg, Russell surmised. He hoped some would have had actual experience in the field. When the contingent arrived, Russell learned otherwise. Weisshart recalls that they were mostly young captains with no experience operating against denied areas. Russell's hope that some of the contingent had field experience was out the window.

However, a lack of operational experience was only part of the problem. While these young officers had gone through the psyop course at Fort Bragg, Russell was to discover that their instruction hardly touched on the kinds of operations Weisshart wanted to develop and expand against Hanoi. John Harrell, one of those captains, later described his psyop training. Prior to joining MACVSOG, he spent three and one-half years at the Special Warfare Center at Fort Bragg. He attended the psychological operations officer course and other courses concerned with various aspects of propaganda. He was also assigned to different units that trained for psyop missions. In all of this, Harrell did not receive preparation for the kinds of psywar operations he would be involved in during his tour in SOG. In fact, he "didn't even know that [covert psywar] was the mission until [he] arrived in Saigon in January of 1964."[8]

It was the same kind of personnel problem that Russell was facing in his attempt to staff OP 34. The specializations he required for psywar operations did not exist in the special warfare community, contrary to what the policy makers in Washington thought. Expertise in

planning and executing black psychological operations against denied areas was not to be found in the U.S. military. Another young captain who ended up in SOG in 1964, John Hardaway, noted that the Army "didn't have any experience, as far as I can tell, to draw on. . . . I stayed in Psyop the first eight years I was in the Army. In fact, I was one of the old veterans by the end. We just didn't have psychological warfare specialists and we didn't have that much experience. The guys that were teaching us at Fort Bragg were captains, and they weren't people who had an extensive background in PSYOP."[9]

These young Army officers also lacked knowledge of North Vietnam. Psywar requires an intimate understanding of the target in all its political, social, cultural, structural, and historical dimensions. Asked whether he or his fellow officers had any understanding of the psychological pressure points in North Vietnam, Hardaway responded, "I don't think so." What SOG needed were individuals who "could speak the language, who were schooled in the target audience, in the culture, in the fact that they are different."[10] These attributes did not exist among the captains assigned to Herb Weiss-hart.

Worse, perhaps, these officers were lent to SOG on short-term temporary duty assignments because Russell was having trouble getting approval for the personnel billets he needed, where one-year tours were normal. He was in a squabble with MACV and Pacific Command over some 40 positions they had cut from his initial personnel request of roughly 150 people. Washington wanted to escalate covert operations, but Russell was told to reduce the number of people he thought it would take to do the job.

The way around this shortfall was temporary-duty assignments. It was a quick fix, and that was all one could say good about it. Thus, young captains with no training or experience in black psywar and little or no understanding of their target were assigned, on a six-month basis—hardly enough for on-the-job training to help Weisshart expand his psywar operations against Hanoi.

Still, Russell thought, perhaps these young captains could learn from the CIA officers he expected to augment SOG's psyop section. There were plenty of gaps in his psywar section, and he hoped to receive a large number of CIA officers to fill them. In February 1964, SOG requested that thirty-one CIA officers be assigned to it. The

agency had no intention of assigning that large a contingent. According to the records, "The feeling in Saigon was that the agency would be withdrawing from the 34A Program within six months." Therefore, the CIA rejected the request and assigned thirteen officers.

By 1966 its cadre was reduced to nine.[11] As a result, the issue of CIA personnel assigned to SOG was the subject of a meeting in the Pentagon between Colby and Major General William Peers, the Joint Chiefs of Staff's Special Assistant for Counterinsurgency and Special Activities. CIA's "uncooperative" support of SOG, as Russell viewed it, would continue to impede SOG for years. Peers could not budge the agency to provide more personnel to SOG. Colby acknowledged at that time that "personnel-wise CIA had not properly supported MACVSOG."[12] CIA's focus in Vietnam was in the South, says Ted Shackley, who served as station chief there in the latter part of the 1960s. Those personnel demands were considerable in 1964 and came first. SOG got short shrift as a result, acknowledged Shackley.[13]

Furthermore, the quality of those few CIA psywar officers assigned to MACVSOG was uneven. Very few of them knew the Vietnamese language, culture, history, and contemporary setting. Additionally, service in the psywar section of CIA's Directorate of Plans was not considered "career enhancing" or the "fast track." According to Phil Adams, a CIA officer who served in SOG, "Psyop was considered a very unimportant branch of CIA; the big thing in CIA was intelligence—positive intelligence [collection through espionage]. That was number one, and number two was paramilitary operations. Those are considered important, and this I think is in a way the big failure of psyop."[14]

A large number of Vietnamese worked for SOG's psywar section (OP 39), many of whom were from the North and had come South in 1954. They provided an understanding of the North Vietnamese target. They knew its political, social, cultural, structural, and historical dimensions. They also could translate the propaganda messages into the proper dialect, serve as announcers for the radio broadcasts, and provide the personnel for the Sacred Sword of the Patriots League operation.

Finally, Russell needed an experienced military officer to serve as the chief of the psywar section. He was sent Lieutenant Colonel Martin Marden. Like Ed Partain, the first chief of OP 34, Marden

was a fine officer. But was he an expert in black psywar? Did he have experience operating against denied areas? According to Weisshart, who worked with Marden, the answer was "No, no more than anybody else [from the military] as far as I could see."[15]

Only one of the five military officers who served as chiefs of OP 39 had any knowledge or experience in black psywar. Marden was replaced by Lieutenant Colonel Robert Bartelt, an old Special Forces hand. Considered a dynamic leader, Bartelt had joined the 77th Special Forces Group in 1955. His knowledge of psyop was mainly in the area of overt operations. Lieutenant Colonel Albert Mathwin replaced Bartelt in August 1966. He had no operational experience in psyop but had served a tour in the Pentagon in the psyop section under the Army's deputy chief of staff for operations. How did he end up as the chief of OP 39? Mathwin related the following story. He was getting ready to retire. However, before doing so, he wanted to do his duty and serve a tour in Vietnam. He learned of an opening in SOG, volunteered, and got it. In preparation for his command of OP 39, Mathwin was sent to attend the psyop course at Fort Bragg.[16]

Next came Lieutenant Colonel Thomas Bowen, a 1948 graduate of West Point. A good part of his career was in armored and infantry units.[17] He had served a prior tour in Vietnam and received the Bronze Star. In June 1968, Lieutenant Colonel Louis Bush replaced Bowen. A 1949 graduate of West Point, he had the most background in psyop of all OP 39 chiefs. Bush had dealt with the subject both on the faculty of the Special Warfare School at Fort Bragg and as the executive officer of the Seventh Psychological Operations Group in Okinawa. He served only five months as the chief of OP 39, leaving in November 1968.

The personnel picture was a mixed bag for Clyde Russell, SOG's first chief in 1964. His Army officers were eager but inexperienced. This did not change appreciably in the years that followed. CIA officers knew the techniques and had practiced them but were generally unfamiliar with North Vietnam. The Vietnamese could provide an understanding of the context up North. It was hardly ideal, but maybe it would mesh, Russell apprehensively hoped.

Next, Russell and Weisshart set up what came to be called the Psychological Operations Group, or OP 39. As OP 39 evolved during 1964–1965, four subdivisions were formally designated: research and

analysis; printed media, forgeries, and black mail; radios; and special projects. The subdivisions were highly compartmentalized. Consequently, officers in one subdivision were not always aware of what was taking place in other subdivisions. The different subdivisions were also dispersed in Saigon. Combined with the fact that the chief of OP 39 was generally inexperienced, operational coordination and integration suffered.

OP 39's research and analysis section was first headed by John Harrell and was generally staffed by military personnel. Harrell had no training or background for his assignment. He "had no idea what that was going to involve; I didn't even know what kind of documents or anything else I was going to be handling, other than classified. I didn't know what they pertained to."[18] Essentially, the mission of the subdivision was to collect, collate, and interpret information from North Vietnamese sources that could provide insight into Hanoi's psychological vulnerabilities, its psychological pressure points. Harrell noted that he "had absolutely no training on North Vietnam or Vietnam in general."[19]

Another task of the research and analysis section should have been to use the same sources to determine what impact the psywar program was having on the North Vietnamese. This mission, however, would never be executed because the research and analysis section was never assigned personnel trained in these matters.

The printed media, forgeries and black mail branch was itself compartmentalized. Printed media consisted mainly of propaganda leaflets. Responsibility for it was assigned to the military contingent, who coordinated production with their Vietnamese counterparts. It worked this way, according to John Hardaway, who had responsibility for the mission in 1964. He would receive guidance on what the themes in the leaflets should propagate and then would "write [the] leaflets myself." Next, he "would take them to my counterpart and they would translate those and look them over to make sure they were right. These people were from North Vietnam who had come South in 1954. So, on the printed media side we were involved with them very close. Everything went through them."[20] But since Hardaway did not speak Vietnamese, there was no way to review the product once the Vietnamese were finished.

Psyop themes developed in OP 39 were woven into forged North Vietnamese documents. The actual forging was done by CIA special-

ists. It was a standard form of tradecraft. The CIA collected enemy documents that had been captured or acquired in other ways. The agency's master forgers could replicate anything the North Vietnamese published. These CIA specialists were not attached to SOG but appear to have received thematic ideas for the forgeries through liaison arrangements with agency officers in the psywar section. Once the document was completed, it could be inserted into enemy channels in any number of ways, including SOG operations in Laos. Recon teams would plant the items on an enemy casualty or in one of its command, logistics, or other NVA facilities on the trail.

Black mail operations were completely in the hands of CIA officers in SOG. These letters, which were posted in third countries, were divided into two categories. One consisted of propaganda messages to North Vietnamese residents, purportedly from North Vietnamese citizens living abroad. The general idea was to besmirch the leadership in Hanoi. Other letters were addressed to North Vietnamese officials. Here the objective was to raise suspicions about their loyalty in the minds of the internal security officers who supervised and read all mail coming into the country.

OP 39's third subdivision operated three black radio stations, all of which broadcast, on a falsely attributed basis, into North Vietnam. One was the Voice of the SSPL, ostensibly broadcasting from "inside" a liberated area of North Vietnam. Another was Radio Red Flag, supposedly a dissident clandestine communist radio in North Vietnam. The third was a false Hanoi Radio, which hugged up against the real Hanoi Radio frequency and copied its programming style. All came under the direction of the CIA officers attached to the psywar section, men who had conducted similar operations elsewhere. A United States Information Agency liaison officer provided policy and thematic guidance. Additionally, the subdivision had manufactured in Japan a pretuned transistor radio that could only receive one of SOG's black radio stations. While CIA officers directed the radio operations, Vietnamese attached to SOG did the actual broadcasts and provided the cultural context for programming.

The final subdivision of SOG's psywar section involved "special projects," the largest of which was the fake resistance movement, the Sacred Sword of the Patriots League. In this complex operation North Vietnamese citizens were abducted and indoctrinated at Paradise

Island, a location purported to be a North Vietnamese coastal village that had been liberated by the SSPL. Later they would be returned to North Vietnam to spread the word about the SSPL. Paradise Island was actually located south of the 17th parallel. Other elements of the operation included the SSPL radio, leaflets, and gift kits. The last contained items that were hard to get in North Vietnam—cloth, thread, fishing line, soap, and so on.

While the SSPL was the largest of SOG's special projects, smaller ones included contaminated NVA ammunition, booby-trapped items, and counterfeit currency. The technical expertise required to develop these products was generally provided through the CIA's Far East logistics office on Okinawa.

While SOG employed an array of psywar techniques, it never developed an integrated psywar plan. When asked whether he ever saw one, Phil Adams, an experienced CIA officer who had run black radio operations against denied areas in Eastern Europe, observed: "No, I don't remember any master plan. I don't remember anyone having a concrete idea of just exactly what we were supposed to do and how we would go about it."[21] His response was consistent with those of other military and CIA officers who served in OP 39.

Rather than a master plan, general guidelines for operations were developed through the CIA–USIA–military liaison relationship in OP 39. Those officers assigned were told to read OPLAN 34A. According to Major Richard Holzheimer, who joined the organization in April 1965: "When I first got there . . . they said, 'Here's our plan, 34A, read it.'"[22] OPLAN 34A generated a broad mission concept for OP 39, which sought to convince Hanoi that it should stop directing and supporting the war in the South. To accomplish this objective, the psywar section used a mélange of psyop techniques aimed at the North Vietnamese leadership and population. The code name for these efforts was Project Humidor.

OP 39's psywar operations sought to convince Hanoi's leaders that they had real internal security problems. They were to think that the population was becoming increasingly dissatisfied with a war that wasted the lives of its children, that citizens were secretly organizing opposition groups, and that security on the home front was becoming tenuous. At a minimum, OP 39 hoped its psywar operations would cause Hanoi to divert resources to deal with this perceived threat.

Washington, however, had a larger objective. It wanted North Vietnam to surmise that the United States was, sub rosa, fostering these internal security problems and that if Hanoi wanted the United States to stop, it would have to turn off its Viet Cong operations in the South. However, OP 39 was tasked to draw a fine distinction in its message to the leadership up North. These covert operations were intended only as punishment and retribution for Hanoi's war in the South; Washington did not want Hanoi to think they were intended to topple the NVN regime through subversion and unconventional warfare. In other words, SOG operations were not to be seen as similar to what Hanoi was fostering against the South Vietnamese government. The United States was fighting a limited war, and its covert operations would be constrained.

Consequently, with respect to the population in North Vietnam, OP 39's goal was to lead it to express distrust, disaffection, and even mild forms of dissent with their government's conduct of the war and the war's impact on daily life. OP 39 also wanted the citizens of North Vietnam to believe that there were internal resistance elements organizing against the government. Policy makers hoped that pressure from the population would lead Hanoi to moderate its policy toward the war in the South.

What kind of pressure should the population of North Vietnam exert once it had become disaffected and distrustful? According to those who ran SOG's psywar program, it was to promote only nonviolent forms of opposition inside North Vietnam. SOG was prohibited from encouraging the North Vietnamese population to initiate any type of armed resistance against the regime. OP 39 was required to draw a fine line and subtle distinctions in its attempt to influence the behavior of the North Vietnamese population.

There is little evidence that OP 39 followed any master plan in developing its 1964–1965 psywar program, any more than the administration, JCS, Pacific Command (PACOM), or MACV had a master plan for winning the war. Active and passive psyop techniques were never integrated and coordinated into the type of "mighty Wurlitzer" operation envisioned by Frank Wisner. Compartmentalization contributed to this lack of integration, as did the bureaucratic differences between the military and the CIA. Thus, there are serious questions about the strategic purpose of SOG's psywar operations. Did they make sense, given the nature of the North Vietnamese regime?

PSYWAR OPERATIONS AGAINST NORTH VIETNAM

By 1965, SOG had expanded Project Humidor considerably. At its height, it included an array of operational components. What did SOG's psywar effort involve and how was it run?

Sacred Sword of the Patriots League

OP 39's most complex operation was its attempt to create in the minds of the North Vietnamese a notional or fabricated resistance organization. CIA had employed the concept in other covert actions. In fact, Herb Weisshart explained that "It was based on a similar notional resistance movement program developed elsewhere in 1952 and still in effect in 1963."[23] "Elsewhere" likely referred to the People's Republic of China, given his other assignments and education in Chinese studies.

To create a fake organization, one must, in intelligence terms, establish a legend for it, a believable story. Weisshart puts it this way: "Soon after my arrival in South Vietnam [in 1963] we sought a legend and an easily recognized symbol upon which to base a notional resistance movement in North Vietnam. Several of my staff had previous experience in leaflets, radios, propaganda, and notional internal resistance operations. We casually interviewed several Vietnamese and learned of the Sacred Sword legend."[24]

In effect, Weisshart sought to find a way to ground the notional operation in an important event in Vietnamese history and mythology—the fifteenth-century invasion of Vietnam by China. The new dynasty of the Ming, established in 1368 with the ouster of the Mongols, sent a huge army to Vietnam in 1406. After one year of fighting, Vietnam found itself again under Chinese rule. The Ming occupation was extremely harsh and led to the formation of a Vietnamese resistance movement. It was led by Le Loi, who was a rich farmer and aristocrat from the province of Thanh Hoa.

How Le Loi formed this movement and conducted a ten-year protracted war against the Ming is a complex and fascinating story. It involved several psychological, political, and military innovations. For example, to establish legitimacy and win the support of the peasants, Le Loi employed a psychological operation that the Chinese had

once used. According to one account, "With a stylus moistened with animal fat, he wrote on the leaves of trees in the forest." The message was "Le Loi is the king. . . . After ants ate away the fat, the leaves displayed the perforated slogan. This prompted people to cry 'prophecy,' and thousands of peasants joined in."[25] Le Loi then declared himself the Prince of Pacification and began enlisting the peasants to fight to evict the hated Chinese and reclaim Vietnamese independence. However, because the Ming were so strong and repressive, he had to develop a clandestine organization and go underground.

Le Loi realized it would be suicidal to fight the Ming army along conventional lines. It was too powerful. Thus, he adopted clandestine guerrilla tactics. From his base in the Ha Tinh mountains, Le Loi launched surprise attacks on the Ming forces deployed in Vietnam. In 1428, the Chinese evacuated all remaining forces from Vietnam.[26] Le Loi acceded to the throne, adopted the name Le Thai To, and established the Le Dynasty, which ruled Vietnam for more than three centuries.

In Vietnamese history, Le Loi is considered an architect of national unity and a leader who never lost courage in the fight to oust the Ming invaders. Along with these historical facts is an enchanting myth of why Le Loi was able to gain victory over the vastly superior Chinese armies. The tale has to do with a magical sword that he purportedly used during the war of liberation.

According to legend, after he had defeated the Ming and become king, Le Thai To resided in Hanoi. One day he was sailing on Lake Luc Thuy (or Green Water), which is located in the city, when a large turtle appeared. The king drew his sword to protect himself, but the turtle quickly grabbed it out of his hand. With the sword in his mouth the turtle plunged to the depths of the lake. King Le Thai To was distraught. He ordered that the lake be drained and dredged. This was done, but to no avail. There was no trace of either the turtle or the sword. It then dawned on the king that his campaign to oust the Ming had received "the mandate of heaven." In other words, the gods (heaven) had lent him the sword to oust the Ming, and having done so, it had to be returned. The sword was to remain in the lake for safekeeping in case it was needed in the future. In honor of the sword, the king changed the name of the lake from Luc Thuy to Ho Hoan Kiem, the Lake of the Returned Sword.

CHIEFS OF MACVSOG

Clyde Russell, the first chief
of SOG 1964–1965.
(Photo provided by John Plaster)

Don Blackburn, the second chief of SOG
1965–1966 and later of SACSA.
(Photo provided by Don Blackburn)

Jack Singlaub, a working dinner. From the
left: Col Tran Van Ho (STD chief),
Singlaub (chief of SOG 1966–1968),
Major George Gaspard (OP 34), SOG
liaison officer to the STD (identity unknown),
LTC Bob McKnight (chief of OP 34).
(Photo provided by George Gaspard)

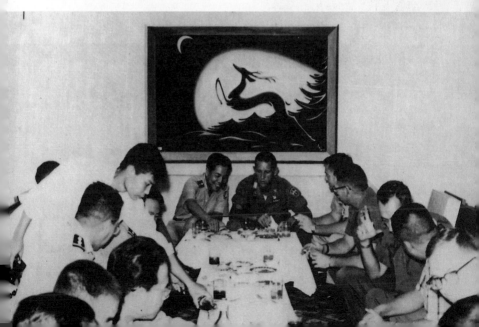

PERSONALITIES

William Sullivan, U.S. Ambassador to Laos. The men of SOG called him the "Field Marshal."
(Photo provided by William Sullivan)

William Colby, CIA chief of station in South Vietnam in the early 1960s. He started the covert operations against North Vietnam.
(Photo provided by Jonathan Colby)

Arthur "Bull" Simons, who established SOG's OP 35. Here he conducts the final equipment check for the Son Tay rescue mission into North Vietnam, November 19, 1970.
(Photo provided by Ben Schemmer)

Robert Rheault, Chief of the 5th Special Forces group in 1969. SOG played a key role in preventing his court-martial.
(Photo provided by John Plaster)

AGENT OPERATIONS IN NORTH VIETNAM

Long-term agent team during training. The man in the center of the front row was the STD handler for the team. *(Photo provided by John Plaster)*

Strata Team Helicopter carrying Strata Team 93 over the southern panhandle of North Vietnam during a 1968 insertion mission. *(Photo provided by John Plaster)*

Sabotage Target. Table top model of a petroleum storage facility in North Vietnam, used to train agent teams. *(Photo provided by John Plaster)*

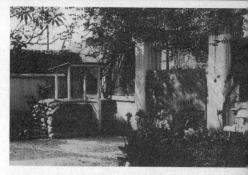

Entrance to OP 34 headquarters in Saigon, located across from ARVN's General Staff compound. *(Photo provided by Robert McKnight)*

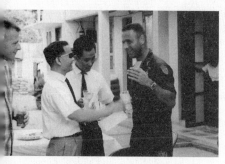

Members of OP 34 in December 1968 during their Christmas party. The month before, they had been ordered to shut down most operations inside North Vietnam. *(Photo provided by Robert McKnight)*

Chief of OP 34. Lt Col Bob McKnight (right), one of the architects of the diversionary program, receiving the Bronze Star. *(Photo provided by Robert McKnight)*

THE HO CHI MINH TRAIL

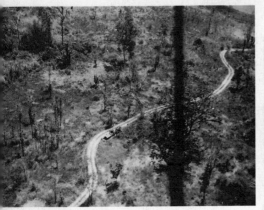

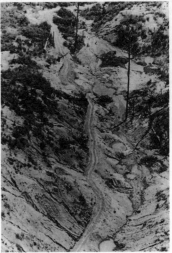

Above and right, low level view of the trail. The trail in Laos as seen from a helicopter. This area had been hit hard by B-52 strikes. *(Photo provided by John Plaster)*

Ground Level View. This was the way the trail looked to a recon team on the ground in Laos. In the foreground is an NVA supply route. *(Photo provided by John Plaster)*

Leghorn, SOG's top secret radio relay outpost on a Laotian mountain top. *(Photo provided by John Plaster)*

General Vo Ban. This 1995 photo shows the officer selected by the North Vietnamese leadership in 1959 to build the trail. *(Photo provided by Edward Emering)*

OP 35 RECON TEAMS

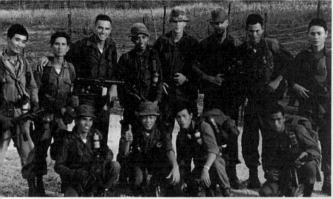

Recon Team Iowa. Dick Meadows (third from left) and his Chinese Nung recon team. *(Photo provided by John Plaster)*

Behind Enemy Lines. Recon team New Hampshire deep in Laos. *(Photo provided by William Curry)*

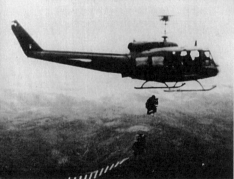

Escape from Laos. Members of a SOG team being extracted by ladder from Laos after a firefight with the NVA. *(Photo provided by William Curry)*

Mission Completed. Recon team members (top second left) Doug Miller, Medal of Honor recipient; (top far right) John Plaster; and (bottom left) Chuck Hein, killed in Laos. *(Photo provided by John Plaster)*

OPERATIONS

Members of a hatchet force boarding aircraft for Operation Tailwind in 1970. *(Photo provided by John Plaster).*

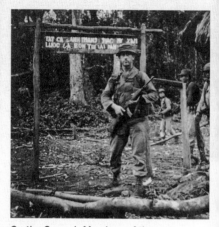

On the Ground. Members of the hatchet force in NVA way station after overrunning it. *(Photo provided by John Plaster)*

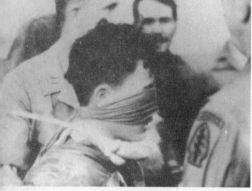

Snatch. Recon team returns from Laos with an NVA prisoner. The SOG team leader is John Plaster (background right). The prisoner was a Ho Chi Minh Trail truck driver. *(Photo provided by John Plaster)*

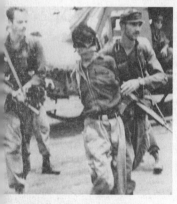

Snatch. Recon team with prisoner, exiting helicopter that extracted them from Laos. *(Photo provided by John Plaster)*

Snatch. Recon team leader Dick Meadows with an enemy prisoner captured in Laos. *(Photo provided by John Plaster)*

Wiretap. SOG recon teams wiretapped NVA lines of communication on the trail. This is how it worked. *(Photo provided by John Plaster)*

GOING NORTH

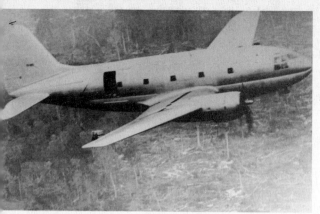

Unmarked C-46 used to insert and resupply agent teams in North Vietnam. *(Photo provided by John Plaster)*

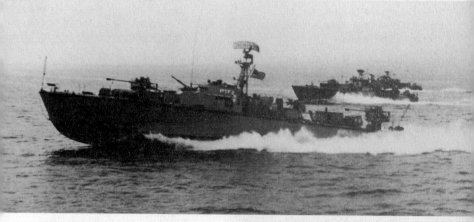

SOG Nasty boats used for operations against the North Vietnamese coast. These boats still have markings and are flying the U.S. flag. When used against North Vietnam, all markings and the flag were removed. *(Photo provided by John Plaster)*

Commandos. Three South Vietnamese Nasty boat commanders and the intelligence officer and assistant operations officer of SOG's Naval Advisory Detachment who trained them. *(Photo provided by Bernard Trainor)*

SOG HEROES

George Sisler. SOG's first Medal of Honor recipient, Lt. Sisler died on a mission in Laos. *(Photo provided by John Plaster)*

Jerry "Mad Dog" Shriver. Fierce recon team leader, Sgt. Shriver was MIA in Cambodia after raid on COSVN head-quarters. *(Photo provided by John Plaster)*

Larry Thorne. Capt. Thorne (first from the left) on the day of SOG's first recon team insertion in Laos. He was MIA from the operation. *(Photo provided by John Plaster)*

David Mixter. Sgt. David Mixter (back row, second from left) was the last SOG recon man lost in Laos. He was awarded the Silver Star posthumously. In this photo he can be seen in his outward bound class of 1966. *(Photo provided by Willem Lange)*

Every schoolchild in North Vietnam knew the story of Le Loi, his magical sword, and how he defeated the Ming. In fact, Weisshart learned, the Vietnamese Communist Party (VCP) placed Le Loi second only to Ho Chi Minh in the pantheon of Vietnamese national leaders.

All this was too good to be true, thought Weisshart. It was the perfect basis for the legend of the notional resistance movement he intended to make a central element of OP 39's psywar campaign. He decided to name his fictional creation the Sacred Sword of the Patriots League and to draw several parallels between it and Le Loi's movement to oust the Chinese in the early 1400s.

Whom did the SSPL represent, and why were they organizing a clandestine movement to oppose the regime in Hanoi? The Sacred Sword's leadership, like Le Loi, was Vietnamese nationalist in orientation. Weisshart made them former members of the Vietminh, who had fought against the French colonialists. According to his fabricated legend, they had become disillusioned with communist rule in the North as a result of the disastrous land-reform program begun in 1953. By the summer of 1956, the excesses of that land reform had, in some places, resulted in outright rebellion. It occurred in the southern panhandle of North Vietnam, including in Ho Chi Minh's home province of Nghe An. It was ready-made for Weisshart to link the origins of the SSPL to it. According to the legend he spun, the SSPL formed during this actual period of uprisings over the land-reform program. Communist repression produced the SSPL. It made sense and was plausible.[27]

The regime in Hanoi had reacted quickly to this disorder and quelled the uprisings. As Weisshart developed the legend, this forced the SSPL to turn into a clandestine organization and go underground, just as Le Loi had done. The SSPL did so by seeking refuge in the mountains located in the Ha Tinh province, where Le Loi had gone to build his resistance movement. The names of the fictitious leaders of the Sacred Sword organization included individuals who had Le as either a family name or a given name. For example, the founder of the SSPL was Le Quoc Hung. "In December 1961, the league held its first national congress, at which Le Quoc Hung was named [SSPL] president."[28]

The OP 39 mythmakers next had to establish the goals of the SSPL. What was it that the SSPL was fighting for and what did it hope to

accomplish? As an organization of nationalists and patriots, the SSPL declared its opposition to all foreign influence in Vietnam, be it due to friendly assistance, actual occupation, or Vietnamese becoming subservient to outside powers who sought to dominate Vietnam in more subtle ways. Consequently, the SSPL declared in its propaganda that all foreign troops, advisers, and influence should leave both South and North Vietnam. It criticized the leadership of the VCP for falling under the dominance of China. They were becoming the stooges of this hated enemy that had, throughout the history of Vietnam, sought to turn Vietnam into one of its dominions. China was at it again, this time using proletarian internationalism as a ruse to mask its real intention of suborning Vietnam to its will. Communist, Ming, or whatever—they were all Chinese and had the same intentions, said the SSPL. They should be kept out of Vietnam.[29]

China was using the Vietnamese as a surrogate force to fight the Americans. The People's Republic of China had learned a bitter lesson in Korea. It had found out the hard way that it can be very costly to take on the American military in a direct, face-to-face fight. It was much better to have others fight and die for you. China was more than happy, said the SSPL, to fight the Americans to the last Vietnamese. Hanoi had dragged Vietnam into this U.S.-Chinese fight and was doing the People's Republic of China's bidding. It was a win-win situation for the Chinese. They would bog down the Americans in a costly, protracted war and bleed Vietnam to the point where it would have no choice but to become China's vassal. Hanoi had to change its policy, the SSPL declared.

In its propaganda the SSPL asserted that its secret cells were proliferating, as Vietnamese nationalists were drawn to them. Its organization included both a political and a military wing. In 1965 the SSPL claimed to have 10,000 members, including "1,600 regular military."[30] Opposite is a copy of what the real SSPL membership card for a military cadre looked like, with the English translations for SOG records.[31]

Next, decided Weisshart, it was time to go on the air with the SSPL message. He needed a radio station to broadcast to the people. This resulted in the creation in April 1965 of the Voice of the Secret Sword of the Patriots League (VOSSPL), said to be located in the mountains of Ha Tinh province, Le Loi's home base. OP 39 also started produc-

SSPL MEMBERSHIP CARD

MẶT TRẬN GƯƠM·THIÊNG AÍ·QUỐC Số 1109/CMT/NB
 XỨ UY NAM·BỘ

CHỨNG MINH THƯ

XỨ ỦY MẶT·TRẬN GƯƠM·THIÊNG AÍ·QUỐC NAM·BỘ
Chứng nhận : Người mang giấy này là đồng chí
có bí số , cấp bậc Cán bộ Quân·sự nống cốt
của Xứ Ủy Nam Bộ có nhiệm vụ Liên Lạc, phát triển
và sinh hoạt với các Tổ Tỉnh trên toàn Xứ .
 Yêu cầu các Bộ phận triệt để giúp dỡ đồng chí
mọi phương diện để hoàn thành nhiệm vụ.

.........Ngày......tháng......năm 1971
BCH. XỨ ỦY NAM·BỘ
ỦY VIÊN THƯỜNG VỤ

Lê·hùng·Cường

The SSPL Southern Committee Nbr 1109/CMT/NB

IDENTITY CARD

The SSPL Southern Committee Certify: The bearer is a member
having the secret number grade hardcore military cadre of
the SSPL Southern Committee entrusted with the mission to take
relations, develop and coordinate activities with diverse secret cells
in the whole Southern region. The strict assistance on all aspects
from our agencies to him will be warmly welcomed.

Date1971
FOR THE SSPL SOUTHERN
EXECUTIVE COMMITTEE
MEMBER FOR CURRENT AFFAIRS

ing SSPL propaganda leaflets, dropped at night over North Vietnam
through air operations. To distribute them SOG employed third-
country personnel flying missions into North Vietnam. Pilots from
Nationalist China, serving as mercenaries, flew unmarked aircraft for
these missions to drop the SSPL leaflets. Prior to this mission they had
worked for CIA in Asia since the early 1950s.

Through these means of communication, the SSPL began to declare
that it maintained a clandestine organization in North Vietnam that

was not only expanding, broadcasting, and distributing leaflets, but even liberating territory. This was said to be taking place in the southern panhandle of North Vietnam "below the 19th parallel," where the SSPL said it maintained "safe zones."[32]

By the end of 1964, the SSPL operation was up and running. Weisshart and OP 39 had created the legend, basing it on actual Vietnamese history and mythology. They played the Chinese card to defame the VCP leadership in Hanoi and undermine its conduct of the war. It was a good start, MACVSOG's first leaders concluded. The next step was to make the whole ploy more believable. To do so, the SSPL needed a liberated zone where OP 39 could bring North Vietnamese citizens for indoctrination. Accomplishing this ruse would not prove easy.

Paradise Island

How could SOG establish a liberated zone for the SSPL, when Washington had prohibited liberating any territory in North Vietnam and refused to authorize the creation of a guerrilla resistance movement against Hanoi originally called for in OPLAN 34A? OP 39 had to come up with a way around these Washington-imposed constraints.

South of the 17th parallel, along the South Vietnamese coast just beyond Da Nang, was the island of Cu Lao Cham. Also known as Paradise Island, its location can be seen in the map opposite.[33]

It would become the liberated territory to which kidnapped North Vietnamese citizens would be brought for SSPL indoctrination. It seemed like a preposterous idea. How could an island south of the 17th parallel be made to appear as liberated coastal territory inside North Vietnam? How could OP 39 turn what seemed to be an implausible concoction into a highly scripted affair that was credible?

First, on the island itself, OP 39 created villages that were exact replicas of villages one would find along the coast of North Vietnam. Visually, there was no difference, as SOG was sensitive to every detail. The challenge was to bring North Vietnamese citizens to the island and make them believe they were still in North Vietnam. To do so, SOG created an SSPL naval element. Beginning in May 1964, unmarked gunboats went into northern waters and abducted mainly North Vietnamese fishermen and brought them to Paradise Island.

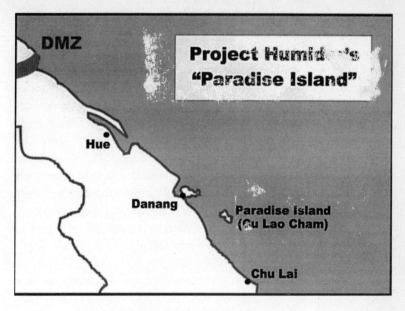

DMZ

Project Humid...'s
"Paradise Island"

Hue

Danang

Paradise Island
(Cu Lao Cham)

Chu Lai

PARADISE ISLAND MAP

The personnel who did the talking on these unmarked gunboats all spoke "a northern or central Vietnamese dialect" and, in many cases, had migrated South in 1954.[34] The boats flew the SSPL flag and the personnel on the boats claimed to be members of the movement.

The boat operations were a joint OP 39–OP 37 affair. The Naval Advisory Detachment (NAD), the cover name for OP 37, was located in Da Nang. It maintained the boats and crews that executed these abduction operations using SSPL personnel attached to OP 39. Major Roger McElroy was one of the few Americans to actually go North on one of these missions. He recalled that the boats "were made out of wood so they would not pick up radar detection easily. They were kept in Da Nang; they were not kept out on the island. . . . Sometimes I'd go with the boat and sometimes not, and I was in disguise. . . . I would put on sterilized camouflage fatigues [with no labels or country-specific insignia] and put a net over my face, and gloves on." When he went North, McElroy would generally stay "down below."[35] He went along only to communicate with U.S. Naval Forces off the North Vietnam coast "to let them know that we were in the waters so they wouldn't blow us up. I was there to communicate with the

Americans, I wasn't there for the operation. That was all being handled by my counterpart and whoever ran that boat."[36]

Once abducted, the fishermen or other North Vietnamese picked up on shore were told that they were in the hands of the Sacred Sword of the Patriots League, a secret patriotic movement, and were to be taken to liberated territory along the coast. The abductees, for security reasons, were informed that they would have to be blindfolded, bound, and put below deck. They were also told the trip would be purposefully long to mask the real location of the SSPL villages. The gunboat would then head to Paradise Island, a trip that often took several hours. Once in one of the island's coves, the captives were brought on deck, their blindfolds were removed, and they saw before them a liberated village somewhere along the coast of North Vietnam. This was only the beginning of the subterfuge. Next came their indoctrination.

The main purpose of this elaborate charade, according to Don Blackburn, the second chief of SOG, was "to convince them they were in a liberated coastal area of North Vietnam. When they were sent back, they would spread the word that there was a real resistance movement and liberated areas in North Vietnam."[37] The detainees stayed in the liberated coastal village for approximately three weeks. During this period, they met only Vietnamese who spoke a northern dialect. They spent their time eating, talking about life under communist rule, and learning about the SSPL. Some of the detainees were taken into the hills of the island to small villages "resembling types found in the hills of North Vietnam. The purpose of these locations was to . . . lend credibility to the guise that the SSPL secret zone was located in the highlands of North Vietnam."[38]

Jack Singlaub, who replaced Blackburn as SOG chief, described the three-week program as follows: "We would spend our time feeding them well, fattening them up, so to speak; we cured any medical problems they had, whether it was rashes or whatever. This indicated that things were better in the resistance area than they were in their own village. We collected information from them and provided them with information about the Hanoi government on corruption, etc. So when they went back, they were healthier and certainly had more poundage. We'd give them very high-calorie foods. But we spent a lot of time discussing the fallacies of communism, and they would tell us

about acts of corruption and dishonesty among officials. We would then be able to broadcast very specific cases to create disruption inside."[39]

In the final days before their departure, the detainees were told of other SSPL cells operating in their region and given secret ways of contacting them. This, of course, was for the edification of the North Vietnamese security forces that were sure to interrogate the detainees once they returned. Finally, they were given gift kits to take back with them. With cloth, soap, and other such items in short supply in North Vietnam, the gift kits were snapped up by the fishermen. Also included were transistor radios all tuned to the Voice of the SSPL frequency, which the detainees had heard every day of their stay on Paradise Island. Once their stay was over, the detainees were again blindfolded and returned to North Vietnam in the same manner they were brought to Paradise Island.

In 1966, its most active year, 353 North Vietnamese were cycled through Paradise Island. Between 1964 and 1968, a total of 1,003 detainees were indoctrinated there.[40] OP 39 proposed ways to expand the project to make it even more credible. They believed that one could maintain this fiction for only so long. If something more plausible were not added, Hanoi would eventually see through the ruse.

OP 39 proposed several ways to make the operation more realistic and Washington approved some of the more modest ones. For example, when detainees were taken in armed encounters between North Vietnamese junks and SSPL boats, the "detainees were tried by an SSPL court, found guilty of crimes against their country, and sentenced to death. Clemency was then granted under the pretext that the SSPL was an organization devoted to peace." Next the detainees went through extensive indoctrination, and "prior to their return, they made statements condemning their actions and took the SSPL oath of allegiance."[41] This was then used in SSPL propaganda broadcasts. A second example involved "detainees who appeared to be sincere in their desires to assist the SSPL cause." Some were "recruited as SSPL agents . . . trained in making crude leaflets and methods of spreading the word of the SSPL. In addition, they were assigned low-level missions to collect intelligence." A few were sent back to "organize defections to South Vietnam among friends." Finally, anyone who wanted to defect would be sent South for resettlement after his

story was featured on "South Vietnamese television and . . . in the *Saigon Daily News*."[42]

Other more ambitious or exotic operations to make the SSPL–Paradise Island project appear more realistic were turned down when SOG sought approval by its chain of command. One ploy, for example, would have encouraged the North Vietnamese population, through the Voice of the SSPL broadcasts, to start armed action through "selective assassination of hated North Vietnamese officials."[43] A related proposal was to instigate detainees to assassinate officials after their return from Paradise Island. The SSPL could provide them with the necessary means. Both were rejected by Washington. Eventually, at the encouragement of the SOG leadership, MACV proposed in early 1968 that the SSPL make the transition from a notional to a real resistance operation. This too was turned down. According to a Joint Chiefs of Staff review of this request and earlier ones to establish a real resistance movement against North Vietnam, SOG was "told repeatedly that the one development fundamental to a viable SSPL organization—the resistance movement concept—could not be approved at the Washington level."[44]

Members of OP 39 never learned why these and similar proposals were rejected.[45] Declassified documents reveal that Washington had four concerns. First, expanding the SSPL–Paradise Island operation would have violated U.S. overt policy, which proscribed destabilizing or overthrowing of the Hanoi regime. Washington believed that covert action should reflect overt policy. Second, policy makers fretted that such actions might get out of hand, actually causing internal problems for the North Vietnam. It could turn into a situation that Washington was unable to control (as if Washington could control *any*thing Hanoi did). Third, policy makers worried that destabilizing North Vietnam might provoke Hanoi to escalate the war in the South. Finally, if the Hanoi regime started to come apart, the Communist Chinese might get into the act, as they had in the Korean War.[46]

Black Radio Operations

In addition to the Voice of the SSPL, OP 39 ran other black radio operations with distinctive missions. One was to signal to the North Vietnamese population that, in addition to the SSPL, there were other

sources of opposition to the Hanoi regime actively organizing inside the North. A second purpose was to manipulate Radio Hanoi through a deception technique known as snuggling—creating a false radio broadcast that is located right next to the legitimate one on the radio dial.

The head of the United States Information Agency in Vietnam, Barry Zorthian, realizing that coordination was going to be critical, recommended and received approval to establish a joint agency. In May 1965, a Joint U.S. Public Affairs Office (JUSPAO) was established by White House directive to coordinate all U.S. psychological operations in Vietnam, including covert psywar against North Vietnam. The director of JUSPAO was to issue policy direction to all military and civilian agencies involved in white, gray, and black psychological operations and to check on their performance through a quality-control office. Organizationally, one of its five divisions was assigned responsibility for North Vietnamese affairs. It handled propaganda into the North and along the Ho Chi Minh Trail in Laos and Cambodia.

In operations against North Vietnam, JUSPAO had responsibility for operating the Voice of Freedom (VOF). The VOF was a gray radio station, meaning that it "disseminated [information] with a thin veil of cover. . . . Gray propaganda hides its source from the uninitiated public, but not from sophisticated observers." Clandestine radio broadcasting is one of the most common channels for gray propaganda.[47] The VOF broadcast mainly news, cultural programs, and entertainment into North Vietnam. Its major themes included countering Radio Hanoi propaganda; informing North Vietnamese citizens about life in the free world; presenting accurate information about the war; and providing the people of North Vietnam with a basis for comparing their living conditions with those in the South. In 1968, it broadcast a total of seventy-five hours a week in five languages.[48]

A USIA official with foreign service officer rank directed the activities of VOF. He was also assigned to MACVSOG and provided SOG's psywar section with policy guidance for its black radio and other psywar operations. There is little doubt that guidance from Washington was unambiguous: no theme could be broadcast over SOG's black radios that called for the overthrow of the Hanoi regime or the use of armed force against it. Those who ran OP 39's psywar operations followed these constraints to the letter.

SOG's black radio stations included Radio Red Flag, the voice of a fabricated breakaway faction of the North Vietnamese Communist Party. It criticized the Hanoi regime for being highly pro-Chinese and asserted that the People's Republic of China had manipulated North Vietnam into escalating the war, resulting in great suffering and needless loss of life. Red Flag was more favorable to the Soviet Union.[49]

This was a concept that the CIA had used elsewhere. In fact, Phil Adams, who was sent by the CIA to SOG in the summer of 1966 to establish Radio Red Flag, had run a similar operation against Albania in the early 1950s. Reflecting on those days, he recalled, "For our radio station, I hired about five or six Albanians, intellectuals, who had fought against the communists. The gist of our story was that we were dissidents of the Albanian Communist Party somewhere in the mountains of Albania. Not too plausible, but the idea was to reach disaffected communists and convince them that the regime was not carrying out communism the way it should, it was committing atrocities against party members, in other words to try to disaffect Albanian communists."[50] Overall, the Albanian operation, Adams concluded, was a disaster: "It was assumed that the Albanian regime was weak and unstable, which was completely false. We were parachuting teams in and I managed the psywar [efforts]. . . . the teams were rounded up, a lot of people were killed, and I left pretty cynical about the whole operation."[51]

In spite of failures like Albania, CIA officers assigned to SOG felt black radio operations were worth another try. When Adams arrived, Radio Red Flag's station was being built about five miles outside Saigon. "So, the first two months I helped get parts for the engineer. We practically built the station because we had a couple of Filipino engineers that were next to useless. Anyway, we finally got that built by early 1967; then my job was to hire people to man it. I found a couple of Army sergeants who had experience back in the States running a small radio station. So, we got it going, I think mid–1967, and again the story line was that we were dissident communists and a couple of our Vietnam writers had been members of the [North Vietnamese] Communist Party who defected."[52]

CIA ran a similar radio operation of its own against the Viet Cong in the South known as Red Star Radio. "The station purported to be a dissident communist group in South Vietnam that branded the

National Liberation Front [or Viet Cong] as puppets of Hanoi working for the Chinese communists. Its main theme was South Vietnam for the South Vietnamese."[53]

SOG's snuggling operation was also an old CIA ruse. William Colby had employed the technique in the early 1960s in South Vietnam, creating a false VC Radio Liberation whose "broadcast [was] made on a frequency immediately adjacent to a regular broadcast so that listeners inadvertently tune in to the wrong station."[54] Colby's fabrication sounded exactly like the real thing, except for certain false segments that, it was hoped, cast aspersions on the VC in the minds of the listeners.[55] For example, it might report on a battle that made the VC look reckless with the lives of its soldiers.

SOG created a false Radio Hanoi. The idea was exactly the same as Colby's earlier ploy. Weisshart recalled that "the false Hanoi radio and the pre-tuned transistor radios were discussed and being planned at the time I was still at MACVSOG."[56] It mimicked Radio Hanoi in every detail, except for the substitution of key portions of otherwise bona fide programming. One SOG veteran cited two examples of how this worked: "an interview with a Hanoi doctor commending improvements in artificial limbs . . . and proudly announcing that production of these new prostheses will triple by the end of the year"; the description of a "great victory by some NVA unit but in such a way that despite all the glory, medals and party commendations, the listener inescapably concludes, 'What a bloodbath.'"[57] There were numerous permutations of these and other themes.

One final electronic deception technique in OP 39 black radio operations involved what in the intelligence lexicon is called ghosting. It entails "secretly interrupting another broadcast and overlaying one's own broadcast on the 'legitimate' broadcast signal."[58] North Vietnamese radio broadcasts and other official electronic communication channels were interrupted and substitute information inserted. This involved manipulation of Radio Hanoi by interrupting a news report with contradictory information, for example. Likewise, false orders to NVA units in the South were inserted in official electronic channels.

The biggest challenge to OP 39's black radio operations was the fact that much of the target population did not possess a radio. SOG therefore provided them. Through an operation code-named Peanuts,

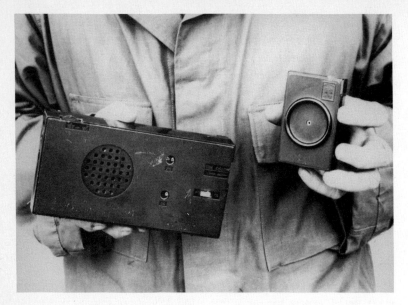

PRETUNED RADIOS

SOG had transistor radios produced in Japan. The photo above is an example of one of these radios.[59]

They were pretuned so that they could receive only SOG radio stations. Many thousands of radios were inserted into North Vietnam through the SOG gift kits floated ashore or air-dropped at night. They were supposed to be from the SSPL. Others were "inserted into known enemy base camps [in Laos and Cambodia] . . . by MACVSOG reconnaissance teams and others. These radios were enclosed in a carrying case with the name of an actual or notional NVA/VC troop written on the case."[60] At its high point in 1968, the Peanuts program inserted over 10,000 radios.

Leaflets and Gift Kits

To enhance Sacred Sword of the Patriots League's credibility, OP 39 employed leaflets and gift kits. Given the fact that SOG had C–130 aircraft, it was easy to insert leaflets by the tens of thousands, and SOG did precisely that. In addition to SSPL leaflets, a number of other nonattributable or falsely attributed leaflets were inserted by air over North

Vietnam. For example, the fabricated breakaway faction of the Vietnamese Communist Party operating Radio Red Flag also spread its message through leaflets. The messages were variations of those broadcast over Voice of Freedom, VOSSPL, and Red Flag.

The different types of leaflets were described by Herb Weisshart as including those that "were promoting straight news ... SSPL leaflet support" and those that targeted specific elements of the North Vietnamese population.[61] An example of a specific group was the Catholic population in the southern panhandle region. According to Weisshart, "We did try to reach Catholics with leaflets and radio broadcasts. We went over Vinh and other places in that part of North Vietnam ... [T]here would be some specific material targeted towards them, of interest to them, possibly affecting them."[62]

Leaflets were also used in Laos in conjunction with SOG operations against the Ho Chi Minh Trail. SOG recon teams would leave them behind or the leaflets could be inserted by air. On page 154 is an example of one aimed at members of the North Vietnamese Army.[63] The part in Vietnamese is from an actual leaflet, the English translation is for SOG records.

Leaflet production was assigned to that section of OP 39 directed by young military officers, who had to rely on their Vietnamese counterparts. The USIA officer assigned to SOG, according to John Hardaway, who had responsibility for leaflet operations in 1964, provided guidance on thematic content. John would produce the leaflets and then have his Vietnamese counterpart check them for content before translating into Vietnamese. He recalled that in 1964 there was great interest in Washington in leaflet operations: "I remember sitting there at night working on briefings for McNamara on how many leaflets we were dropping."[64]

As with the leaflets, the gift kits came from nonattributable or falsely attributed sources. In the case of the latter, it was the SSPL. According to Weisshart, the kits included "writing pads, soap, pencils, a candle, towels, cloth, books, etc. It was a gift of useful items designed to favorably influence the audience of recipients toward the unknown anti-Hanoi donors or to the SSPL. It sought to inspire them to discuss the SSPL with trusted friends and neighbors." Also included were the pretuned radios. The kits never contained food, Weisshart noted, "because Hanoi could poison it and then it could be used against you."[65]

CALLING CARDS

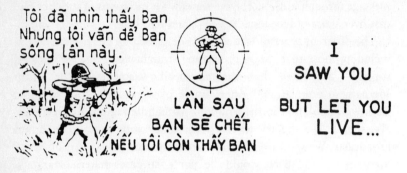

CALLING CARD LEAFLET

As with leaflets, OP 39 inserted large numbers of gift kits into North Vietnam. Success was measured by the number distributed annually into the DRV. In 1967, through air insertion alone, 22,000 gift kits were scattered over North Vietnam at night.[66]

Black Mail and Forged Documents

Forgery played a key role in SOG's work. Forgery involves the production and circulation of authentic-looking but false letters, documents, and other kinds of communiqués. The principal targets of forgeries are generally foreign government officials. However, they may also be aimed at mass audiences. "The forger either attributes statements to people who did not make them or he manufactures false information."[67]

OP 39 forged both letters and documents. The CIA had ample experience in these kinds of operations, and not surprisingly, forged letters and documents found their way into SOG, usually supervised by a CIA officer who was also responsible for liaison with the agency's master forgers.

SOG's black mail operations consisted of many variations and permutations, grouped into two general categories. The first involved "poison pen" letters. During the Vietnam War, the CIA developed

special databases of information on North Vietnam, including a "who's who" of senior and mid-level party, military, and government officials. This included, whenever possible, an individual's official and private mailing addresses. These officials were ideal targets for a poison pen letter sent from Paris, Hong Kong, Tokyo, or Bangkok.[68]

The intent of these letters, like many of SOG's other operations, was to manipulate the security-conscious regime in Hanoi. For example, in a letter to a North Vietnamese official from a Vietnamese living abroad, the author would pretend to be responding to the recipient's concerns, purportedly contained in an earlier letter sent to the author, criticizing the party's conduct of the war. Such criticism was an act of disloyalty in North Vietnam, and the security apparatus would, at minimum, keep an eye on this official.

Below is an example. In it the author, who is writing from the Netherlands, refers to a letter he had received from the targeted North Vietnamese official. He is responding to alleged information from the official about the mistreatment of American POWs and the 1970 Son Tay raid to attempt to rescue a large number of prisoners at a location twenty miles northwest of Hanoi. The forged comments were aimed at raising loyalty questions about the official.[69]

My Dear Mr. Tinh,

Two weeks ago I received your letter . . . [T]he situation of our North has become tenser and tenser especially since the American landing on Son Tay Province last November to liberate captured American pilots. I did not believe in the rumors previously. But my doubts have disappeared after I read your recent letter . . . The Americans and Southern traitors have paid great attention to their soldiers' fate. So when being told about our State's maltreatments toward those captured American pilots, they could not keep quiet. They cried out fiercely to denounce our evil actions and searched for all means to ask our State to exchange war prisoners with them . . . But our State rejected squarely such demands . . .

Not only the US but also many other world countries raised their voices to criticize our maltreatments toward captured American soldiers and considered such cruel actions inhuman. On March 2, 1971, the Dutch Veterans' Association proposed a conference of the

International Red Cross in their country to ask our State to end our cruel actions towards war prisoners. Besides, the local inhabitants usually asked us: "Why didn't your DRVN Government respect the Geneva Convention about war prisoners though having signed in it?" We could not answer them correctly. Please give us your own opinions about this matter in your next reply so that we can solve this difficulty.

Well, as my letter is already long, let me stop temporarily here to wish you and your family a . . . healthy life.

Yours faithfully,
Tran Van Toan

An even more insidious example would link the target to subversive activities. A North Vietnamese counterintelligence specialist reading the fabricated letter would be led to find connections between the recipient and a SOG agent team or the SSPL or other foreign intelligence activities aimed at North Vietnam, either at home or abroad.

The second general category of SOG's black mail operations consisted of propaganda messages to North Vietnamese residents, purportedly from Vietnamese citizens living abroad. These spanned the spectrum from "soft-sell emotional letters from notional sources to average citizens of North Vietnam" to "hard sell letters on political subjects written by notional sources to Democratic Republic of Vietnam cadre and intellectuals in North Vietnam."[70]

There also were false letters from actual North Vietnamese Army prisoners held in the South to their families back home. The letters could have any one of several messages. For example, the POW might criticize Hanoi's willingness to sacrifice its soldiers and note that, while in detention in a POW camp, he was being treated well by the government of South Vietnam. A follow-up letter might tell the family that he had decided to become part of Chieu Hoi, an amnesty program for enemy soldiers. Finally, he might announce that he was joining the South Vietnamese military to become a Kit Carson Scout. In this capacity, he would help American and Army of Vietnam military units through his familiarity with North Vietnamese movements, tactics, and related operational issues. Of course, none of this was true and the POW knew nothing about it.

A variation of the NVA prisoner of war letters was a project code-named Soap Chips. These were purportedly letters from home to NVA soldiers fighting in the South. OP 35 reconnaissance teams would plant them on the bodies of dead NVA they would come across during operations in Laos and Cambodia. The letters portrayed conditions back home as dismal. The idea was that the letters would be read by other soldiers removing the bodies. The letters might also play the Chinese card, charging abuse of Vietnamese women by officers from the People's Republic of China and nothing was being done about it. SOG also sent death notifications to relatives of NVA killed in action in South Vietnam.[71]

According to Bob Andrews, who served in SOG's psywar section in 1968, there were many other variations of the black mail program and several ways of getting the letters into North Vietnam. He explained how Bangkok was used: "There was at that time a number of international mail clearinghouses around the world. One of them was in Bangkok, and we would send batches of these letters to Bangkok, and the Bangkok [CIA] Station had a Thai agent in the mail system and he'd dump them into the mail going into North Vietnam."[72] At its height, over 7,000 black letters were sent in one year through Bangkok and other cities to North Vietnam.[73]

SOG used forged "North Vietnamese documents and materials to imply authorship by either real or notional individuals, groups, or organizations."[74] It is difficult to pin down specific examples because the CIA keeps all such items classified, claiming that to release them would reveal important methods and techniques. Here is what we know. The CIA maintained a large inventory of captured or otherwise-acquired documents. The agency had the technical expertise to replicate these items in every detail. CIA's top secret Far East logistics office in Okinawa, produced forgeries that supported SOG operations. These forged documents "were inserted by MACVSOG operations units, the 25th Division, 173rd Airborne Brigade, [and] 101st Airborne Division [of the U.S. Army], SEAL teams of U.S. Navy Forces Vietnam, and ARVN divisions into . . . Laos, Cambodia, and South Vietnam to be discovered by the enemy."[75]

Other Black Psychological Operations

SOG conducted a number of smaller psywar operations that were generally tactical in nature. Several of them fall into the category of

dirty tricks, and often required the technical wizardry of the U.S. Army Counterinsurgency Support Office (CISO) and the CIA's Far East logistics office. These two organizations provided MACVSOG with unique access to a wide variety of such exotic devices as tainted enemy ammunition, other booby-trapped items, special wiretap devices, and rice contaminants.

The largest of these operations involved doctored enemy ammunition. The idea came from the third chief of SOG, Jack Singlaub, in 1967. He recalled that Eldest Son, as the operation was known, was "sensitive . . . I got Westmoreland's approval and the agency had to give approval because we used their facilities [to develop the product]. SACSA [Special Assistant for Counterinsurgency and Special Activities] arranged to get the doctored ammo through the agency people in Saigon and in Okinawa."[76] The doctored items included AK–47 and 82mm mortar rounds that had been produced in the People's Republic of China and acquired by the CIA in third countries. Agency specialists disassembled the ammunition, booby-trapped it, and reloaded the AK–47 magazine or mortar shell so that it was impossible to know that it had been tampered with. These bullets and shells would explode when used by enemy soldiers, either killing or maiming them. On page 159 is a photograph of an AK–47, destroyed by one of these doctored rounds.[77]

Getting the product into the hands of the NVA became the responsibility of OP 35's recon teams. They carried the doctored AK–47 ammo on missions in Laos and Cambodia and planted it on the bodies of dead NVA soldiers or scattered it about if the recon team came in contact with enemy forces. (The NVA was meticulous about gathering up guns, ammunition, and other military equipment left after firefights.) SOG also built false caches of enemy ammunition in areas known to have real ones.

Intercepted NVA communications revealed that the doctored ammunition was a concern to NVA soldiers. To try to magnify this concern, SOG arranged to have stories broadcast and printed in U.S. armed forces media channels warning American personnel of the dangers of firing enemy weapons. In addition to deceiving the enemy, this was also necessary to protect U.S. forces because there were instances when American personnel were injured.

Bob Andrews related an example involving a U.S. Navy warrant officer who lost his eyesight as a result of firing a captured AK–47. "Well,

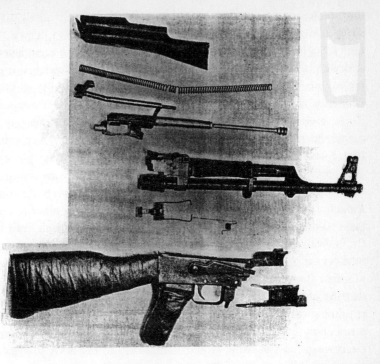

DESTROYED AK-47

in the fall of 1968, we were looking at some way to call more attention of the North Vietnamese to Eldest Son and to convey the idea to them that the failures of the AK–47 ammo were due to the Chinese. We were searching for a way to make this thing big. . . . We found out that a U.S. warrant officer, flight warrant officer, had picked up an AK–47 and unfortunately got hold of one of the clips with the bad rounds, and when he fired it, it went off in his face and he was blinded. I developed the idea that we should reinforce the idea on the [U.S.] Armed Forces Network that there's a MACV regulation that prohibits the firing and keeping of enemy weapons. So, we broadcast the incident, said here's what happened to one of our own guys because he violated this regulation and the reason was, this was faulty ammo."[78]

To manipulate Vietnamese animosity toward the Chinese, Andrews "went up to [MACV's] Combined Material Exploitation Center and worked a deal with the head officer to do a false analysis of the Chinese-produced weapon that the warrant officer used. He reported

that the weapon was faulty and it looks like it was deliberately made so by bad forging, and this entire lot of AK–47s would likewise be faulty. So, he produced this report with a cover marked 'confidential' and we planted it in a bar in Saigon and immediately watched it get picked up."[79] Forged documents were also used to discredit the Chinese and make North Vietnamese soldiers wary of their weapons. These took the form of communiqués from NVA headquarters to commanders in the South acknowledging the problem, explaining that North Vietnam's Chinese comrades were taking steps to solve their production difficulties, and cautioning that it was wrong to think that the People's Republic of China had deliberately doctored the ammunition and weapons. SOG had a number of other booby-trapped items produced that were left on the Ho Chi Minh Trail for the NVA to scarf up. Most of these were military-type items that were in short supply for the NVA. They included radios and their batteries.

Other forged documents also played on the North's long-standing distrust of the Chinese. William Rydell, a CIA officer specializing in psychological warfare who served as director of OP 39 in 1970, recalls how he sought to do so through a Tet holiday greeting card. Every year, Ho Chi Minh would send a card to the NVA soldiers in the South. "Well, he died in the fall of 1969 and he never sent one down for 1970 for obvious reasons. So, we decided to pick out an individual in the leadership of North Vietnam who was the most pro-Chinese and have him send down a Tet greeting card [for 1971]."

He selected Truong Chinh, a senior VCP official who, in fact, did lean strongly in the People's Republic of China direction. Rydell explained that "the Vietnamese I worked with thought this was a tremendous idea . . . [the card] was extremely effective." In fact, Hanoi held a "press conferences in Laos, they had one in Paris, denouncing this secret service operation."[80] SOG distributed more than 22,000 cards in Laos, Cambodia, and South Vietnam.[81] On page 161 is a copy of the actual forgery.[82]

OP 39 also produced posters that recon teams would leave on the Ho Chi Minh Trail. Colonel Dan Schungel, chief of Op 35 in 1969, related: "In a place where we would think that there would be a lot of NVA troops going by on a supply mission or something like that, we would put up some dreadful poster of Ho Chi Minh [with a young boy] with a message under him saying something derogatory about

Ho Chi Minh, and make it an easy reach of the Vietnamese soldier, anticipating that one would come and tear it down. Right below, we would put a little mine about the size of a shoe polish can that would blow off his foot when he stepped on it." There were several variations of this kind of "dirty trick."[83] Another was a poster showing a nude, large-breasted Asian woman. Below the image was a headline asking the question, "Who's sleeping with your wife and has she got jugs like these?" or stating, "If your wife has jugs like these, she is probably sleeping with a Chinese military adviser in North Vietnam." Below the poster waited the mine for the enraged NVA soldier.[84]

Finally, there was a limited counterfeiting project. However, Washington had serious anxiety about going too far with it. According to Bob Andrews, "I know forged currency was discussed, but higher headquarters told us, 'Don't do that.' That was a political no-no."[85]

GREETING CARD

THE PSYWAR PROGRAM —
NOT A MIGHTY WURLITZER OPERATION

The psywar program directed against Hanoi combined several instruments. These techniques and tactics were a sophisticated effort, but

they were only part of the story. The more important issue was whether they served a strategic purpose.

Strategic Uncertainty

Were the psywar tactics sufficient to help realize SOG's strategic goals? What did OP 39 want the North Vietnamese leaders to worry about? How did they hope to deceive Hanoi and to what end? Was the psywar effort realistic, and could it be achieved? The same questions apply to the North Vietnamese population. Did the psywar operations directed against them have a strategic purpose, and if it did, could it have been accomplished within the limitations placed on OP 39?

The strategic objective of the psywar program was to convince Hanoi's leadership that the security of the home front was becoming increasingly suspect and ineffectual. The challenge was to make Hanoi believe that all of SOG's fabricated actions were the work of real opposition elements inside North Vietnam. How long could OP 39 successfully employ such smoke-and-mirrors tactics to deceive North Vietnam? At some point it was going to become evident to Hanoi that it was all a hoax. Then what?

In effect, the completely fabricated nature of the operation turned out to be the major flaw in SOG's psywar program. SOG's senior commanders and others up the chain of command realized this by 1966. Reflecting on the psywar program, Don Blackburn observed that it became more than a nuisance to the North Vietnamese, and beyond that "wasn't accomplishing anything." He contrasted it with the enemy's efforts and noted that the key difference was that "they followed their propaganda up by doing something more."[86] Hanoi was not running a notional operation in the South, but a full-fledged insurgent apparatus. Psywar was an integral element of its strategy.

Blackburn hit on what others who reviewed the psywar program came to realize. Something else was needed if the leadership in Hanoi was to believe that it was facing a serious subversive challenge. Starting in 1967, SACSA and SOG made several proposals after evaluating the psywar effort. Many of these recommendations focused on the key element of OP 39's effort, the Sacred Sword of the Patriots League. To strengthen the SSPL's image and believability, new operations both inside and outside North Vietnam were needed.

These proposals included setting up an SSPL front organization in South Vietnam; issuing international appeals by the SSPL to Hanoi to end the war and bring peace; encouraging SSPL detainees on Paradise Island to defect to the organization and then sending them South to be used for propaganda purposes; and having SSPL representatives attempt to establish a foothold in the United Nations.[87] By taking the SSPL onto the international stage through front organizations, SOG might intensify Hanoi's fear of organized resistance. But none of these initiatives were authorized by Washington.

For action inside North Vietnam, the proposals consisted of adding a number of new twists to the SSPL legend. For example, increase the radio messages to notional SSPL units; expand the programming of the Voice of SSPL; and announce activities such as more central committee meetings, a new program of actions, and an increase in defections to the SSPL. Several of these recommendations were implemented.[88]

While the proposed changes had merit in terms of enhancing the SSPL's legend, if all had been implemented, would they have affected Hanoi's conduct of the war in the South? That, after all, was the objective of OPLAN 34A, of which the psywar program was an integral part. While the covert war conducted by MACVSOG bothered Hanoi—stopping it was one of Hanoi's conditions for opening peace talks—SOG operations never changed North Vietnam's support of the insurgency in South Vietnam.

Something more was needed, and it was no mystery what that entailed. Each of the first three chiefs of MACVSOG—Clyde Russell, Don Blackburn, and Jack Singlaub—had proposed it. SOG had to foster the development of a real resistance movement inside North Vietnam. Notional resistance and fabricated agent operations might worry Hanoi, but that was all. This was the conclusion of the "Evaluation of SOG" report completed in February 1968 by MACV's Ad Hoc Evaluation Group, chaired by Brigadier General A. R. Brownfield, Jr., who earlier had served as the deputy SACSA. He criticized the psywar program as "not clear and too broad." Its mission had to change if it was to support the objectives of OPLAN 34A.[89] The problem was that the policy makers in Washington were not about to allow SOG to attempt either to establish a real resistance movement or to encourage the population in North Vietnam to take action.

The Hungarian Legacy

When Colby had refocused the CIA's efforts against North Vietnam in 1963 to emphasize psywar, the agency's officers in Saigon found themselves drawing the same fine lines and distinctions that had been drawn in Eastern Europe following the Hungarian rebellion of 1956. Psywar's purpose, as Washington viewed it, was to provide information but not to encourage rebellion. MACVSOG's psywar venture against the North Vietnamese population was never freed of this restriction. Reflecting on his year as chief of OP 39 in 1966, Al Mathwin noted that "instigating the population to violence was not an objective. We were not supposed to do that," he explained, "because we would not provide support to those who might have rebelled."[90]

The impact that the "lessons of Hungary" had on shaping MACVSOG's psywar undertaking was profound. There is no question that the outcome of the Hungarian revolution had a traumatizing effect on the U.S. national security bureaucracy in general, and the CIA in particular. In 1956, the United States had the opportunity to support an attempt to overthrow a communist regime. Secretary of State John Foster Dulles had been promoting the concept of "roll back" or overthrow of communist regimes, which implied that the U.S. might support such activities. In fact, roll back and the need to liberate Eastern Europe had been a theme articulated by Dwight Eisenhower during his 1952 presidential campaign. However, when the Hungarian people revolted, President Eisenhower and his administration blinked. No help was to be given to the Hungarian people, even though it appears that CIA-directed Radio Free Europe (RFE) broadcasts had come very close to encouraging the uprising. As the Hungarian revolt intensified, RFE even retransmitted local broadcasts from inside Hungary that included appeals for help and rumors that U.S. intervention was on the way. These rebroadcasts may have sustained the hopes of those in the streets in Hungary that the United States would save them. But the Eisenhower administration was not about to act.[91]

The CIA drew an important lesson from Hungary. Bill Rydell, who as an agency operator had run psywar and agent operations against denied areas since the 1950s, explained it this way: "You didn't have

to have too much common sense to figure out that after 1956 we're not going to do things like this again because it risked an atomic war." He noted that "prior to 1956 our policy was liberation." However, "provok[ing] people into rising up in denied areas was rejected after Hungary. . . . We were not going to go in and help or promote such actions. . . . I know that after 1956 we were very, very careful about such operations. . . . We were not going to run operations to instigate uprisings."[92] At the CIA, Rydell pointed out, "you could see the evolution and the change in what our denied area operations were tasked to do. How they were pushing one thing before 1956 and how after 1956 they started drawing back."[93]

The "lessons of Hungary" became a CIA mantra. Consequently, any notion of attempting to instigate an uprising was proscribed from the outset. While President Kennedy, in 1961, may have wanted to do to North Vietnam what they were doing to us in the South, by the time MACVSOG was established in 1964, that policy objective was fading fast. In the special warfare arena, the United States would support and assist governments threatened by revolutionary insurgency, but would not promote armed anticommunist resistance efforts.

The strategic implications of the lessons of Hungary for OP 39 are clear. Its psywar operations against the population of North Vietnam lacked any strategic purpose. In fact, the kinds of fine distinctions that SOG was trying to draw about what it wanted the North Vietnamese population to do and not do probably existed only in the mind of SOG officials. Certainly, the operations made little strategic sense. The inescapable conclusion was that the entire psywar effort against North Vietnam was muddled.

Many who ran the operations share this view. Perhaps Bob Andrews best sums up the impact of the constraints on psywar targeting and operations: "We had to go all the way back to SACSA for anything major, and then they had to staff it through the Pentagon, and God knows what they had to do at the executive level. Pretty soon what it did to you over there was it made you say to yourself, 'Think small, don't think big; because if you think big, you'll never get it done.' So you always tried to get it underneath the bar that required it to go to SACSA, which meant that you were always going for the mediocre, the petty, and the picayune." He asserted that "The one threat the North Vietnamese could not countenance would [have

been] the loss of control. . . . [M]any of the things we did could have been effective if done properly."[94] Maybe this was true and maybe it was not. But constraints placed on OP 39's operations prevented the proposition from being tested.

With the creation of the Diversionary Program (Forae) in late 1967, OP 39 had the opportunity to turn this lack of strategic purpose around when it was tasked to support OP 34's attempt to run the triple cross against Hanoi. Its assistance took several forms. First, the Sacred Sword of the Patriots League operation was refocused and integrated into Forae. This included changes in the indoctrination of North Vietnamese detainees at Paradise Island. These two operations were to be directly linked to and support the Diversionary Program. OP 39 also developed special categories of fraudulent letters to support Forae. This involved linking the information in the letters to false information about agents and espionage fed to the North Vietnamese personnel being manipulated by the Borden and Urgency projects of the Diversionary Program.

These steps were only the beginning. Much more could have been developed to integrate psywar operations into Forae. Many new concepts were "in the works" when MACVSOG received the message from Washington in November 1968 telling it to stop all operations that involved crossing the border with North Vietnam. For the Diversionary Program, this amounted to an almost total shutdown, just as it was getting off the ground. With the shutdown, OP 39 lost any possibility of establishing a strategic purpose for its psywar program.

Other Flaws in the Psywar Program

While a lack of strategic purpose was the primary defect in SOG's psywar program and the reason these operations were never able to affect Hanoi in the way intended in OPLAN 34, there were other shortcomings as well. Three stand out and likewise contributed, in an ancillary way, to OP 39's limited accomplishments.

First, compartmentalization of the different operational components of OP 39 resulted in a lack of coordinated planning and integration. According to Phil Adams, who was assigned by the CIA to it in 1966, "I don't remember any master plan. I don't remember anyone

having a concrete idea of just exactly what we were supposed to do and how we would go about it. Everything was sort of hazy."[95] Not one former military officer or CIA operator assigned to SOG's psywar venture could recall seeing or taking part in the development of an integrated psywar operational plan. This was the price of overcompartmentalization.

Second, the personnel issues that plagued MACVSOG throughout its existence also affected its psywar section. Expertise in black psychological operations was hard to come by, as Clyde Russell had found out in 1964 when he began building SOG. Personnel problems did not get better in the ensuing years. The psywar section, according to Phil Adams, suffered from a dearth of expertise during his time in the organization. He noted that "as for the Army personnel, none of them had any qualifications. . . . I don't remember anyone from the Army having a background in black psychological operations, having training and so on."[96] He adds, "I don't believe there were any Americans there who were trained in Vietnamese culture. All the Army guys were artillery and infantry." What about the agency officers assigned to SOG? "The CIA people were not much better," he observed.[97] The same pattern continued after Adams departed SOG in late 1967.

Finally, there was the matter of estimating the impact of psywar operations on the North Vietnamese target. One of the branches of OP 39 was Research and Analysis. It would seem reasonable to expect that its functions included the collection, collation, and interpretation of information from North Vietnam sources for two purposes: to provide insight into the psychological vulnerabilities of North Vietnam for target development, and to use the same sources to determine what impact the psywar program was having.

This second objective was never pursued by OP 39's Research and Analysis branch. John Harrell, the first chief of the branch in 1964, noted that there was "no attempt to develop an assessment mechanism. I didn't have the assets to do that."[98] Richard Holzheimer, who replaced Harrell in 1965, told the same story. He did not "remember getting any tasking on anything like that. . . . No, we did not do that." Asked whether there was an annual psywar assessment, he answered, "Not that I recall."[99] By the late 1960s, OP 39 was measuring effectiveness, according to Derek Theissen, who was an officer serving in the branch at that time. However, "effectiveness was mea-

sured principally in terms of items delivered and not in terms of North Vietnam reactions. During 1969–70 we were fully engaged in the bean-count syndrome as opposed to detailed analysis of impact."[100]

It seems inconceivable that a systematic attempt to evaluate the impact and effectiveness of the psywar campaign was not made. When asked why not, CIA officer Bill Rydell, the director of OP 39 in 1970–1971, explained: "It is difficult enough to do this in an open society. [I]t's virtually impossible in a police state behind the Iron Curtain. The enemy rarely, if ever, gives you any indication of your effectiveness. You scour the newspapers for the slightest little hint, scouring letters, anything to give you a clue. You can't conduct anything as systematic as a poll, that's one of the problems. And they very rarely, if ever, protest in public. No, because that's the best sign."[101] It was the stock answer that was always given about the difficulty of evaluating psychological operations aimed at denied areas. However, Hanoi was hardly mute about SOG's psywar efforts— just the opposite.

COLBY MAY HAVE BEEN RIGHT

As with its agent operations, MACVSOG's psywar program received a great deal of attention in Hanoi. Recall that the counterintelligence review of OP 34 in early 1968 revealed that North Vietnam claimed to have identified a much larger number of spy commando teams than SOG had inserted. This overestimation and the internal security alarms it set off about phantom agent teams and related espionage activities not only appeared in the NVN press and public radio broadcasts, but also was showing up in internal party documents, directives, and special decrees. It likewise was taking the form of a mounting organizational effort to guard against and track down real and imagined enemy agents and spies. Police and counterintelligence operations, including arrest, investigation, penetration, provocation, entrapment, and denunciation, were all on the rise. Finally, new and harsher penalties—including execution—were enacted for involvement in espionage and counterrevolutionary activities.

The same pattern of overestimation and alarm can be seen in the way Hanoi reacted to MACVSOG's psywar program. This actually

started as early as 1965, and was the subject of concern and warning in North Vietnamese press accounts and radio broadcasts. For example, the leading daily newspaper, *Nhan Dan*, the official organ of the VCP, warned that to destroy North Vietnam's "will to resist," the United States employed "psychological warfare, political warfare, or the fourth kind of warfare (after military, economic, and diplomatic warfare) . . . as a national policy."[102] Frequently, *Nhan Dan* and other official organs in North Vietnam repeated this warning, telling the population that "the U.S. imperialists are now doing their best to carry out their espionage warfare and psychological warfare aimed at destroying our rear [area]." They asserted that the United States was seeking to create violent rioting and rebellion inside North Vietnam as part of its war aims.[103] In other words, the same kind of subversion Hanoi was fostering in the South.

In retrospect, Hanoi had it only half-right. To be sure, SOG's psywar and other covert operations were aimed at North Vietnam's rear area, or home front, one of its centers of gravity. Hanoi expressed serious concern over the security of the home front because internal stability was essential if it was going to be able to take on a superpower in South Vietnam. However, what the leadership in Hanoi could not know was that there were restraints on SOG's psywar campaign, particularly when it came to encouraging violence and insurrection. Probably the North Vietnamese assumed that promoting disorder and revolt would be the obvious objectives of such activity. After all, why else would you do it?

Hanoi's official press publications and radio broadcasts were quite specific in detailing the various techniques and tactics employed by OP 39. The reason for this was straightforward. They believed it was essential to expose and discredit these actions, lest the population start believing they were real. Worse, the people might develop a sympathetic attitude toward the SSPL, maybe even want to join this fabricated organization. Things could get out of hand.

As time passed, these public exposés became increasingly precise. For example, the VCP's monthly theoretical magazine, *Hoc Tap*, sought in a June 1967 article to unmask the Sacred Sword of the Patriots League as a fabrication. It explained that through the SSPL radio broadcasts and other activities, the United States sought to convince the North Vietnamese population that "This movement, which

exists only in their imagination, has succeeded in organizing bases against the people's government in a number of provinces and cities of North Vietnam."[104] Hanoi also commented on the capture and indoctrination of fishermen, which supported SOG's SSPL operation. The United States was "seizing fisherman and people who go out to sea in order to interrogate them and to entice or force them to join the organization of the Sacred Sword of the Patriots League and they select some people and give them the task of going back to North Vietnam and secretly working to create agents for them."[105] This entire notion of an internal resistance movement in North Vietnam was anathema to the leadership and had to be discredited. Hanoi devoted the time and effort to do so.

In addition to the SSPL/indoctrination program, Hanoi sought to expose other SOG psywar operations. This included the various black radio stations, including Radio Red Flag. Hanoi explained that "the Red Flag station" seeks to "make its listeners believe it is revolutionary, this station has dealt with aggressive U.S. imperialism, U.S. imperialist frenzied aggression, and so forth." However, this was just a subterfuge, Hanoi protested, masking its real intention, which was "aimed at sowing disunity in our party's internal organization and separating our country from the socialist states. It has distorted the patriotic movement in the North, invented losses of the southern liberation forces, and criticized the extermination of tyrants."[106] Similar articles tried to discredit OP 39's leaflet, gift kit, and black mail operations, all described in detail to expose their real source and purpose.

However, exposing these operations was not enough. There likewise was significant attention paid to explaining to the cadres and population how to neutralize psywar and other covert operations carried out by MACVSOG. This took various forms, including numerous "stories of vigilance," in which local citizens or officials captured an agent or unmasked other SOG operations. Hanoi's official communications contained many examples of such actions. For example, an article in *Quan Doi Nhan Dan,* the North Vietnamese Army daily, reported how the local "Quang Binh border-security fighters eradicated a whole commando team on Don Pu Mountain."[107] Likewise, *Nhan Dan,* the daily newspaper of the North Vietnamese Communist Party, carried a story of how good local security work led a "fisherman from . . . Ha Tinh Province [to] confess to the local people's gov-

ernment that he was a spy for the U.S." He had been captured by "an enemy commando boat and enticed to act as their lackey."[108]

The VCP also developed "Guidelines and Measures" to instruct local cadre and officials on how to most effectively neutralize these operations. According to a June 1967 article, "In order to effectively counter the enemy's psychological warfare we must carry out regular basic propagandizing and educating of cadre, party members, and the masses about the situation and task . . . using many different methods."[109] This was translated into extensive training and educational efforts at the local level.

An assessment of the extent to which Hanoi's official newspaper and broadcasting organs contained articles and stories similar to those just mentioned revealed growing concern and alarm between 1965 and 1967. Furthermore, given the ways in which these matters were approached in the North, which included a major emphasis on practical guidelines and measures to counter covert operations, it seems reasonable to conclude that SOG's psywar operations were having an effect: in all probability, a disproportionate effect influenced as much by Hanoi's counterintelligence-state mentality as by what SOG was actually accomplishing. But then, it does take two—a deceiver and a deceived—for a deception operation to work. Evidently, MACVSOG's psywar program had the attention of the leadership in Hanoi.

In 1968, Hanoi's anxiety about these operations mushroomed. The United States was said to be intensifying its espionage and psychological warfare activities against North Vietnam to "agitate the counterrevolutionary clique in the North to rebel against our regime. They are trying to create disorder in our rear sections."[110] Examples of this burgeoning apprehension over the intensification of U.S. covert action directed against North Vietnam can be found in many of Hanoi's official organs. This was not just due to its counterintelligence anxiety but reflected reality. What Hanoi was reacting to, in part, was MACVSOG's Diversionary Program, which included the integrated psywar activities of OP 39.

However, there was more to North Vietnam's reaction than just an increase in public exposés or restatement of guidelines and measures to effectively neutralize these operations. Hanoi also enacted new and much harsher punishments for anyone found to be involved in these

counterrevolutionary activities. Fifteen specific offenses were identi-
fied, and each carried a punishment of a long prison sentence, or life
imprisonment, or execution.[111] The specifics of these new measures
received wide coverage throughout North Vietnam. They suggest that
Hanoi took the operational elements of the Diversionary Program
seriously and wanted to convey that message to its population. These
harsher penalties were essential, reported *Nhan Dan,* to "serve as the
basis for an effort to combat the activities of spies and other counter-
revolutionaries."[112]

What does this say about SOG's psywar campaign? The short
answer is that when integrated with the Diversionary Program it
reveals that William Colby seems to have been right. Recall how he
put it: psywar could "have an impact because the communists are so
hyper about the danger of resistance that if you suggest that there was
any opposition group within their ranks, it would drive them crazy."
Consequently, even in spite of all of the constraints, lack of strategic
purpose, and other problems that plagued OP 39, between 1965 and
1967, its operations were apparently having Colby's desired effect.
This was not realized within the organization because a systematic
means of evaluating the impact and effectiveness of the psywar cam-
paign had never been developed. That was beyond the scope and
capability of OP 39's Research and Analysis branch.

During 1968, Hanoi's reaction to OP 39's operations up North
became increasingly apparent to SOG, even though it was still not
measured in a systematic manner. Recall that this deception operation
sought to convince Hanoi that it had uncovered only the tip of the
iceberg and that, in fact, plotting and conspiracy really did "run very
deep," as Hanoi itself claimed. Hanoi was becoming increasingly sen-
sitive to the threat of subversion. Spy mania and fear of psywar
seemed to be gripping it, even though OP 39 still could not encourage
the North Vietnamese population to take up arms.

But then came the order to shut it down in November 1968, due to
the Johnson administration's decision to accept Hanoi's requirements
for beginning the peace negotiations. For OP 39, this meant ending
the Paradise Island program and other operations it had initiated to
make the legend of the SSPL believable. All of its active psywar
actions had to be stopped, along with most of OP 34's Diversionary
Program. Quite literally, one day early in November 1968, Major Bob

Andrews and the other military and civilian operators in OP 39 were told to stop. Andrews recalled it this way: "We stopped everything going North. Immediately stopped. Whatever little plausible denial we had went out the window. It just came down from headquarters to stop, that's it. We still kept getting together trying to gin up some operations. No, no, we were told."[113]

All that was left was OP 39's more passive and relatively ineffectual operations, including the radios and black mail activities. With the shutdown of the Diversionary Program, OP 39, like OP 34, was for all intents and purposes out of business.

5

FROM THE SEA

The idea that the CIA could run covert maritime operations, or marops, against North Vietnamese coastal targets was preposterous to the commander in chief of the Pacific Command, Admiral Harry Felt. He wondered what in the world the CIA knew about operating at sea, even in small boats on covert missions. In the early months of 1961, the agency had begun launching such actions up North. Having reviewed the results in the fall of 1962, Admiral Felt was underwhelmed by what had been accomplished. He believed the CIA was out of its league, and the after-action reports infuriated him. Felt's critique was blunt: the CIA program should have been under a full head of steam a long time ago.[1]

The admiral had a point. There was no evidence that the CIA's marops had much of an impact on Hanoi. The craft employed had a difficult time even getting there and were insufficiently armed to do much damage, even if they made it into North Vietnamese waters. But then, Bill Colby, the architect of the CIA's program, had never expected to accomplish much to begin with. He was only following Washington's demands.

Although he damned the agency's efforts, Felt insisted that North Vietnam was vulnerable to covert maritime operations. It had no coastal defenses to speak of and a navy that was of little consequence.

This made power plants, bridges, rail lines, and other targets near the shore highly vulnerable, he kept telling Washington. They would be easy pickings for effectively planned and executed covert marops.[2] Hit enough of them, he reasoned, and Hanoi would buckle and stop fomenting insurrection in South Vietnam. In July 1962, Chief of Naval Operations Admiral George Anderson chimed in. He also called for a secret maritime "campaign of harassment" against North Vietnam to dissuade it from backing the VC.[3]

ORIGINS OF COVERT NAVAL OPERATIONS

The Navy's senior leaders felt the agency had no business attempting such operations, at least not without the supervision of the U.S. Navy. In fact, the idea that the spooks could do anything more than sneak into North Vietnamese waters to insert an agent seemed farfetched to the Navy brass. Nevertheless, the Saigon Station found itself tasked with doing more than that from the sea.

The architect of the CIA's covert marops was Tucker Gougelmann. A tough former Marine, he had a distinguished combat record in the Pacific, where he had been severely wounded. As a CIA officer, Gougelmann ran denied-area operations against Eastern European regimes in the 1950s and served in Korea. In 1960, the agency sent him to Vietnam.

Gougelmann set up a base in Da Nang in 1961 and began sending boats up north. Marops were one element of the CIA's program of action against Hanoi. Other components included agent insertions and psychological warfare. In the summer of 1961, the agency added cross-border operations into southern Laos to learn about the Ho Chi Minh Trail, but only a handful of missions were launched. Using only Vietnamese personnel, with no airlift available for insertion, these teams did not penetrate very far into Laos.

The maritime operations Gougelmann initiated were equally small-scale. Their "primary objectives" were "collection of intelligence and reconnaissance on the NVN coastal area." Gougelmann inserted one of the first spies sent into North Vietnam, the singleton agent Ares, in February 1961. Others followed. According to declassified JCS documents, these initial operations "were essentially passive . . . avoiding combat as practicable."[4] In 1962, Gougelmann was instructed by

Washington to start "harassment and short-term sabotage raids . . . as a limited response to the escalation of North-South hostilities and as preparation for the future establishment of resistance activity within North Vietnam."[5] President Kennedy was cajoling the agency to increase the intensity of covert operations up North.

Gougelmann's naval assets consisted almost exclusively of South Vietnamese motorized junks, a major reason Admiral Felt found the results of the CIA's efforts so wanting. Motorized junks were hardly built for harassment and sabotage operations, where speed and stealth were prerequisites.

When Washington decided to escalate covert marops to the level of harassment and sabotage, it assigned U.S. naval support and equipment to improve the CIA's capacity to carry out these missions. In August 1962, the MACV commander, General Harkins, "proposed the use of U.S. motor torpedo boats, supported by a naval logistic unit based in Da Nang, for the runs to the North." The Kennedy administration agreed to the request at the end of September.[6]

The Navy identified craft in its inventory that it believed suitable. In October, Deputy Secretary of Defense Roswell Gilpatric directed Chief of Naval Operations Admiral Anderson to reactivate two mothballed, aluminum-hulled motor torpedo boats built in 1950 for CIA marops, PT–810 and PT–811. Armed with two 40mm and two 20mm guns, they were redesignated PTF (Patrol Type, Fast) –1 and PTF–2. Their sea trials were fraught with malfunctions. A Navy captain who briefed Secretary of Defense McNamara on the technical difficulties these boats encountered during MACVSOG maritime operations noted that they had never advanced beyond the experimental stage. They had always been real dogs, and that is why both were mothballed.[7]

Notwithstanding their problems, McNamara was enthusiastic about their reactivation, believing it to be "a step in the right direction."[8] However, more was needed if Hanoi was to get the message that a real price had to be paid for fomenting insurrection in the South. To this end, he requested that "priority attention also be given to the procurement of foreign-made craft" and directed the secretary of the navy to "take immediate action to procure two boats of the Norwegian Navy's Nasty class,"[9] noted for their speed and stealth. The purchase was completed in early 1963, with the two mahogany-

hulled boats designated PTF–3 and PTF–4. They were put into service at the Navy's Little Creek facility in Virginia.

Even though the two Nasties were for a highly classified covert operation, the Navy decided to publicize the purchase of its new PTF boats. Admiral Anderson had one of the Nasties dispatched to Washington "to perform amphibious support and coastal operations" used "by the Navy's [new] Sea-Air-Land (SEAL) Teams in unconventional and paramilitary operations."[10] On May 15, the Washington press corps was assembled on the banks of the Potomac, as guests of Secretary of the Navy John Connally, for a demonstration—an unusual way to prepare for a highly sensitive covert operation.

After a stopover in San Diego, the Nasties were transported to Hawaii and readied for duty in Southeast Asia. While there, the "Chief of Naval Operations allowed the Office of Information to provide press and film coverage" of the new addition to the Pacific Fleet. However, at the same time the Navy began to grow concerned over the wisdom of publicizing boats that were purchased to conduct covert operations. A cover story was created in which the Navy claimed that the mission of the Nasties was to counter the Soviet motor torpedo boat, the Swatow. It was a transparent disguise. In Southeast Asia, where the Nasties were to be assigned, only the North Vietnamese had Swatows. Finally, Anderson directed that the Nasties "be given a minimum of publicity."[11] In retrospect, the entire public relations exercise was ill-conceived; it revealed serious flaws in the Navy's understanding of covert operations. It was an inauspicious entry into the world of covert action for the U.S. Navy.

The CIA received the Nasties in the latter months of 1963. To navigate the boats in North Vietnamese waters, the agency recruited Norwegian and German mercenaries. To assist the CIA in training South Vietnamese commandos for the sabotage missions, the Navy detailed members of its newly created SEAL detachments to the agency. It also provided a logistics unit to maintain the boats.

As this was taking place, Kennedy ordered the execution of Operation Switchback, which took covert operations against North Vietnam away from the CIA and assigned them to the Pentagon. It included Tucker Gougelmann's covert maritime operations, such as they were. In the early days of MACVSOG, McNamara believed that covert marops could be highly effective. You did not have to wait for

agent teams to set up networks or for psywar efforts to influence enemy perceptions. Marops could have an immediate impact, he reasoned.

The transfer took longer than anticipated. Chairman of the Joint Chiefs Maxwell Taylor dragged his feet on the matter and waited nearly five months before he assigned responsibility for developing the operational plan to Pacific Command in May 1963. Admiral Felt had his staff get to work producing Operational Plan (OPLAN) 34A. Pacific Command's draft was sent to General Taylor on June 17, 1963. Taylor did not approve the draft until September 9, but waited another two months before sending it to Secretary of Defense McNamara. OPLAN 34A was finally put on the agenda of a "Special Meeting on Vietnam" that McNamara convened on November 20, 1963 in Honolulu.

At the conference, McNamara was highly critical of the CIA's covert efforts against Hanoi and asserted that it was time for a change. It was now the military's turn. He was confident that it could attain better results. Admiral Felt had been saying this for over a year. What was needed was a much larger effort. McNamara saw covert marops as a way to get at Hanoi, to hurt it, to make it realize that the United States meant business. It would send the message the North Vietnamese leadership needed to hear.

In his Vietnam memoir, McNamara recounted the events that eventually resulted in President Johnson's adoption of OPLAN 34A following the Honolulu meeting. Two weeks after the conference, he met with President Johnson to go over Vietnam policy. According to McNamara, LBJ "was convinced the U.S. government was not doing all that it should." During the meeting, "he specifically asked whether planning for covert operations should be expanded." According to McNamara's recollection, "President Johnson wanted the covert program strengthened,"[12] and he concurred. Of the initial covert missions authorized for execution, maritime operations in particular, it came to be argued, could provide the greatest immediate impact on the leadership in Hanoi while posing the least risk to Washington.

To achieve 34A's objective—to convince Hanoi's leadership that it was in its own best interest to cease its aggressive policies in the South—would take time. But the policy makers were in a hurry. By escalating harassment and destruction of facilities, they expected

covert paramilitary operations to weaken North Vietnam's will imme-
diately. The thirty-odd targets selected for the first phase of 34A oper-
ations were chosen, in part, because of the instant results criterion.
Consequently, covert maritime operations moved to the forefront of
those options. Marops could have the real-time effects Washington
wanted to have on Ho Chi Minh and his comrades. At least that was
the perception.

Urgent attention was given to the maritime component of OPLAN
34A. On December 20, McNamara visited Saigon to see how things
were progressing. He wanted preparation for covert operations accel-
erated. Things were not moving fast enough. Hanoi needed to get the
message, and marops was to be the messenger. According to one
account of McNamara's visit, he "showed great interest in developing
. . . several actions [under consideration]."[13] At the top of his list was
marops. This was typical McNamara, always in a hurry. Things had
to get done quickly and results had to be produced.

When McNamara learned that only a few Nasties and Swift boats
were available for these missions, he ordered the Navy to buy four
additional Nasties.[14] With a cruising range of 860 miles at 38 knots,
the Nasties, it was asserted, "would greatly improve the capability to
conduct covert marops." Given the publicity that the Navy had
already generated over the acquisition of the Nasties, it was decided
to create a cover story for their appearance in Vietnam. They "were
being turned over to the RVN [Republic of Vietnam] for unilateral
actions in defense of their coastal waters against infiltration of hostile
forces from NVN."[15]

In sum, the senior policy makers in Washington saw the marops
component of MACVSOG as the quintessential instrument for imme-
diately getting Hanoi's attention and bending its will. In early 1964,
SOG's Naval Advisory Detachment (NAD), the cover name for OP
37, was established in Da Nang. No sooner did this take place then
Washington began clamoring for results.

THE NAVAL ADVISORY DETACHMENT

Those assigned responsibility for establishing the NAD immediately
encountered several of the same obstacles that affected other opera-
tional divisions of SOG: identifying and selecting appropriate person-

nel; formulating a maritime operational concept and rules of engagement (ROE); devising an organizational structure for OP 37; establishing liaison arrangements with its South Vietnamese counterpart; and setting up command-and-control procedures. Each of these challenges proved difficult to resolve under the pressure of policy makers who wanted instant results.

Selecting Personnel

The NAD officially began work in January 1964. Located in Da Nang, it was assigned responsibility for a wide range of covert maritime operations. A year later, a small liaison cell for marops—the Maritime Operations Section (OP 31)—was set up at SOG headquarters in Saigon. It functioned as a staff element; the NAD was the action arm.

The immediate problem facing SOG's leadership was to locate experienced personnel in the Navy and Marine Corps to staff OP 37. This was hard because each of these services, and particularly the Navy, considered covert operations of little importance and outside their operational responsibilities. It simply was not one of their missions. Thus, when SOG went to the Navy with personnel requests for OP 37, the outcome was predictable.

The difficulty of selecting the first chief for the NAD illustrates the problem. He was to hold the rank of Navy commander. Finding an officer of that rank was the easy part. The Navy had plenty of commanders. However, in 1964, almost none of them had operational experience in unconventional warfare. As a result, of the first four chiefs of the NAD, only one had anything in his record approximating that background. Officers were not promoted to higher ranks of the Navy by running covert operations; advancement came from going to sea in big ships. Thus, when Commander Jack Owens arrived to take charge of the embryonic Naval Advisory Detachment, he found himself in command of an organization he knew nothing about. He had just left an assignment on a destroyer. Owens's entire career had been spent in the mainstream Navy.

Owens served one year and was replaced by Commander Bob Fay. His professional background was much more in line with the mission of the NAD. Fay was "an experienced frogman who had entered the

Navy during World War II. He began his career as a frogman in 1951 and had served with a number of [special] units including UDT [Underwater Demolition Team] 2."[16] Commander Fay's underwater demolition experience was an important factor in selecting him. Unfortunately, he became the first member of the Navy's special warfare community to be killed in Vietnam. On October 28, 1965, his jeep was hit by a Viet Cong mortar shell six months after he took command of the NAD.[17]

Fay was replaced by his deputy, Commander William Hawkins. According to the NAD's operations officer at the time, Hawkins was "a reservist, and I don't know how they got Bill because he was strictly surface, black-shoe navy, had no background in this sort of thing at all, and as a matter of fact, pretty much stayed out of the operational side of the house."[18] Next came Commander Willard Olson, who, like Hawkins, had no preparation in special warfare. His deputy was Commander Robert Terry, who like Fay had extensive underwater demolition experience. After Olson's tour was over, Terry moved up to become chief, but only on a temporary basis. He was replaced by Commander Norman Olson.

Norm Olson was the kind of chief OP 37 needed, but this was three years after NAD was activated. He had extensive underwater demolition operational and command experience and had served as a staff officer for a naval operations support group concerned with special warfare. As the group's operations officer in 1966, Olson had kept tabs on the NAD. Olson recalls that "during that period [we were] very frustrated in what was going on up at Da Nang. . . . [T]he bottom line was SOG chief Singlaub wanted somebody to go in there and clean the place up. . . . I was nominated."[19]

Olson was referring to Singlaub's displeasure with a lack of discipline among the NAD personnel, many of whom were not following military procedures. It looked bad and was just how the brass expected special operators to behave. Singlaub wanted it stopped, and Olson did just that. He was a professional officer who understood the need for military discipline in NAD-type organizations. He was the "real deal," just the kind of chief OP 37 needed.

One might think that having found the right kind of NAD chief, the Navy personnel system would have nominated a replacement for Olson with the same credentials. The opposite happened. His replacement,

Commander Andrew Merget, had no knowledge of special operations. He noted that his professional "expertise was strictly in fleet/surface operations, specifically destroyer operations. So I had no connection with covert operations."[20] Following Merget was Commander Charles Edson, who likewise came out of the mainstream Navy.

The deputy chief for operations of the NAD was always a Marine Corps major or lieutenant colonel. None of the Marines assigned to this position had any experience in covert paramilitary operations. It was not a mission for the corps. However, most did have what was considered related experience. A case in point was Lieutenant Colonel Mick Trainor. In later years he would rise to the rank of lieutenant general and after retirement become a military correspondent for the *New York Times* and faculty member at Harvard's Kennedy School of Government. Trainor would point out that he "had been a recon company commander in the late 1950s–early 1960s, so that gave me some entree [to SOG], plus the fact that I had done an exchange tour with the British commandoes. I guess those two put together qualified me for special operations. . . . [But] I had never done any covert work."[21]

Those who followed Trainor, such as Marine Lieutenant Colonel Wesley Rice in 1966, had similar backgrounds. Rice "had been in reconnaissance, I had a tour with the Royal Marine Commandos. I had just come from commanding . . . the Second Force Reconnaissance Company. I was parachute qualified, scuba qualified, Ranger qualified, pathfinder qualified, I'd been to underwater demolition school, you name it. I'd been to them all. It appeared that this billet had some prerequisites [such as] . . . reconnaissance or special operations experience. We didn't call it special operations in those days."[22]

Given the fact that the chief of the NAD was generally mainstream Navy, it was critical that at least the officer in charge of its operations have a background in Marine reconnaissance and commando operations. These had some relationship to the operations SOG ran against North Vietnamese coastal targets. Trainor and Rice trained, advised, and supported the South Vietnamese commandos who carried out these missions. To conduct the training, they had command of a SEAL team detachment and Marine Corps reconnaissance personnel. If given the right South Vietnamese personnel, Trainor and Rice could get them ready for commando operations.

Also assigned to OP 37 were Navy personnel to train the South Vietnamese boat crews and maintain the craft. Navy PTF crews instructed their counterparts "in tactics, gunnery, navigation, and detailed operation of PTFs."[23] A Navy team provided training to repair and service the three Swift and seven Nasty boats.

In sum, identification and selection of personnel for the Naval Advisory Detachment was a mixed bag. However, a much bigger personnel problem appeared in 1964 that would plague the NAD throughout its existence: the South Vietnamese who were selected to carry out covert maritime operations against North Vietnam lacked motivation and discipline. As we shall see, this had a major impact on operational effectiveness.

Marops Missions and Rules of Engagement

The NAD was assigned an ambitious agenda of activities against North Vietnamese coastal targets. Its "area of operation extended from the 17°N to 21°N latitude, and from the NVN coast line to approximately 30 miles off the coast."[24] This was south of North Vietnam's main port facilities in the Haiphong region,[25] as can be seen on the following map. Given the types of boats used, it often involved a demanding voyage.

Six specific missions were assigned: "interdiction and harassment" to include "interception, capture, interrogation and destruction . . . of North Vietnamese logistic craft and armed junks"; interruption in the movement of DRV supplies South; bombardment of coastal targets; "cross-beach operations by sea-commando teams" against coastal military and civilian installations; insertion of agent teams into the North; and "delivery of psychological warfare material including propaganda leaflets, radios, and gift kits."[26]

While both challenging and daring, the rules of engagement (ROE), from the outset, hampered execution of these missions. The main impediment was the prohibition against the participation of American personnel in covert maritime operations against North Vietnam. While Navy SEAL and Marine reconnaissance personnel trained the South Vietnamese commando teams for cross-beach operations, they could not lead them on actual operations. The same was true of the Navy personnel responsible for instructing the crews who navigated the boats.

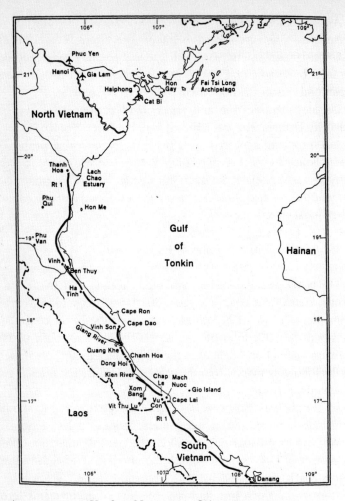

AREA OF U.S. NAVAL OPERATIONS IN
NORTH VIETNAM, 1964–1965

They likewise could not go on missions. This had a serious impact on the effectiveness of the entire effort, especially after the North Vietnamese began to take steps to counter OP 37 activities. The South Vietnamese, all too often, were not up to the task. Leadership by example was needed, but the rules of engagement prohibited it. While other factors contributed to the paucity of OP 37 accomplishments, none was more significant than the absence of U.S. operational leadership.

The rules of engagement also placed geographical limits on OP 37's area of operation (AO). According to the records, "Due to the shortage of marops craft and the inadequate PTF capability, 19°–30'N was set as the normal northern limit for marops. Missions north of 19°–30'N were considered only on a highly lucrative and exceptional basis."[27] Going above this point involved a long and arduous voyage. However, that was where many of the more lucrative targets were located.

There was likewise an area limitation with respect to the Chinese communist island of Hainan. OP 37 craft could go no closer than "40 nautical miles ... to lessen the possibility of encounter with CHICOM [Chinese Communist] patrol craft or aircraft."[28] As with other operational aspects of the Vietnam War, SOG's marops were affected by the legacy of the Korean War. Fear of China was always on the minds of the policy makers. These geographical constraints not only circumscribed what marops could accomplish, but made those operations more predictable and detectable.

Finally, in most of their operations, the marops forces were on their own. Only "certain high risk missions proceeding above 19°–30'N [received] ... the support of prescheduled U.S. air support." However, if a PTF was attacked by "NVN superior forces, they were authorized to contact U.S. ships and/or aircraft for assistance."[29]

OP 37's Structure and Liaison Relations

While the organizational structure of the Naval Advisory Detachment, as it evolved during 1964, consisted of seven sections, the key elements were those responsible for instructing the Vietnamese boat crews and the commando teams—Operations/Training and SEAL/Marine Recon Training. Also of critical importance was the Mobil Support Team (MST), which maintained and repaired the boats.[30]

MACVSOG's maritime effort was initially envisaged as a joint command, with U.S. and Vietnamese personnel working side by side. However, it quickly evolved into two separate commands with different responsibilities. The NAD planned the missions, trained the Vietnamese boat crews and commandos, and provided the resources. Its South Vietnamese counterpart, the Strategic Technical Directorate's Coastal Security Service (CSS)—which consisted of a headquarters and support

section, five fifteen-man sea commando teams, ten PT boat crews, and a maintenance element—was subordinated to OP 37. Its principal role was to recruit the boat crews and commando teams.

Even after the two separate commands were established, joint planning was supposed to take place: "The Commander, CSS . . . with the advice of the officer-in-charge, NAD, planned, coordinated and implemented special operations and missions."[31] In practice, this was not the case until Norm Olson became chief of the NAD in 1967. For the first three years, the CSS was effectively cut out of the process. OP 37 mission planning in 1964, explained Jim Munson, the NAD deputy chief of operations, worked as follows: "I would come up with a target list and I would explain to Jack Owens [the NAD chief] how it related to the overall mission categories, and it would be sent down to Saigon and then Saigon would forward it to Washington and we might or might not get approval. Most of them were approved. Sometimes we were assigned missions."[32] What about the Coastal Security Service? According to Munson, "CSS wasn't involved at all. . . . We had the overall responsibility, my staff and I."[33]

In 1965, Mick Trainor replaced Jim Munson. When asked whether he involved the CSS in planning or informed it when operations were going to be executed, Trainor said candidly, "I did not." Asked why not, he did not hesitate: "I would not trust anybody but an American, and when the Vietnamese were getting ready to go [on a mission] they went into isolation under American scrutiny."[34]

This lack of trust in its South Vietnamese counterparts cut across all operational divisions of MACVSOG and was not unique to OP 37. The reason given was always security. That CSS was penetrated by enemy intelligence was a constant refrain of those who served in the NAD.

Not every chief of the NAD agreed with this exclusionary approach, but most did. A partial exception was Norm Olson. While recognizing the risks involved, he modified the arrangements. Olson felt that the NAD should operate jointly with the CSS and explained that during his command "we had them pretty actively involved. I dealt directly with my counterpart in CSS; I would say, look, we're supposed to have parallel organizations. . . . What you and I have got to do is manage. . . . So what I tried very hard to do was have . . . any decisions that were made . . . [done so] with complete openness.

Obviously, there were certain things you didn't share, but they didn't as well. But we had a very close relationship and we tried to make sure that the counterparts were all participants at every level down to the operational level."[35] It was a good idea but still a gamble. Even though Olson changed the arrangements, the issue of trust did not go away for OP 37.

The NAD had other concerns about the Coastal Security Service that affected cooperation. For example, members of OP 37 were frequently critical of the quality of the Vietnamese boat crews and commando personnel recruited by the CSS. According to one report: "Periodically, during the development and expansion phases of the marops program, the motivation and capabilities" of the Vietnamese personnel were "frequently challenged" by the NAD leadership. Vietnamese "discipline was [seen] as neither in accord with U.S. standards nor remedied by CSS officers. Desertion rates were at critical levels; there was indifference to material damage and loss; attainment of military goals was distantly second to mercenary gain."[36]

This last point, for NAD officers, was a major impediment to conducting effective marops against North Vietnam. Many of the members of the Vietnamese boat crews and commando teams were in it for the money. The pay was good by Vietnamese military standards. However, OP 37 commanders saw this as "an undesirable stimulus" and no substitute for "patriotic motivation." It had a detrimental effect on mission success, and unfortunately, as the documents state, "a workable alternative was not developed."[37] The lack of motivation, commitment, and discipline continually plagued covert marops.

Command and Control

Approval of OP 37 missions was closely managed by Washington. Senior players in the Johnson administration believed that of all the covert options contained in OPLAN 34A, marops could provide the greatest immediate impact on the North Vietnamese leaders, with the least risk to the United States. In 1964 especially, as with SOG's other operations, the White House wanted to keep a close hold over marops because of the political sensitivity it attached to all such covert measures. The cumbersome approval process for covert marops was spelled out in a "Staff Memorandum by the Chairman of the Joint Chiefs of Staff"

dated December 8, 1964.[38] They were the same stultifying procedures that plagued the other operational diversionaries of SOG.

Once a request came to the SACSA from SOG/NAD, it was put in the appropriate format for review, and an action officer hand-carried it to General Earl Wheeler, chairman of the Joint Chiefs of Staff from 1964 to 1970, for his approval. He might sign off on it or, depending on the type of operation, take it to the chiefs for consideration. Next, the action officer walked the request to either Secretary of Defense McNamara or his deputy, Cyrus Vance, for approval.

Following Pentagon approval, the action officer was driven across the Potomac River to the Department of State. There the proposal was reviewed by either Secretary Dean Rusk or his undersecretary for political affairs. The next stop was the office of national security adviser McGeorge Bundy. Even after he signed off, the authorization process might not be complete. Bundy took certain requests to President Johnson. In these cases LBJ's concurrence was needed to complete authorization.

It was a laborious process and in 1965, General Wheeler sought to streamline it. Changes were needed so that it would no longer be necessary to submit individual execution requests for each approved maritime operation all the way back through the same chain of command. Instead, Wheeler wanted SOG to be able to "[s]ubmit packages of up to five missions from the 30-day program for execution approval by Pacific Command, the Joint Chiefs of Staff, and higher authority." The "approval of each package constituted final approval for execution of the included missions at the discretion of COMUSMACV."[39]

In 1967, the mission-execution procedures were further streamlined so that Pacific Command "was authorized to approve for execution all missions whose concepts had been previously approved at the Washington level." Still, twelve hours before the actual execution of a specific mission, OP 37 had to send an "intend-to-execute message" to "give higher authority a final opportunity for disapproval."[40] This was streamlining in a marginal fashion. Until the order to stand down came in November 1968, marops remained closely monitored through these procedures. This was true even after the policy makers lost interest in the use of covert maritime operations against North Vietnam, because they never stopped fretting about the political consequences and international fallout if SOG operations were exposed.

OPTIONS AND IMPACT: 1964–1968

In 1964, Washington was confident that covert marops would have an immediate effect on the leadership in Hanoi, signaling that it could incur real harm if it continued to foster the war in the South. Once Hanoi understood this message, it would just be a matter of escalating the pressure to the point where it was no longer cost-effective for North Vietnam to back the Viet Cong. This was an application of cost-benefit analysis to strategic thinking, an approach to defense matters in vogue at the time among the civilian strategists who populated Kennedy's and Johnson's national security bureaucracy. It was a straightforward economics-based assessment of how to manipulate Hanoi's behavior.

Getting Started: 1964

The Johnson administration was in a hurry and expected immediate results from covert marops. On February 1, 1964, the administration initiated the first phase. Barely two months later, in April, it expressed disappointment over "the lack of success in the [marops] program to date."[41] The results were unsatisfactory; there was no sign that North Vietnam was feeling the pain. Senior U.S. officials in Saigon agreed. Ambassador Henry Cabot Lodge stated that OPLAN 34A operations "were certainly having no effect on Hanoi." Admiral Ulysses S. Grant Sharp, the new commander in chief at Pacific Command, concurred with Lodge.[42] The first harassment, interdiction, and sabotage operations executed by OP 37 accomplished little.

There were several reasons for the slow start. To begin with, the maritime capabilities that the CIA transferred to MACVSOG were of limited use and could hardly execute the missions assigned to the NAD. Furthermore, additional naval craft and military equipment promised for the operations were not readily available. The South Vietnamese personnel needed for added boat crews and commando teams was not being provided by the CSS, and those who were lacked motivation. Consequently, SOG had to rely on civilian mercenaries. Political turmoil within the South Vietnamese government immobilized its military efforts, including attention to the escalation of covert operations up North. Finally, the NAD lacked adequate intelligence on North

Vietnamese targets. It was a mismatch. The available resources could not support policy objectives.

The paucity of the initial results should have been expected. Instead, Washington instructed SOG to crank up its missions against North Vietnam's coastal facilities. It wanted operations initiated that "embodied destruction of greater scope and intensity involving targets of greater criticality than those in Phase I."[43] Defense Secretary McNamara believed that "advantage was to be gained from harassing North Vietnam. . . . Hence, despite the negligible results . . . the 34A maritime operation was continued."[44]

Between April and December 1964, the NAD launched thirty-two missions. Targets included North Vietnamese security posts, bridges, island garrisons, and radar stations. Consistent with Washington's wishes, these actions "embodied destruction operations," including "twelve shore bombardments" and destruction of three enemy junks. Several cross-beach raids were likewise made against "targets of greater criticality." These results also were disappointing, and had a marginal effect, at best.

This was the opinion of Lieutenant Colonel Jim Munson, the NAD's deputy chief for operations in 1964. He was responsible for planning marops and knew the capacity of the South Vietnamese to carry them out. While thirty-two missions may have been initiated, he explained that the results were not significant: "I would note that most of the missions launched never made it, they aborted and came back. Those that did not abort were destructive, but it seemed like a mighty small pinprick."[45]

The successes were small potatoes. For example, on June 12, a storage facility was destroyed, and at the end of the month a small bridge was blown up. In July, a reservoir pump house was hit. Later in the month, three fishing junks were sunk. Did any of this have an impact on North Vietnam's will to continue the war in the South? Munson did not think so: "It's not consonant with trying to make the North Vietnamese understand that they can't send their soldiers down the Ho Chi Minh Trail with impunity."[46]

In addition to these "destruction operations," the NAD began supporting SOG's psywar program through "leaflet bombardment and delivery of gift kits . . . and through indoctrination of NVN prisoners to be later returned to NVN."[47] Munson would point out that he had no idea what these psychological operations accomplished. The NAD

was only the conduit for insertion of psywar materials. The operation belonged to another part of SOG, and Munson assumed that they were assessing success or failure.

The fact that marops got off to such a slow start in 1964 did not keep Washington from clamoring for an escalation of the operation. This continued even after the Gulf of Tonkin incident in August. The events surrounding the episode and their implications for U.S. involvement in the Vietnam War have been the subject of many inquiries. There is no question that SOG operations contributed to the North Vietnamese attack on the USS *Maddox* on August 4, 1964.

The *Maddox* was part of Operation DeSoto, which sought through electronic measures to assess North Vietnam's radar, air defense, and coastal patrol capabilities. DeSoto patrols, which began in March 1962, initially collected such information on Communist China. North Vietnam did not become a DeSoto target until December 1962. In January 1964, General Westmoreland requested that "the DeSoto Patrol scheduled for February be designed to provide the forthcoming 34A program with critical intelligence."[48] As a result, missions were planned for the Gulf of Tonkin "no later than August 1, for the primary purpose of determining DRV coastal patrol activity."[49]

By the end of July 1964, Washington was still grousing about the ineffectiveness of 34A operations. McNamara was "troubled that the tempo of attack was not building up in consonance with improving capabilities." The reason had to do, in part, with improved North Vietnamese coastal warning and defense measures. He inquired as to whether "standoff gunfire or rocket attack might be more advantageous operations ashore."[50] By the summer, it was becoming apparent that cross-beach commando raids "were both ineffectual and highly hazardous."[51]

On July 30, four 34A PTFs headed north to bombard North Vietnamese targets. According to official accounts, "The four boats reached a point southeast of Hon Me at 19°N 106° 16'E. Here, they parted company, with PTF–3 and PTF–6 heading for Hon Me and PTF–5 and PTF–2 for Hon Nieu."[52] Both missions shelled their targets—a gun emplacement and military structures and a communications station—before returning south with North Vietnamese Swatows in hot pursuit.

These attacks appear to have played a key role in Hanoi's decision to attack the *Maddox*. The ongoing DeSoto patrols also likely con-

tributed to that decision. The North Vietnamese strikes led to the Gulf of Tonkin Resolution, which set the stage for the escalation of U.S. involvement in the Vietnam War. However, the incident did not result in the actual decision to escalate. The Johnson administration had already determined it was necessary. The incident was the vehicle through which the president was able to act on what he had already decided. Likewise, Hanoi's attack on the *Maddox* has to be understood within the context of its December 1963 decision to escalate the war in South Vietnam. The die had already been cast by Ho Chi Minh and his cadre of leaders.

Buildup and Escalation: 1965

In December 1964, SOG was ordered to intensify covert maritime operations yet again.[53] During 1965, "170 missions sortied from Da Nang over a period of 358 possible operational days."[54] This was a significant increase over 1964. Coastal targets were being bombed and cross-beach raids carried out. SOG boats were sinking or damaging enemy junks and other vessels. With respect to coastal bombardment by the Nasties and Swift boats, forty-nine actions were initiated against the same kinds of targets as selected in 1964. Sixteen cross-beach missions were executed, and marops "destroyed more than 50 enemy junks and did damage to 19 enemy vessels, including three patrol craft."[55]

The NAD also continued to support SOG's psywar program by kidnapping North Vietnamese fishermen, who were taken to Paradise Island for indoctrination, part of the Sacred Sword of the Patriots League operation. In 1965, 126 North Vietnamese citizens were taken to Paradise Island. The NAD advanced SOG's psywar mission in another way as well, distributing gift kits, pretuned radios, and leaflets. In 1965, "1000 radios were delivered, 28,742 gift kits dispensed, and 1,124,600 leaflets dispensed by 81[mm] mortar."[56]

How effective were these operations? According to one 1965 assessment, "In addition to causing harassment to NVN shipping and having a desirable psychological impact on the NVN population along the coast, the operations caused the NVN government to divert additional resources to protect its coastline."[57] MACV opined that the marops program was "the most productive of all 34A programs . . .

and the most lucrative from the viewpoint of accomplishments." The operations were also judged successful in terms of the intelligence collected. They were a "primary source of information on activities within the DRV." Finally, MACV saw an important residual impact, "causing constant alert of NVN shore defenses and burdensome concern that an attack was imminent at any place along the coast south of the 20th parallel."[58] However, this buildup of Hanoi's coastal defenses also affected OP 37's cross-beach raids. By the end of 1965, they were becoming very difficult to execute effectively, and their success rate plummeted.

Mick Trainor, the NAD's deputy chief of operations, also believed that SOG's maritime operations annoyed the North Vietnamese, in particular the interdiction of enemy junks and other naval craft: "We had to have an effect, because in 1966 they were sending out junks with explosive charges to hurl onto the [SOG] PT boats when they came alongside. So, if they did that, they were obviously upset about these operations." On one occasion, North Vietnam even attacked these SOG boats with aircraft. Still another indicator of the NAD's impact on Hanoi in 1966, believed Trainor, was that due to losses Hanoi sent its attack patrol boats, the Swatows, into safe northern waters. "We got the better of the Swatows," noted Trainor.[59]

Trainor was less sanguine about shore bombardments and had his doubts about the Sacred Sword of the Patriots League (SSPL) spoof: "The story that they were told . . . [was that] they had been put ashore on the mainland and they were being clandestinely marched up into the mountains . . . to this SSPL camp . . . Now, I'm from a coastal area, [and] those fishermen aren't going to believe that. You can smell the sea, you know when you're near the sea, but they were fishermen, what were they going to do? They went along with the gag. . . . I thought the thing was fundamentally undermined by that alone."[60] Trainor confirmed that the cross-beach raids accomplished little by the end of 1965. In terms of snatching NVN officials, he does not recall that commando teams ever extracted "anybody significant."[61]

In sum, 1965 was considered a good year for SOG marops. MACV believed they had an impact on North Vietnam. This was true, as far as it went. While marops did cause Hanoi to divert resources to beef up its coastal security defenses, the war in South Vietnam did not deescalate.

Hanoi Strikes Back: 1966

In 1966, the NAD executed "126 primary and 56 secondary" missions, roughly the same as the previous year.[62] However, the scope of these operations narrowed considerably: "The most effective operations conducted by marops in pursuance of OPLAN 34A were PTF maritime interdiction missions"[63]—operations mainly against North Vietnamese junks and other vessels in coastal waters. These resulted in the capture of 353 prisoners, all taken to Paradise Island for indoctrination. Of these, 352 were returned. Additionally, "2,000,000 leaflets [were] distributed by mortar, 60,000 gift kits [were] delivered," and "2,600 radios [were] distributed." Finally, "86 enemy craft were destroyed and 16 . . . damaged."[64]

Operations directly against North Vietnamese facilities, whether by bombardment from the Nasties and Swift boats or by cross-beach commando raids, had little success in 1966, in part because Hanoi continued to improve its coastal defenses. Thus, when the OP 37 boats tried to carry out a bombardment, they were frequently engaged by the enemy's coastal guns or attacked by their surface vessels. While improved coastal defenses made stand-off bombardment difficult, they handicapped cross-beach commando raids even more. The numbers speak for themselves: "thirty-four cross-beach missions were attempted in 1966; only four were considered successful."[65]

As a result of these developments, OP 37 reduced the scope of its maritime operations. This caused problems for the NAD in maintaining the Vietnamese commando teams. The decline in operations "against northern targets created an undesirable training environment for action team personnel. Loss of combat bonus pay caused disaffection and increased AWOL rates."[66] A commando team did not have to successfully carry out a cross-beach raid to receive a bonus. In fact, it was not even necessary to set foot on North Vietnamese territory. One received a bonus simply if the boat disembarked from Da Nang and headed north on a commando raid. When the boats stopped embarking on missions with commandos aboard, the bonus pay dried up.

SOG requested and received permission to employ action teams in southern operations against "known or suspected VC infrastructure as well as VC/NVA military targets along the coast of I Corps [the northern sector of South Vietnam]. . . . Action teams were accompanied on these operations by U.S. advisors."[67] This improved the com-

mandos' success rate because SEAL or Marine recon personnel could lead and support the commando teams. However, this had little to do with the objectives of OPLAN 34A.

A second factor contributing to the dismal record of OP 37 operations against North Vietnamese coastal targets in 1966 was the reluctance of the Vietnamese crews and commando teams to engage the enemy. Trainor recalled: "I'd catch hell; why couldn't they get ashore? . . . I understood why you couldn't send Americans up north, but with these teams you were not going to get them to perform unless you had Americans there or unless you had very strong leadership on the part of the team commanders, and it just wasn't part of their culture. So, without the Americans the likelihood of getting ashore was problematic . . . the team would not go in. They were always great for excuses on why they couldn't do something."[68]

Trainor put his finger on the Achilles' heel of MACVSOG's marops. Without U.S. leadership and combat support, the Vietnamese teams remained reluctant to execute commando raids and close-in bombardment missions. In August 1966, Trainor was replaced by Lieutenant Colonel Pat Carothers. He knew a great deal about recon and commando operations. Prior to Vietnam, Carothers pointed out, he "had five years of force recon company experience. I was in 1st Force Recon as a platoon commander and then . . . operations officer. . . . I was also commanding officer for two and a half years for 2nd Force Recon. I was [assigned] to the Royal Hellenic [Greek] Pararaider Forces. . . . I was [assigned] to 1st Parachute Regiment of the French Foreign Legion on Corsica. That was the regiment that two months later was disbanded by De Gaulle for its revolt in Algeria. I did some time with the French Naval Commando Amphibious Force in Toulons."[69]

With this background, it did not take OP 37's new deputy chief of operations long to see why missions against coastal targets were accomplishing little. Carothers believes the main problem was with the Vietnamese boat crews: "I could not fault the action teams. . . . The decisions were made before they ever got to the beach that [the mission] would be unsuccessful and return to base. . . . It was the boat crews and the skippers that made the decision."[70] Contributing to this reticence may have been the fact that in 1966 five PTFs were destroyed by the enemy, making the boat captains and crews much more circumspect about these operations.

In March 1966, Commander Bob Terry became chief of OP 37. Most of his professional experience had been in underwater demolition and with SEAL units. He noted that "he had been involved in several missions that were similar to SOG's maritime operations," but not in a covert capacity. The only difference between overt and covert is that it's a deniable operation."[71] Terry's assessment of the Vietnamese commando teams was that they accomplished little: "We tried a lot of things, not successfully. The team operations were harassment at best . . . [A]s far as going across the beach and actually effectively engaging a hostile force or capturing someone, we didn't have a whole lot of success."[72] Why? Terry explained: because the NVN "had an extremely effective hamlet-to-hamlet security apparatus; any strange face was not going to exist for very long." The Vietnamese commando teams knew this and were "not too hot to go up there."[73]

Regardless of whether it was the Vietnamese boat crews or commando teams or a combination of the two, the results were the same: marops directed against shore targets accomplished little in 1966.

Further Narrowing of Marops Missions: 1967–1968

Covert maritime operations in 1967 were further curtailed, focusing almost exclusively on "interdiction of waterborne craft, primarily fishing junks, and detention of large numbers of fishermen for intelligence and psychological exploitation."[74] A total of "151 missions were launched. . . . 125 were completed, 19 were aborted due to weather and 7 aborted due to material or personnel casualties."[75] During these interdictions, 328 North Vietnamese citizens were captured and transported to Paradise Island for indoctrination. The NAD also continued to dispense psywar materials.

The main objective of marops in 1967 was support for SOG's psychological warfare program. The original objective—covert harassment and destruction of vital facilities along the North Vietnamese coast to signal to Ho Chi Minh and his comrades that there was a high price for fostering the war in the South—was now seen as wholly unrealistic. There was no doubt by 1967 that the proposition had been nothing more than a pipe dream.

In addition to support of psywar, interdiction operations included the destruction of "102 enemy craft," most of them nothing more than fish-

ing junks. However, the rules of engagement were not very discriminating when it came to targeting North Vietnamese waterborne craft. Any junk, no matter what size, could be targeted by Nasties or Swift boats for sinking. This made little sense, given that fishermen from these boats were then captured and indoctrinated. Chances of successfully propagandizing captured fishermen was sharply reduced by sinking the fishing boats they relied on for their livelihood.

When Norm Olson took command of the NAD in the fall of 1967, this contradiction quickly became apparent.[76] He had immediate doubts about that part of the interdiction mission aimed at sinking enemy craft. In reflecting on the number of craft sunk in 1967, he stated: "I'm absolutely convinced that probably 100 out of the 102 were fishing junks. I don't think they were . . . combatants that were coming out to attack [our boats]. I don't ever recall that. Maybe there were some small gunboats, but I would say the vast majority of those craft were fishing boats."[77] Olson recalled only one instance in which the interdicted craft could have been classified as a military target: "When I was there I think the only thing that we nailed was a sizable North Vietnamese trawler that had all kinds of weaponry. I mean all kinds of small arms. . . . That's the only one that I can recall."[78]

Pat Carothers, the NAD's deputy chief of operations in 1966, pointed out that waterborne craft even smaller than fishing junks were considered legitimate targets for interdiction and sinking. These included basket boats. Carothers described a basket boat in the following way: "[An individual fisherman] would weave a basket and then they would tar it, make it waterproof, and they would stand in this thing [to fish]. It's only five feet across. They have their fishing gear down below at their feet and they have one oar or paddle." When asked whether such small craft, Vietnam's version of a rowboat, was included in the NAD's annual total of enemy craft interdicted and sunk, Carothers replied that they were part of "the count."[79]

None of this made any sense to Norm Olson. Shooting up fishing junks, let alone basket boats, and calling it a successful interdiction of enemy craft was preposterous. Such operations were more likely to have negative consequences, since fishermen were one of SOG's primary psywar targets. However, for the Vietnamese crews, sinking North Vietnamese craft, apparently even basket boats, was the way to earn a bonus. In retrospect, it seems almost impossible to believe. But

according to Olson: "They'd get a bonus for that." The former chief of the NAD pointed out the obvious: "If you're an ordinary fisherman and your [boat is] getting blown away, you're not going to like those guys from the south who are coming up and doing this to you." It was dumb, thought Olson, "particularly if you're trying to portray yourself as part of the Sacred Sword of the Patriots League."[80]

This was one of a number of problems Norm Olson encountered. In 1968, he was instrumental in establishing new rules of engagement governing the sinking of North Vietnamese craft. "To support psychological warfare operations in early 1968, additional restrictions were introduced prohibiting marops destruction of junks less than 10 meters in length, unless they were determined to be carrying military supplies or an uncommon amount of foodstuff or cargo. Smaller junks obviously employed in fishing were spared."[81] So were the basket boats. As a result, the number of enemy craft destroyed by SOG in 1968 dropped to forty. The revised rules of engagement made a difference—but the bonus incentives remained in effect.[82]

Olson also had problems inside OP 37. Chief of SOG, Jack Singlaub had told him the NAD needed discipline and focus and to fix these problems immediately. Olson recalled: "One of the problems of these kinds of operations is there's a lot of latitude. There's a sense that there are no controls."[83] He was given "clear guidance from General Singlaub to go up there and straighten the place out. There were some pretty significant morale issues on the American side of the house. There wasn't a hell of a lot of discipline, and that took a lot longer [to fix] than I thought it would. It was deeply entrenched. Probably the first six months that I was there I spent a great deal of time sorting that out and trying to make some changes and getting people out of there that were causing problems."[84]

Olson also felt that relations with the South Vietnamese Coastal Security Service, OP 37's counterpart, were in need of repair. When he arrived in Da Nang, he found that "We didn't have very good relationships with our counterparts, and I felt that was extremely important and I dedicated a lot of my time to fixing that as best I could and truly establishing a counterpart organization that was a shadow of our organization. . . . My bottom line was that decisions would be made by myself and the Vietnamese commander, and I would hold him accountable for everything that occurred in his organization."[85]

Olson hoped to let CSS feel that it was trusted: "My responsibility was to ensure that I had that relationship with my counterpart."[86] He was willing to live with the security implications of this policy.

By 1968, cross-beach operations against North Vietnam had been almost completely halted. According to Olson, "It was a very difficult [mission] because we couldn't get them in there."[87] He decided to seek authority to expand their use in South Vietnam: "What I wanted to do was actually take the commando teams into the field and find out what they were really capable of doing. Well, we arranged through Singlaub to send a group down to the Delta and work with the Mobile Riverine Force [TF 117], an Army and Navy combined effort. One of the things they didn't have was any kind of forward element that they could go out and conduct reconnaissance and find out what was going on. So, we figured this was a great opportunity for us to go down, get some real training and be able to observe the people."[88] According to SOG's 1968 end-of-year report, these "operations were considered valuable to TF 117 . . . obtaining valuable intelligence for the Mobile Riverine Force."[89]

In addition to riverine operations, NAD commando teams were employed in I Corps to "develop cross-beach operations through the conduct of actual operations targeted primarily against the Viet Cong infrastructure."[90] The goal was to harass and capture members of the Viet Cong infrastructure shadow government and to destroy its supply system in the coastal region of I Corps. A similar operation—Dewey Rifle—was initiated by the NAD in II Corps (the central highlands of South Vietnam) in 1968. During the year, twenty-five successful missions were carried out in I Corps, and twenty-two in II Corps. The results in I Corps: "6 VC KIA, 6 VC prisoners captured, 2 firefights on landing, numerous documents captured, 11 ambushes/area sweeps conducted, no enemy contact made." The outcome in II Corps was similar.[91] It was small potatoes, but a marked improvement over what had happened in northern commando raids.

The counter-VC-infrastructure operations of OP 37 were a very small part of the larger U.S. pacification and counterintelligence effort conducted in South Vietnam under the auspices of the Civil Operations and Revolutionary Development Support (CORDS) program. First headed by Robert Komer, who held the rank of deputy to General Westmoreland, CORDS was established in May 1967 to

improve rural pacification and security in the South Vietnamese coun-
tryside. American personnel for CORDS were drawn from the mili-
tary, State Department, U.S. Information Agency, and CIA.

One objective of CORDS was to disrupt and destroy the VC infra-
structure, an operation that came to be known as the Phoenix
Program. Its direction was assigned to Komer's deputy, Bill Colby,
who had been reassigned to Vietnam after a tour at CIA headquar-
ters. When Komer left, Colby replaced him as director of CORDS.
Phoenix became a contentious issue because its mission was to iden-
tify and neutralize VCI personnel. Charges of torture and assassina-
tion later led to several congressional investigations. At these hear-
ings, Colby insisted that most of the estimated 20,000 Vietnamese
killed in Phoenix operations died in combat situations and not
through assassination.[92] Others strongly disagreed, and to this day the
Phoenix Program remains a most controversial subject.

SOG's maritime commando teams fared better in South Vietnam than
in the North for several reasons. First, VCI-controlled areas in South
Vietnam were much more accessible than what the commando teams
faced in North Vietnam. Additionally, the Vietnamese commandos bene-
fited from U.S. supervision and leadership. Finally, if a team got into trou-
ble, significant combat support could come to its rescue. But operations
in the South had nothing to do with OP 34A's original maritime mission.
In fact, SOG commando operations were initiated in South Vietnam, in
large part, only because of the failures against North Vietnam.

In sum, by the fall of 1968, Norm Olson had the NAD back on
course. In terms of operations, "a total of 157 missions were
launched in the first ten months of 1968. Of these, 140 were com-
pleted successfully, 11 were aborted due to weather and six were
aborted due to boat material problems."[93] However, he could not
refocus the NAD on the initial missions of marops—that was not pos-
sible. They had devolved into support for SOG's psywar program.
While psywar support was important, it was only a part of what the
policy makers had initially hoped covert marops would achieve.

Standing Down Marops Against North Vietnam

While Norm Olson fixed several of OP 37's problems and got it
back on a steady course, his achievements were eclipsed by policy

decisions in Washington that resulted in Washington's message on November 1, 1968, telling MACVSOG to stop all operations that involved crossing the North Vietnamese border. For the Naval Advisory Detachment this amounted to a complete shutdown of its already reduced mission: "On 1 November [1968] all maritime operations north of 17° ceased."[94]

The situation stayed that way in 1969. The boat crews and commando teams were maintained, but their area of operation was south of the 17th parallel. Their mission was to "conduct covert maritime interdiction, intelligence collection, psychological warfare, cross-beach operations including ambush/capture missions and general harassment of VC/VCI/NVA in the coastal areas of South Vietnam."[95] This resulted in "116 VC/NVA killed in action, 34 VC/NVA captured, 165 VC suspects detained, 20 sampans destroyed, 71 bunkers destroyed, 37 weapons/29 grenades captured, and 8500 pounds of rice captured. Additionally, numerous enemy documents were found in these raids."[96] While a marked increase from operations in 1968, it was only a diminutive effort against the VC infrastructure.

In 1970, the tempo of marops in South Vietnam remained at the 1969 level. The requirement to be prepared to resume operations up North at any time remained in effect, but no NAD boat or commando team was given such a mission. OP 37's focus was the Vietnamization of marops. It was planned that by year's end, the CSS would be "capable of planning, coordinating and executing the missions," as well as "repair and maintenance of the boats and facilities." The planned hand-off of marops to the CSS and the stand-down of the NAD were scheduled for January 1, 1971. "A six month extension was granted to ensure adequate training for the Vietnamese Navy replacements."[97] In July 1971, the CSS assumed operational responsibility for planning and conducting all marops missions.

The Strategic Impact of Marops: High Hopes—Few Results

In 1964, Washington's policy makers had high hopes for covert maritime operations. They were confident that marops would have an immediate impact and jolt Ho Chi Minh and his comrades. Harassment and destructive operations visited on North Vietnam

from the sea were seen as the principal covert instruments to get
Hanoi's attention and persuade it to stop promoting the war in South
Vietnam. Through these actions against vital facilities along the coast-
line, Ho Chi Minh would quickly learn there was a price to be
incurred for subverting South Vietnam. If he did not stop it, the
covert war would be intensified. Hanoi never budged.

What McNamara and other policy makers expected out of marops was
wholly unrealistic. The entire idea had been nothing more than an illusion,
especially in light of the problems OP 37 encountered. Most of these
obstacles were never removed. The leadership and expertise of the chief of
the Naval Advisory Detachment was a case in point. It was a mixed bag
from beginning to end. While Norm Olson was the right man, most of the
time the personnel process failed to find other officers like him.

Likewise, the quality and motivation of the Vietnamese boat crews
and commando teams were always in question. This proved to be an
enduring problem because many were in it only for the money. The
bonus system encouraged a mercenary mentality and was no substi-
tute for patriotic conviction.

From the outset, the rules of engagement also inhibited successful
execution of the mission. The principal impediment, but not the only
one, was that SOG members could not accompany the Vietnamese
crews and commandos north. This had a major impact on the effec-
tiveness of the entire effort, especially after the North Vietnamese
began to develop countermeasures. SOG's only response was to nar-
row the focus of covert maritime operations to offshore operations.

Last, there was the matter of trust and cooperation between the
NAD and the STD/CSS. The belief that their South Vietnamese coun-
terpart was riddled with spies permeated every operational division of
MACVSOG, and that included OP 37. SOG's maritime operations
were initially envisaged as a jointly orchestrated effort, with U.S. and
Vietnamese personnel working side by side. However, the issues of
security and trust caused it quickly to evolve into two separate com-
mands in which the United States dominated the process. This had a
detrimental impact on operations.

Added to these obstacles was the problem of the policy makers'
expectations. They were totally unrealistic about the impact these
pinprick operations could have on North Vietnam's leadership.
Washington did not understand its counterparts in Hanoi. It was

going to take more than a handful of covert marops to influence Ho Chi Minh's decision calculus.

Even if the NAD had not encountered these substantial obstacles, Washington still would have been expecting too much, too quickly from covert marops. The marops program in 1964, once again, revealed how little understanding senior players in the Kennedy and Johnson administrations had of covert action.

6

CROSSING THE FENCE

As Hanoi and Washington normalized relations in the early 1990s, American citizens with different views on the war began to travel to Vietnam. Businessmen who saw Vietnam as the next Asian economic miracle and wanted to get in on the ground floor were among the first. To them, the war was ancient history. Their interest was in making money, and Vietnam looked like a good prospect.

American veterans of the war also returned to visit old battlefields, remember buddies who had been killed, and meet those they had fought. Retired Lieutenant General Hal Moore made such a trip in 1990. Twenty-five years earlier, in 1965, Lieutenant Colonel Moore had commanded the First Battalion of the Army's elite Seventh Cavalry. On October 23 of that year, his unit was dropped by helicopter into the Ia Drang Valley, a longtime communist sanctuary and infiltration route into South Vietnam's central highlands. Upon landing, Moore's 450-man force was surrounded and hit hard by 2,000 North Vietnamese regulars. A few days later, another battalion of the Seventh Cavalry experienced a similar assault. Savage fighting went on for weeks.

The battles in the Ia Drang are among the most significant of the war. In the words of Moore, "Both sides claimed victory and both sides drew lessons, some of them dangerously deceptive, which

echoed and resonated throughout the decade of bloody fighting and bitter sacrifice that was to come."[1] Having decided to write the story of the brave soldiers who died in the Ia Drang, Hal Moore returned to Vietnam in 1990. He met with the NVA commanders he had faced in 1965. Together, they walked the battlefields of the Ia Drang and remembered those ferocious encounters.

Finally, there were the peace activists. While they had opposed U.S. involvement in the war, few had the opportunity to meet face-to-face with North Vietnamese leaders. This began to change in the 1990s, as such encounters took place in Hanoi and elsewhere. Other political activists likewise were involved in such meetings.

One such session took place in 1995 between a human rights activist from Minnesota and a retired NVA colonel. A hardened veteran who had fought many battles against American soldiers, Colonel Bui Tin was no ordinary NVA commander. On April 30, 1975, Hanoi had given him the honor of receiving the unconditional surrender of the South Vietnamese regime. Earlier, in December 1963, he had been involved in the decision by the North Vietnamese Politburo to expand its use of the Ho Chi Minh Trail. As they chatted, the human rights activist asked many questions about the war. Toward the end of the meeting, he came to the heart of the matter. "Colonel, was there anything the United States could have done to prevent your victory?" he asked. In the dogmatic canon of the antiwar movement, the answer has always been an unequivocal "No." After all, they believed, North Vietnam had the "mandate of heaven" on its side. There was nothing the United States and its military machine could have done. Hanoi's victory was in the stars.

The colonel's answer was a devastating refutation of this protest-movement orthodoxy. To prevent North Vietnam's victory, Bui Tin observed, the United States would have had to "cut the Ho Chi Minh Trail." The human rights activist queried, "Cut the Ho Chi Minh Trail?" "Yes," he repeated, "cut the Ho Chi Minh Trail inside Laos. If Johnson had granted General Westmoreland's request to enter Laos and block the Ho Chi Minh Trail, Hanoi could not have won the war." He then explained the strategic importance of the trail for Hanoi's escalation and conduct of the war. It was the only way "to bring sufficient military power to bear on the fighting in the South. Building and maintaining the trail was a huge effort, involving tens of

thousands of soldiers, drivers, repair teams, medical stations, and communications units." If it had been cut, Hanoi could not have intensified the fighting with NVA regulars, as it did in 1965. This did not mean that the United States and its South Vietnamese client would automatically have won. No, they still had to defeat the Viet Cong and win the support of the people. Nevertheless, cutting the trail would have made those tasks significantly easier.[2]

It was a telling revelation from one who should know. As the discussion unfolded, Colonel Bui Tin's observations became more and more convincing—they actually made sense. This raises a fundamental question. If this made such obvious sense, how is it that the "best and the brightest" didn't figure it out during the war? It is a good question.

WHILE HANOI BUILDS, WASHINGTON DITHERS

The importance of the Ho Chi Minh Trail cannot be overstated. The 1959 decision to build it was of strategic magnitude. So was Hanoi's bold move in late 1963 to expand it in order to escalate the war in the South. The trail was actually a labyrinth of paths, trails, and roads through steep mountains and dense jungles that served as a remarkable logistical supply network, command-and-control redoubt, and troop staging area. From this sanctuary, NVA forces could easily slip into South Vietnam to attack targets and then quickly return to the safety of Laos. After the war, Hanoi would extol the trail as "a miraculous epic of this century."[3]

Laos was a political hot potato in the early days of the Kennedy administration. The 1962 Geneva Accords, which the United States played a central role in brokering, had declared Laos neutral. All foreign troops were to leave Laos, including the North Vietnamese Army units. Washington wanted to believe in the viability of that neutrality, but Hanoi's expanding activities in Laos kept getting in the way. In Saigon, General Harkins, the MACV commander, downplayed North Vietnam's presence as "unconfirmed rumors."

While Harkins believed there was no hard evidence of Hanoi's expanding use of the trail to arm the Viet Cong and infiltrate NVA regulars, U.S. Special Forces operating along the Laotian border had little difficulty confirming these activities. Since 1961, Special Forces personnel had supported several CIA-sponsored projects initiated at

the behest of President Kennedy. These included Combat Intelligence Teams, Border Surveillance and Mountain Scouts, and Civilian Airborne Rangers. Each of these projects deployed small units either to watch and strike at enemy troops crossing the border or to collect intelligence inside Laos.[4]

Bill Colby began these activities in the summer of 1961. The area of operations, according to declassified documents, "was from Attopeu north to Tchepone and National Route 9 opposite the I and II Vietnamese Corps areas"—a stretch of less than fifty miles. Attopeu is located in the southeastern corner of Laos near the Cambodian border and due west of South Vietnam's central highlands. "During the period [1961–1963], 41 team size operations were conducted."[5]

Special Forces Captain Jerry King observed plenty of evening activity, as his CIA-sponsored indigenous team patrolled inside Laos. King's team, which included one other Special Forces adviser, a Thai Ranger, and three Laotians, was operating near Tchepone during July 1962. On one mission, the team almost walked into an entire regiment of the North Vietnamese Army. Fortunately, they were able to scurry for cover. Still, King got a good look at uniforms, insignia, and weapons. There was no question that it was a regiment of NVA regulars.[6]

Despite what General Harkins believed, what King's team saw just ten kilometers outside Tchepone was neither an aberration nor an anomaly. Here was eyeball proof of the CIA's June 1962 assessment that Hanoi could infiltrate 1,500 troops a month down the trail. By 1963, North Vietnam's increasing presence in Laos contributed to a deteriorating situation and series of crises in South Vietnam. The price of the 1962 Geneva Accords was Hanoi's unencumbered use of the Ho Chi Minh Trail.

Fighting It Out with the Crocodile over Laos

The joint MACV-CIA team that drafted OPLAN 34A felt strongly that something had to be done about the trail. It wanted covert paramilitary operations in Laos added to 34A. This was conveyed to Secretary McNamara and CIA Director John McCone in Saigon in December 1963. Apparently they were persuaded and "directed that this matter be presented for high-level consideration in Washington."[7]

Key administration officials also were worried about Laos. Michael Forrestal of the National Security Council Staff, returning from a trip to Vietnam in early December, told President Johnson that he found "considerable interest [among U.S. officials] in stepping up operations across the Laotian border . . . against the Ho Chi Minh Trail." He suggested that modest, "carefully controlled intelligence operations . . . be considered." At minimum, the United States ought to know what Hanoi was up to in Laos. However, Forrestal cautioned against going any further and implored LBJ to measure expansion of these operations "against the risk of discovery, which would upset the delicate balance of forces in Laos."[8] The "delicate balance" was an elliptical reference to the 1962 Geneva Accords that Averell Harriman, as the Kennedy administration's ambassador-at-large, had brokered.

In Washington, Harriman's fingerprints were all over Vietnam policy. In August 1963, he had helped draft a now-infamous cable that signaled U.S. acquiescence to the South Vietnamese generals plotting to overthrow Diem. The Crocodile, as Harriman was known, along with Roger Hilsman, George Ball, and Michael Forrestal, concluded that the South Vietnamese president had to go. Apparently, JFK concurred. Diem and his brother were assassinated on November 1, 1963, with U.S. connivance.

Harriman was also maneuvering deftly to neutralize anyone proposing that MACV initiate covert paramilitary operations against the trail. In a memorandum to the National Security Council, he commented on a telephone conversation he had initiated with Forrestal on this matter, throwing cold water on Forrestal's proposed "carefully controlled intelligence operations." Harriman was determined to keep MACV out of Laos. He blindsided Forrestal, portraying his modest proposal as nothing short of the first step in the demise of the 1962 Accords.[9]

In late December, Harriman was at it again, this time through one of his special assistants. In a memorandum instigated by Harriman, William Jorden claimed to have examined all "available evidence of continuing support in the form of men and material for the Viet Cong from [North Vietnam]" and found that it was declining. "The rate [in 1963] appears below that of 1962, which in turn was less that 1961." He noted that "MACV estimates that 7,600 men have entered South Vietnam from the north since January 1961."[10] All of the alarm over Laos was a tempest in a teapot, he implied.

Jorden appears to have overlooked those MACV intelligence estimates that reported 35,000 men had come South, an infiltration rate five times higher than mentioned in his memo to Harriman. MACV's "Infiltration Study," released in the fall of 1964, had concluded that "the total could be as much as 45,000 for the period 1959 to date."[11]

A memorandum similar to Jorden's was drafted, at Harriman's behest, by another of his special assistants, William Sullivan, on December 31. The purpose was the same: neutralize those beating the drums over Laos. Like Jorden, Sullivan sought to throw cold water on the NVA infiltration issue.

They called Harriman the Crocodile because he was a brutal bureaucratic infighter. In fact, he was just warming up. If he had anything to do with it, MACV would not violate his Accords on Laos.

Under the conditions of Operation Switchback, the CIA's covert cross-border mission in Laos was to be transferred to the military.[12] However, at that time it was not clear where operational responsibility would be assigned inside MACV. In February 1964, Westmoreland received a shock from Washington. The CIA's covert operations against the trail would not be resumed by MACV because "agreement could not be reached on the concept of operations or the necessary constraints to control the operations since the Geneva Accords of 1962 prohibited the introduction of foreign troops into Laos." As a result of this impasse, no U.S. personnel were "authorized to accompany any covert GVN [Government of Vietnam] elements into Laos."[13] Harriman was the architect of these arrangements. He was digging in to ensure that his "delicate balance" in Laos remained intact.

Early in 1964, reports of North Vietnamese activity in Laos received still more high-level attention in Washington. At an April National Security Council meeting, CIA Director McCone reported that intelligence "now indicates greatly increased use of Laos for infiltration of men and materials from North Vietnam to South Vietnam." During the session "the president was shown numerous aerial photographs which revealed major improvements in the road network." A consensus began to emerge over the need to do something about Laos. At this point, Harriman stepped in. The way to handle the matter, he proposed, was to push the International Control Commission, which had responsibility for supervising the Accords, "to send

inspectors." Their presence could have a calming effect. If not, Harriman "favored sending non-U.S. patrols into Laos to try to find out the size of the military buildup." He stood firmly against U.S. advisers taking part in these patrols. It was a clever diversion. Leonard Unger, then U.S. ambassador to Laos, weighed in. He informed the National Security Council that he wanted to keep MACV out of Laos.[14] The State Department was closing ranks.

The Joint Chiefs harangued Defense Secretary McNamara to lift the ban. The "border restrictions were limiting the effectiveness of military operations in Vietnam." In March 1964, at the urging of the Joint Chiefs, McNamara requested authorization for "hot pursuit [by] South Vietnamese forces over the Laotian line for border control."[15] This was contentious for Harriman, but it was increasingly doubtful that he could prevent a change in U.S. policy. The Joint Chiefs were building a case for "crossing the fence" that McNamara and Mac Bundy, the special assistant to the president for national security affairs, found convincing.

Still, Harriman had to be dealt with, as Forrestal told Bundy in April. LBJ had been coaxed into supporting "hot pursuit," and Bundy was about to send a telegram to Saigon authorizing it. Michael Forrestal of the National Security Council staff cautioned Bundy that "to send the telegram without Averell's approval is just asking for trouble." The telegram had already received presidential approval, but that was not enough. It still required an endorsement from Harriman. Forrestal had learned from Sullivan that Harriman "would not object to the substance" of the telegram, but to go forward without his concurrence would amount to blindsiding him.[16] You just did not want to do that, Forrestal told Bundy, and he knew the consequences of doing so from experience. Harriman was placated and reluctantly agreed to "hot pursuit."

Intelligence reports in May 1964 contained more evidence of "extensive enemy military activities in Laos." As a result, the Joint Chiefs received permission to "authorize COMUSMACV . . . to initiate joint planning with the South Vietnamese government for cross-border operations and to proceed with limited covert intelligence patrols in Laos." The chiefs finally got their way. However, the restrictions placed by Washington on these intelligence collection operations made it clear that the State Department was still in the

game. Cross-border operations were limited to those "areas in Laos between Route 9 and the 17th parallel [Provisional Military Demarcation Line] adjacent to the border, and the area east of Tchepone." As the map below depicts, this was a relatively small part of the Ho Chi Minh Trail, but considered the critical entry point.[17] "No U.S. advisers could lead the teams." The Vietnamese that crossed the border were "not to wear GVN or other uniforms," and they could engage the enemy only in "self defense."[18]

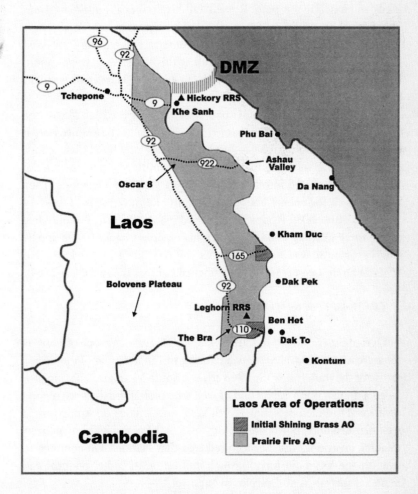

(Reproduction provided by John Plaster)

Who in MACV was going to train these GVN teams? It was at this point that Clyde Russell was summoned to a meeting in April 1964 with General Westmoreland. When the MACVSOG chief entered Westmoreland's office, he found McNamara, General Westmoreland, Ambassador Lodge, and JCS chairman General Taylor. They wanted to know "how soon could [SOG] launch operations into Laos." Russell learned that they "wanted boots on the ground to provide direct observation of enemy use of the Trail." The teams should be ready to launch in a month. Russell had his doubts about the mission. He felt U.S. advisers were absolutely essential to lead these Vietnamese units, and he said so. McNamara agreed, but explained that Secretary of State Rusk "does not at this time feel that we should risk the exposure of American forces in Laos."[19] Harriman was still getting his way.

In roughly thirty days, SOG had several teams ready to "cross the fence" in an operation code-named Leaping Lena. The results were a disaster, confirming Russell's worst fears. In late June, five teams, each consisting of eight members of the South Vietnamese Special Forces, were inserted into Laos along Route 9 east of Tchepone. They were to look for enemy activity, especially the movement of military equipment and NVA troops. They found plenty of both. But only five of the forty Leaping Lena team members made it back. It was apparent that Hanoi was accelerating its military presence in Laos. No other Leaping Lena teams were launched "across the fence" in 1964.

The Devil Is in the Details

Over the next fifteen months, MACVSOG was kept out of Laos as the bureaucratic clash continued. During this hiatus, Hanoi intensified its use of the trail. It saw the 1963 crisis in South Vietnam as having provided a golden opportunity and moved to exploit it. Intelligence reports confirmed this fact, depicting North Vietnam's infiltration strategy as "a well planned and coordinated effort . . . to subject the RVN to a covert military invasion." Intelligence predicted that Hanoi "will continue to support the VC main force through infiltration of cadre, political and financial specialists and surplus man power."[20]

The worsening situation in Vietnam in 1964 confronted LBJ with a conundrum. It was a presidential election year, and he had pledged not

to "send American boys nine or ten thousand miles away from home to do what Asian boys ought to be doing for themselves."[21] Having established himself as tough but prudent on military matters, outflanking Barry Goldwater, whom he portrayed as an extremist, Johnson put Laos on the back burner. American soldiers were not going to violate the 1962 Geneva Accords. MACVSOG would stay off the trail.

The prohibition against any American military personnel operating across the borders with Laos and Cambodia was made clear to Lieutenant Colonel Ray Call when he was a Special Forces adviser assigned to the Civilian Irregular Defense Group (CIDG), a CIA operation initiated in 1961 to prevent the Viet Cong from penetrating Vietnamese border areas where tribal minorities were clustered. MACV took over the program in 1963. Call explained later that in 1964 the border was sacrosanct: "We weren't allowed in Laos, we weren't allowed in Cambodia. Many a time, I had to land my helicopter and get out and stop my troops from coming across the border chasing the enemy." For having once set down on the other side of the "fence," Call found himself in front of General Westmoreland with a lot of explaining to do. After that, Call "made it a point" to instruct his subordinates "that [he] didn't want helicopters or anything else going into Laos or Cambodia."[22] The war was not to get in the way of election-year politics.

Having routed Goldwater, LBJ refocused on Vietnam in 1965, only to find the situation dismal and getting worse. The government of Vietnam was in disarray, its generals continued to plan coups, and the Viet Cong were taking over more and more of the countryside. On February 7, Hanoi upped the ante with a major attack on the U.S. air base at Pleiku. Nine American soldiers died in the attack and another 128 were wounded. It caught President Johnson by surprise. Mac Bundy, his national security adviser, was in South Vietnam at the time and flew to Pleiku for a firsthand look. David Halberstam reports that Bundy "visited the wounded [and] the scene made a strong impact on him." The war was no longer a geostrategic abstraction. For weeks after the visit, when Mac Bundy was questioned about it, "the words would pour out, boys dying in their tents, we have to do something, we can't just sit by, we have to protect our boys."[23]

The Pentagon agreed, and the Joint Chiefs called for lifting the restrictions on the Ho Chi Minh Trail. They finally got their way. In

March 1965, Operation Rolling Thunder began, with the objective of interdicting North Vietnam's infiltration of men and supplies into South Vietnam through a bombing campaign. It focused on the top end of the trail pipeline. The chiefs also wanted to do something about its extension through Laos.

The White House agreed, and in March the Joint Chiefs of Staff were authorized to begin covert cross-border operations into Laos. SOG got the mission. Unlike the Leaping Lena operations, this time U.S. personnel would lead the teams. SOG's plan "provided for operations in three phases beginning with short-stay, tactical intelligence missions progressing to longer-stay intelligence missions progressing to long duration missions to develop resistance cadres."[24] It was a very ambitious design that the State Department opposed.

Although the Pentagon had persuaded the White House to lift the ban on Laos, the details still had to be worked out among the Defense and State departments and the CIA. As is often the case, the devil was in the details. A major bureaucratic fight ensued over the number of operations per month, the composition of covert recon teams, the ways that teams infiltrated, how far they could penetrate, and the kinds of operations executed.

By now, William Sullivan was the new American ambassador in Vientiane, Laos. President Kennedy had taken steps to empower his ambassadors to ensure that they were in charge of the country team in all U.S. embassies. He wanted to harness the Pentagon and CIA overseas, suborning them to the ambassadors. In 1962 all embassies received this notification.[25]

Under these guidelines, an ambassador could exercise real power. Sullivan, a real "details man," was more than willing to wield it. He earned the nickname the Field Marshal for the adroit way he fought over every detail of SOG operations in Laos. Sullivan was a skillful infighter who had done his apprenticeship with the master bureaucratic warrior Averell Harriman. If Sullivan was to have anything to do with it, SOG operations in Laos would be limited: the United States had to keep faith with the 1962 Geneva Accords.

In early 1965, President Johnson had appointed Harriman ambassador-at-large with responsibility for all Southeast Asia. His mission was twofold: to build international support for the U.S. war effort in South Vietnam and to attempt to move peace talks with Hanoi for-

ward. Both proved to be thankless tasks, leading Harriman to lose faith in the war effort. He also backstopped Sullivan's opposition to SOG operations in Laos. After all, they were his Accords, and the new ambassador-at-large for all Southeast Asia did not want the war to escalate.

In the late spring of 1965, Don Blackburn relieved Clyde Russell as the chief of MACVSOG and immediately found himself in the middle of this interagency conflagration over Laos. He believed something had to be done "to stop that flow coming down the trail." While Westmoreland concurred, Blackburn did not feel COMUSMACV was pushing hard enough. Sure, Westmoreland wanted to bomb the trail, but who was going to find the targets? Much of the trail could not be seen from the air. Blackburn decided to go to Washington and lobby for relaxing the proposed restrictions on SOG operations against the trail. He failed. It was no contest.

The proposed constraints on Shining Brass, the code name for SOG operations against the trail, remained largely unchanged. Sullivan dictated what SOG's covert recon teams could and could not do in Laos. His main concern—"that U.S. military personnel would be captured during these operations and paraded as flagrant violators of the 1962 Geneva Accords"—resulted in numerous limitations.[26] Teams could infiltrate Laos only on foot. Insertion by air was prohibited. The area of operations was a zone five kilometers deep and encompassed only a part of the 200-mile Laotian border. It was not a big area, only approximately fifty miles. The South Vietnamese Air Force could resupply or evacuate a team. Targets identified by SOG and approved by the embassy in Vientiane could be bombed, but only by U.S. aircraft based in Thailand.[27] There were no formal limits on the number of operations conducted in a month, but all requests had to pass through Vientiane. Consequently, the Field Marshal had de facto veto power.

These ground rules were finalized in September. It was not going to be easy for Bull Simons, the man Don Blackburn picked to organize this new division of SOG—OP 35. In the early summer of 1965, Simons had received a call from the Headhunter. He needed someone to run covert operations in Laos. The objective, Simons was told, was to interdict traffic on the Ho Chi Minh Trail. He would also be starting from scratch. However, that was only the half of it. Simons did not learn about Sullivan until after he arrived in Saigon.

Bull Simons Gets to Work:
Organizing to Cross the Fence

When the Pentagon had an impossible mission requiring a highly unorthodox approach, it called on Colonel Arthur D. Simons. Some of his "believe it or not" operations remain classified to this day. However, one is well known and illustrates the assignments he took on during his military career. In 1970, he selected and trained fifty-six men to fly 400 miles from Thailand to a location 20 miles northwest of Hanoi to rescue American prisoners of war. When the raiders arrived at 2 A.M. on November 21, they found that the POWs at Son Tay had been moved. Still, this was an extraordinary operation that was carried off almost flawlessly. The raiders suffered only two minor casualties, took care of business on the ground, and exfiltrated on schedule. If the prisoners had been there, Bull Simons would have brought them home. Son Tay was a mission made to order for him. Simons believed that "the more improbable something is, the surer you can pull it off."[28]

Blackburn knew Simons was perfect for SOG's new mission. It was not the first time he had called on Simons for help. Whenever Blackburn had a tough mission and "wanted it done right, a difficult job, the first person he called on was Bull Simons," noted Ray Call, who served as Simons's deputy in OP 35. Those who knew Simons agreed that he "was smart, he knew how to command the respect of the troops as well as the fellow officers, both junior and senior. He wasn't the least bit afraid. He was not cowed by rank. . . . He had no qualms whatsoever of being absolutely, brutally frank, whether it was with an enlisted man or a more senior officer. He told it like it was and he garnered respect. Those senior to him, if they wanted to get the job done, they asked him to be a part of it, a controlling part."[29]

Bull Simons was the obvious choice, but when Blackburn put in the request, the answer came back "No." The mainstream Army did not think he was qualified. General Westmoreland had established a requirement that any colonel serving at the MACV-headquarters level had to have graduated from one of the war colleges and be considered promotable to general officer.

Simons had not attended a war college; he was too busy executing highly classified unorthodox missions. Even if there had been time, he

still would not have been war-college selected. While his efficiency reports as a commander were top-notch, Simons was a reserve officer who had selected a career path far outside the U.S. Army's mainstream. Sure, he had ranger combat experience in World War II, an extensive Special Forces background, firsthand knowledge of Laos gained training local tribal groups to fight the NVA as part of the White Star mission in the early 1960s, and other derring-do achievements. But he had not been to a war college! Therefore, he was not fit for the assignment. This was preposterous, fumed Blackburn. But then, he knew personally what the mainstream Army thought of special operators. He had not been promoted for twenty years. He'd been the Army's youngest colonel at the end of World War II, but by 1965 no officer had held that rank longer.

In reality, no one in the U.S. military was more qualified to organize and command covert operations against the Ho Chi Minh Trail than Bull Simons. Blackburn pulled a lot of strings to get him to Vietnam, including "a special, written exception to Westmoreland's policy."[30]

Once in Vietnam, it did not take Simons long to figure out that his assignment was going to be one of the toughest yet. The enemy had a two-year head start expanding its Ho Chi Minh Trail network. Ray Call, Simons's deputy, believed Hanoi took full advantage of Washington's aversion to doing something about Laos: "In the period after I left in 1964 through 1965, things were building up pretty fast over there. . . . They started using that Ho Chi Minh Trail [much more extensively], and they weren't making any bones about it. You could see areas where they had to use bulldozers to cut passes and build bridges. A great many miles of it was under jungle canopy, but there were a lot of areas where it wasn't. The trail went pretty deep into Laos."[31]

North Vietnam's expansion of the trail created ample targets for OP 35 teams to pinpoint for air strikes. Furthermore, since the North Vietnamese had had a free ride for nearly two years, they were operating out in the open on many parts of the trail. This made them vulnerable, at least early on. Still, the abundance of targets was not a complete blessing, as Ray Call would note: "They were putting far more material in there than we could possibly destroy with team-designated air strikes. The more we destroyed, the more they moved

down. What we needed to destroy was the entry point for whoever supplied them, China or Russia. Once they got that material off-loaded, we had no limit on the number of targets that were available. It was a matter of how many teams you wanted to risk."[32]

Putting Together an All-Star Team

Simons's first order of business was picking a team of specialists to plan and execute the mission against the trail. He was able to get far better qualified people than SOG got in its formative stages. He began with Lieutenant Colonel Ray Call, an expert in unconventional warfare. Simons needed someone to plan the operations, establish a command-and-control headquarters in Da Nang, and accompany Shining Brass forward into the field. Ray Call had the right background for the job. He had joined the 77th Special Forces Group in 1959: "I had been commissioned in Germany during World War II and then I was two years in a combat role in Korea. . . . So, I felt that with two wars behind me it was about time I got into something that was a little more exciting than straight infantry." The answer was Special Forces. In 1960, Call took a team from the 77th to Vietnam to train Vietnamese rangers. Next, he was sent to language school "to learn Laotian." Call was to join one of Bull Simons's "White Star teams to Laos." With the signing of the 1962 Geneva Accords, he never got to use his Laotian.[33]

In 1964, Call was back in Vietnam working "border security . . . The North Vietnamese were coming down through Laos . . . and then into Vietnam at certain strategic points. Most of those points were in the III Corps area [located below the central highlands to just south of Saigon] where I was operating. I had twelve or thirteen border camps." Call's units were part of the Civilian Irregular Defense Group program. The rank-and-file were "everything from Montagnards to Nungs to delta people."[34] He gained experience working with Vietnam's ethnic minorities in those recon operations.

He went to work for Blackburn at the Special Warfare Branch of the Army's Combat Developments Command. This later led to a surprise assignment to MACVSOG. Call received a letter from General Westmoreland thanking him "for volunteering to come back to Vietnam." He "didn't know anything about it." Blackburn had vol-

unteered him for OP 35.[35] Call was the right choice to plan recon operations and establish a command-and-control cell in Da Nang.

Da Nang was over fifty miles from Laos. The next order of business in the fall of 1965 was to establish a launch site, or forward operating base (FOB), for the recon teams. Simons and Call selected a Special Forces border-surveillance camp at Kham Duc, only ten miles from Laos. To command it, they picked Major Charlie Norton, an "SF original" from the early 1950s whose career was full of special operations assignments in Europe, Asia, and at Fort Bragg. Blackburn grabbed Norton for the assignment. Norton explained: "When I arrived in country, I spent one day in MACV training. When Colonel Blackburn discovered this, he had it changed and I went over to MACVSOG after that."[36] Simons knew him as well, having worked with Norton at Fort Bragg's Special Warfare Center.

Simons had his FOB commander, and he next began looking for an operations officer for Kham Duc. He needed someone who knew how to operate behind enemy lines—an experienced hand who had actually done it, understood what was involved, and could prepare covert teams to sneak into Laos and operate against the trail. He picked Captain Larry Thorne.

Thorne's background was the stuff of novels. Born in Finland in 1919, he entered the Finnish army in 1938 and spent World War II conducting unconventional operations against the Soviet army. Stalin, after the Soviet-Nazi conquest of Poland in 1939, began addressing his security concerns in the Baltic region. Mutual defense pacts were extracted from Latvia, Estonia, and Lithuania, followed almost immediately by the deployment of Red Army troops to these states. He wanted a similar arrangement with Finland and planned to occupy its southern region. The Finns would have none of it, rejected Soviet demands, and mobilized forces along the frontier.

On November 30, 1939, the Red Army invaded with a million-man force. Finland countered with 300,000, half of whom were reservists. The Finns conducted an outstanding defense. It took fifty-four Russian divisions to subdue them, and on March 12, 1940, Finland capitulated. Stalin was willing to use his soldiers as cannon fodder in overwhelming, mass assaults. Finland suffered about 25,000 killed. Estimates of Red Army dead range from ten to twenty times that number.

Larry Thorne fought in the 1939–1940 war and kept on fighting even after it was over as a guerrilla. Germany invaded Russia in June 1941 and Finland allied with Berlin. Thorne kept on fighting, and his exploits became legendary. For example, in 1942, he took a commando unit deep behind Red Army lines and annihilated a 300-man convoy without losing a man. There were several other punishing operations in the Red Army's rear. Thorne was awarded every Finnish combat medal; twice he received the equivalent of the U.S. Medal of Honor. In September 1944, Finland surrendered to the Soviet Union. Thorne didn't. He joined the Germans, attended their school for guerrilla warfare, and then fought with their marines until the war ended.

The Soviets wanted to get their hands on Thorne and forced the Finnish government to arrest him as a wartime German collaborator. They planned to take him to Moscow to be tried for war crimes. Thorne had other plans. He escaped, made his way to the United States, and with the help of Wild Bill Donovan became a citizen. The wartime head of the OSS knew of Thorne's commando exploits and figured that war was no different than his earlier Wall Street business experience. You prepared for both by investing in "futures." The United States would need the talents of special operators like Larry Thorne in the years ahead.

Donovan helped Thorne join the U.S. Army. Not surprisingly, he found his way into the 77th Special Forces Group and in 1956 was commissioned a first lieutenant. With the advisory buildup in Vietnam, Thorne commanded a Special Forces team. He was decorated for valor and awarded a Purple Heart. It was the fourth time he had received a medal for wounds suffered in combat. His first three were from the Finnish government. Thorne was just what Bull Simons had in mind for Kham Duc's operations officer.

Finally, there were the Special Forces sergeants, the men who would lead SOG's teams "across the fence." From late 1965 until the end of U.S. involvement in the war, they fought it out with the NVA in Laos and Cambodia. One would be hard-pressed to find a braver or more daring group of soldiers. Several would be awarded the Medal of Honor. As time passed, SOG recon missions became increasingly perilous. Among OP 35's recon teams, "Purple Hearts were earned at a pace unparalleled in American wars of this century."[37] It was the price of taking on the NVA on its turf.

The most legendary of these amazing sergeants was Dick Meadows. On June 6, 1997, a monument was dedicated in his honor at Fort Bragg. The ceremony was attended by many of America's most renowned special operators from the Cold War, including those who served with Meadows in MACVSOG. The award from the ceremony reads, in part: "During more than thirty years with the Army, from the Korean War through the Vietnam War to the Iranian Hostage Rescue, Dick Meadows epitomized the meaning of the Quiet Professional. His battlefield actions are the stories from which legends are made."

Dick Meadows was born in a dirt-floored cabin in Virginia, the son of a moonshiner. He lied about his age to join the Army in 1947. As a paratrooper, Meadows distinguished himself in combat during the Korean War, becoming that conflict's youngest master sergeant at age twenty. In 1953, he joined the 10th Special Forces Group, and remained in Special Forces or Ranger units for the rest of his career. In 1960, Meadows was the first noncommissioned officer in an exchange program with the elite British SAS. While there, he participated in operations against terrorists in Oman, serving as a troop commander, a position normally held by an SAS captain. He was awarded SAS Wings, one of only two foreigners ever to receive them.

In the early 1960s, Meadows had been part of Bull Simons's White Star project in Laos, training Kha tribesmen to fight the NVA and Pathet Lao. Not surprisingly, he was picked for MACVSOG's new mission in early 1966. Meadows was exactly the kind of recon team leader Simons was looking for. For the next two years he led Chinese Nung mercenaries behind enemy lines in Laos and North Vietnam. His exploits were extraordinary. For example, he filmed NVA regulars coming down the trail, providing unambiguous evidence that Hanoi was lying about its noninvolvement in Laos. Meadows personally briefed General Westmoreland, taking him "to the movies." He also proved that the Soviets were arming the NVA with artillery, when he led a team into an NVA cache in Laos. They photographed the weaponry and brought back Soviet artillery sights. He also held the SOG record for the number of enemy prisoners captured and brought back across the fence.

While Meadows may well be the most notable example, MACV-SOG attracted many highly skilled and talented NCOs from the ranks of the Special Forces. Simons drew them to SOG. For the next five years, these brave men caused Hanoi a good deal of grief. They took

on the NVA and earned the reputation of being a threat to the enemy's use of the trail.

SOG's covert reconnaissance teams generally consisted of three Americans and nine tribal-minority soldiers. Initially, the indigenous team members were Chinese Nungs who had immigrated to Vietnam decades earlier from China's Kwangi Province. They first settled along the mountainous eastern segment of the Chinese-Vietnamese frontier, about 120 miles north of Hanoi.[38] During the first Indochina War, the French had recruited Nungs and other tribal minorities to fight on their side. They served in counterguerrilla units led by French officers and NCOs, a standard French colonial practice. Most tribal minorities had no love for majority ethnic groups, who almost always treated them with disdain. The Vietnamese tribal minorities, including the Nungs, fit this colonial pattern. They had intense enmity for ethnic Vietnamese.[39]

Following the French defeat in 1954, many Nungs moved South to escape communist retribution. They were ideal for SOG's recon teams—and were available. Ironically, the South Vietnamese government considered them unfit to draft into the ARVN. Ray Call saw it quite differently. He believed the Chinese Nungs were "far better combat soldiers than the average South Vietnamese. . . . They were good fighters." When Call joined SOG, he recruited Nungs and they became "the majority of his recon teams."[40]

As Shining Brass expanded, Montagnards, or "mountain people," as the French had referred to them, were recruited for new teams. They were the largest minority in South Vietnam, living mainly in the central highlands region.[41] As with the Nungs, the French had taken advantage of Montagnard distrust of the ethnic Vietnamese. Again, it was a classic divide-and-conquer tactic. France had found ways to reinforce cleavages between the highland tribes and ethnic Vietnamese.

As the Kennedy administration expanded U.S. involvement in Vietnam, the highlands came to be seen as a critical region. It was a vital Viet Cong area, through which they infiltrated forces and supplies. The VC tried to win the Montagnards over to their cause but without much success.[42] The United States first recruited the Montagnards into its counterinsurgency programs in 1961. The CIA employed them for intelligence operations and defense against communist attempts to gain control of the highlands. This became the Civilian Irregular Defense Group program.

Not surprisingly, when SOG Chief Jack Singlaub was directed by MACV to escalate covert operations against the trail, he turned to the Montagnards.

Organizing OP 35

OP 35 was principally a field organization with a small headquarters staff in Saigon. Its command-and-control detachment, located at Da Nang, was tasked to "supervise the FOBs; prepare operations orders; coordinate with various supported and supporting elements; and coordinate communications, administration and logistics support for the FOBs."[43] To execute operations, recon teams launched from forward operating bases near the Laotian border. The first was located at Kham Duc. In late 1965, five recon teams—Iowa, Alaska, Idaho, Kansas, and Dakota—were assigned to it.

Teams were permitted to enter Laos only on foot, not by helicopter, and were limited in terms of where they could cross the fence. The border between Laos and South Vietnam, which ran from the DMZ south to Cambodia, was 200 miles in length. But SOG recon teams in 1965 could cross into Laos only along a portion of that border, starting about fifty miles south of the DMZ. This makes clear just how much Bill Sullivan was able to sequester covert operations against the trail. His restrictions became odious to Simons, especially after Sullivan managed in 1966 to prevent recon teams from penetrating deeper than five kilometers into Laos.

As a result of OP 35's early achievements in 1966, Washington ordered SOG to increase the number of missions and extend operations to the entire 200-mile-long border; the depth restriction remained, however. Simons had to increase the number of recon teams from five to twenty and added reaction companies to OP 35. The latter were to hit targets identified by recon teams. A second forward operating base was established at Kontum, and the one at Kham Duc was relocated just outside Hue at Phu Bai in the northern part of South Vietnam. From here, SOG recon teams could hit targets in Laos from the 17th parallel to the Ashau Valley. This was approximately half the border region. The other half was covered by a new FOB at Kontum, in the central highlands.[44]

Two additional detachments—Command and Control Central (CCC) at Kontum and Command and Control South (CCS) at Ban Me

Thuot—were added to OP 35's field organization by 1967, reflecting MACV's demand for even more operations against the trail. Each detachment maintained two forward launch sites. The Command and Control North (CCN) mission area was from the 17th parallel to the Ashau Valley, while CCC covered the rest of Laos. CCS focused on Cambodia, which was assigned to OP 35 in May 1967.[45]

In two years, the embryonic organization created by Bull Simons had grown considerably. Its three detachments had a total of 110 officers and 615 enlisted personnel.[46] There are no records of how many indigenous members were in each detachment, but the number was substantial, for assuring that each command-and-control detachment had thirty teams would have required over 800 Nungs, Montagnards, and other minorities. Adding six reaction and three security companies, the number of indigenous personnel surely reached into the thousands. This growth necessitated development of a complete training facility to prepare the tribal minorities for covert operations.[47]

Missions Against the Trail

Once Blackburn received the go-ahead to start covert cross-border operations, this new SOG mission reflected the big plans he had in mind. Blackburn intended to replicate Bull Simons's successful White Star project.

Blackburn's original design called for a three-phase program. First, recon teams would be infiltrated into Laos to identify NVA headquarters, base camps, and supply caches. Once found, they would be attacked by air strikes. Phase two involved deploying of company-size units cross-border to execute strikes against NVA facilities uncovered by recon teams. Finally, indigenous tribesmen in the areas surrounding the trail would be recruited and organized into resistance cadres for long-duration operations against the NVA.[48] It was an ambitious blueprint.

Phase three was a replay of White Star, whose objective had been to train indigenous Kha tribesmen to fight the communist Pathet Lao, employing guerrilla tactics. White Star had worked. According to Blackburn: "We took the Bolovens Plateau and held it until the Geneva Agreement in 1962. . . . We put the cork in the bottle during White Star, and it was to our advantage."[49] The Bolovens Plateau was

"the key area for north-south movement" in Laos. Blackburn explained, "At that time the Pathet Lao were controlling the Bolovens. Bull Simons developed an operation that ran the Pathet Lao off the plateau."[50] If it worked once, why not again?

Blackburn intended to "put the cork back in the bottle" and cut off the NVA in Laos. His plan was to "move toward the Xe Kong river. The Bolovens Plateau was on the west side of the Xe Kong. . . . When we were talking about pushing over to the Xe Kong River, it was to work with those Kha tribesmen in there to preclude the North Vietnamese from pressing them into labor and other duties on the trail. So, it was to deny these [indigenous tribal] people to the enemy. Now, in doing that denial, this would evolve into a guerrilla element."[51] Blackburn was on a roll. SOG would turn the clock back to the successful White Star days.

There was only one problem with Blackburn's master plan: Ambassador Sullivan had to agree. The Headhunter's three-phase blueprint was dead on arrival in Vientiane. Sullivan had opposed any role for MACVSOG in Laos. After Blackburn received authorization to operate against the trail, the ambassador fought a highly effective rear-guard action to restrict SOG activities as much as he could. He was not about to endorse this three-phase program. According to Blackburn, "Ambassador Sullivan wouldn't go along with it" and blocked it.[52] It would not be the last time he had his way with SOG.

Ray Call's assignment, as deputy chief of OP 35, was to execute Blackburn's phase one: "We weren't going in on a combat operation. . . . We were there to locate a target and call in an air strike on it."[53] By the time Call arrived in the fall of 1965, the rest of Blackburn's master plan was ancient history. Call noted that "during my period we were never tasked to do any of that. . . . There was no long-range goal that we were supposed to meet. What we were supposed to do was to interdict the Ho Chi Minh Trail by means of recon teams identifying targets for air strikes. There was no intent whatsoever for us to go in there on a resistance mission."[54]

A review of Shining Brass operations reveals that their primary mission remained the interdiction of the trail by covert recon teams to identify targets for air strikes. Other missions, though, were added, including the capture of enemy soldiers—referred to in the SOG lexicon as a "snatch." While these captures were difficult to execute, pris-

oners could provide valuable current intelligence, for instance, on the intentions of specific enemy units.

Recon teams conducted bomb damage assessments (BDA) following air strikes by B–52s in Laos. They photographed the damage and counted the enemy bodies. Teams placed taps on North Vietnamese land lines of communications and recorded conversations, mainly between NVA headquarters and combat units.

In June 1967, a project called Mussel Shoals was begun at the direction of Secretary McNamara. It involved the use of sensors to electronically monitor enemy movements in jungle areas. In Laos, the application of this electronic battlefield concept was intended to cut traffic on the Ho Chi Minh Trail. It involved thousands of electronic sensors and a computerized nerve center in Nakhon Phanom, Thailand. Once movement was detected, information would be relayed to the Air Force for a bombing strike. The sensors were inserted mainly by air although some were hand-carried in by SOG recon teams.

Recon teams were also used to rescue U.S. personnel evading enemy capture or being held as prisoners. In September 1966, Pacific Command established the Joint Personnel Recovery Center (JPRC) as a separate staff division within SOG. Recovery operations took two forms: "raid type operations against known or suspected enemy prisoner of war camps"; and "the search of an area where personnel who are evading, or who have escaped, are known or strongly suspected to be."[55] These efforts were called Bright Light missions.[56]

In addition to recon teams, OP 35 also developed larger reaction/exploitation companies whose missions included route interdiction, ambush and raids, recon-team rescue, short-term area denial, and cache destruction.

The Chain of Command and the Field Marshal

The same stringent mission authorization and execution procedures assigned to the other operational divisions of SOG applied to OP 35. Thus, each month, it prepared a mission schedule for the next thirty-day period. It was submitted to Westmoreland for approval and then sent to Pacific Command for comment. Next, it went to the Office of the Special Assistant for Counterinsurgency and Special

Activities (SACSA) in the Pentagon, which coordinated the requests through the Defense and State departments, CIA, and White House. Even after a schedule of missions had been authorized, the oversight process was not finished. The same chain of command had to be cleared to execute each specific operation. As extraordinary as these approval procedures were, for Shining Brass there was an additional hurdle. The ambassador in Vientiane had to give his blessing. It proved to be the toughest step in the oversight process. For example, it took Blackburn nearly a year of battling to get Shining Brass extended to the entire Laotian border region.

If the devil was in the details, Sullivan proved to be the grand master of that game, as three chiefs of MACVSOG would attest. What "Sullivan wanted to do to restrict us was to confine our recon teams to two small grids," Don Blackburn, the chief of SOG in 1965, would recall. "I don't know why he gave us a 20x5 grid here and 20x5 grid there; I never understood that."[57]

Jack Singlaub, who replaced Blackburn in 1966, groused about the Field Marshal as well. "Bill Sullivan insisted that he control everything on his side of the border, including these [Shining Brass] operations. Of course, that border was not a well-defined area." Nevertheless, if Sullivan felt a SOG operation violated his restrictions, "he would send out a blast that I was operating out of control and was crossing into territory for which I had no authority. He would make a big issue of this . . . and accuse us of deliberately violating our arrangements." Singlaub met with "Ambassador Sullivan at least once a month. Sometimes, when there was a flap, we would go more frequently. Quite often, General Westmoreland would go along." Singlaub remembers that after one particularly heated session, "General Westmoreland made the comment" that Sullivan "acted like a warlord."[58]

Sullivan was still at it when Steve Cavanaugh took over SOG in 1968. Every operation still had to be cleared in Vientiane. At one point, Cavanaugh recalled, he was trying to get permission to launch teams deeper into Laos "beyond the depth [restriction]. . . . Every time I did this, I had to get Sullivan's permission. Sometimes it was allowed, sometimes it wasn't."[59] He "visited Vientiane a number of times" but found the embassy was "adamant about permission. If you want to go deeper," they told him, "let us know and we'll approve it,

but on a case-by-case basis." Next, Cavanaugh asked the SACSA to try to get him "authority to launch deeper" into Laos. "Nothing ever came of it, nothing at all."[60] He thought he could end run Sullivan. That was not very likely.

It had become too much for Bull Simons to stomach in 1966. Sullivan frequently complained about recon-team violations, remembered Ray Call. He would "file complaints" with MACV. "He had MACV scared of him as far as I can see."[61] While Simons might not be able to outfox Sullivan in an interagency bout over restrictions, he found another way to send his teams deeper into Laos. He simply redrew the border between South Vietnam and Laos.

According to Call, "We met up at Bull's hotel room in Saigon. He had a map on cardboard. . . . He said, 'We'll change the border, it's just approximate anyhow.'" Simons then took a ruler and moved the border "approximately twenty kilometers" west by "putting little red dots down along the border and then connecting all of them. After he finished, the Bull said [to Call], 'I'll have these new maps [drawn up] for you in three days.' . . . He hand-carried them over to the engineers and they made up a stack of maps with the old border missing and with the new border in its place. It took about twenty kilometers of Laos and gave it to Vietnam. It was always disputed anyhow. Bull settled the dispute."[62]

Simons got away with it. When asked whether the embassy in Vientiane ever found out about this cartographic chicanery, Call answered: "They never said anything to me about it . . . I think I would have heard. It was serious enough, and they would have told me to cease and desist."[63] It was one of the few times SOG put one over on Sullivan. But then, there was only one Bull Simons in the U.S. Army.

FIGHTING IT OUT WITH THE NVA ON THE TRAIL

By the fall of 1965, the details had finally been agreed to and five recon teams were ready to cross the fence. The mission was completely covert; teams infiltrated into Laos were "sterile." They wore no rank or unit insignia, and their uniforms were made elsewhere in Asia specifically for SOG. The weapons carried were non-U.S. They had been acquired clandestinely and could not be traced. Teams had nothing on them that could identify who they were.

Russians always exhibited in getting him, it is quite possible that Major Thorne was intercepted, or forced down, and taken alive back to the Soviet Union."[66] There is no evidence to substantiate such claims. However, it is also a fact that evidence of Larry Thorne's demise was never found by SOG.

Operational Success and Mission Expansion: 1966–1967

SOG's initial accomplishments impressed the brass. As a result, they expanded Bull Simons's area of operations in Laos and charged him to increase the number of missions in 1966. MACV's senior leadership wanted to strike at the "enemy's logistic system and lines of communication in southern Laos."[67] The military ramifications of Hanoi's buildup of the trail had finally become clear: it permitted the NVA to escalate the war in the South.

SOG teams were bringing back substantial evidence of North Vietnamese activities that could not be detected by aerial photography. There was more going on in Laos than a handful of VC guerrillas hiding out. Westmoreland wanted to lift the restrictions under which Simons's teams had to operate. He proposed "using helicopters for infiltration" of recon teams. "While initial operations were deemed successful, penetrations had been extremely shallow. With infiltration by helicopter . . . overall effectiveness would be enhanced appreciably."[68] Admiral U. S. Grant Sharp, the commander in chief, Pacific (CINCPAC), also wanted to turn SOG loose. Like Westmoreland, he was impressed with the exploits of the recon teams. According to Ray Call, Sharp sent several "well-done messages" following his review of operations.[69]

Ambassador Sullivan had other ideas. He was not about to abandon the restrictions he had imposed on operations against the trail. In the negotiations that followed, there was some easing of the initial constraints. In April, a joint State-Defense agreement established the following modification: "[T]he use of helicopters for infiltration of teams was approved." However, the "depth of [helicopter] penetration into Laos was not to exceed five kilometers." The inserted team could go five miles further on foot. As a consequence, a team now could operate in a zone ten kilometers inside Laos, along the entire 200 miles.[70] Sullivan had conceded five kilometers.

The brass at MACV and Pacific Command were clamo
operations to begin as quickly as possible. They wanted result
October to the end of the year, seven recon operations were ex
These early actions, according to Ray Call, caught the enem
guard. SOG had the element of surprise.[64] The results were enco
ing. SOG teams found plenty of NVA targets for air strikes. In o
the first actions, a large NVA supply depot was identified. On and
operation, a team located a truck park and fuel-supply facility. A
37 air strikes, numerous secondary explosions continued to
recorded for some time. Other missions identified bridges, additio
truck parks and fuel depots, storage sites, and other NVA faciliti
The bomb-damage reports were promising, frequently claiming th
the targets were "80–100 percent destroyed."[65]

It was just what the brass had hoped for. Important enemy targets
were being destroyed. Bull Simons had Shining Brass off to a fast
start. However, success was not without cost. On one of the first mis-
sions in October, a team was launched to recon a site suspected of
concealing a major enemy logistics base. Inserted by two H–34 heli-
copters at a landing zone (LZ) along the border, the unit crossed into
Laos on foot. Intelligence had warned of significant enemy activity in
the region. Because of this and reports of bad weather, it was decided
to send a third H–34 in case a rescue might be needed. Larry Thorne
was on the third helicopter.

In spite of heavy fog, the area was successfully reconnoitered by a
forward air controller (FAC) in a small Cessna O–1, and the team
inserted at the preselected LZ. As night approached and heavy fog
closed in, the two lead helicopters headed back to Kham Duc. Thorne
remained overhead, waiting to hear from the team that it was safely
on its way. When he received the signal that his men were safe, he
instructed the pilot to return to base. By then the fog had eliminated
almost all visibility. The H–34 and Thorne disappeared into the dark-
ness, never to be heard from or seen again.

Extensive searches of the area failed to turn up any evidence of
Thorne, the pilot, or the helicopter. Operating across the fence had a
high price. A true legend was lost. There was much speculation about
what had happened to Larry Thorne, in light of his World War II
exploits against the Soviet army. One officer who served in SOG spec-
ulated that "Given Larry's background and the extreme interests the

The brass wanted "authority to organize three 540-man battalions of Nungs as an exploitation force for Shining Brass . . . CINCPAC recommended approval."[71] The purpose was twofold. First, they would provide security for OP 35's launch sites (FOBs), which needed protection from enemy attacks. Second, exploitation units could strike targets identified by recon teams in Laos. They could also help rescue teams in trouble. Each Nung battalion consisted of "a Hornet Force of platoon size, a Havoc Force of company size, and a Haymaker Force of battalion size."[72] White House approval, Westmoreland told Sharp, was contingent on "agreement by the U.S. Embassy in Vientiane."[73]

Sullivan acquiesced, but with conditions: "[E]xploitation force operations will be limited to platoon size with not more than three U.S. advisers; penetration into Laos will be limited to 10 kilometers; duration of operations will be limited to approximately five days; notification of intent to launch will be given to the U.S. Ambassador, Vientiane, 48 hours in advance."[74]

In spite of these onerous restrictions, Bull Simons had a good year in 1966. A total of 111 recon operations were executed, reaching "a high of fifteen per month in September."[75] Recon teams under the command of Charlie Norton, who ran OP 35's forward operating base at Kham Duc, were finding significant enemy supplies and facilities across the fence in Laos. "We found a whole bunch and we caused them a lot of grief, a lot of problems." Norton believed that "if that kind of an effort had been directed all along the trail, we could have disrupted it."[76] It was a good start, but given the restrictions, Norton felt that it "was a pinprick to Hanoi."[77]

Besides identifying targets for air strikes, SOG recon teams executed other operations. In 1966, for example, "15 prisoners were captured" by SOG teams.[78] Several were brought out by recon team leader Dick Meadows who, on one occasion, captured two at once. As his team lay in wait a group of five NVA walked right by. Meadows jumped out and announced to the stunned enemy soldiers that they were now his prisoners. Three of them challenged Meadows and he shot them dead in an instant. The other two decided Meadows had made them an offer they could not refuse.[79] OP 35 also executed Bright Light missions to rescue downed U.S. pilots evading enemy capture or Americans being held prisoner. The first was carried out

inside North Vietnam on October 1 and was led by Dick Meadows. The team just missed rescuing the pilot. He was captured by the enemy less than one mile away from Meadows's recon unit. A total of four rescue missions were conducted during 1966, according to the records, "one in-country, two in NVN, and one in Laos. The last mission recovered the pilot."[80] Finally, thirteen exploitation force operations were executed, all platoon-size missions consistent with Ambassador Sullivan's prerequisites for operations in Laos.[81]

Most recon missions in 1966 took three to five days. If a team "made contact with the enemy or discovered targets, the FAC [forward air controller] called in tactical air support." The recon team leader "directed the air strikes by communicating with the FAC." When it was time to bring the team out, "gun and troop ships were launched and the exfiltration took place." The troops involved might include a Hornet Force (code name for SOG platoons) especially if the team was actively engaged with enemy forces at the time of its extraction.[82] If it was really hot, tactical air support was called in to hold the NVA at bay. Although a team consisted of only twelve men, a mission could involve extensive support forces.

Adding to the success of operations in 1966 was the fact that in spite of the high risks involved, casualties were held down (although this would change in later years). According to the records, "[F]riendly losses included three U.S. and 16 VN KIA and five U.S. and 25 VN MIA."[83] Ray Call attributed this to the element of surprise: "[T]he North Vietnamese didn't have any idea that somebody was going to go in there and call in an air strike on them. It [the trail] wasn't secure."[84] Charlie Norton concurred: "I honestly think that they didn't see us in the original areas we went into."[85] It was a real advantage. Of course, surprise has to be exploited, and that's when Bull Simons was at his best. Shining Brass would not be the last time he put one over on Hanoi by doing the improbable.

Success in 1966 led Pacific Command to insist on "increased ground reconnaissance operations in Laos" in 1967. MACV also wanted more, and in February proposed the following changes in the restrictions imposed on Shining Brass. First, the depth limitation would increase to 20 kilometers for recon teams and the helicopter used to insert the team. Two, the size of an exploitation force would no longer be confined to one platoon. MACV wanted to employ mul-

tiple platoons "to exploit suitable targets and routes vulnerable to ground interdiction."[86] Finally, the number of recon teams would increase to "perform up to 42 missions per month." These changes were enacted in March, at which time the code name Shining Brass was replaced by Prairie Fire. The exploits of OP 35's teams were weakening Sullivan's grip.

These changes made a difference. Operations in 1967, according to MACVSOG's end-of-year report, were "marked by expansion in scope and in tempo, the introduction of new concepts, and the elimination of some restrictions which had previously impeded a full utilization of assets."[87] The report left out that a higher casualty rate was the price paid to attain this growth.

Prairie Fire teams executed 187 missions. Identifying targets for air strikes remained the core of OP 35 efforts. Additionally, 68 exploitation operations were carried out.[88] Lieutenant Colonel Jonathan Carney, the deputy chief of OP 35 in 1967, believed that "we hurt North Vietnam . . . killed a lot of people, and caused them to expend a lot of capabilities trying to prevent our operations. It hurt their logistic effort to an immeasurable degree."[89] Pacific Command and MACV saw it the same way and pushed for more operations. Hanoi also was taking notice and began developing a range of countermeasures to protect its Laotian investment.

OP 35 expanded its repertoire of activities beyond what it had performed in 1966. It became part of Secretary McNamara's aforementioned anti-infiltration system. "[I]n December, 1966 the Secretary of Defense directed that an electronic system be developed and implemented to inhibit infiltration of men and equipment from North Vietnam and Laos into South Vietnam. This system was designated the Mussel Shoals anti-infiltration system."[90] Also known as "McNamara's fence," it involved seismic and acoustic sensors to detect enemy movement. When a target was identified by these "people sniffers," an air strike was to be called in to destroy it. SOG teams carried the sensors into Laos to emplace them. It was not a mission they welcomed because the sensors were heavy and cumbersome. Frequently, a team had to move fast because the enemy was often in hot pursuit. The sensors might slow them down.

The biggest change in 1967 was the addition of Cambodia to SOG's area of operations. North Vietnamese activities in Cambodia

had started to worry MACV back in 1965. It was evident to Westmoreland's field commanders that the NVA had developed significant infiltration routes, command centers, bases, and supply facilities there. The fact of the matter was that the Ho Chi Minh Trail did not end at the Laotian-Cambodian border, even though SOG teams had to stop at that point. NVA troops and supplies kept right on going. SOG teams actually observed this, but once the enemy was over the border, they could not call in air strikes. Cambodia was off-limits, constituting even more of a safe haven than Laos.

Hanoi, of course, did not draw the same geographical boundaries around the war that Washington did. All of Indochina was its war zone, not just South Vietnam. Moreover, the extension of the trail into Cambodia was only half of it. The North Vietnamese were also purchasing considerable quantities of rice from the Sihanouk government and transporting arms through the port at Sihanoukville to NVA units fighting in South Vietnam.

MACV had requested as early as the end of 1965 authority to carry out military actions "wherever U.S. troops operated in areas adjacent to the Cambodian border." Something had to be done about enemy sanctuaries and staging areas. Westmoreland wanted to be able to call in artillery and air strikes against enemy weapons firing from Cambodia at U.S. troops, send U.S. troops over the border in hot pursuit of the enemy, use observation aircraft for "surveillance missions within a 10 kilometer strip on the Cambodian border," and employ covert recon teams "to a depth of five kilometers on the Cambodian side of the border."[91] MACV argued that authorization of these operations should be granted "because they were necessary to the defense of South Vietnam."[92] To the military brass in Saigon, it seemed a reasonable request.

Washington turned it down. The State Department would not concur. Even though Prince Sihanouk was playing ball with Hanoi, the geostrategic thinkers at Foggy Bottom, as the State Department is sometimes called, believed the prince could still be won over through crafty negotiations. Even as evidence of North Vietnamese activities accumulated in 1966, State continued to cajole President Johnson to keep Cambodia off-limits. It claimed to be making progress with the prince. Furthermore, it argued, evidence of Hanoi's involvement in Cambodia was sketchy. LBJ was persuaded. He also feared the domestic political repercussions of widening the war into Cambodia.

In 1967, General Westmoreland pressed again for the authority to send SOG recon teams into Cambodia for a look-see. At minimum, he believed, they could "provide early warning of enemy movements," to permit "the timely deployment of friendly forces to counter [them]." State fought the idea, but this time it would lose out. In May, MACVSOG was directed to start cross-border operations in Cambodia. The mission was code-named Daniel Boone, its purpose was "intelligence collection primarily in the tri-border area" of Laos, Cambodia, and South Vietnam.[93]

It was a big win for MACV, but the operational details still had to be worked out. The geostrategists at Foggy Bottom dug in and proved to be as adept as Sullivan at fighting over the particulars. State produced more than its share of skilled details men. The "constraints were many," according to declassified documents,[94] even more constricting than the ones imposed in Laos. First, the area of operations was limited to the northeastern half of Cambodia, from the border with Laos, adjacent to South Vietnam's central highlands south to an area known as the Fishhook. This region, shown on the following map, was heavily occupied by the enemy and included the NVA's main headquarters in the South, known as COSVN (Central Office for South Vietnam).[95] Areas south of the Fishhook remained off-limits to SOG. Once having crossed the border, a team could go no deeper than five kilometers.

This was only part of what Foggy Bottom was able to mandate. SOG teams had to walk in and out of Cambodia. Helicopters could only be used for "exfiltration . . . in emergency situations." No tactical air strikes or commitment of exploitation forces were authorized. Once over the border, a team was on its own, no matter how dangerous the situation might become. Time on the ground was to be "held to the minimum time required for investigation." Teams were to "avoid contact" and "engage in combat only as a last resort to avoid capture." Finally, the number of missions should "not exceed ten in any 30 day period."[96]

The restrictions made those dictated by Sullivan almost look moderate and limited what Daniel Boone could accomplish. By summer, Pacific Command and MACV were insisting on relief from them. They claimed that critical enemy targets were being missed. To the SOG teams, it seemed like a ridiculous way to fight a war, but then, they were not schooled in geopolitics. The constraints imposed on

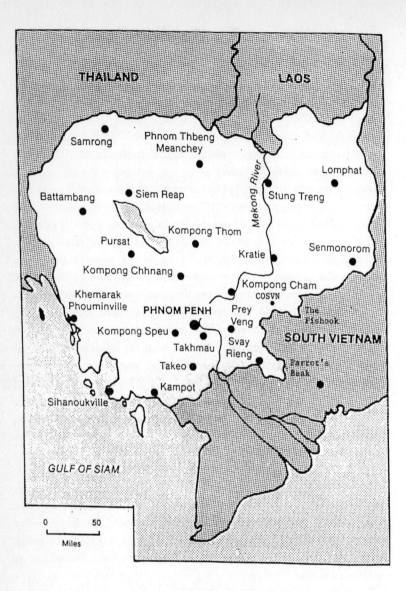

MAP OF CAMBODIA
(Harry Summers, *Vietnam War Almanac*, p. 105)

SOG operations in Cambodia were hard to fathom, given how Hanoi was conducting the war.

By August, the Pentagon squeezed some concessions out of the State Department. Authority was "granted for the employment of helicopter-lifted Daniel Boone teams to a depth of 20 kilometers along the entire Cambodian border." However, the other "operational restrictions . . . remained in effect."[97] By the end of the year, forward air controllers (FAC) were permitted "visual reconnaissance of target areas, selection of landing zones, communications relay and control of helicopter troopships and gunships during infiltration and exfiltration."[98]

Daniel Boone paid dividends despite all the obstacles. The teams found a substantial NVA presence in Cambodia. Hanoi had extended the trail south from Laos and laced it with NVA troops, base camps, supply depots, weapons caches, command bunkers, and the central office for South Vietnam (COSVN). SOG teams were providing intelligence on enemy activities that could not be obtained from any other source. From July 1 through December 31, "99 Daniel Boone reconnaissance teams launched from the tri-border area south to the Fishhook. . . . Sixty-three teams were successful in entering Cambodia."[99]

Overall, 1967 was another good year for OP 35. The number of successful operations more than doubled. In Laos, SOG teams were finding targets, while in Cambodia they collected intelligence that gave MACV a picture of NVA activities. However, increasing success entailed increasing costs. The number of Americans who died on those missions rose from three in 1966 to forty-two by the end of 1967. Fourteen others were missing.[100] SOG men often found themselves in real melees on the trail, fighting against much larger enemy forces. This is what Lieutenant George Sisler's OP 35 platoon encountered during a bomb damage assessment in January 1967. No sooner had it landed in Laos than the SOG unit was hit by an NVA company that was soon reinforced with additional troops. The situation quickly turned desperate. Sisler's heroic actions that day earned him SOG's first Medal of Honor. He not only repulsed the NVA onslaught almost single-handedly but also directed the helicopters in for the rescue. Lieutenant Sisler died doing so. His story of extraordinary bravery was repeated many times in 1967 by the men of SOG.[101]

Official reports on Prairie Fire and Daniel Boone contain an impressive array of facts and figures. OP 35 had expanded its scope and tempo, introduced new concepts, and added to its repertoire of activities. However, these reports skirt the big question of whether OP 35 was hurting the enemy. There is no doubt that it was having an impact, as the following MACV report details: "Prairie Fire operations have been effective and have achieved significant results in harassing and slowing the enemy. They have caused the enemy to shift some of his infiltration routes to areas further from SVN with a consequent increased time for transit and a greater opportunity for TAC [Tactical Air Command] air exploitation." Furthermore, the enemy had to become "concerned for his LOCs [lines of communication] and to expend his resources on security that might otherwise be employed in SVN."[102]

Extensive countermeasures developed by the NVA would reveal that the operations initiated by Bull Simons worried Hanoi. But the trail was central to Hanoi's strategy, and the real question was not whether OP 35 operations were hurting the NVA. They were. The issue was how much. Were they having a critical impact? Earlier, Charlie Norton described it as a "pin prick to Hanoi." Perhaps Ray Call summed it up best when he alluded to the SOG-NVA mismatch that existed on the trail. Hanoi began building the trail in 1959. In 1964, it greatly expanded that effort. As Call observed, the changes were considerable.

Bull Simons had caught the NVA off-guard in Laos and put it on notice that the free ride on the trail was over. The message was clear: the U.S. Air Force could pay you a visit. And it did. Throughout 1966 and 1967, tactical aircraft (TAC) hit SOG-identified targets repeatedly. However, once the NVA understood how the teams operated and developed an array of countermeasures in response, that mismatch which had shrunk would become greater. SOG faced bigger difficulties in operating across the fence in 1968 and 1969.

Mission Expansion and NVA Countermeasures: 1968–1969

In Vietnam, the first week of the lunar new year is an important time of celebration and ceremony. The Vietnamese believe that this period of reflection, commemoration, and ritual will determine one's

fortunes for the rest of the year. The leadership in Hanoi hoped for big victories in 1968 and kicked it off with a major offensive during the lunar new year celebration. The events of that week, which began on January 30, spread throughout South Vietnam. It was a sign of things to come. For Washington, the Tet offensive signaled that U.S. fortunes in Vietnam would suffer some severe blows in 1968 and beyond. It would turn out to be a watershed year for the Johnson administration.

For two years prior to the Tet offensive, American military and political leaders had reported progress in the war. General Westmoreland, only a few months before Tet, had claimed that military trends were increasingly favorable and that within two years U.S. troop withdrawals could begin. He could see "light at the end of the tunnel." Tet shattered that optimism, even though it technically was a military victory for the United States. By February, it was clear that Westmoreland's expectations had been delusionary. Tet hit the White House hard and jolted the American public. Even supporters began to counsel President Johnson to get out of Vietnam. On February 27, the dean of American newscasters, Walter Cronkite, urged the administration to disengage. The broadcast was a hammer blow to LBJ, who remarked: "If I've lost Cronkite, I've lost Middle America."[103]

Another hammer blow fell in March when the "Wise Men," a group of experienced American diplomats and former public officials whom the administration had called on to help Johnson decide what to do about Vietnam, urged him to get out. It was too much for LBJ. On March 31, before a nationwide television audience, he announced his decision to unilaterally halt the bombardment of North Vietnam, press for peace talks with Hanoi, and not seek reelection. For the remainder of his presidency, Johnson looked for ways to accelerate the Paris peace negotiations. In early November, this included accepting Hanoi's "price for peace" conditions for proceeding with the talks. It was a major sea change in U.S. policy and strategy.

The year 1968 was also a watershed for MACVSOG. Johnson's willingness to accede to Hanoi's "price for peace" conditions amounted to a shutdown of most SOG operations up North. Covert operations against the trail in Laos and Cambodia also suffered in 1968. For half the year, SOG recon teams and exploitation forces were redeployed inside South Vietnam's borders, supporting U.S. field

forces fighting to turn back the Tet offensive. Once it wound down, OP 35 refocused externally. What they found was a very different situation across the fence. Tactical advantages they had enjoyed dissipated in the face of NVA countermeasures. For two years, SOG teams had used surprise, diversion, deception, and operational deftness to outfox the NVA on the trail. However, by 1968, according to a former team leader, "the enemy's Laotian defenses" had become "redundant, layered, and in depth."[104] Hanoi knew it could not sustain its war in South Vietnam without unfettered use of the trail, and it took the necessary steps to defend it.

In devising countermeasures, North Vietnam did not have access to the sophisticated technology McNamara employed in Laos against the NVA's use of the trail. Seismic and acoustic sensors were not part of Hanoi's war chest. All it had to ferret out SOG recon teams was people, but it had plenty of them.

Hanoi's first step was to deploy one or two men at numerous points along the Laotian border to look for the helicopters inserting SOG teams. This actually started in late 1966, according to Ray Call, when the NVA began "putting the routes of entry . . . under observation. They knew where we were coming from. They had their spotters right along the ridge where we had to cross over by helicopter into Laos. There was communication going back and forth, whether by radio or drums. Our teams could hear drum signals." It did not take a rocket scientist to figure this out, noted Ray Call: "They were just using plain common sense."[105]

Next, spotters were assigned to watch likely recon team landing zones. Again, the enemy was using common sense, according to Call: "They started putting spotters at the places where the helicopters could land . . . They knew that a team didn't stay in very long and couldn't travel very far [due to the terrain]. . . . They knew that we needed to use those [LZs] to shorten the distance that the troops had to travel. If the Ho Chi Minh Trail was ten, fifteen kilometers in [from the Laotian border], they knew our troops were not going to come fifteen kilometers by foot, they're going to be inserted within five kilometers."[106] Charlie Norton's teams reported that indigenous tribesmen living along the trail in Laos were being pressed into service as spotters. Although hardly high-tech, it was "a pretty elaborate signal system. When the teams went in, they were

reporting all kinds of things such as bells ringing, gongs, drums and so on."[107]

The NVA studied SOG's operational patterns, mapped out their routes, and gained understanding of the nighttime conditions necessary for insertion of a team. SOG chief Jack Singlaub pointed out that "[i]t didn't take long for them to figure out what phase of the moon we would find most appropriate for operating, and so they didn't have to keep somebody out there all of the time. They would try to determine our operational methods. They had some system of human air watch, people either positioned in tall trees or on platforms sticking up above the jungle, listening for aircraft."[108]

The map on page 242 approximates NVA supply and troop infiltration routes from Laos into South Vietnam. To protect the routes, command posts, truck parks and fuel depots, storage sites, and related facilities along the trail, Hanoi assigned NVA units to rear-area security duty.[109] It was another low-tech solution involving lots of soldiers. At the time of the Tet offensive, the enemy had "committed over 25,000 soldiers to defend his sanctuaries on the Ho Chi Minh Trail."[110] In the fall of 1968, then-chief of SOG Steve Cavanaugh watched as Hanoi expanded its trail defenses into "a very sophisticated security system which we never were able to really understand."[111]

It was an extraordinarily redundant and layered defense, but Hanoi was not finished. It had offensive countermeasures in mind as well. Trackers began hunting down recon teams. At first, the NVA used local tribesmen because they were skilled hunters who knew the trail inside out. They coordinated with military units that had responsibility for ambushing the SOG teams. Later, the NVA trained their own trackers and deployed tracker units at key points along the trail for use on short notice.

North Vietnam also developed special operations forces to attack recon teams. They evolved out of the NVA's first airborne unit, the 305th Airborne Brigade, which was formed in 1965. According to Douglas Pike, author of *PAVN: People's Army of Vietnam*: "No use was found for it, so it was converted to the 305th Sapper Division." It then became part of the Sapper Command, a famed element of the NVA also known as the "Special Action Force." Becoming a sapper was not easy: "Entrance requirements are strict: Party member nomi-

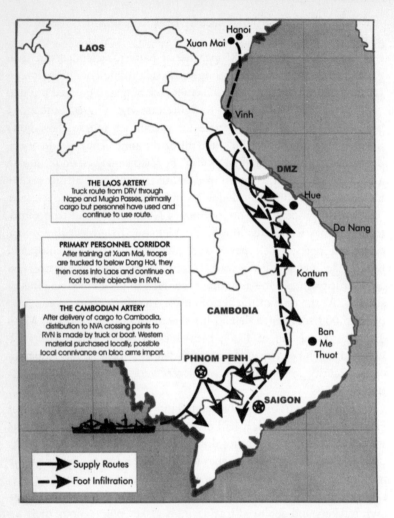

MAP OF THE HO CHI MINH TRAIL
(Reproduction provided by John Plaster)

nation plus two seconds by party members; ideological purity; youth; and a certain character (boldness, willingness to take risks)."[112] When the 305th Brigade was transferred to the Sapper Command, elements of it were trained to become "special counter-recon units [hunter-killer teams] whose mission was to hunt down and kill SOG teams."[113]

SOG men that encountered these NVA hunter-killer teams found they gave no quarter. No mercy was shown, as a SOG hatchet force (a SOG company) found out. Operating cross-border in Laos, the hatchet force had targeted the Ho Chi Minh Trail's command and control center. It was extremely well protected. No sooner had the SOG unit landed than the NVA opened up. The large enemy force included NVA counter-recon teams. They surrounded the hatchet force and closed in to finish it off. The lone surviving Green Beret NCO, Charles Wilklow, "watched the NVA carry away several American bodies, then mount their heads on stakes like trophies." Severely wounded, Wilklow was dragged to a clearing in the hope of luring in a helicopter rescue force. When it failed to appear, the North Vietnamese left Wilklow to die a slow death. Miraculously, on the night of the fourth day of this horrific ordeal, the Green Beret NCO managed to muster the strength to crawl nearly two miles to another clearing where he was spotted and rescued.[114] Wilklow survived but his experience was a harbinger of what awaited SOG men in Laos.

Other countermeasures included financial rewards for those fighting against SOG teams. According to Larry Trapp, who served two tours in OP 35, including one as deputy chief, Hanoi established "bounties on recon team leaders," either living or dead.[115] It became standard practice for the North Vietnamese and Viet Cong, both of whom placed a bounty on the heads of many U.S. military commanders and civilian officials in South Vietnam.

Last but not least there were the spies. Through espionage, Hanoi also sought to counter OP 35 recon operations by learning about them before they took place. North Vietnam concentrated on the South Vietnamese to do this. The higher they could penetrate and plant or recruit agents, the better. One big fish could really pay off, as Jack Singlaub illustrated. When he was in command, Singlaub believed that OP 35 "had an operational security problem" that accounted for the NVA's rapidly improving capacity to detect recon teams at the time and place of insertion. No sooner was a team on the ground than it would be hit by enemy forces. Singlaub could never find out how the NVA was being tipped off, but he was sure it had to do with flaws in SOG's operational security.

Some years after the war, he found out the real answer, or at least part of it. It turned out to be another North Vietnamese hammer

blow. Singlaub learned in the late 1980s "that the North Vietnamese had decorated a colonel who had successfully penetrated the office of the Prime Minister." He explained that as chief he only "briefed General Cao Van Vien [chairman of South Vietnam's Joint General Staff] on these sensitive [OP 35] operations." Vien assured Singlaub that he took the information directly to the office of South Vietnam's president. It seemed like a secure arrangement to Singlaub.

Unbeknownst to the SOG chief, Vien was also sharing this information with South Vietnam's prime minister. "He didn't want the prime minister to be surprised, so he apparently developed a way of informally telling the prime minister [about SOG operational plans]. Well . . . the prime minister was accompanied by his trusted colonel." As it turns out, the prime minister's trusted colonel was the same fellow who was decorated in Hanoi in the late 1980s. Singlaub provided details of just how sophisticated North Vietnamese penetration operations really were: "Somehow they had communications that allowed them to be able to alert Hanoi on short notice. I can understand how they got word to North Vietnam for an operation that's going to take place a week later, but my gosh, some of these things were pulled off in less than forty-eight hours."[116] Big fish provided big payoffs.

But big fish were not always available. The North Vietnamese understood this and focused their espionage efforts on both the high end and low end. Small fish also did considerable damage.

In 1968, Lieutenant Colonel Lauren Overby was in command of Command and Control North's Forward Operating Base 4 (FOB 4), located south of Da Nang. Right after he left his command in early August, FOB 4 was hit hard by enemy sappers who slipped into the compound undetected in the early-morning hours. Many men were wounded in the assault and twelve killed. The sappers knew exactly where to go once they were inside. In addition to attacking the men, they also blew up FOB 4's main operational planning bunker and other key storage facilities. It was a surgical strike by NVA special operations forces. How did they pull it off?

According to Overby, the NVA had built a "replica of the camp [FOB 4] in the jungle" that SOG discovered after the attack. It could only have been built with insider knowledge, intelligence gathered by an agent the North Vietnamese had inserted into FOB 4: "It was a woman. She was one of the mess orderlies," according to Overby, and

she disappeared into thin air after the attack. The mess orderly was able to observe everything inside FOB 4. She had walked the compound and committed the layout to memory. The sappers knew just where to go.[117]

This example points to a serious security problem that SOG was never able to solve and one the enemy exploited. SOG knew the North Vietnamese would try to penetrate its counterpart, the Standard Technical Directorate (STD). To guard against that possibility, the SOG leadership cut STD out of operational planning and denied it access to sensitive information. Every former SOG man interviewed believed the STD had been penetrated. Asked if his STD counterpart was involved in operational planning at FOB 4, Lauren Overby emphatically answered: "No, we never got him involved in it." Overby believed the North Vietnamese had planted "some double agents in the STD."[118]

Because SOG kept the STD at arm's length, the North Vietnamese looked for other ways to penetrate. This is where the mess orderly fit into Hanoi's espionage strategy. SOG needed the Vietnamese to perform support activities at its various camps, detachments, and headquarters. The Vietnamese did the cooking, cleaning, and laundry, and served as drivers, secretaries, and clerks. However, as Overby pointed out, SOG did not conduct "a security check on any of the locals who worked around the [SOG] camps."[119] That was left to its South Vietnamese counterpart. It was a perfect way to get inside SOG facilities, and Hanoi exploited it. Other examples abound.

Major Pat Lang joined MACVSOG in 1972 as it was preparing to hand off all operations to the STD and disband. Lang was an intelligence officer who ended up in SOG's Strategic Technical Directorate Advisory Detachment. One day he was given a number of counterintelligence investigation files. In 1971, several of the local Vietnamese who performed support activities for SOG in Saigon had fallen under suspicion. As Major Lang pored over the material, the information staggered him.

Lang recounted that several of the individuals investigated fit the profile of agents planted by enemy intelligence. The inquiry a year earlier had unearthed some very disturbing facts, mainly from polygraph interviews. For example, one of the Vietnamese was a driver assigned to SOG headquarters. He chauffeured the chief of SOG around Saigon and its

environs. The driver's 1971 polygraph, according to Lang, had decep-
tion written all over it. But he was still driving for SOG. Lang was able
to bring the driver in for another round of polygraphing. It lasted three
days, and the results were even worse than before. Most startling was
the fact that his cover story this time was at variance with what he told
investigators in 1971. The driver was a planted NVN intelligence agent.
His mission was to listen as he drove. It was a brilliant gambit. SOG
turned the spy over to the South Vietnamese.[120]

Another dossier was on a bartender, but no ordinary one. He
worked at a closed compound in Saigon that was under the auspices
of SOG. Known as House Ten, the compound served as a rest and
relaxation facility for SOG recon teams. As with the driver, the bar-
tender's mission was to listen. And deception oozed from the results
of his polygraph interview as well. Also at House 10, working in the
bar as waitresses, were two attractive Vietnamese women. Their poly-
graph results were similar to the bartender's.[121] One can only imagine
the very useful operational-level information they were able to pick
up listening to recon team members discussing their most recent
adventures. For example, a new insertion technique or deception
devices used to mislead NVA trackers might be mentioned.

While North Vietnamese intelligence concentrated on the South
Vietnamese to learn the operational plans of OP 35, it was not averse
to seeking the same information from Americans. In at least one
instance, it appears that they used an intelligence technique known in
the espionage business as a "honey trap." Sometimes this takes the
form of sexual entrapment, at other times sexual enslavement. The
way it works is straightforward. An intelligence agency employs an
attractive man or woman as bait to lure a vulnerable target. Once
entrapped or enslaved, the target is induced to commit espionage.

According to officers who served in SOG, one young enlisted
American working in SOG as a clerk was lured into a honey trap.
Pete Hayes knew the clerk because he had worked for Hayes during
Hayes's second tour in SOG in OP 35 in the late 1960s. After Hayes's
tour was over, he learned that the young clerk had been uncovered,
and it was determined he was passing documents to the enemy. Hayes
never learned what happened to the clerk after he was unmasked.[122]

In 1968, the halcyon days OP 35 teams enjoyed operating against
the trail in 1966 and 1967 came to an end. First, Tet resulted in a sig-

nificant number of SOG recon team operations that should have been executed in Laos (Prairie Fire), out of necessity, being directed inside South Vietnam. Of the 546 operations initiated by SOG units assigned to Laos, 310 (57 percent) were cross-border missions and 236 (43 percent) took place in-country. When compared with the 275 cross-border operations launched in 1967, this amounted to only a marginal increase in Laos. MACV and Pacific Command brass had expected more out of Prairie Fire in 1968.[123]

Trends for Daniel Boone, OP 35 operations in Cambodia, were even more concentrated internally as a result of the Tet offensive. It "conducted 726 operations, of which [only] 287 (39 percent) were cross-border missions while 439 (61 percent) were in-country." Furthermore, most of the cross-border operations into Cambodia occurred only after Tet died down. According to the records: "Daniel Boone returned to a primary cross-border role in October and 53 operations were conducted in Cambodia. During the last three months of the year, cross-border missions . . . averaged 46 per month."[124]

Tet not only refocused Prairie Fire teams in-country, but the NVA "siege and subsequent close-out of the Khe Sanh Combat Base precluded [SOG] operations into the northern fifth of the Prairie Fire area of operations from January to mid-June and tied up approximately 600 [SOG] personnel in a static defensive role." Then, the "loss of the Kham Duc launch site on May 12, 1968 further degraded MACSOG's capability to provide coverage of Laos." The Kham Duc site had responsibility for "approximately one-third of the total [Laotian] AO, containing vital target areas."[125]

It was not just Tet that undercut SOG effectiveness in Laos. Consider the following evaluation of operational trends: "Throughout the year there was a noticeable increase in enemy security elements protecting the LOCs [lines of communications] in the Prairie Fire area of operations. Teams encountered increasing resistance. . . . The percentage of regular NVA elements encountered . . . has risen steadily. As the year progressed, antiaircraft weapons were sighted in increasing concentration and further south than previously."[126]

President Johnson's bombing halt in North Vietnam also helped the NVA's security buildup on the trail. It "released large numbers of personnel to expand and secure the lines of communications, bases, and

staging areas in Laos."[127] For the men of OP 35, this was like rubbing salt into an open wound. It was bad enough that they had to contend with all that the enemy was doing to secure the trail, but did Washington policy makers have to make it easier for Hanoi by halting the bombing? Furthermore, they wondered, how much sense did it make to accept such demands by Hanoi in order to start negotiating a peace arrangement? What were the geostrategic thinkers in Washington doing?

The real impact of North Vietnamese countermeasures can be seen in the decreasing operational effectiveness of recon teams and their increasing losses. The trends were alarming. Larry Trapp, former deputy chief of OP 35, recalled that in 1968 the NVA deployed "a lot of their forces in Laos, looking for recon teams. We had to use all kinds of diversionary actions, but still the time on the ground [for a recon team] was changing and becoming briefer. Also, we found that they would try to locate a team and surround it and hold it. . . . They knew that we would come after them. Then they'd move their anti-aircraft guns around it. It was a major effort."[128]

Out at FOB 4, Lieutenant Colonel Lauren Overby was having a tough time in 1968. While his teams were identifying enemy targets and calling in air strikes, the enemy was all too frequently attacking recon teams as soon as they were inserted. Overby noted that it "became almost impossible to keep a team on the ground for any length of time. They may have had more success in Cambodia [Daniel Boone]. I'm not aware of that. . . . My area of operations was becoming increasingly difficult. My launch space was about six miles from the border. They probably had somebody watching my launch."[129]

For the teams carrying out Prairie Fire operations, 1968 was a bad year in terms of casualties. The numbers were on the rise. In Laos, 18 were killed, 101 wounded, and 18 missing. Because of SOG's involvement in Tet, in-country losses added another 21 killed, 78 wounded, and 6 missing. OP 35 teams carrying out Daniel Boone operations in Cambodia and South Vietnam were not hit as hard. Still, 17 SOG men died, 56 were wounded, and 3 were missing. What makes these casualty figures so arresting is the fact that in 1968, OP 35's command-and-control detachments were composed of approximately 100 U.S. officers and 600 enlisted men.[130]

Things did not get any better in Laos in 1969. However, OP 35 did not back down: the number of Prairie Fire operations across the fence

rose by 40 percent. A total of "452 missions were executed, of which 404 were recon team size and 48 were exploitation force missions. On average, Prairie Fire was executing 38 operations a month."[131] The brass wanted more, and SOG delivered.

The records for Prairie Fire in 1969 stated that "in all statistical categories . . . operational results rose over those for 1968. Significantly, enemy KIA more than doubled over the previous year and enemy weapons captured nearly tripled. Some of the more successful operations were roadblock/interdiction missions in the tri-border area." The recon teams were also uncovering important enemy refinements of the trail in Laos. For example, they found a fuel pipeline. Not only did the NVA have truck-repair parks along the trail, they were in effect opening up gas stations. What next? wondered the men of SOG. They soon found out that the NVA was wiring the trail with a multichannel communications system.[132]

Recon teams were providing MACV with "a major portion of the hard intelligence on VC/NVA use of Laos as an infiltration and staging area." In particular, they were able to provide valuable evidence of the enemy's expansion of the tri-border area as a "prime infiltration route for the movement of troops and equipment into the Republic of Vietnam." In certain parts of the Prairie Fire region, recon teams "provided the only hard intelligence concerning [the enemy's] logistic build-up."[133]

This was the good news. Unfortunately, there was also plenty of bad news for those recon teams operating in Laos in 1969. They still were under many of the restrictions imposed by Ambassador Sullivan. While there had been some relief, the teams were still constrained in terms of how deeply they could penetrate, but the enemy operated under no such restrictions. In 1969, the NVA refined its countermeasures, including an "increased ability to react swiftly to [SOG] heliborne operations." This "posed a significant threat to cross-border operations," according to MACVSOG's end-of-year report for 1969.[134] Prairie Fire teams "continued to encounter strong enemy resistance." There seemed to be more and more NVA assigned to trail security. Finally, the report noted, enemy activities to secure the trail were aided by "the bombing halt in North Vietnam." It "enabled the enemy to increase his infiltration . . . and up-grade the posture of his security forces." This included adding more "AAA [anti-aircraft

artillery] positions through the Prairie Fire Area of Operations," since they were no longer needed up North.[135]

This was the situation that Colonel Jack "the Iceman" Isler inherited when he became chief of OP 35 in 1969. It was his first tour in Vietnam. Isler had transferred into Special Forces from the infantry in the early 1960s and had been Colonel Steve Cavanaugh's deputy when Cavanaugh commanded the 10th Special Forces Group in Europe. When Cavanaugh became chief of SOG in September 1968, he asked Isler "to come work with me."[136] Once on the job, Isler quickly became "aware that there was a hell of a lot of restrictions . . . we couldn't do what we really should be doing. . . . It was never really explained to me what the reason was for why we can't go beyond certain limits in Laos."[137] He was to learn that the restrictions were the legacy of the recently departed U.S. ambassador to Laos, Bill Sullivan.

Isler's teams were having a rough go of it. Their time on the ground during an operation "was shrinking. . . . It was tougher all the time." The NVA was making it "much more difficult to get a team in and to stay on the ground for any time at all. Some of them did get to stay but it was touch and go. They always seemed to be right on top of us a great deal of the time."[138] When Bull Simons began operating against the trail, he planned for recon teams to stay in Laos for five or six days. By 1969, however, Isler's teams were staying "no more than two days. Many times it was six hours. Put a team in and go right back in and get it out. There were so many NVN security forces out there, our teams would just run into them."[139] The bombing halts did not help matters: "Every time we had bombing halts . . . they just built up that much more. That hurt us."[140]

As the effectiveness of NVA countermeasures continued to rise, so did its capacity to inflict casualties on Prairie Fire recon teams. During 1969, "U.S. casualty figures were 50% per mission as compared to 44% in 1968 and 39% in 1967."[141] On every other recon operation in Laos, one U.S. team member was killed, wounded, or missing. For the 452 missions executed, U.S. casualties included 19 killed, 199 wounded, and 9 missing. Prairie Fire operations were the responsibility of CCN in Da Nang and CCC in Kontum. These two detachments had a combined U.S. strength of 72 officers and 409 enlisted personnel in 1969.[142] If one considers the fact that the U.S.

members of a recon team were largely NCOs, the casualty figures are stunning. It was a large number of Purple Hearts for such a small military unit.

Things were easier for SOG teams in Cambodia, now code-named Salem House, where the NVA presence was not as great. During 1969, "the per mission casualty rate for U.S. personnel was 13%," significantly below the 50 percent experienced on Prairie Fire operations in Laos.[143] However, because of the restraints placed on Salem House, recon operations did not accomplish all that they could.

During 1969, 454 recon missions were carried out in Cambodia. Their purpose was exclusively intelligence collection. The State Department would allow nothing more. MACV requested "the use of tactical aircraft in Cambodia, along with exploitation forces" to hit targets "detected by Salem House reconnaissance teams." To MACV, it only made military sense, because "the increased use of Cambodia posed a continuing offensive threat to allied forces and installations in RVN. This threat is particularly evident in the tri-border area. . . . The recent introduction of enemy armor capabilities in this area serves to emphasize the importance of Cambodia to the enemy as safe haven." MACV wanted to attack the NVA in Cambodia and compel it "to increase the forces committed to a defensive role and decrease his offensive capability to infiltrate RVN."[144] It seemed like a reasonable request.

State did not see it that way. It was still trying "to resume diplomatic relations . . . with Sihanouk" and argued that the MACV proposal would muddy those efforts. "A decision to expand combat operations into Cambodia . . . by committing U.S.-led troops to this initiative" was, Foggy Bottom asserted, not "wise at present." As a result, State refused to concur with the MACV request, and the secretary of defense decided that "the proposal should not be pursued."[145]

There was at least one exception to this restriction, and it cost SOG dearly. One of its most skillful and highly decorated recon men— Sergeant First Class Jerry Shriver—was lost. Shriver's daring exploits, which made him a legend within the Special Forces community, had led Radio Hanoi to refer to him as a "mad dog." By 1969 Shriver was into his third year operating against the Ho Chi Minh Trail. On April 24 he was part of a hatchet force company that deployed to Cambodia in a daring raid against COSVN's secret headquarters.

It was a disastrous mission that began with a massive B–52 assault. It hardly made a dent in the enemy forces waiting for what amounted to a reinforced platoon of the hatchet force company. There were not enough helicopters to lift in the entire force, and once under way, one of the helicopters had to turn back because of a mechanical failure. No sooner were the SOG raiders on the ground when they were pinned down by enemy fire. Under these harrowing circumstances, Mad Dog Shriver again distinguished himself in battle when he led an assault into the teeth of the NVA forces to free his trapped comrades.

It is unclear what happened to Jerry Shriver. Some on the raid believe he was killed in the melee. Others assert Shriver was captured and taken to Hanoi. A massive air strike was needed to extract the badly mauled SOG force.[146]

As 1969 came to an end, it was apparent that the United States' days in Vietnam were numbered. Massive troop withdrawals were on the horizon as Washington adopted a policy of Vietnamization. However, war on the trail continued and SOG remained fully engaged with the NVA.

SOG Fights On as the U.S. Phases Out of the War: 1970–1972

Early in 1969, President Richard Nixon remarked to his senior staff, "I'm going to stop the war. Fast."[147] That was not all. He intended the United States' exit from Vietnam to be honorable and to have no hint of defeat or sellout. Nixon thought he could convince Hanoi to accept his plan for ending hostilities. After all, it was now dealing with someone who was not averse to employing maximum military power. The days of limited and graduated force were over. Nixon would deliver his own hammer blows to Hanoi if it did not play ball with him.

To this end, Nixon sent a message to North Vietnam declaring his sincere desire for peace and suggesting as a first step the mutual withdrawal of all U.S. and NVA troops from South Vietnam. To make the point that there were dire consequences for not complying, he initiated an intensive secret bombing of NVA sanctuaries in Cambodia. Hanoi had better accept Nixon's terms for ending the war or there would be hell to pay. To keep things quiet at home, the administration

proclaimed a "comprehensive peace plan" to make clear to the American people its goal of ending American involvement in the war. As a sweetener, Nixon announced the withdrawal of 25,000 U.S. troops from Vietnam.

Hanoi was not impressed with these proposals. Having stood up to 500,000 troops and powerful weaponry that inflicted extensive casualties and hardships, Hanoi found Nixon's bluster and the sideshow in Cambodia hardly convincing. North Vietnam's delegation to the Paris peace talks rejected the president's gambit as a "farce." To put a fine point on their truculence, the head of the delegation stated that they were prepared to sit in Paris "until the chairs rot" before they would accept such terms.[148] Nixon was furious over what he called Hanoi's "cold rebuff."[149] He ordered national security adviser Henry Kissinger to convene a special study group and devise a massive bombing campaign against the North's major cities and a blockade of all major ports. Nixon wanted to hit North Vietnam with "savage, punishing blows."[150] If it did not want to play ball, he was ready to take the gloves off.

Kissinger's special studies group focused on the impact a "savage" bombing campaign might have on Hanoi's will. Their conclusion was not what Nixon wanted to hear. A massive bombing campaign and blockade would not force Hanoi to accept Nixon's terms. The North Vietnamese leadership had been at war too long to fold under the pressure of another bombing campaign. They were intransigent. Furthermore, bombing was not likely to significantly undermine Hanoi's military capacity to continue fighting in South Vietnam. The first year of his presidency was coming to a close, and Nixon was far from being able "to stop that war. Fast."

At this point, Nixon and Kissinger turned to "Vietnamization" as the way out. The United States would resuscitate and modernize the ARVN so that it could take over the ground war. This was not a new idea. The French had tried it in the 1950s. They called it *jaunissement*, or yellowing. It did not work. When the United States took over the war in 1965, it was with the intention of giving the ARVN breathing space to develop into a force that could do its own fighting. But little progress had been made between 1965 and 1968.

Why did the administration think it could work now? Because Sir Robert Thompson, the British counterinsurgency expert, told them

the situation was ripe for Vietnamization. A recognized expert in defeating guerrillas, Thompson had played an instrumental role in the defeat of insurgents in Malaysia in the late 1950s. The Kennedy administration requested that he head the British mission to South Vietnam in 1961. Thompson stayed until 1965, but his ideas about "winning the hearts and minds" of the population through pacification got nowhere. When Johnson decided to take over the war from the South Vietnamese, Thompson cautioned against relying on American military power as the answer.

In October 1968, Thompson informed Nixon that South Vietnam "was growing stronger and that if the United States continued to furnish large-scale military and economic assistance it might be strong enough within two years to resist a communist takeover without external help."[151] Nixon eagerly embraced Thompson's evaluation. The proponents of Vietnamization argued that there was a window of opportunity, because Hanoi and the Viet Cong were hurting from the losses suffered during the Tet offensive. With the enemy reverting to a defensive strategy and limiting its military activity, Vietnamization's time had come.

Transforming the ARVN in two years into a modern and professional army that could stand up to the NVA was, by any stretch of the imagination, a daunting task. The United States would provide huge quantities of the newest weaponry to arm a million-man force.[152] The cost of such an undertaking was not an issue. It was a drop in the bucket. The bill for U.S. involvement in Vietnam, going back to the Truman administration, was more than $150 billion. In the countryside, the policy of Vietnamization sought to accelerate pacification in order to extend government control, enhance village security through the training of local militia, and improve living conditions. American combat troops would keep NVA and Viet Cong forces inside South Vietnam at bay. Finally, there were the enemy sanctuaries in Cambodia and Laos. Here is where MACVSOG came into the picture.

Vietnamization was a pipe dream, given the timetable. Two years was not enough even under ideal conditions. The flaws in the strategy quickly became apparent, given Nixon's decision to withdraw 150,000 combat troops during 1970. MACV warned that this could seriously undermine Vietnamization, because it would limit the United States' capacity to keep the NVA and Viet Cong off balance. It did just that. By the end of 1970, the capacity of American forces to

conduct offensive operations had been severely downgraded. Soon, MACV would move to a strategy of defending enclaves near major bases and cities. This amounted to relying on the ARVN to hold the countryside.

Nixon's decision to accelerate troop withdrawals in 1970 had no effect on OP 35's operational tempo. Prairie Fire recon teams kept up the fight against the NVA on the trail in Laos. They executed 441 missions, 95 percent of which were reconnaissance ones. The use of exploitation forces was becoming highly problematic because of the difficulty of getting larger formations in and out of Laos under fire. While U.S. conventional forces were cutting back on operations and leaving Vietnam, for Prairie Fire teams the war was hardly winding down.

Colonel Dan Schungel took over OP 35 in February 1970. He was an old Special Forces hand who served his first tour in Vietnam as the deputy chief of the Fifth Special Forces Group. In that capacity, Schungel had helped run the Civilian Irregular Defense Group program. His next assignment was back at Fort Bragg as the commanding officer of the Seventh Special Forces Group, a position he held until early 1970.

Although Schungel's teams executed 441 operations against the trail, fewer and fewer of those fit his description of an effective reconnaissance team operation. "A recon team would be totally successful," he asserted, "if it would be able to operate the entire duration of a mission without making direct contact with the enemy. Now, visual contact is good. If you can make visual contact with an enemy formation without making physical contact, call in an air strike on it, injure the enemy formation or perhaps utterly destroy it—that is a real bonus for a recon team." In 1970, not many of Schungel's recon teams were making just visual contact. Rather, the NVA was making direct contact with them. The chief of OP 35 remembers that "more and more our helicopters either met [a waiting enemy] or the recon team that had just been discharged was soon engaged by enemy security forces. . . . Too often, the recon teams got engaged in heavy combat and had to have a lot of support just to get this small element out of there. This was costly."[153]

It was readily apparent to Schungel that the enemy countermeasures had become quite effective. For example, by 1970, the North

Vietnamese had established a "sophisticated communications system, [which] allowed the enemy to monitor the insertion of teams, direct trackers into the area, and thereby directly influence the short stay-time experienced, particularly in the northern Prairie Fire area of operation." To further enhance this effort, NVA "mobile tracker teams were strategically placed along all significant high point observation sites" along the trail in Laos.[154]

In 1970, Pete Hayes was back in SOG for his second tour, this time as CCN commander. His recon teams saw their missions compromised at an increasing and alarming rate, often as soon as they hit the ground in Laos. On one occasion, Hayes recalls, the waiting NVA actually "called the team by name and they named an individual [team member] by name." In another instance, a team "got shot up and they said that the people who came out shooting at them—it was in real rainy weather—came out in dry uniforms. So they had been there set up and waiting under cover."[155] These kinds of harrowing stories were told more and more frequently by those running recon missions in 1970.

In light of these developments, it is surprising that Prairie Fire teams suffered fewer casualties in 1970 than they had in 1969. Schungel's teams had 12 Americans killed, 98 wounded, and 4 missing. The year before, one U.S. team member was killed, wounded, or missing for every other recon operation in Laos. In 1970, this dropped to one casualty in every fourth operation.

If Prairie Fire teams were being found by the enemy at a rate at least equal to that of 1969, how could casualties be falling in 1970? What accounts for this seeming contradiction was OP 35's ability to extract teams safely, even as enemy forces were closing in. Schungel observed that teams "engaged in heavy combat" received "a lot of support" to get them "out." SOG could call in awesome air support to rescue a team in trouble. Schungel notes: "Many of the [RTs] had to be extracted under fire. That was when it got costly because the helicopters used to extract them and those used to support the extraction had to hover and were extremely tempting and vulnerable targets. We did lose some helicopters. We lost people who were killed and wounded in these hot extractions."[156]

To protect rescue helicopters, SOG had access to impressive tactical air support that often cut down enemy forces closing in on a recon team. Pete Hayes, the CCN commander in 1970, always got what he

needed for a rescue attempt: "I got all the TAC air [tactical air command] I needed and my FAC [forward air controller] coverage was superb and helicopter gunship support was really good."[157] When the going got especially tough, he could even use "CS/CN gas [tear gas] within the Prairie Fire Area of Operations," but only "on a case by case basis . . . to assist in the extraction of a team."[158]

One former recon-team leader, with three tours in SOG, summed up Prairie Fire operations in 1970 as "close-quarters, all-out gunfights against masses of NVA."[159] Even so, SOG was still making an important contribution. Prairie Fire recon teams "contributed a major portion of the hard intelligence on VC/NVA use of Laos as an infiltration/staging area."[160] Such intelligence became increasingly valuable, given Nixon's decision to withdraw 150,000 combat troops during 1970. With fewer forces at hand, warning of impending enemy strikes became increasingly crucial. SOG recon teams also tied up considerable NVA troops in Laos on trail security duty.

While Prairie Fire teams were still holding their own against the NVA in 1970, disturbing developments took place that were a harbinger of bad things to come. Recon teams and exploitation units engaged in fifty operations inside the borders of South Vietnam.[161] This was ominous, for it signaled that the enemy was closing in as U.S. combat forces withdrew from the war.

In Cambodia, Salem House operations experienced dramatic changes in 1970. During the first four months of the year, the enemy continued to use Cambodia as a sanctuary for strikes into South Vietnam. Recon teams verified many enemy locations, infiltration routes, and logistical complexes. They painted a detailed picture of what the NVA was up to.

Nixon had been "secretly" bombing Cambodia since early 1969 to keep the enemy off-balance while he withdrew U.S. troops. The bombing did not achieve the intended effect. Rather, it contributed to unrest inside Cambodia, and on March 18, 1970, Prince Sihanouk was deposed by General Lon Nol. Nixon now decided to do something about the sanctuaries. A combined U.S.-ARVN force would cross the border and destroy them. Code-named Operation Binh Tay, the incursion had mixed results, although it likely bought some time for Vietnamization. Hanoi's sanctuaries were rendered unusable, at least temporarily.

The Cambodian incursion also had some unintended consequences. First, it saddled the Nixon administration with another fragile client government in Southeast Asia. The Lon Nol government, which engineered a coup in January 1970 to oust Sihanouk, had little legitimacy in Cambodia and was no match for the Khmer Rouge. The United States kept it afloat, but once Washington withdrew, its days were numbered. In 1975, the government of Lon Nol collapsed and he fled to Hawaii.

Second, at home the Cambodian operation caused a huge domestic political reaction. The Nixon administration did not expect it. Students across the country demonstrated against this escalation of the war. On May 1, 1970, students of Kent State in Ohio marched against the war and some rioted. The situation escalated and resulted in the Ohio National Guard killing four students. This incident triggered further demonstrations and a massive march in Washington. As a result of these developments, on June 30, ground operations in Cambodia were terminated and all U.S. personnel were ordered out. As for MACVSOG, it "was no longer authorized to employ U.S.-led teams in Cambodia." Only "all-indigenous teams were authorized" to cross the fence.[162] During 1970, Salem House teams executed 577 operations in Cambodia, all but 19 of which were recon missions. The overwhelming majority of these were conducted by all-indigenous units. TAC air could be used after May to hit targets located by these teams.

Because of Nixon's cross-border incursion, the "overall results of [Salem House] operations in 1970 reveal a marked increase in both the number of operations conducted and in team stay-time over similar statistics in 1969." It was a good year. Operation Binh Tay was "successful in causing severe dislocations of enemy troop concentrations and logistic operations. Enemy border base areas were, for the most part, rendered useless and were not reoccupied until late 1970." The NVA and VC were not gone, but had simply "relocated deeper" inside Cambodia. In December, they began "reestablishing border sanctuaries."[163] As a result, 1971 would not be such a fruitful year for Salem House operations inside Cambodia. Still, it was easier than "crossing the fence" into Laos.

OP 35's final fifteen months were marked by spiraling danger for recon teams. While Nixon's accelerated timetable of troop withdrawals reduced available combat forces to 75,000 by the end of

1971, SOG teams were largely unaffected by the draw-down. They remained at almost the same force strength and fought at roughly the same pace as in the previous two years. While ever-improving NVA countermeasures had yet to make Laos impenetrable, nevertheless it was very tough to keep a recon team on the ground for any length of time. The last chief of MACVSOG, Colonel Skip Sadler, explained that by the end of 1970, "only 40% of SOG teams remained in Laos for over twenty-four hours, so strong had the NVA become. . . . They were in position, they know you're coming, and that's a recipe for deadly results."[164]

Consequently, SOG lost some of America's finest young men including Sergeant David Mixter. The son of a prominent New England family, David Mixter had available to him all the best opportunities the country could offer. During the summer of 1966, at the age of seventeen, he "signed on for the challenge of an Outward Bound course at the . . . Hurricane Island Outward Bound School [in Maine]." The twenty-six-day course had "a profound effect on young David Mixter." He would write after completing the program that it had given him "a feeling of self-confidence which I have never had before . . . When a seemingly impossible task is taken on and conquered, there is a wonderful feeling that cannot be described . . . I hope I get feelings like that . . . from every task I take on in the future." He closed by specifying the principle that would guide him in these endeavors: "The first and most important thing to me is honor."[165]

Rather than attending an elite New England university, David Mixter chose the Army's elite Special Forces. In 1970, he volunteered for SOG and would receive a Silver Star for bravery. It was awarded posthumously. On January 29, 1971, while on an OP 35 recon mission in southern Laos, Sergeant Mixter died in a pitched battle that left a dozen dead NVA in close proximity to where he fell.

At the Hurricane Island Outward Bound School in Maine there is a fleet of twenty-two boats in which young Americans take on and conquer seemingly impossible tasks. Boat number thirteen of that fleet has a bronze plaque mounted on the stern bulkhead in the cockpit that reads: "Given by his family. In memory of Special Forces Sergeant David Ives Mixter . . . killed in action in Southeast Asia, January 29, 1971."[166] Shortly after his death, his parents had the boat

constructed in his memory. Since then many young men and women have learned of David Mixter and how to conquer impossible tasks.

David Mixter was the last SOG recon man to be lost in Laos. A gravestone in Arlington Cemetery commemorates his sacrifice and pays tribute to his gallantry.[167]

In spite of these bad odds and losses, Prairie Fire teams kept producing highly valuable intelligence. At the end of 1970, they began to detect a sharp buildup of NVA capabilities in Laos. Hanoi was moving in large numbers of men and supplies, posing a serious threat to the northern provinces of South Vietnam. With American combat troops all but gone from that region, it was ripe for the picking.

Nixon decided that something had to be done about Laos. He believed Hanoi was preparing a major offensive for his 1972 presidential reelection campaign. A cross-border incursion against those sanctuaries would neutralize any election-year surprises Hanoi had in mind and buy more time for Vietnamization by upsetting the NVA's rear-area supply network and staging areas. Nixon believed a similar move had worked the year before in Cambodia, so why not Laos? There was only one problem with Nixon's reasoning: the situation in Laos was far different. The NVA presence was much more substantial and, as Prairie Fire teams were finding out, undergoing further expansion. Also, this time the ARVN would have to go it alone and assume the burden of the fighting on the ground. While the United States could provide air support, no American combat troops or advisers were allowed to accompany ARVN. Congressional restrictions prohibited it, the result of the Hill's reaction to the Cambodian invasion and its growing hostility to Nixon's Vietnam policy.

As preparation for the incursion took shape, the objective of the mission turned quite ambitious. It now encompassed cutting the Ho Chi Minh Trail in Laos along Route 9, then destroying the NVA infrastructure in that region. To do so, ARVN forces would have to secure the area from the Laotian border to Tchepone. Cutting the trail had long been a fantasy of senior American military leaders. In fact, General Creighton Abrams, the MACV commander, imposed this objective on Lam Son 719, the code name for the operation. It was a bold but risky design. The ARVN committed its best units to Lam Son 719. These included the First Airborne, First Infantry, and Marine Divisions, as well as the First Armored Brigade and First Ranger Group.

SOG's leadership did not think Lam Son 719 was doable. It was a prescription for disaster, according to Skip Sadler, the last chief of MACVSOG. Based on the eyeball observations of his recon teams, Sadler briefed Lieutenant General Hoang Xuan Lam, the commander of the ARVN forces, and Lieutenant General James Sutherland, the U.S. XXIV Corps commander, who would support the operation with air strikes and artillery fire from South Vietnam. Sadler laid out the hard facts about what was going on in Laos. During the briefing, Sutherland remarked that he believed the biggest problem for Lam Son 719 was going to be getting the ARVN forces into position in Laos to cut the trail. While conceding that getting ARVN in was not going to be easy, Sadler cautioned Hoang that his "biggest worry ought to be how in the hell you're going to get out."[168] SOG proved to be prescient.

In preparation for the incursion, SOG executed an elaborate series of deceptions to divert the enemy's attention. In the area west of Khe Sanh they dropped dummy parachutists with exploding devices and faked several recon insertions. In addition, they inserted recon teams and exploitation units into that area. During Lam Son 719, SOG teams also executed diversionary actions in the Ashau Valley in South Vietnam to tie up NVA forces and gather intelligence. Highway 922, which ran through the Ashau, was part of the exit route for the ARVN force coming out of Laos. These diversions had little impact on the situation. The NVA was lying in wait for the ARVN forces. General Giap, the NVA's commander-in-chief, had prepared well for ARVN's arrival. He knew exactly where they were going and was not fooled by SOG's deception tactics.

Lam Son 719 kicked off on February 8. SOG's warning went largely unheeded, and the incursion into Laos turned into a major debacle. The ARVN forces took a brutal beating at the hands of a waiting NVA force of four seasoned divisions. It was no contest. The enemy knew the rugged terrain and took full advantage of it. NVA artillery spotters, intimately familiar with the topography, directed withering fire against the invading force.

These conditions, along with bad weather, restricted ARVN ground movements and impeded U.S. air support. In six weeks of fighting, the NVA regulars smashed South Vietnam's best units. Some suffered a casualty rate as high as 50 percent. Even more devastating

was the fact that this catastrophe opened the door for Hanoi to move in and take control of the western portion of I Corps and the DMZ. The road was open to Hue. During the rest of 1971, the NVA continued its buildup in preparation for the 1972 Easter offensive.

In the United States, the media portrayed the Laotian incursion as a catastrophe. The video footage of the chaotic retreat of ARVN forces vividly told the American people that Vietnamization was not working. The disaster, reflected in South Vietnamese soldiers clinging desperately to the skids of helicopters, was hard to refute. Still, the administration did its best to declare Lam Son 719 a success. President Nixon, in a television broadcast to the nation on April 7, 1971, proclaimed, "Tonight I can report that Vietnamization has succeeded."[169] It was a vintage example of the old trickster at his best. However, it was left to the SOG teams to deal with the reality of the situation on the ground in South Vietnam.

As a result of the Lam Son debacle, the Prairie Fire area of operations now included the northern region of South Vietnam. Saigon had conceded it to the enemy. In South Vietnam, "U.S.-led reconnaissance teams were employed to locate, interdict, and destroy enemy personnel and equipment on infiltration routes and LOC's [lines of communication] in RVN contiguous to the Laotian border."[170] In Laos, OP 35 missions were only executed by all-indigenous units. One of the by-products of Lam Son 719 was that U.S.-led Prairie Fire teams were banned from executing all clandestine operations across the fence. The Nixon administration felt it could not afford to have an American soldier captured in Laos; Congress would go berserk.

From January 1, 1971, to March 31, 1972, OP 35 mounted 474 operations in an expanding area of operations. The breakdown of these missions exposes the consequences of the Lam Son 719 debacle. Of the 474 actions, 278 were conducted inside the borders of South Vietnam by U.S.-led teams. The figures depict the extent to which the North Vietnamese had moved their rear base areas across the Laotian border. A significant NVA buildup was under way during the remainder of 1971, as U.S.-led recon teams were able to certify.

Often, teams operating on either side of the border in 1971 found themselves fighting for their lives. They felt like hunted animals. During this final fifteen-month period, many recon operations were compromised by enemy countermeasures. In fact, one former team

leader reports that by the fall of 1971, "seven out of every nine missions had teams fighting for survival."[171]

Colonel Roger Pezzelle commanded OP 35 during its final nine months. It was a job he first sought in 1969. Pezzelle was, in his own words, "one of the original Special Forces volunteers in 1952." He "served as an A Team leader with the original 10th SF Group" and, from that time on, had a career that took him from one special operations assignment to another.[172] In January 1969, Pezzelle was "nominated to be the OP 35, to replace Bill Johnson." He really "wanted that damn job and lobbied for it . . . I was to replace Bill Johnson on the 22nd of June 1969. Then this was reversed." Jack Isler was selected by the chief of SOG, Steve Cavanaugh. Pezzelle "was infuriated" because he felt he deserved the assignment. "I was qualified," he insisted, more than twenty-five years later, with a lasting tinge of indignation.[173]

Pezzelle took command in the summer of 1971. He would preside over the shutdown of OP 35 while his teams engaged the enemy right up to the end. At that time, "everybody was leaving for home," Pezzelle observed, "except SOG. SOG was working just as hard as it ever worked or harder because we had to make up for others leaving the area." The draw-down of American forces meant that "air support started to slack off." Pezzelle "had a lot of support problems, particularly for CCN. The 101st Airborne was supposed to supply me with helicopters. . . . [On] two or three occasions, I had to go up and inform the commanding general of the 101st Airborne Division . . . that the aircraft that we had requested were authorized by General Abrams without exception, on a thirty-day basis and in writing." TAC air support was also "harder to get" in 1971.[174]

The final nine months were arduous ones for U.S.- and Vietnamese-led recon teams operating in Laos and the northern part of South Vietnam. "Things were pretty tough," according to the last chief of OP 35. The enemy's response to recon insertions "was very quick. The American teams, as skilled as they were, oftentimes were shot out of the area very quickly. . . . [I]n the DMZ, and just south of the DMZ, they would respond to an infiltrated team within minutes with company and battalion-size units. In August, we inserted Team Kansas just south of the DMZ, and within minutes they were under assault from a platoon, followed up by the rest of the company, fol-

lowed up by a battalion." What Team Kansas encountered was, in 1971, the "typical North Vietnamese response in that area, up in the northern part of South Vietnam and in Laos."[175]

Pezzelle "never sensed or felt that contributing to the decreasing effectiveness of recon operations, was a slackening of desire on the part of teams." Other factors accounted for it, including the fact that "the North Vietnamese were really moving in great numbers [of troops]. . . . They were running trucks into South Vietnam just like an army moving through a combat zone, moving supplies up to their troops." Their bases inside South Vietnam were so well developed, according to Pezzelle, that a team "discovered tanks opposite Kontum [in the northern portion of the central highlands in II Corps]. Nobody would believe us, so we took a picture."[176]

Enhancing the NVA's ability to respond so rapidly was the fact that SOG recon teams had become their "primary target." Almost everyone else had gone home. Consequently, the "North Vietnamese developed a very good capability for reacting to SOG operations. . . . They looked at the terrain to see where we could land and they looked at our operations to see how our operational techniques functioned. They could literally ambush infiltrating groups in the air as well as on the ground."[177] Pezzelle believed that this early warning was also due to the size of the North Vietnamese commitment to security on the trail. He characterizes it as "enormous. The whole trail was developed out of a sense of security. It was maintained out of a sense of security. I think the commitment was just enormous, both in air defense and on the ground." Of course, he added, the bombing halts made the task of securing the trail easier. "It gave them enormous advantages."[178]

Beyond these countermeasures, Pezzelle pointed to the ever-present problem of enemy spies. He recalled that during Sadler's time as chief of MACVSOG, "it was demonstrated that we had a mole. I think they smoked him out or suspected him so strongly that they got rid of him. They suspected him because they were losing teams hand over fist."[179]

Also contributing to the operational troubles of the recon teams were the constraints imposed by Washington. The last chief of OP 35 had to adhere to many of the same restrictions that exasperated his predecessors. "Every recon action taken in Laos or Cambodia had to

be requested. We put in an operational intent request to CINCPAC via MACV and to JCS and then, if they did not say that we could not go in three days, then we were allowed to run that reconnaissance." When asked what he thought of an authorization system that required every recon mission to go to the White House for clearance, Pezzelle rolled his eyes and answered: "Ridiculous, isn't it?"[180]

As 1971 came to an end, OP 35 made its final contribution to the war. Based on the intelligence reports of his recon teams, Pezzelle was able to provide "MACV with a good indication of where the [NVA's] spring 1972 offensive was coming." In his opinion, SOG had called it "right on the head." On March 30, 1972, Hanoi launched a massive, conventional invasion of South Vietnam. The offensive, which was spearheaded by Soviet tanks, initially consisted of 120,000 NVA troops attacking across the DMZ, in the central highlands, and over the Cambodian border northwest of Saigon.

It has been reported that the NVA achieved "almost complete surprise," that the United States "completely misjudged the timing, magnitude, and location of the invasion."[181] While SOG was able to provide substantial evidence that a major offensive was in the offing in the spring, it was unable to pinpoint when and where it would start at the end of March. Why? Because MACVSOG was out of business. On April 30, 1972, SOG's final stand-down took place when a communiqué from Pacific Command directed that all remaining SOG programs be transferred to South Vietnam's Strategic Technical Directorate. However, the stand-down had been underway during the previous six months. Consequently, in that critical period between January and the end of March, MACV's eyes and ears on the ground inside enemy territory were no longer present. SOG's reconnaissance operations had come to an end.

The price of this intelligence failure, at least during the initial stages of the NVA assault, was spectacular enemy success. Hanoi was closing in on victory. While American air power would save South Vietnam from falling in the spring of 1972, the Easter offensive was a harbinger of coming events in 1975. By then, American military forces, including those of MACVSOG, were long gone.

7

THE GREAT DIVIDE

SOG and U.S. Military Strategy

On June 13, 1942, in spite of considerable resistance from the Joint Chiefs of Staff, the Office of Strategic Services (OSS) was established. The chiefs did not believe that OSS-type organizations could contribute much to war fighting and opposed its creation. They were also wary of William "Wild Bill" Donovan, the OSS chief, perceived as a loose cannon who just might convince President Roosevelt to assign a high priority to subversive operations in the war. A skilled political operator, Donovan was a swashbuckler who believed such skullduggery could make a difference.[1]

This put Donovan on a collision course with the senior military leadership. He was a civilian dabbling in their domain and proposing unorthodox military operations that they saw as madcap schemes. But he had Roosevelt's ear and convinced him of the importance of secret commandos and guerrilla units in wartime. Meanwhile, the chiefs did all they could to curtail the OSS.

To win over the JCS, Donovan advanced the proposition that all OSS operations must be carried out under the auspices of the senior military leadership. It was a clever tactical move and one that

appealed to the chiefs. If OSS operations could not be prevented, the chiefs at least wanted to have some measure of control over them. Donovan's motive was not simple political expediency, though. He believed in what he was proposing.

During the war, the OSS carried out all the tricks in the covert-action bag—subversion, sabotage, commando raids, psywar, and cooperation with partisan guerrilla forces. It did so under the jurisdiction of the military and in support of the overall war effort. This paid off, and the OSS made important contributions to the allied victory. In hindsight, Donovan's approach seems unimpeachable. In wartime an OSS or SOG should be integrated into the overall strategy for fighting the war. Donovan saw this as a bedrock principle.

During the Vietnam War the American military leadership never gave Donovan's approach a moment's notice and probably never had heard of it. The Pentagon did not consider SOG's covert paramilitary campaign as part of an integrated strategy for fighting the Vietnam War. According to three former SOG chiefs, Donovan's bedrock principle was unknown to General Westmoreland and the other generals who fought the Viet Cong and NVA.

Chief of SOG Don Blackburn was emphatic about this matter. To Westmoreland and his corps commanders, "SOG was a very small, insignificant part of the total picture. They [the Pentagon and MACV leadership] were so conventionally oriented that SOG was not of much importance to them." He continued: "It wasn't only Westmoreland. It was Max Taylor . . . it was Harkins, who was before Westmoreland . . . it was Abrams. . . . [T]hey did not know anything about what SOG could contribute." Then Blackburn dropped a bombshell: "I lived in the same quarters with Westmoreland's deputy for a year, and he never asked me one question about SOG operations." Instead, Blackburn angrily believes, he "kept me from getting promoted. Though he asked me to live with him [in Vietnam], when I came up on the promotion list he blackballed me."[2]

Blackburn believes the senior commanders did not have the kind of strategic view of the war that their counterparts in Hanoi did. For Westmoreland the war was a conventional fight in South Vietnam. For General Giap it was a protracted armed struggle in which all military and paramilitary means would be employed throughout Indochina. According to Blackburn, Westmoreland "was over there

to command the conventional forces in South Vietnam. SOG fell under the authority of MACV, but the missions of SOG were not part of his authorized area of operations to direct."[3] Being outside his official responsibility only added to the ease with which Westmoreland could ignore what SOG might contribute.

This was reflected, declared the Headhunter, in Westmoreland's unwillingness to push hard for SOG operations in Laos, a place that was off-limits to his units. "I think that he just figured Laos was not his problem. . . . [H]e didn't consider it because he could not do anything in Laos. . . . He was not delegated to devise an answer to that problem."[4] Westmoreland's focus "was on those massive American forces" inside South Vietnam, said Blackburn, "and he constantly, right up to the last, was asking for more American forces to come in there. Consequently, I had one hell of a time getting the support I needed to get [my] people across the border into Laos. . . . [I]t was a struggle."[5]

Jack Singlaub's experience as chief of SOG was similar. While he had an excellent professional relationship with General Westmoreland and the corps commanders, Singlaub did not believe this translated into their understanding what SOG could offer. He puts it this way: "There was a lack of education of how special operations could assist conventional operations. Prior to the commitment of U.S. ground forces, the only action or possibility of action was covert operations. Once conventional forces were introduced, the assumption was that they could achieve our objectives. Everybody was very optimistic: all it takes is a few U.S. divisions in there and we'll whip their tail. It didn't happen."[6]

Singlaub was chief of SOG when General Creighton Abrams replaced Westmoreland in July 1968. Abrams had stronger views on Special Forces and special warfare than his predecessor. Westmoreland tolerated SOG but did not expect much out of it. Abrams's attitude could hardly be characterized as tolerant. According to Singlaub, Abrams felt strongly "that Special Forces takes top personnel and concentrates them in one place, denying them to the rest of the units"; it "degraded the regular units."[7]

Furthermore, what could SOG accomplish in comparison with conventional units? Not much, according to Abrams. He was, in Jack Singlaub's words, "very anti–Special Forces, he was anti–special oper-

ations. . . . Special operations, to him, was like the raid that he ran in World War II, when Patton sent Abrams's task force out to break into a POW camp. . . . That was a bold action, and he thought that's the kind of thing that armor can do very well. His mentality was such that he would not have considered sending a parachute unit in to do that," an outlook reflected in the way Abrams viewed SOG.[8]

Steve Cavanaugh ran SOG for two years following Singlaub's departure in September 1968. When asked if he detected any understanding of Donovan's thinking among the senior leadership at MACV during that time, the answer was no. This was due to a "mindset that this was a conventional war . . . there was still a lack of appreciation of special operations . . . Special Forces were still not held in high regard."[9] He believed that "as far as MACV was concerned, they could have cared less" about SOG. "They weren't advocates for me."[10]

Blackburn, Singlaub, and Cavanaugh all provided accounts that seem baffling in light of the high priority President Kennedy assigned to covert operations against North Vietnam in 1961. How is it that SOG's covert campaign never received senior military support? Why was no attempt made by the Pentagon or MACV to integrate SOG into the military strategy for fighting the war? The answer lies in the senior military leadership's attitude toward special warfare and shows that little had changed since Donovan laid down his bedrock principle.

PENTAGON OPPOSITION TO KENNEDY'S SPECIAL WARFARE VISION

The Pentagon leadership's unwillingness to see any meaningful value in SOG was part of its truculent opposition to Kennedy's demand that it develop special warfare capabilities. That edict challenged everything the mainstream military stood for.

The raison d'être of the American armed services had been shaped by twentieth-century experiences. They had been victorious in two world wars and successfully prosecuted a limited war in Korea. In each, conventional strategy and forces had been the answer. As a result, the American military developed a conventional mindset. Technological advances in mobility and firepower only reaffirmed this approach.

The problem, as Kennedy envisioned, was that the nature of war was changing. If the U.S. military continued to follow a conventional course, it would end up being most prepared to fight the least likely war and least ready for those conflicts it was most likely to be engaged in. From the early days of his presidency, JFK sounded this warning. While the Pentagon still had to be able to defeat the Soviets at the German border, the real action was in the Third World fighting guerrillas. Kennedy told this to the 1962 graduating class at West Point: "This is another type of war, new in intensity, ancient in origins—wars by guerrillas, subversion, insurgents, assassins; wars by ambush instead of by [conventional] combat. . . . It requires . . . a whole new kind of strategy, a wholly different kind of force, and therefore a new and wholly different kind of military training."[11]

It was a message the mainstream military did not want to hear. Kennedy refused to give in and kept pushing for the expansion of Special Forces to meet the communist insurgency challenge. His brother Robert Kennedy went so far as to query Maxwell Taylor: "Why can't we just make the entire Army into Special Forces?"—a view the mainstream found alarming and reckless.[12]

The Kennedy administration took several steps to goad the military services and particularly the Army into developing counterinsurgency capabilities. The president went so far as to convene an Oval Office meeting with the Army's major commanders. He is said to have told them: "I want you guys to get with it. I know that the army is not going to develop in this counterinsurgency field and do the things that I think must be done unless the army itself wants to do it."[13]

Kennedy did not convince the brass. Opposition to special warfare was formidable. It started with Maxwell Taylor, who had come out of retirement to become Kennedy's special military representative. In 1962 he returned to active duty as chairman of the Joint Chiefs of Staff. Taylor was a proponent of firepower and maneuver by well-armed conventional forces. He believed that White House enthusiasm for counterinsurgency "really wasn't necessary."[14] Highly mobile conventional forces could take care of guerrillas. Taylor's predecessor as chairman, General Lyman Lemnitzer, asserted that the Kennedy administration was "oversold" on counterinsurgency. General Earl Wheeler, Army chief of staff from 1962 to 1964 and Taylor's successor as chairman, concurred.[15]

The Army brass closed ranks against special warfare. It did all it could to neutralize what the president had in mind. Rather, as Army chief of staff General George Decker stated in 1962, "Any good soldier can handle guerrillas."[16] With a little extra training, conventionally trained infantrymen could accomplish the counterinsurgency mission. It was not what Kennedy wanted to hear and showed the limits of mainstream thinking.

The Pentagon felt the same way about covert special warfare. While Kennedy directed the military to take over and expand CIA operations against North Vietnam in 1963, it demonstrated no eagerness for the assignment. As with its view of OSS operations, if there was no way of avoiding the matter, the Joint Chiefs of Staff at least wanted some control, particularly after the Bay of Pigs fiasco.

In the aftermath of the Cuban debacle, Kennedy had asked Max Taylor to head an investigation to determine what went wrong. At the time, Taylor was president of the Lincoln Center for the Performing Arts in New York City. He focused on command-and-control issues rather than operational ones. Taylor's most devastating criticism was aimed squarely at the White House: "Top level direction was given through ad hoc meetings of senior officials . . . without consideration of operational plans in writing and with no arrangement for recording conclusions and decisions reached."[17] White House handling of the Cuban operation looked like a real amateur hour. The administration's review process, said Taylor, was "inadequate for a proper examination of all the military ramifications."[18] This last point was a real zinger. It also begged the question of where the experts on military matters—the Joint Chiefs of Staff—had been in the process. Why had they not been more centrally involved?

The chiefs were missing in action because they had been cut out of the planning process by the CIA. This was strongly insinuated by Lyman Kirkpatrick, the CIA's inspector general in his report on the Cuban operation, completed in 1962. He was highly critical of the agency's performance. Inside the CIA, the report was considered a devastating blow by one of its own. In fact, it was so incendiary that the director locked it in his safe. It stayed there until it was declassified in 1998.

According to Kirkpatrick, "The Agency became so wrapped up in the military operation that it failed to appraise the chances of success

realistically." In future operations the CIA "must govern its operations with clearly defined policies and carefully drawn plans, engaging in full coordination with the Departments of State and Defense as appropriate. . . . In our view, the Clandestine Service tends to assume responsibilities beyond its capabilities and does not give sufficient consideration to the abilities of the other departments of government to conduct or participate in these operations."[19]

The Joint Chiefs did not need Kirkpatrick to tell them what they already knew. They had been snookered by the spooks. The CIA used Pentagon resources, including soldiers detailed to the agency, but did not ask for the chiefs' advice on the Cuban operation.

To prevent a recurrence, the chiefs wanted control over all military involvement in future covert operations. However, wanting control did not mean the chiefs were pining to take on an aggressive covert-operations agenda. They opposed the very idea and had little appreciation of what it could contribute. This became evident in how they dealt with the transfer of the CIA's covert operations against Hanoi to the Pentagon.

The decision to turn the covert war over to the military can be traced to a meeting convened by Secretary McNamara in July 1962 at Camp H. M. Smith in Hawaii. Attended by representatives from the departments of Defense and State, the Pacific Command, the CIA, and MACV, its purpose was to begin the Pentagon's takeover of the CIA's paramilitary programs in Vietnam. In light of the Bay of Pigs and National Security Action Memorandum 57, it was clear that civilian policy makers in Washington intended to assign a much larger role in these black activities to the Defense Department.

The Pentagon tried hard to dodge that bullet in the fall of 1962. Playing to the White House's preoccupation with covert action, newly appointed JCS Chairman Max Taylor recommended to the National Security Council's 303 Committee, which had policy oversight of all covert operations, that "further efforts [be undertaken] to broaden the CIA's program of action against North Vietnam." However, he did not propose that this escalation be carried out by the military. Instead, Taylor counseled that "the CIA be directed to initiate a greatly intensified covert effort against targets in North Vietnam." Taylor even identified specific targets. It was a thinly veiled attempt to pass the buck. The White House did not buy it and "[T]he Chairman's recommendation was not adopted."[20]

In January 1963, Taylor sent a team of senior military officers, headed by Army chief of staff Earl Wheeler, to Saigon to gather information the chiefs could use to assess the military and paramilitary requirements in South Vietnam. On February 1, Wheeler submitted his findings. Taylor liked what he saw and directed him to "brief the president."[21]

Wheeler called for an expanded program of "raids and sabotage missions against North Vietnam." It was just what the White House wanted to hear. However, the report did not propose that the Defense Department run this expanded effort. It was ambiguous about who should be in charge, stating that "This unconventional effort would be coordinated with the secret intelligence activities of the CIA."[22] Taylor and the chiefs were still trying to pass the buck.

The foot-dragging continued for most of 1963. In May 1963 the chiefs had finally directed Pacific Command to begin its development. Because Admiral Felt had been pushing for hit-and-run operations against the North Vietnamese coast, the command responded quickly and submitted OPLAN 34A to Taylor on June 17.

The draft plan remained in Taylor's office for three months before he signed it. Why was there such a long delay? Admiral Felt wanted to implement the maritime component of the plan but could not get approval from the chairman. Thus, the summer passed with no action taken. Taylor approved 34A on September 9 but once again stalled the authorization process. He deliberated over the plan for another two and a half months before presenting it to Secretary of Defense McNamara on November 20. Why did the chairman wait so long?

The answer is twofold. Part of it lies in his conviction at the time that the special warfare initiative of the White House "really wasn't necessary." Maxwell Taylor came out of the mainstream and believed in the conventional way of war. Blackburn had it right: "It wasn't only Westmoreland. It was Max Taylor . . . it was Harkins . . . it was Abrams. . . . They were so conventionally oriented." He added, "I always thought Max Taylor was an outstanding soldier." However, the Headhunter mused, when it came to Vietnam and SOG, "What in the hell did he contribute? . . . What went through his mind?"[23] A second reason for Taylor's foot-dragging was his wanting to avoid the burden and taint of failure. If the military didn't take on special operations, it couldn't be blamed if anything went wrong (like the Bay of Pigs).

Even after OPLAN 34A was authorized by the White House in January 1964, the military leaders continued to show little enthusiasm for it. This crippled SOG's potential effectiveness as it was being organized. For example, the chiefs were unwilling to assign a general to command SOG. According to declassified documents concerned with MACVSOG's "Inception, Organization, Evolution," OPLAN 34A planners saw SOG as a "supporting command, equivalent to a field force, under the control of the commander of MACV," General Westmoreland.[24] In Vietnam, the MACV commander had four supporting commands or field forces under his authority. These were designated I, II, III, and IV Corps. Each was commanded by a lieutenant general who assisted Westmoreland's field commanders for fighting the war.

If SOG was going to play the role of a MACV supporting command, its chief had to be accepted by both the Joint Chiefs of Staff and MACV. That never happened. The Pentagon leadership had no intention of assigning a general officer position to an organization like SOG, not even of one-star rank. To be effective, the chief of SOG had to be able to play at the senior level and be accepted as a member of that club. A general officer's slot was not to be squandered on SOG. As a result, the chief of SOG was often in an impossible position, trying to act imaginatively and propose new covert initiatives. If one recalls the difficulties Blackburn encountered when trying to get authority to conduct operations against the Ho Chi Minh Trail, it becomes obvious that he was not a member of the mainstream club.

The mission in Laos was not the only example of a lack of support from the Pentagon brass. It can also be seen in how SOG frequently lost in interagency confrontations with the State Department and the CIA. Why? For starters, two chairmen of the Joint Chiefs of Staff, Max Taylor and Earl Wheeler, were not prepared to fight a major political battle over SOG requests because there were more important Vietnam War–related issues at stake. For the Joint Chiefs, SOG was peripheral and unrelated to the main war effort. The White House had foisted it on the Pentagon. Grudgingly, the chiefs knew they had to put up with it, but that was all they were willing to do. The same perspective existed at MACV, where General Westmoreland saw little value in SOG.

GENERAL WESTMORELAND AND SOG

William C. Westmoreland epitomized the mainstream Army both in terms of his military experience and professional outlook. Westmoreland had entered West Point in 1932 and graduated four years later as the top-ranking cadet, first captain in the corps. During World War II he served in North Africa and Sicily before becoming chief of staff of the Ninth Infantry Division and taking part in the 1944 invasion of Europe.

In Korea, then-Colonel Westmoreland commanded the 187th Airborne Infantry Regimental Combat Team. This experience solidified his faith in mobility and firepower as the most effective means of war fighting. During the 1950s, Westmoreland commanded the elite 101st Airborne Division and served as superintendent of West Point. His next operational command, in the early 1960s, was as head of America's rapid reaction force, the XVIII Airborne Corps. The 101st Airborne Division and the XVIII Airborne Corps were the embodiment of the Army's dogma of firepower and maneuver by superior conventional forces. Advances in technology only intensified and deepened this conviction for the mainstream Army.

In 1964, when Westmoreland, as the MACV commander, began planning how to fight the Vietnam War, it was not surprising that firepower and maneuver became the core elements of his strategy of attrition. He sent U.S. soldiers on search-and-destroy missions throughout South Vietnam to kill, wound, or capture enemy troops faster than they could be replaced.

How did SOG fit into Westmoreland's war plan? He did not believe it had much to contribute and therefore paid little attention to it, and he reaffirmed that conviction in an interview for this book. Westmoreland recalled that he was "quite aware" of Washington's fixation on escalating covert operations against North Vietnam. However, he noted that at the time he saw little benefit in doing so: "Covert operations don't have much of a profound impact. It's an activity that might stir some apprehension in the minds of the enemy. But it's so small and the focus is so narrow. The people involved in it think they are very important and they're going to win the war. They totally exaggerate the importance of their effort."[25]

Westmoreland did not confine his criticism to those who planned and executed covert operations against Hanoi. He also thought the "best

and the brightest" in the White House had an overblown and misplaced faith in what covert action could accomplish. In particular he singled out McNamara: "I don't think there's any question about it, I think he did overestimate it." So did "professors who had been brought in" to the Kennedy administration and remained in senior positions under Johnson.[26] The latter comment was directed at Mac Bundy, the former dean at Harvard University, and Walt Rostow, who had been an economist at the Massachusetts Institute of Technology. Both were champions of covert operations. Westmoreland saw it differently: "The importance [of covert operations], I think, was exaggerated in the minds of a lot of these people in Washington at that time."[27]

What about SOG? Didn't it at least provide him with valuable intelligence on enemy activities on the Ho Chi Minh Trail, information that couldn't be obtained either through overhead photography or by electronically breaking into North Vietnam's communication systems? Westmoreland demurred and damned SOG's intelligence efforts with faint praise: "Well, it was helpful in that they were able to get a team of Special Forces people and put them on a hill where they could observe the Ho Chi Minh Trail, and they would count the number of coolies they saw marching down the trail but . . . they didn't know what the coolies were carrying. . . . What I'm really saying is it was a well-intended effort and it did provide us with some intelligence. But the intelligence was not great; it wasn't going to win or lose the war."[28]

Westmoreland had the same opinion of other operations that SOG's recon teams executed against the trail. SOG's main mission was to infiltrate small teams into Laos to identify enemy troops, convoys, base camps, supply depots, truck parks, weapons caches, command bunkers, and related targets for tactical air bombardment. The former commander of MACV characterized the impact of these operations on the enemy as "an annoyance rather than anything else." SOG "blew up a bridge, yes, but the enemy just went downstream, say maybe one or two miles, and they'd use another bridge. . . . So, I put it in this context—it was an annoyance."[29]

What about covert operations up North? Westmoreland was blunt: "It was basically a waste of effort." He believed that putting agent teams into North Vietnam was useless and that it "played into the enemy's hands."[30] Asked why the focus of the agent program was not changed to organize a resistance movement, as Russell, Blackburn, and Singlaub

had requested, the former head of MACV exclaimed: "That was a decision from Washington. . . . Lyndon Johnson would not be a party to broadening the war. And that was considered broadening the war."[31]

Policy makers were alarmed, Westmoreland observes, that fostering instability in North Vietnam might cause China to intervene. They did not want a second Korea. "If we were going to expand the war . . . [t]o what extent was China going to get involved?" It was a major concern of the White House. Westmoreland believed, "[W]e played our cards to the point where China did not get involved in the war."[32]

In Westmoreland's mind SOG had no strategic contribution to make: "It was a sideshow as far as the military was concerned. . . . The contribution was a kind of pinprick."[33] Was there *any* role for SOG? Westmoreland did not think so: "Not if you're thinking in terms of winning the war."[34]

He conceded that Washington's many restrictions on SOG operations inhibited what it might have contributed. Had things been different, had Westmoreland had complete authority to use SOG as he wished, would its contribution have been more significant? After contemplating the question, Westmoreland answered: "Conceivably, but on the scale of maybe ten percent, it could have been more effectively used." He reiterated that SOG just was "not very important." Pausing, he changed his mind: "You're talking about maybe a five-percent increase."[35]

If he had it to do over again, would he now try to integrate SOG operations into an overall war effort? Westmoreland still had doubts: "I don't think it would have any great impact. . . . The area of warfare that you're talking about is kind of a sideshow."[36] Westmoreland added that SOG's activities took place in North Vietnam, Laos, and Cambodia—all outside his area of operations. In the chain of command, these areas were under Pacific Command. Westmoreland noted, "I never particularly made an issue of it—saying it should be my authority, not theirs, because in the final analysis SOG didn't amount to a damn. The impact of it was totally incidental."[37]

THEATER STRATEGY AND SOG

Westmoreland's remarks about geographical limitations on his area of operations point to another important reason that SOG was not integrated into MACV's strategy. The way Washington assigned combat responsibilities in the Southeast Asian theater totally thwarted a unified

approach. There *was no* military strategy for fighting the Vietnam War. If there had been, it would have consisted of several coordinated operational campaigns aimed at those parts of the theater in which Hanoi carried out its own war efforts.

Campaigns are supposed to focus on strategic aims or objectives, and there should be a symbiotic connection between campaigns and military strategy. Strategy sets the focus for campaigns, and in turn, all campaigns support the aims of strategy. This implies an interrelationship between policy, which is devised by the civilian leadership, and military strategy and operational campaigns, the domain of the generals. Policy sets the goals that strategy seeks to attain. Campaigns are meaningful when they are consolidated into strategy.

The U.S. strategy for fighting the Vietnam War was bereft of any such approach. Instead, disharmony was at play, and coordination and integration never occurred. In part, this resulted because there was no unity of effort within the theater. The way in which missions were divided up provides a telling example. General Westmoreland was the commander of forces in the field in South Vietnam. He had no authority outside its borders. In his area of responsibility, he devised the strategy for fighting the NVA and Viet Cong. Although his concept of operations had to be cleared in Washington and supervised by Pacific Command, he determined how the United States would fight the ground war. Within the Pentagon, Westmoreland's approach found a receptive audience in the JCS because it was quintessentially mainstream. At Pacific Command, which was headed by an admiral, there was little interference. What did an admiral know about fighting a ground war?

Technically, the head of Pacific Command in Honolulu exercised military responsibility for the entire Southeast Asian theater of war. In reality, however, his primary role was command of U.S. Navy and Air Force units that carried out combat missions in the skies over South Vietnam, North Vietnam, Laos, and Cambodia.

Admirals U. S. Grant Sharp and John McCain, the Pacific Command chiefs from 1964 to 1972, cleared all their bombing operations with Washington. While Westmoreland did the same, the MACV commander had more latitude in shaping his concept of operations than did Sharp and McCain, at least until the war turned sour in 1968. The bombing campaigns executed by Pacific Command received much closer scrutiny from Washington than the ground war. Part of the reason

was that air wars were easier to understand and depict. Almost every morning, there were easels in the secretary of defense's office and the deputy secretary of defense's office with a large schematic showing which targets had been struck in North Vietnam the night before or which ones were proposed for the next raids. There was no way to picture the scores of small unit engagements taking place in the South during the same period. The most intensely supervised aspects of the war were scrutinized so closely because the bombing campaign could be reduced to comic book terms.

In Laos and Cambodia, Sharp and McCain had to contend with powerful American ambassadors. Wanting to harness the Pentagon and CIA overseas, President Kennedy had taken steps to empower his ambassadors to ensure that they were in total charge of the country in which they were assigned. Consequently, while Laos was critical to North Vietnamese strategy for fighting the war, it was off-limits to MACV and Pacific Command. The only way in was through Ambassador Bill Sullivan, and he made it clear that he called the shots. The same was true in Cambodia: the American ambassador, beginning with Leonard Unger in 1964, was a powerful player in terms of whether U.S. covert or overt military operations were executed there.

However, these were not the only factors that constrained the command's use of this instrument against Hanoi. Equally important was its own lack of interest in such operations. With the exception of Admiral Felt, who ran Pacific Command during SOG's first six months, there is no evidence that the senior leadership in Honolulu paid much attention to covert operations. In Felt's case, his interest was confined to covert maritime actions against the North Vietnamese coast. At the time, it was one of the few options available to the theater commander. When U.S. military involvement in Vietnam burgeoned in 1965, Admiral Sharp paid little attention to SOG operations. The war would now be fought the American way, with large forces and conventional strategy.

Covert action had no allure for the Navy's senior leadership, and Sharp exemplified this perspective. A 1927 graduate of the Naval Academy, he commanded a destroyer in World War II. Following the war, his career path to the rank of four-star admiral was through service in the mainstream Navy.

Sharp's attitude toward SOG is reflected in comments by William Murray, who from 1964 to 1966 served as an action officer in the

Special Operations Division of the Office of the Special Assistant for Counterinsurgency and Special Activities (SACSA). He was responsible for shepherding SOG maritime mission requests through the military and civilian authorization process in Washington after Pacific Command had messaged them.

Murray had served with Sharp in earlier assignments and knew him well. When the admiral came to Washington, they would meet for dinner. The main topic of discussion was always OPLAN 34A and SOG. From these sessions Murray gained a good understanding of how Sharp felt about the covert war against Hanoi.

Sharp worried about it, Murray recalled. Why? Because if a SOG operation went sour and was exposed, Sharp believed "he was going to get blamed." Covert operations could get you in trouble, recalled Murray: "He felt there was too much of a free wheeling approach to MACVSOG. Freewheeling was a continuing problem. Sharp wanted to keep SOG reined in." When asked whether the head of Pacific Command ever commented during one of those dinners that SOG was making a contribution to the war effort, Murray responded without hesitation: "No, I don't think so. At least he never expressed it to me."[38] There is nothing in any declassified document that suggests Admiral Sharp ever pushed hard on initiatives to intensify covert operations against North Vietnam, or to employ them in a more effective way. Murray made clear that Sharp was not interested and expended little capital on SOG's behalf.[39]

In sum, SOG was not just persona non grata with the mainstream military leadership in MACV and Pacific Command, it was an orphan in the chain of command because of the attitude of indifference of the senior leadership. None of the top generals or admirals in the theater wanted it because they saw little value in such operations—"kind of a sideshow." The brass paid as little attention to it as they could. SOG operations were not integrated into U.S. military strategy for conducting the war because of this indifference.

INSIDE THE PENTAGON:
THE FIGHT FOR CONTROL OF COVERT OPERATIONS

The most enthusiastic proponent of President Kennedy's special warfare vision in the Pentagon was Brigadier General Edward Lansdale.

Kennedy had been impressed by Lansdale in the very early days of his tenure in the White House after inviting him to brief the National Security Council on January 28, 1961. From the presentation it was clear to JFK that this unusual Air Force general knew a great deal about Vietnam and special warfare. As a result, according to Lansdale, Kennedy told him that "I'd like you to go over there [South Vietnam] as the ambassador."[40]

The professionals at the State Department were flabbergasted, adamant that Lansdale not go to Vietnam as ambassador. It was not bad enough that he was a military man; he also had been a CIA operator in the Philippines and South Vietnam; even worse, his CIA exploits had been fictionalized and extolled in a best-selling novel, *The Ugly American*.[41] Inside the State Department, all these facts reinforced the belief that Lansdale was not fit to serve as an ambassador anywhere, let alone in a sensitive post like Saigon. Foreign-service professionals pushed to prevent the appointment and finally persuaded Secretary of State Rusk to tell Kennedy that if Lansdale were appointed as ambassador, then "the president could find himself a new secretary of state."[42] This put an end to Lansdale's diplomatic prospects.

Kennedy next told Admiral Arleigh Burke of the Joint Chiefs of Staff that he wanted to send Lansdale to Vietnam as chief of the U.S. Military Assistance Advisory Group. To qualify for that assignment Lansdale would have to be promoted from a one-star brigadier general to a three-star lieutenant general. The suggestion did not go far. The chiefs considered Lansdale out of the mainstream, with weird ideas about warfare, including his belief in all that psywar business that they considered a waste of time. Promoting Lansdale from one-star to three-star general was out of the question.

Lansdale worried the chiefs. His ideas about special warfare mirrored White House views, and he had gained the confidence of President Kennedy. Furthermore, Lansdale was a political operator on the Washington scene. He was very visible promoting his ideas about Vietnam and special warfare. The chiefs feared that all this hoopla about new ways of fighting war was getting out of hand and decided to silence Lansdale. Admiral Burke sent a memorandum to Lansdale raising questions about Lansdale's public speeches and pronouncements on Vietnam and what needed to be done there. The message

was unambiguous—Lansdale was put on notice to keep his mouth shut.[43]

Lansdale Gains the Upper Hand Over the Joint Chiefs

While Lansdale was persona non grata with senior military leaders in the Pentagon, he had his supporters on the civilian side of the Department of Defense, including Deputy Secretary of Defense Roswell Gilpatric. In a February 24, 1961, memorandum to JCS Chairman Lemnitzer, Gilpatric directed that Brigadier General Lansdale be designated to establish and head the Office of the Assistant to the Secretary of Defense (OATSD). In this capacity, Lansdale was to have responsibility for "5412 [Committee] matters; special defense activities as approved by the Secretary of Defense; [and] CIA relationships of special interest to the Secretary of Defense."[44]

In effect, Lansdale was to be McNamara's action officer for all military involvement in covert special warfare. His immediate boss, Deputy Secretary of Defense Gilpatric, was McNamara's representative to the National Security Council's 5412 Committee (later the 303 Committee), which had policy oversight of all U.S. covert-action programs. This put Lansdale at the epicenter of the game.

A week later, Gilpatric sought to strengthen Lansdale's position: he informed Lemnitzer that "General Lansdale, as ATSD, would provide staff support for all matters related to 5412 [Committee] actions. . . . In that capacity, General Lansdale would recommend appropriate items for discussion and monitor the necessary follow-through actions required as a result of the meeting."[45] Gilpatric instructed Lemnitzer to "designate officers of general/flag rank from the Joint Staff to provide advice and support to General Lansdale in the performance of his duties."[46]

None of this went down well with the JCS. An intense fight ensued inside the Pentagon for control of covert operations. Lansdale fired the first shot with a memorandum to Director of the Joint Staff Lieutenant General Earl Wheeler in which he prescribed "the most effective means of having the Joint Staff render support for [his] mission." With Lansdale operating under the authority of Gilpatric and ultimately McNamara, the tone of the memo was clear—Wheeler and

the Joint Staff were working for Lansdale. It stated, "A small team in the Joint Staff will be activated under Brigadier General David W. Gray, USA, Chief of the Subsidiary Activities Division, J–5. Members of the team, while responsible to their superiors, will be in a position to work directly and fully with General Lansdale's office."[47] It was a straightforward power play, called by Lansdale.

He was not alone in playing hardball. Joint Chiefs of Staff Chairman Lemnitzer, in a March 14 memorandum to McNamara, reinterpreted what Lansdale thought Gilpatric had decreed. "The Joint Staff, desirably and feasibly, should assume the responsibility for processing CIA requests for peacetime support of covert operations as set forth in General Lansdale's memorandum."[48] In other words, the Joint Staff was not working for Lansdale. The JCS would give direct counsel and advice on all questions of military involvement in covert operations to the senior civilian leadership of the Pentagon.

Lansdale responded with a memorandum on March 27 that further outlined ways in which the Joint Staff should provide "support for him in the discharge of his new responsibilities as Assistant to the Secretary of Defense." To this end, "A small, secure staff element in the Joint Staff will be established to furnish such support. This special operations element will be quickly responsive to the Assistant to the Secretary of Defense as required in connection with his responsibility for special activities and operations of interest to the Secretary of Defense."[49]

The Joint Chiefs upped the ante at the end of July. Putting Lansdale in his place was only one of two reasons for their growing concern. A second was the Bay of Pigs. The chiefs were irate over the fact that the CIA had cut them out of the planning process and were intent that this not occur again. Furthermore, they did not want Lansdale to have responsibility for all military involvement in covert special warfare, including "CIA relationships of special interest to the Secretary of Defense."[50] The chiefs could only imagine what Ed Lansdale and the CIA might cook up behind their backs.

In a July 29 memorandum to Secretary of Defense McNamara and CIA Director McCone, the Joint Chiefs announced that "[a] Special Operations Division in the J–5 Directorate of the Joint Staff had been activated."[51] The chief of this new division was to be kept apprised on all 5412 Committee actions under consideration that involved the

military. By taking this action, the chiefs thought they had inserted themselves back in the loop and put Lansdale back under their control and stopped his freelancing.

McNamara informed them otherwise on August 7: "There was an apparent misunderstanding of the role desired for the [Special Operations] Division in support of the Assistant to the Secretary of Defense." He "did not agree with the Joint Chiefs of Staff to keep the Chief, Special Operations Division, J–5, fully informed on 5412 [Committee] actions under consideration." Furthermore, he did not expect Lansdale to inform the Joint Chiefs through the J–5 of all covert-operations issues under consideration by the secretary of defense.[52] The Joint Chiefs were thus once again out of the process.

On September 12, 1961, Lansdale followed up McNamara's memorandum to the Joint Chiefs with one of his own, rubbing salt into an open wound. He stated: "All matters involving the Department of Defense peacetime support of the CIA operations will be monitored directly by the Office of the Assistant to the Secretary of Defense." Lansdale's office would determine whether the Joint Staff would be included in discussions over specific covert operations "depending on the nature of the request [from the CIA]." Finally, he ordered that "action be taken to amend or rescind implementing instructions promulgated by the Joint Chiefs of Staff which were not in consonance with the above."[53]

In effect, Lansdale wanted the chiefs to recant their July 29 memo to McNamara in writing and adhere to the guidelines spelled out in his September memorandum. As 1961 came to a close, Lansdale held the upper hand.

The Chiefs Eviscerate Lansdale

Lansdale may have won the first round, but the Joint Chiefs were not about to give up. There was too much at stake. They could see the special warfare frenzy from the White House spinning out of control if they did not exercise supervision over it. However, up to this point the chiefs, while under a lot of pressure to take up President Kennedy's challenge, had been slow to do so. They looked like obstructionists, and JFK let the brass know of his displeasure with their lack of action. In a note to McNamara, the president stated that he was "not satisfied that the Department of Defense, and in particu-

lar the Army, was according the necessary degree of attention and effort to the threat of insurgency and guerrilla warfare."[54]

Also, there were the implications of NSAM 57 for the Pentagon. It specified that "Any large paramilitary operation wholly or partially covert which requires significant numbers of militarily trained personnel, [and] amounts of military equipment," would become "the primary responsibility of the Department of Defense with CIA in a supporting role."[55] Until Kennedy took office, the Pentagon had been able to avoid any major involvement in covert operations. The Bay of Pigs and NSAM 57 debacle changed all that. A strategy of avoidance would no longer work for the chiefs. As 1962 began, the Office of the Assistant to the Secretary of Defense had responsibility for those activities that fell under NSAM 57. This was anathema to the chiefs. Lansdale was out of control, as his self-promotional endeavors demonstrated. In their estimation, he was an eccentric aberration of what a general officer should be. Even worse, policy makers were listening to him. To undermine these developments, the Joint Chiefs adopted a new strategy of cooptation.

The chiefs responded by creating an organizational machinery that gave the impression the Pentagon was committing itself to special warfare, while making sure the brass had control of such operations. In a clever bureaucratic move, "The Chairman, Joint Chiefs of Staff directed the establishment of the SACSA [Office of the Special Assistant for Counterinsurgency and Special Activities] effective 23 February 1962. The Special Operations Division of the J–5, complete with personnel and functions, was transferred to SACSA."[56]

Ironically, SACSA, as it was referred to in Pentagon vernacular, ended up playing a supporting role for SOG at the Washington level. However, the reason the brass created SACSA was to slow the Kennedy administration's special warfare policy, not to embrace and advance it. The new agency had two tasks: to prevent future CIA end runs like the Cuban operation, and to undermine Lansdale's role as the Pentagon's guru on counterinsurgency and unconventional warfare.

To head the new agency, the Joint Chiefs, with the White House's approval, selected Marine Major General Victor "Brute" Krulak. Krulak was to become one of the "military's most skilled bureaucratic players in Washington," and "a figure of immense import in the constant struggle over Vietnam."[57] Looking back on the 1962–1964

period, one can only marvel at the involvement of this two-star
Marine general in high policy on Vietnam. His role greatly out-
reached his major general rank and attests to his political acumen.

At the time Krulak held mainstream views on the Vietnam conflict and
military strategy. He was no fan of special warfare, as promoted by
Lansdale. From 1962 to 1964, Krulak was aligned with JCS Chairman
Max Taylor and Taylor's protégé in South Vietnam, MACV commander
General Paul Harkins. David Halberstam in *The Best and the Brightest*
wrote that during this period, "What he [Krulak] really did was serve as a
messenger between Saigon and the Pentagon, and represent the military in
intergovernmental meetings, where his special assignment was to destroy
any civilian pessimism about the war."[58] Harkins's message, which was
Taylor's message, was that the United States was winning the war. Krulak
defended this position in the interagency battles over Vietnam.˙

Krulak had also worked himself into the position of a Kennedy
administration insider by playing on his World War II combat experi-
ence with the new president. After reintroducing himself to JFK,
Krulak befriended his brother Bobby Kennedy and their military
adviser, Max Taylor. He also gained the confidence of Secretary of
Defense McNamara, who was keenly attuned to Krulak's special rela-
tionship with the president.

˙Later, Brute Krulak would turn against the Pentagon mainstream. Known not
just for his bureaucratic and political perspicacity but also for possessing a
sophisticated intellect and deep appreciation of the war-fighting arts, he saw
through Westmoreland's strategy of attrition, whose foundations Harkins laid in
1962–1964. Harkins's war-fighting concepts came from his patron, Max Taylor.
It is said that Brute Krulak was one of the few American military leaders who
understood the minds of the North Vietnamese. In the spring of 1964, after his
tour as SACSA, he became Commanding General Fleet Marine Force Pacific
(FMFPAC) in Honolulu. From there he watched the war unfold. At this point, his
intellect and war-fighting instincts took over. What transpired was a real
epiphany that led Krulak to turn on the mainstream. He began sending memos to
McNamara and writing papers on why the attrition strategy would fail and how
to put the United States on a winning course. The more Krulak visited Vietnam
(he was in country almost every month that he served in command of FMFPAC),
the more unrelenting he became in his efforts to change the way the war was
being fought. When he could not budge Westmoreland, he went over his head
and played on the relationship he had built with McNamara during the Kennedy
days. However, Krulak's efforts were to no avail and probably cost him the job of
commandant of the Marine Corps. Westmoreland's strategy was unassailable. It
had the support of the senior leadership in the Pentagon and White House and
was popular with the public, to the degree that he was *Time* magazine's 1966
Man of the Year.

For these reasons, Krulak was picked to be the Special Assistant for Counterinsurgency and Special Activities. He was not selected because of his extensive background and operational experience in special warfare. Krulak had none. As SACSA, he was the gatekeeper the Joint Chiefs wanted. In the counterinsurgency area, he deflected the criticism by U.S. officers in the field in South Vietnam who argued for a commitment to that approach for fighting the war. Instead, he followed the Taylor and Harkins line in 1962 that the United States was succeeding by adhering to conventional, mainstream methods.[59]

Krulak strongly disagreed with Lansdale about special activities and covert operations. He would play a key role in the termination of the Office of the Assistant to the Secretary of Defense and forced retirement of Ed Lansdale, the man President Kennedy said reminded him of a character straight out of an Ian Fleming novel. However, it is important to note that Lansdale also contributed to his own demise. The ways in which he sought to suborn the Joint Staff to his will is one example. He came to be seen by McNamara, Gilpatric, and others as a grandstander, a lone wolf, and a self-promoter. His views on Vietnam, which challenged the administration's policy, also contributed to his eventual demise.

As a result, Lansdale's influence on Vietnam policy decreased precipitously. One of his biggest mistakes was crossing swords with Maxwell Taylor. In the fall of 1961 he took on Taylor, much to his detriment. Lansdale had been assigned to take part in a fact-finding trip to South Vietnam headed by Kennedy's military adviser. Taylor saw it as his trip. Lansdale thought he was back inside the Vietnam policy circle. At a pre-trip meeting in Taylor's office on October 13, he got a rude awakening.

At the session, he gave Taylor a list of Vietnamese, including President Diem, whom he knew personally and from whom he planned to get firsthand accounts of what was going on. Taylor would have none of it and told Lansdale that his movements in South Vietnam would be controlled and that he would not be allowed to meet with his old friend President Diem. Instead, he would be assigned the task of looking into the possibility of erecting an electronic fence along South Vietnam's borders to stop enemy infiltration, an idea Lansdale found idiotic.

Lansdale told Taylor he could best serve the mission by meeting with Diem and a number of other influential Vietnamese he knew from his

earlier tour there. Taylor ignored him. Once in Saigon, Lansdale was quietly brought to the presidential palace by Diem's personal secretary for dinner. During the rest of the visit he contacted many of those on the list he had given to Taylor and ignored the electronic fence. It was the kind of lone-wolf operation that had marked Lansdale's entire career.

These actions confirmed for Taylor, who was soon to put his uniform back on in 1962 and become chairman of the Joint Chiefs of Staff, all he needed to know about Ed Lansdale. In the Pentagon, Taylor was instrumental in Lansdale's removal from Vietnam policy and reassignment to Cuban operations. As the Pentagon's point man on covert operations, Lansdale found himself in 1962 assigned to Operation Mongoose, the name Bobby Kennedy selected for the administration's continuing efforts to overthrow Fidel Castro. Mongoose came to occupy a great deal of Lansdale's time, as the SACSA's authority expanded over many of the aspects of special warfare that had once been assigned to his office. The Pentagon could not have been happier.

For example, it was the SACSA and Krulak who were the ones involved in the planning that led to OPLAN 34A and SOG, not Lansdale. Reflecting on Lansdale's demise, Brute Krulak painted a picture of his waning popularity within the Kennedy administration. "Some people thought highly of him, some thought just the reverse. He was skillful in exploiting those who thought highly of him. I never quite understood how McNamara felt about him. If I had to guess, I would guess that he became very suspicious." Krulak notes that while it was true that in the early days of the administration Lansdale had gained their confidence, he did not "believe that confidence lasted. I don't believe that the director of Central Intelligence [John McCone] had much confidence in him. I heard him say so informally on the golf course."[60]

During a May 1963 visit to several Latin American countries, the ax fell on Ed Lansdale. He received a message that the Pentagon had issued orders for his retirement from active duty. He had not been thinking about retirement and had not put in papers to do so. By the time he returned to the United States on June 1, 1963, he was officially out of the military. Lansdale was then ordered back on temporary duty until October 30 to wrap up his affairs.[61]

The mainstream had finished off one of the military's most knowledgeable special operators and had done so with extreme prejudice. The SACSA then presided over the dismemberment of Lansdale's office. In a

memorandum to the chairman of the Joint Chiefs on September 30, 1963, Deputy Secretary of Defense Gilpatric, once one of Lansdale's supporters, assigned all responsibilities of the Office of the Assistant to the Secretary of Defense to the SACSA. Specifically, the SACSA would "Assume DOD staff responsibility for the Washington-level planning and direction of those special activities and special operations in which DOD participates." Furthermore, it would be the SACSA that would "Provide staff support . . . direct to the Secretary of Defense and the Chairman, Joint Chiefs of Staff for their 5412 [Committee] and Special Group (Counterinsurgency) responsibilities."[62] The brass had lost a round or two to Lansdale, but in the end they knocked him out of the ring.

SACSA AND SOG

As OPLAN 34A was being drafted in 1963, the Joint Chiefs assigned Pentagon oversight of it to the SACSA and Brute Krulak. After SOG was established, the SACSA supervised all its activities between 1964 and 1972. Personnel from SACSA literally walked operational requests from the SOG leadership through a chain of command that ran all the way to the White House. In the lexicon of the Pentagon, the authorization procedures were highly "stovepiped." Normal bureaucratic intermediaries were bypassed in order to keep SOG's covert activities secret and under the tight control of the brass.

Brute Krulak was directly involved in these early developments, and at the end of 1963 he attended those 5412 Committee meetings that culminated in the approval of OPLAN 34A. He remembers that "Bobby Kennedy was a very strong personality and he influenced it [34A] very greatly. There was one other influence . . . Deputy Secretary of Defense Roswell Gilpatric." What about McGeorge Bundy? Krulak said Bundy's interest in 34A was "strong"—and then adds cryptically that Bundy "never let ignorance becloud the issue."[63] The decision to escalate covert operations against Hanoi, Krulak would point out, started with the Kennedy brothers. They wanted to undermine the North in the same manner that Hanoi was fostering guerrilla subversion against the South Vietnamese government. President Kennedy expressed this view at a National Security Council meeting only days after entering the White House, and, Krulak recalled, "Bobby said it too in 5412 [Committee meetings]. He was a get-even sort of guy."[64]

In retrospect, Krulak was critical of the senior policy makers' passion for escalating covert operations against North Vietnam. He believed they had little understanding of the complications involved. "The farther they got away from reality, the more enthusiastic they became," he quipped, and then added, "[David] Halberstam wrote a book and he called these fellows whose names we have just mentioned the best and the brightest. They were neither one."[65]

As the first head of SACSA, Krulak had responsibility for establishing that organization. By the time 34A was finalized in late 1963, SACSA consisted of four divisions: Plans, Doctrine, and Resources; Programs and Review; Special Plans; and Special Operations. While there were changes in the organization during the latter half of the 1960s, the one constant was the Special Operations Division (SOD), and it was in this section of SACSA that responsibility for SOG was placed.

Oversight of SOG

SACSA managed the authorization and execution process for all SOG mission requests. It kept a close hold on SOG activities for a small number of the most senior military and civilian officials in the Pentagon. In Krulak's words, "The idea was that we were going to show them [SOG operations] to very few people."[66] The stovepipe "wasn't a very military arrangement, but that was the way McNamara wanted it. And that's the way General Taylor wanted it."[67]

To comply with this requirement, action officers in SACSA's Special Operations Division (SOD)—three to be exact—were the only ones with the clearances to handle day-to-day SOG matters. The SOG mission was so sensitive that they worked "in a vault" in the Pentagon basement.[68] They also had to sign a secrecy oath not to reveal a single aspect of what they were doing to anyone who did not have a need to know about it.

One Army officer who served in the Special Operations Division in 1965 described the work environment as follows: "SACSA and particularly the SOD was very much compartmentalized. You really didn't know what was going on in the room next door. Across the hall was JPRC [Joint Personnel Recovery Center] coordination, which dealt with prisoners of war." He knew nothing about it. "You only knew what was going on in your own little bailiwick, and ours was probably more classified and more totally closed than anybody else in the SACSA."[69] It was spooky business.

In 1964–1965 the three SACSA action officers included Commander William Murray, Lieutenant Colonel Harold Bentz, and Lieutenant Colonel John Van Dyn. This assignment put them in direct contact with JCS Chairman Wheeler, Secretary of Defense McNamara, Secretary of State Rusk, national security adviser Bundy, and their deputies. For officers of their rank, conferring with and briefing officials at the top levels of the U.S. government was very unusual, and it gave them a purview of one of the most highly classified policy initiatives in the Johnson administration.

Bill Murray was assigned to SACSA in June 1964 and for the next two years was at the center of SOG-related matters in Washington. He had no experience with covert special operations. All of his operational tours had been on surface ships. However, in a previous assignment with the Office of Naval Research he had been "responsible for the development of underwater swimming devices and electronic devices used in cover and deception operations."[70] Presumably, that was enough to get Commander Murray assigned to SACSA.

Handling the SOG account for the JCS was an extraordinary position for a Navy commander. Murray recalled, "We had very little to do with the J-2, J-3, J-5, which were divisions in the Joint Staff that normal operational requests for authorization had to pass through. None of this applied to us. Our SOG actions never went through anybody at the Joint Staff but SACSA himself, and then directly to the chairman's office." From there a request, according to Murray, was "stovepiped" directly to Secretary of Defense McNamara.[71]

The authorization process—Approval Procedures for OPLAN 34A Maritime Operations—was set forth by Deputy Secretary of Defense Cyrus Vance in a September 30, 1964, memorandum that contained the following diagram.[72] It reflects the general authorization procedures that were eventually applied to all four of SOG's operational divisions. However, it is not completely accurate. For example, the CIA only became part of the oversight process in late 1965, when SOG initiated operations against the Ho Chi Minh Trail in Laos. The agency was not part of the authorization procedures for the other operational divisions of SOG.

How this process actually worked on a day-to-day basis cannot be gleaned simply from wiring diagrams or organizational charts. It must also be seen through the eyes of those SACSA action officers

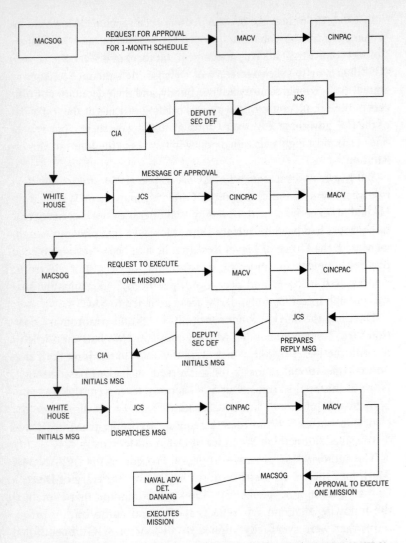

THIS PROCEDURE IS OUTLINED IN A MEMORANDUM FROM DEP SECDEF VANCE TO MR. MCNAUGHTON, 30 SEPT. 64.

APPROVAL PROCEDURES FOR
OPLAN 34A MARITIME OPERATIONS

who managed SOG matters. Bill Murray recalled that all requests by MACVSOG for authorization to execute a package of missions "usually arrived through a very restricted crypto[graphic] system with distribution only to SACSA." They would take the request and turn it into a "regular Joint Chiefs of Staff [action] paper with limited distribution to only certain officials. . . . All of this was accomplished in an incredibly short time when compared to other routine Joint Chiefs of Staff papers."[73] Thus, once Major General Roland Anthis, who replaced Krulak as SACSA in the spring of 1964, approved a paper prepared by the Special Operations Division, it was sent directly to JCS Chairman Wheeler.

Having reviewed the action paper, Wheeler might initial the request on the spot, or he could take it to the chiefs for review before signing off on it. Why Wheeler might sign one request immediately but take another to the chiefs for review is unknown.

Once the chairman had initialed the paper, the SACSA action officer walked the request for review to either Secretary of Defense McNamara or his deputy, Cyrus Vance. During 1964 most SOG requests went to McNamara, who "usually initialed it right off," according to Murray.[74] He recalled that at that time, McNamara was very enthusiastic about SOG and in no way was a force for restraint. Reflecting on his days in SACSA, Murray felt that McNamara should have been more restrained in his promotion of these operations. Murray had his own serious doubts about SOG: "[T]he people assigned to SOG were in general undisciplined, wild-eyed Army Special Forces people . . . who believed that the whole of Southeast Asia could be conquered by a handful of Green Berets." To Murray's dismay, "for a considerable period of time, McNamara also believed this myth."[75]

By the end of 1964 McNamara appears to have lost some of his zeal for these covert operations, and Vance replaced him in the authorization chain of command, as can be seen in the above diagram of the authorization process. As the Defense Department's representative to the 303 Committee (formerly the 5412 Committee), which had policy oversight responsibility for all covert operations, Vance also dealt with SOG matters there. Was he as enthusiastic about covert action against Hanoi as his boss? Murray does not think so: "No. Mr. Vance used to agonize about it. . . . [C]an they do it? Is it safe? Are

we going to get them back? What happens if they get caught? He was worried about the safety of the people."[76] Nevertheless, he rarely stopped a request from going forward.

Following approval by the Pentagon, the next stop for a SACSA action officer in 1964 was not the CIA but the White House. After either McNamara or Vance had initialed the action paper, Commander Murray "got into a waiting car at the E ring [entrance to the Pentagon] and was driven to the State Department," where he would take the action paper to Secretary Rusk. He recalls one occasion "when Secretary Rusk was departing for an official function and [I was] chasing him down the corridor. The importance of these operations can be gathered by the fact that Rusk stopped, saw what I was carrying, and we stepped into a convenient office where he read and initialed the approval."[77]

Once Rusk added his signature, Murray was back in the car. For his next stop he "went to McGeorge Bundy's office," the national security adviser. Generally, he gave the action paper directly to Bundy. He "usually asked me a few simple questions," recalled Commander Murray, "read the paper and initialed it." However, this did not always end the process. On several occasions Bundy told Murray or another action officer: "You go back to your office and when I get approval upstairs I will give you a call. Those initials [on the action paper] are not good enough for release until you get a call, my call, understood?"[78]

Commander Murray would return to the Pentagon to await the telephone call. When asked if Bundy was taking the request to the 303 Committee, Murray said, "No, no. The request was being taken to President Johnson for review."[79] In light of what is known about LBJ's micromanagement of the war, it is no surprise that he was involved in the authorization of SOG requests. Only then could the action officer take "the release message to the communication center, and it was sent 'operational immediate' [top priority] to MACVSOG."[80]

This micromanagement can be seen in a top secret memorandum from Michael Forrestal of the NSC staff to Secretary of State Rusk on August 8, 1964 concerning the planned resumption of 34A operations in the aftermath of the Gulf of Tonkin episode. In the note, Forrestal commented on the authorization of two specific 34A operations—an attack on the "Vinh Son radar post and a RON" (a remain overnight operation by a commando team). These small tactical

actions, Forrestal explained, had been authorized at the top of the executive branch: "I checked this on August 4th with Cy Vance and Mac Bundy, both of whom told me that these actions had been approved at the White House the previous Sunday, August 2nd."[81]

Through the Eyes of Action Officers

The Joint Chiefs established SACSA to serve as their watchdog. It was to keep those involved in Pentagon-sponsored covert operations under close supervision. This is how the brass saw it, according to Colonel Albert Brownfield, who was the deputy SACSA for two years beginning in the summer of 1964.

During his tour, Brownfield had frequent interaction with General Wheeler. The Joint Chiefs chairman wanted control, he asserted: "We spent part of almost every day in the chairman's office. . . . He wanted to know what was going on. . . . I would say that probably 70 percent of the time we spent in the chairman's office was to tell him what had taken place, to review SOG actions. . . . If it was something new that had not been done before, he wanted to make the decision and did." In most instances Brownfield did not remember Wheeler's taking a request to the chiefs: "I don't recall that he ever asked for more time to make a decision which would have allowed him to talk to somebody else. I suspect that he had already been given that much leeway by the Joint Chiefs."[82]

While the JCS may have wanted a watchdog, for several of those who served in the SACSA's Special Operations Division, SOG became a vocation. The three chiefs who followed Krulak—Major Generals Anthis, William Peers, and William Depuy—all championed SOG operations and sought to expedite its missions. For Peers, this was an outgrowth of his OSS experience. He had organized tribesmen in Burma into a large guerrilla force that caused the Japanese real headaches. Murray characterized him as "one of the original special operators . . . Peers had a real grasp of what was feasible."[83]

In the spring of 1967, Depuy replaced Peers. Before taking over, he had commanded the First Infantry Division in Vietnam. In the early 1960s Depuy served as the director of special warfare in the Army's Office of the Deputy Chief of Staff for Operations and Plans. Initially, he was an advocate for SOG. Later, according to an officer who worked for him in the SACSA, "he changed and turned against it."[84]

Depuy had a special relationship with Wheeler and described himself as "the assistant to the chairman for Vietnam"[85] with responsibilities "much broader than just counterinsurgency and special operations." In a 1988 interview, Depuy said that he "became an assistant across the board [to Wheeler]. . . . For example, when General Wheeler went to Vietnam on that very famous trip right after Tet, I went with him as the only member of the Joint Staff."[86] While Wheeler was never a supporter of SOG, in 1968 he became quite critical of it. Depuy's own souring on the operation contributed to Wheeler's enmity.

In effect, Anthis, Peers, and Depuy (until he changed his views in 1968) changed SACSA from a watchdog to a proponent for SOG inside the Pentagon. This is the way that Colonel Brownfield, deputy to both Anthis and Peers, saw his role: "We were not the watchdog, at least while I was there with Anthis and Ray Peers. We saw ourselves as people who tried to expedite whatever mission SOG had that required our help. We tried to remove roadblocks."[87]

Captain Bruce Dunning, who from August 1966 until September 1969 served both as an action officer and as chief of the SACSA's Special Operations Division, shared Brownfield's perspective. "If we were watchdogs, I wouldn't say that we were very fierce watchdogs. We monitored all the SOG programs and wanted to make sure that they were within existing authorities . . . that they weren't going too far. Yet at the same time, as far as us action officers were concerned, a great deal of our work was advocacy. We were trying to protect MACVSOG and protect the programs because we really believed in them."[88]

While these action officers may have become proponents of SOG operations, they did not encounter corresponding support for them from the Pentagon brass. Through firsthand observation and interaction they corroborated that the senior military leadership tolerated SOG's covert operations largely because of pressure from the White House, skeptical that SOG operations had much to contribute to the war.

This is what then–Lieutenant Colonel Robert Rheault was to learn not long after he joined SACSA in July 1966. In a later tour in Vietnam in 1969 as the commander of the Fifth Special Forces Group, he was to experience firsthand the real enmity many in the senior ranks of the mainstream military felt toward special operators. Bob

Rheault was a 1946 graduate of West Point who abandoned the Army mainstream for the Special Forces in the late 1950s. He quickly became a rising star, destined for promotion to general. When he joined the SACSA, Rheault was assigned a very important account: SOG's cross-border operations against the Ho Chi Minh Trail in Laos. He remembered: "My functions there were that I dealt directly with Peers and Depuy. . . . I ran the Shining Brass operations, and I worked directly with them. . . . I would receive the requests that came in from SOG wanting to launch specific operations . . . I would clear it with Peers and Depuy. I would then take it to a contact in each of the services, who was usually at the brigadier level, and get him to agree to it."[89]

The reason for this change in the authorization process described earlier was that OP 35 requests were taken "for approval . . . into the tank," a secure room in the Pentagon where the Joint Chiefs conferred. According to Rheault, "Normally, a lieutenant colonel would never take anything into the tank; it would be passed to somebody more senior. But this was all expedited for OP 35 requests, which were very close hold. I would personally take it into the tank, and the chiefs would look at it very quickly, might ask me a couple of questions, and give it their O.K." The chairman would also have to concur.[90]

From there he walked the paper to Vance's office: "Vance was always a gentleman. He would usually O.K. it. Then I would take it over to Colby [at CIA headquarters]. . . . [He was] a very good guy and would never stop it. Then it would go to the State Department, and that's where the trouble would hit." He found that the geostrategists at State often objected to SOG requests. "[T]hat's where the process broke down. Here you have a disagreement between the Department of Defense where Deputy Secretary Vance has signed off on the request, as has the Joint Chiefs of Staff, and the State Department is saying no." If this occurred, Rheault explained, "then we would have to escalate and bring the request back to Peers or Depuy and they would take it up to the chiefs and see if they could get it through.[91] Those disagreements could turn into real bureaucratic donnybrooks, and the State Department won more often than it lost.

During his trips into the tank, Rheault did not detect any zeal for SOG on the part of the chiefs. When asked to what extent the Joint Chiefs felt SOG operations were a valuable part of the war effort, he

replied: "I don't think they did. . . . The conventional military guys were in control in Washington, and they opposed Special Forces. . . . I think Depuy, because he had a special relationship with Wheeler, was able to get support for SOG's unconventional operations. But I don't think that the Joint Chiefs as a group had a great deal of confidence in SOG being able to influence the war." The chiefs' attitude was, "Let it go, go ahead, but keep it under control."[92]

The only SOG activity that the Joint Chiefs had any interest in, according to Rheault and other action officers, was that carried out by OP 35. Why? According to Rheault, "Because they could see as military officers the importance of having patrols out there to gather intelligence and possibly to do some interdiction, and the Air Force would be happy to have somebody calling in targets for them instead of just bombing the jungle." Nevertheless, even here the chiefs wanted tight oversight: "The way that happened actually was that each of the chiefs had his designated guy who would theoretically look at each proposal closely. In other words, there was usually a one-star at each level who would look at the proposal that I would draft up based on the input that I got from SOG."[93]

After two years in SACSA Rheault was promoted to colonel and was selected to command the First Special Forces Group on Okinawa. This was followed by an assignment to head the most important Special Forces unit in 1969—the Fifth Group in South Vietnam. Here, Rheault found out how General Abrams really felt about special operators.

One of the Fifth Group's operations at that time was Project Gamma, a clandestine intelligence-gathering effort against NVA and Viet Cong forces in Cambodia. The agent teams that crossed the border were made up of indigenous personnel. Early in 1969, those in charge of Gamma found that a significant number of their operations were being compromised and the agents were not coming back. It did not take long to deduce that there was a Vietnamese mole in Project Gamma. In the spring of 1969 some highly sensitive enemy documents were captured that pointed to the agent. Armed with this information, a review of the compromised operations revealed that the mole had known about those missions on which the Gamma operators disappeared. He was arrested and polygraphed. The results reeked of deception.

Rheault was unsure what to do with the spy. The CIA station suggested he be eliminated.[94] It was not extraordinary advice, given that

in wartime spies are generally executed. The mole was shot and his body weighted down and dumped into Nha Trang Bay for the sharks to eat. A cover story was then created about the mole's disappearance for purposes of plausible denial. However, it unraveled, and General Abrams became enraged over the whole affair. It fed all his prejudices about Special Forces as a bunch of reckless misfits. He had Rheault and several other members of the Fifth Group arrested and, after an investigation of the affair, charged with premeditated murder—summary execution of a Vietnamese national. Rheault was jailed immediately. The evidence of the mole's treachery was discounted. These events became headline news in the American and world media.

Then a most extraordinary coincidence occurred. On August 25, one of OP 35's recon teams—RT Florida—crossed the fence into northeast Cambodia. It was a dicey operation, and the team came into contact with NVA trackers using dogs. While trying to evade, RT Florida ran headlong into two NVA officers, who apparently were not part of the enemy forces that were in hot pursuit of the SOG unit. The two were killed on the spot. One of them turned out to be a more senior officer, probably a colonel, who was carrying "a big leather satchel." It quickly became obvious that he was an intelligence officer. Once the team was back in South Vietnam, the documents captured were rushed to Saigon. It was a real "windfall: The bag contained a partial roster of enemy double agents and spies operating inside South Vietnam." One name on the list "was the double agent executed by order of Colonel Rheault."[95]

On September 29, Secretary of the Army Stanley Resor announced that all charges against Rheault had been dropped. For Bob Rheault, the value of SOG operations was unquestionable. They had saved him from a grave injustice. Still, the affair ended his military career, even though in early 1969 he had been selected for promotion to brigadier general. Although he was never told directly, it was clear to Rheault he would never pin that star on or be given another command.

While Rheault's ordeal is the stuff of a Le Carré spy novel, even a Shakespearean tragedy, his experience with the senior military leadership during his tour in the SACSA was not unlike that of other action officers who handled the SOG account, such as Bill Murray, who had preceded him. When asked if during the two years that he took SOG proposals to the chiefs he encountered any enthusiasm on their part, Murray responded without hesitation: "No, not that I ever saw."

They went along with it as long as they felt "it isn't going to get the corporate military into any trouble."[96]

Lieutenant Colonel George Maloney was assigned to SACSA in early 1967 and stayed until late 1969. He encountered not only the indifference and lack of enthusiasm reported by Rheault, Murray, and other action officers, but outright hostility in the Joint Staff, and particularly from the Deputy Chief of Staff for Operations (J–3). "Through the great bulk of the period that I was there, the J–3 was Air Force Lieutenant General J. C. Meyer. He was known to his subordinates as Jesus Christ Meyer. He made it clear to us he thought little of SOG's operations. In so many words he said, I don't want to throw cold water on your efforts, but I don't think the whole unconventional effort is worth a damn. He was of the opinion that air power could whip Hanoi."[97]

Maloney also watched as General Wheeler began to actively question SOG's worth. In early 1968 the chairman ordered Depuy to do a complete review of SOG: "He told Depuy that he wanted an officer to go over and scrub that thing. Look at it from top to bottom, and I spent eight weeks doing this." The review focused on agent operations. Wheeler was aware of the counterintelligence evaluation of the program, as well as Bob Kingston's earlier negative assessment of it. Maloney's appraisal was the same. It was all the chairman had to hear. Maloney recalls that a "general dissatisfaction" with SOG set in.[98]

Next, Wheeler ordered MACV to conduct a review of SOG. It was headed by the former deputy SACSA, Colonel Albert Brownfield, who was at the time MACV's assistant J–3. His report was also critical. Finally, on January 7, 1969, Wheeler and the Joint Chiefs tasked SACSA to conduct a yearlong assessment of MACVSOG. It was intended to be a postmortem for SOG, which, with the exception of operations against the Ho Chi Minh Trail, was moribund as a result of the Johnson administration's decision to halt cross-border operations into North Vietnam in November 1968.

Interagency Oversight of SOG Operations: No Support from the Joint Chiefs

The fact that SOG had no patron in the Pentagon at a rank higher than SACSA was a serious obstacle. All too frequently the SACSA was a loser in the interagency bureaucratic fights in Washington with

the State Department and the CIA. SACSA was a two-star general in the Pentagon, a land of four-star power brokers. Following Lieutenant General Depuy's tenure as SACSA in 1969, the position was downgraded to a brigadier general's billet. The indifference to and lack of interest in SOG by Wheeler and the Joint Chiefs only added to the SACSA's impotence.

The initial decisions about which aspects of OPLAN 34A to execute in early 1964 are illustrative. Recall that the original plan was ambitious and contained recommendations that certainly were sensitive and bold. The most contentious had to do with developing a guerrilla resistance movement inside North Vietnam.

The story of what happened to this proposal exemplifies the Joint Chiefs' lack of interest in and lack of understanding of unconventional warfare. In December 1963, having concurred with the draft of OPLAN 34A, Admiral Felt, the head of Pacific Command, raised two issues for the chiefs. First, if "North Vietnam and Communist China escalated [the war] beyond South Vietnamese capabilities" in response to 34A, were the chiefs "prepared to commit forces?" Second, Felt "expressed doubt that the proposed actions [in 34A] would have a lasting or serious effect on the North Vietnamese leadership."[99] His concerns framed the Pentagon review and greatly influenced the Joint Chiefs' conclusions about 34A. China worried the chiefs, and they expressed their concern over a replay of the Korean War. They also agreed with Felt on the effects of the proposed 34A actions. The chiefs doubted that they would accomplish much.

Next, on December 19 and 20, 1963, Defense Secretary McNamara and CIA Director McCone were briefed on the plan and on the Joint Chiefs' apprehensions. They kicked it up to the 5412 Committee, posing the following questions: "Should there be cross-border operations from SVN into Laos?" And to what extent "should an intensification of pressures on NVN through covert means [i.e., resistance operations]," as proposed in the 34A draft, be executed? McNamara and McCone raised the same issues with President Johnson when they briefed 34A to him on December 21. As a result of the meeting, Johnson tasked McNamara and McCone to establish an "interdepartmental committee (State, Defense, CIA) to select from the plan those operations which were most feasible and which promised the greatest return for the least risk."[100] Johnson signaled

that he wanted to move cautiously on the use of covert operations, especially given that 1964 was an election year.

The criteria established by the White House created a frame of reference that resulted in the expunging from 34A precisely those operations that were bold and strategic. The interdepartmental committee was chaired by Major General Brute Krulak, the Pentagon's special assistant for counterinsurgency and special activities, and included Bill Sullivan, Averell Harriman's protégé at the State Department. The outcome of its deliberations was foreseeable, as the Pentagon and State Department moved to undercut OPLAN 34A.

The interdepartmental review eliminated from 34A all references to resistance, even though the planners considered it the key to the overall design. Why was it eliminated? According to Major General Krulak, he threw cold water on the whole idea during committee deliberations because he felt it was "no good. . . . It just wouldn't work." The former SACSA continued: "I did not believe and do not believe in the sui-generis initiation of internal resistance. People have to want to do it. They have to want to do it so much they're willing to risk a lot to do it, particularly in a society such as North Vietnam. I didn't think we had the horses up there."[101]

When asked how he knew that, Krulak replied: "I didn't know it. Of course, this was a conviction. Everything we did with respect to North Vietnam and covert operations was based on conviction." Krulak added that he also "had severe reservations about the intelligence that one has to have before you can do it, and I seriously doubted that we had it. And I still do."[102]

Krulak and the Pentagon leadership were not alone in sinking the resistance idea. Ambassador Sullivan and the State Department also weighed in against it. The geostrategists from Foggy Bottom were opposed because the purpose of a resistance movement was to destabilize North Vietnam, and that violated U.S. overt policy. This argument was rolled out to reject SOG requests to initiate the resistance movement operation in 1965, 1966, and 1968. It always prevailed, as the following 1965 Joint Chiefs' response to SOG on this matter illustrates: "In the final analysis, U.S. policy precluded the development of this movement. . . . National policy would not authorize resistance and guerrilla warfare."[103]

It was the coup de grace for the resistance idea. The recommendations of the Krulak committee became the basis for U.S. policy. A

State-DOD-CIA joint message on January 16, 1964, stated that "the recommendations of the interdepartmental committee had been approved by the President." In a memorandum at about the same time, Krulak informed Vance that "the President had approved it [his committee's report]."[104] Wheeler and the Joint Chiefs refused to try to "walk the cat back" after this initial decision, even though SOG requested that they do so. The chiefs saw no value in resistance operations. The decision proved irrevocable.

Krulak's committee also dealt with the matter of Laos. Should covert cross-border operations against the trail be initiated? Here also the Pentagon's senior leadership was not interested. And with Sullivan as a member of the interdepartmental committee and Harriman, then the undersecretary of state for political affairs, looming in the background, the outcome was hardly in doubt. The Krulak report warned that "the uneasy political and military balance in Laos could be upset" if Laotian territory were used "for operations against North Vietnam."[105] Oddly it said nothing about North Vietnam using Laos for operations against South Vietnam.

Without Pentagon interest, Laos stayed off-limits to SOG for nearly two years. Throughout this time, the SACSA encouraged the Joint Chiefs and secretary of defense to push the policy makers to reverse this decision. The former deputy chief of the SACSA, Colonel Albert Brownfield, recalled that he "made several efforts to get us into Laos for intelligence purposes as well as for operations against the Ho Chi Minh Trail . . . [but] was never successful."[106]

Even after SOG was authorized to cross the fence in the fall of 1965, Bob Rheault remembered, there were serious confrontations with the State Department over its bureaucratic maneuvers to restrain those operations as much as possible. It drove Peers up the wall, recounted Rheault: "I can remember Peers coined the word 'shove' as a result of his clashes with the State Department, who never wanted any of the OP 35 actions to take place. Peers said, 'Nothing over there but a bunch of shoves.'" Rheault asked Peers "what a shove was. 'A cross between a shit and a dove,'" he explained.[107]

As Rheault carried SOG requests to the State Department, he encountered firsthand its opposition to operations in Laos. He noted that State had a veto and exercised it often. When this happened, "then it was back to the drawing boards. What can we come up with

. . . that will answer these Sullivan objections and still be able to push it through?" Would Depuy take it to Wheeler to get him to weigh in? Rheault noted that "he could, but how often are you going to bring the chairman into the act?" Furthermore, "if the State Department didn't want an operation to happen and they felt they were going to be overridden, they would get on the radio and contact Sullivan and ask him to make an objection."[108]

According to George Maloney, who was the SACSA action officer responsible for SOG operations in Cambodia, his experience in managing the authorization procedures was the same as Bob Rheault's. He characterized it as "a relatively long process."[109] This involved "fight[ing] the State Department tooth and nail" because they were "afraid of getting us into a larger war and wanted all sorts of restrictions placed on SOG activities. They wanted to treat Laos and Cambodia as neutral countries."[110] Every restriction SACSA was able to have lifted from OP 35 came as a result of this kind of protracted conflict with the State Department.

SACSA also did battle with the CIA over SOG. As in its melees with State, victories were few. According to NSAM 57, the CIA was supposed to provide support for those larger covert operations assigned to the Pentagon. SACSA and SOG assumed that this included personnel from the agency. The original SOG request of February 1964 was for thirty-one agency officers. This proposal was finally "approved by the Joint Chiefs of Staff in July 1964" and sent to the CIA.[111]

The CIA was "slow in filling the empty billets" because it believed "that the agency would be withdrawing from the 34A Program within six months."[112] This was the beginning of a two-year dispute between the SACSA/SOG and the CIA over agency personnel support. By January 1965 the original figure of thirty-one was reduced to thirteen by the CIA. In "February 1966, CIA proposed that the number of spaces be reduced from 13 to 9." This reduction had been "the subject of previous discussions in October and November 1965. Both CINCPAC and COMUSMACV had nonconcurred in the changes."[113] Their nonconcurrence had no effect, and the number assigned to SOG stood at nine. The CIA was able to argue successfully that "the situation in South Vietnam and elsewhere had placed a severe strain on the limited number of qualified officers available for such duties."[114]

There is no evidence that the Joint Chiefs even pondered weighing in and fighting on this matter.

The CIA officers assigned to SOG almost always came out of the Psychological Operations Branch of the CIA's Directorate of Plans, a part of the directorate whose operators were seldom promoted to the agency's top ranks. During the skirmishes over personnel billets, SACSA/SOG had requested that the "professional competence" of the senior agency officer assigned to SOG "lay in the field of operations in general." What they wanted was an officer on the Directorate of Plans' fast track, one who could provide advice and insight across the spectrum of SOG's different operations. The CIA turned down the request, and the senior agency slot in SOG was filled by an "officer whose professional competence lay in the psychological operations field."[115] The SACSA was unable to do anything to reverse these personnel support decisions.

Personnel support was not the only place where SACSA/SOG and the CIA disagreed. Another concerned authority for guerrilla/resistance operations. In mid–1964 the SACSA sent forward Clyde Russell's request that SOG be permitted to undertake these activities, as specified in the original 34A. The proposal made it all the way to the 303 Committee. However, at the meeting CIA Director McCone successfully argued that "the formation of guerrilla groups among the Meo [or Hmong] and non-Meo tribes in North Vietnam should remain a CIA function."[116] The 303 Committee backed the agency.

The CIA and SOG likewise clashed over the initiation of the Shining Brass operation in Laos in the fall of 1965. The agency saw it as going far beyond the original 34A mission and raised objections to it. SACSA reported to Vance at the end of November 1965 that "CIA refused to actively support SOG planning for infiltration of new teams . . . because they felt it would adversely affect their program [in Laos]." SOG Chief Don Blackburn said the same thing in January 1966: "Shining Brass activities are not supported by CIA."[117]

In Laos the CIA's operation was under the control of the Field Marshal, Ambassador Bill Sullivan. Sullivan and the CIA formed a powerful alliance in constraining SOG operations in the years that followed. In the interagency wars in Washington, SACSA found itself outgunned.

In sum, SACSA may have become an advocate for SOG, but it was a weak player in the power politics of Washington. In these battles it

could not call on the real power brokers in the Pentagon—the chairman and the Joint Chiefs of Staff—to back it up and fight in its place. The brass was an ambivalent patron at best. The chairman and the chiefs knew how to do battle in the Washington policy arena, but they were not about to do so for SOG. Its operations were just not important enough.

8

PRESIDENTIAL CONTROL OF THE COVERT WAR

Kennedy Aggressiveness and Johnson Trepidation

When the Vietnam War ended, the records of SOG's top secret missions and White House control of them were buried deep in the bowels of the Pentagon. They were never supposed to see the light of day. The committed and courageous men who planned and executed these operations received no public recognition. SOG was too politically sensitive.

Then the Cold War ended. Slowly the story of SOG began to appear. One of its own offered a moving account of these derring-do operations. John Plaster served three years in SOG, two of which were spent leading recon teams "across the fence" into Laos. In 1997 he published a stirring narrative about the men who took on the North Vietnamese Army on the Ho Chi Minh Trail.[1] Finally, the SOG veterans of those exploits, their sacrifices and courage, as well as those of buddies who did not make it back, were emerging in the public record.

This recognition did not last long. Indeed, SOG was vilified in a Cable News Network (CNN) story about a SOG mission in Laos,

code-named Operation Tailwind. The investigative report, which aired on June 7, 1998, alleged that during a top secret SOG operation to assassinate American defectors in Laos, lethal nerve gas—sarin— was dropped on enemy soldiers and civilians. The story was subsequently published in *Time* magazine under the byline of CNN's April Oliver and Peter Arnett.[2]

CNN reported that on September 11, 1970, a SOG hatchet force of 16 Americans and 140 Montagnards landed deep inside Laos to attack "a village believed to be harboring a large group of American GIs who had defected to the enemy." The "unit's job was to kill them," said Oliver and Arnett. Prior to the mission, a small recon team was inserted to see if defectors were there. They "spotted the prize—several 'roundeyes,' Americans, in the village."[3] The next day the hatchet force went in. The actual raid "lasted no more than ten minutes." Oliver and Arnett reported that "A dozen, fifteen, maybe twenty" American defectors were killed, but "no bodies were identified or recovered" because enemy forces were closing in. As the fighting heated up, "the commandos were told to don their . . . M–17 gas masks. Then came the explosions of the gas canisters."[4] The results were instantaneous, CNN reported. As the rescue helicopters lifted off, a member of the raid recalled, "All I see is bodies. . . . They are not fighting anymore. They are just lying, some on their sides, some on their backs. They are no longer combatants."[5]

The allegations, if true, would incriminate American soldiers and pilots who took part in the operation as perpetrators of war crimes. Moreover, such an extraordinary action would have had to have been authorized by the White House, a point CNN drove home—"Any use of nerve gas would have had to have the approval from the Nixon national security team."[6] Could it be true?

CNN claimed it was an airtight exposé, a shocking blockbuster, that had some of the big names in the American media behind it.[7] To many, the account seemed plausible. Then the report started to unravel. Other journalists dissected the exposé, challenged the veracity of CNN's charges, and uncovered glaring gaffes in the reporting.

Newsweek fired the opening shot by raising doubts about the credibility of CNN's star witness, a member of the Tailwind operation, who provided most of its firsthand account.[8] Then CNN's star witness began to backpedal, publicly denying that he was the source of

CNN's explosive charges.[9] The credibility issue worsened for CNN when the veracity of two of its other "eyewitnesses" was shattered. They were never part of the operation.[10]

Another key source for Oliver and Arnett was the former chairman of the Joint Chiefs of Staff, Admiral Thomas Moorer. He was said to "have confirmed the use of sarin in the Laotian operation and in other missions to rescue downed U.S. airmen during the Vietnam War."[11] However, there was no videotape of Moorer actually saying this. Arnett and Oliver claimed he "confirmed the use of sarin off camera but wouldn't say so on the record."[12] In *Newsweek* and elsewhere, Moorer vehemently denied confirming the use of sarin.[13] Other sources, including the Army captain who led the raid, charged that their comments had been misrepresented in the broadcast.[14] In preparing the report, CNN stated that it interviewed 200 sources in all. After the broadcast, several of them told other journalists that they had affirmed it was tear gas, not nerve gas.[15]

The media's reassessment of the exposé amounted to an autopsy. Then CNN's own internal review—undertaken by the highly respected media attorney Floyd Abrams—administered the coup de grace, asserting that "the central thesis of the broadcast could not be sustained at the time of the broadcast itself and cannot be sustained now."[16]

One underlying question was overlooked during this reassessment, however, the answer to which only highlighted the implausibility of the entire CNN account. How likely was it that the White House would have authorized SOG to undertake such a risky and politically explosive covert operation? Historical facts, contained in a plethora of declassified SOG documents, make clear that it was not at all prone to do so. Presidential oversight of all SOG operations, starting in 1964 and continuing through the eight years SOG existed, was characterized not by a willingness to take risks, but by the desire to avoid them. The CNN report on Operation Tailwind had portrayed White House oversight completely backwards.

WHITE HOUSE OVERSIGHT OF THE SECRET WAR

SOG ran Washington's largest covert operation of the Cold War. It executed a wide range of secret missions inside North Vietnam and

against the Ho Chi Minh Trail in Laos and Cambodia, as disclosed in this study. Each of these operations required White House approval. The secret war was not a rogue operation run independently by the CIA or the Pentagon. President Kennedy and President Johnson were both intimately involved, but for very different reasons. JFK aggressively sought to employ covert action to subvert Hanoi and convince it to stop fomenting the war in South Vietnam. LBJ's approach was more cautious. He limited the secret war because he was more concerned with the political fallout that would ensue if these operations unraveled and were exposed to international scrutiny. Consequently, nothing SOG did occurred without the full knowledge and concurrence of the White House. While alluded to in previous chapters, the "hands-on" approach of Kennedy and Johnson will be elaborated here.

Aggressiveness on the New Frontier

During the 1960 presidential campaign, candidate John F. Kennedy declared: "American frontiers are on the Rhine and the Mekong and the Tigris and the Euphrates and the Amazon. . . . We are responsible for the maintenance of freedom all around the world."[17] Once in the White House, President Kennedy feared that those American frontiers were in danger of being pushed back by communist aggression, particularly through guerrilla subversion. He quickly learned that the situation on the Mekong was not good; South Vietnam was in trouble. Kennedy prepared to dig in. He did not intend to lose Vietnam. Rather, as Bobby Kennedy stated, "We are going to win in Vietnam."[18] To do so, the New Frontiersmen concluded that new doctrines and approaches were needed to defeat insurgent communist movements.

To develop these concepts, Kennedy recruited what David Halberstam described as a "new breed of thinkers-doers." These men believed that "One had to stop totalitarianism, and since the only thing the totalitarians understood was force, one had to be willing to use force."[19] However, they rejected old, conventional approaches as irrelevant to the new threats. What was needed was innovative and imaginative thinking, and this led the New Frontiersmen to special warfare strategies and covert-action measures. Senior officials in the

new administration's inner circle, starting with the president, were vigorous proponents of these new measures.

Walt Rostow, one of those insiders, recalled that during Kennedy's first days in the White House, "Khrushchev's speech promoting wars of national liberation and revolution in Southeast Asia, Africa, and Cuba focused the new president's attention on these challenges." He noted that these developments in Kremlin policy "made the Lansdale report [on Vietnam, presented at the first National Security Council session] very critical." Asked whether JFK was a strong proponent of initiating covert operations against Hanoi in response to its support of the Viet Cong, Rostow answered: "Yes, he was. Since the communists were promoting insurrection, he wanted to do the same thing to put Hanoi on the defensive."[20]

In Kennedy's inner circle, the most ardent proponent of covert action was Attorney General Robert Kennedy. He was a member of both the 5412 (later the 303) Committee and the Special Group (Counterinsurgency), the two secretive NSC organs established to direct White House policy over special warfare operations. It was highly unusual for the attorney general to be involved in such matters. After all, his portfolio dealt principally with domestic legal matters, not squelching communist guerrillas and subverting those who supported them. Brute Krulak recalled Robert Kennedy's interest in covert action and his role in the administration's determination to employ it as an instrument of foreign policy. "He influenced that [course of action] very greatly," observed the first Special Assistant for Counterinsurgency and Special Activities.

This was evident in Bobby Kennedy's prodding of the CIA to eliminate the Castro regime in the aftermath of the Bay of Pigs. Following the debacle, the administration established yet another secretive NSC-level organization—the Special Group, Augmented (SGA). Its task was to direct the next phase of the ongoing Cuban operation, code-named Mongoose. The president appointed his brother to chair the SGA. The objective was to escalate covert action against Castro and to do so quickly. When results were not forthcoming, the Kennedy brothers expressed their displeasure.

The head of the CIA's clandestine services at that time, Richard Bissell, was called on the carpet in the fall of 1961, and, according to him, "chewed out in the Cabinet Room of the White House by both

the president and the attorney general for sitting on his ass and not doing anything about getting rid of Castro."[21] In his memoirs, Bissell elaborated on the ways in which the Kennedys badgered the CIA to intensify operations: "The Kennedys wanted action and they wanted it fast. Robert Kennedy was willing to look anywhere for a solution. . . . [His] involvement in organizing and directing Mongoose became so intense that he might as well have been the [CIA's] deputy director for the operation."[22] Robert McNamara likewise remembered "pressure from JFK and RFK to do something about Castro."[23]

According to Richard Helms, the former CIA director, the instrument of choice for getting rid of Castro after the Bay of Pigs was "covert action."[24] As the CIA representative to the 5412 Committee in the early 1960s, Helms observed the Kennedy brothers up close. He remembered "[t]he pressure from Bobby Kennedy as daily."[25] The Kennedys "wanted to get covert operations going against Cuba, Vietnam, and elsewhere and sought to do so quickly."[26]

Secretary of Defense McNamara was the most unlikely Kennedy insider to have been an advocate of covert operations. The former Ford Motor Company president knew nothing about such matters. Nevertheless, from the summer of 1962 to the end of 1964, he was the catalyst pushing for the Pentagon to take over and escalate the CIA's covert war against Hanoi. In 1965, however, his interest waned sharply as his attention was consumed by conventional strategies for fighting the Vietnam War.

William Colby, who, as CIA station chief in Saigon, directed those initial clandestine efforts against North Vietnam, remembered that McNamara was very assertive. He pointed out that McNamara believed the CIA was "only playing at [covert operations] but not really getting a critical mass into North Vietnam that could have an impact." Colby was not concerned with the size of the CIA program, but the toughness of the target. He believed Hanoi was too tough a nut to crack. His views were rejected by the secretary of defense: "[H]e dismissed the argument on the grounds that the CIA doesn't think big enough." The Defense Department "could put more horsepower behind it and make it more effective."[27]

Once the decision was made to assign the covert war to the Pentagon, McNamara's "can do" attitude drove the early implementation of OPLAN 34A. This is what Captain Bill Murray encountered

in 1964, when as a SACSA action officer he took SOG operational requests to the secretary of defense for approval. Murray walked those action proposals right into McNamara's office. Reflecting on that experience, he observed that of all the senior officials in the chain of command, McNamara was "[t]he driving force, I would say. The central force. I could never identify anyone else [in the Pentagon] who was the force behind this operation." Asked if McNamara ever opposed any of SOG's covert proposals, Murray stated: "Oh no, not that I recall."[28]

Also fostering the use of covert operations against North Vietnam were other Kennedy insiders, such as McGeorge Bundy and Walt Rostow. In addition, William Bundy played an important role, according to William Sullivan. In 1964, the older brother of McGeorge Bundy was working for McNamara as the deputy assistant secretary of defense for international security affairs. The Field Marshal asserted that behind McNamara, Bill Bundy drafted the memoranda and cables on 34A. While "the cables went out over McNamara's name," Sullivan believed "most of those cables were initiated and drafted by Bill Bundy."[29]

With all this horsepower backing the escalation of covert action against North Vietnam, it is hardly surprising that when the CIA failed to deliver, the Kennedy administration became displeased with the agency's performance. CIA officers running the operations against Hanoi in the field were told by Washington to step it up. For example, Tucker Gougelmann, who was in charge of the maritime component of the agency's covert program, was instructed to expand sabotage raids in "preparation for the future establishment of resistance activit[ies] within North Vietnam."[30] In other words, he was informed that the next step was to initiate a guerrilla movement inside North Vietnam. Bill Colby, in Vietnam at the time, recalled the pressure from the White House: "[T]hey were hoping to do something quickly [against North Vietnam] to balance the problems we were suffering in South Vietnam."[31]

The CIA's failure to produce results led the administration to look for alternative means of implementation. The Pentagon was the only candidate, as is spelled out in declassified documents that describe how and why OPLAN 34A was conceived. According to the records, three factors account for Kennedy's decision to transfer the covert mission to the military. The first involved the president's commitment

"to prevent communist domination of South Vietnam and to expand the intensity of allied actions." By 1963 the situation in the South had turned into a full-blown crisis. New measures—in the form of intensified actions—had to be taken to stop the hemorrhaging. This included "covert paramilitary ones against North Vietnam."[32]

The second reason for assigning the mission to the Pentagon focused on "[t]he need for a concerted, joint effort against North Vietnam in the field of covert paramilitary actions."[33] The White House had concluded that this was beyond the capacity of the CIA. Only the military, with its expertise in special warfare, could escalate the operation to the level needed to bridle Hanoi.

The third reason, directly related to the second, highlighted the administration's exasperation over "[t]he relative ineffectiveness of the CIA's covert program against North Vietnam."[34] The agency had failed to deliver. However, even in the CIA's lackluster performance there was a glimmer of hope that could be exploited if the operations were expanded. While criticizing the agency for "not actually accomplishing much," the White House found in reports of the CIA's operations that even these meager efforts "were taken very seriously by the authorities in North Vietnam." As a result, "[a] national warning system was established." Evidently, Hanoi feared that the CIA's paltry operations might engender "the formation of active guerrilla bands supported by the North Vietnamese populace." This could lead to "the outbreak of an uprising."[35] Here was confirmation for the White House that it was on the right track in seeking to escalate the covert war. Hanoi was worried about such threats, even feeble ones. It was an opening to exploit, in the administration's view, and it pushed hard to do so.

Kennedy Administration Delusions

Once the Kennedy administration settled on the Pentagon it dug in against all attempts by the brass to pass the operation back to the CIA. Each time Joint Chiefs Chairman Max Taylor tried to do so in 1963, his maneuvers were blocked. McNamara had been given the mission and he intended to execute it. If the White House was in a hurry to step up the covert war, so was Secretary of Defense McNamara.

McNamara's commitment to Kennedy's special warfare agenda was the central reason for his support of the decision to hand over the covert war to the Pentagon, even in the face of opposition from the Joint Chiefs, as Walt Rostow noted: McNamara "strongly backed President Kennedy, who wanted covert operations against North Vietnam out of CIA's hands."[36] It is the same explanation Richard Helms gave: "McNamara's enthusiasm mirrored John and Bobby Kennedy's. If they were for it, so be it."[37]

McNamara developed a personal association with the Kennedy brothers, as he recounted in his 1995 retrospective on the Vietnam War. However, in 1961 he had no association with the newly elected president, having just been appointed president of the Ford Motor Company. Out of the blue, Bobby Kennedy called and said: "The president-elect would be grateful if you would meet with our brother-in-law, Sargent Shriver." McNamara agreed to do so, and the meeting was held later that day. Much to McNamara's amazement, Shriver told him: "I am authorized to say Jack Kennedy wishes you to serve as secretary of defense." McNamara responded: "This is absurd . . . I'm not qualified."[38] Within two weeks he accepted the offer.

Why had Kennedy selected someone with no real experience in national security matters? The answer, as McNamara explained, is that he was recommended by members of the Eastern Establishment. "I believe two people were primarily responsible: Bob Lovett, who knew my reputation at Ford and my work in the Army [during World War II]; and John Kenneth Galbraith, the liberal Harvard economist." They felt that the president-elect needed a secretary of defense who was a "businessman with innovative ideas."[39] Apparently, these key figures advising Kennedy believed the Pentagon required a senior corporate manager and not an imaginative strategic thinker. While he did not start out as an insider, McNamara became a personal favorite of Kennedy's.

According to Roger Hilsman, whom Kennedy appointed assistant secretary of state for Far Eastern affairs in 1963, a second reason for McNamara's support of the Pentagon's role in the covert war can be attributed to his management approach. Hilsman explained that McNamara "wanted personal control of everything and tried to keep everyone else in Washington out of it."[40] He pointed out that "[t]he press frequently accused McNamara of being . . . power hungry and

domineering. As Secretary of Defense, he was on occasion all of these things. . . . McNamara was crisp, decisive, and almost lacking in self-doubt."[41]

Hilsman's insights help illuminate McNamara's role in the 1963 decision to take covert operations against North Vietnam away from the CIA and assign them to the Pentagon. His management style in the Pentagon amounted almost to one-man rule. That put him at loggerheads with the Joint Chiefs. During nearly eight years as secretary of defense, McNamara never hesitated to reject JCS views on professional military matters. Those who disagreed with him in the early years by going directly to the White House or Congress typically lost the argument and were pushed to retirement.

Consequently, it is not surprising that McNamara overruled the Pentagon brass when it came to covert operations against Hanoi. He thought he knew more than they did. The Joint Chiefs' truculent opposition to Kennedy's special warfare agenda did not help matters. McNamara was running the Pentagon, and the Joint Chiefs increasingly found themselves excluded from decisions they opposed. With respect to the covert war, Rostow put it this way: "By 1963 he had increased his power and thought he could do a better job than CIA."[42]

In effect, these two considerations led McNamara to champion a policy of which he had little understanding. He directed the Pentagon to take over and escalate the covert war against North Vietnam, and to do so overnight.

McNamara was not alone in his lack of knowledge. Among the special warfare enthusiasts in the Kennedy administration there was little understanding of the complexities involved in executing covert operations against denied areas. Krulak believed that "those who were enthusiastic about it . . . were enthusiastic because they thought it was an easy and a cheap way [to pressure Hanoi]."[43] While North Vietnam was vulnerable, exploiting it was not going to be simple or attainable overnight. There is little to suggest that those pushing this policy inside the Kennedy administration understood this reality.

Hilsman put it bluntly: "They did not understand. They had no reason to believe we could do to North Vietnam what North Vietnam was doing in South Vietnam. I doubt if any of the members of the 303 Committee had any detailed knowledge."[44] Helms was more blunt: "There was great enthusiasm for covert operations but also great

ignorance of how these things worked and the complexities of how to carry them out."[45]

Similarly, Kennedy and his inner circle of advisers appear not to have known of the Pentagon's lack of capabilities for mounting an intensified covert operation. Since Special Forces were being expanded, they assumed that the means were available for expanding covert operations in North Vietnam. However, this was not the case, particularly with regard to establishing and running agent networks and executing black psywar campaigns. Brute Krulak, as the first SACSA, was in a position to see these gaps in military capability. He believed that running agent networks and orchestrating complex psywar campaigns were beyond the Pentagon's forte. This was even true of the Special Forces, whose "prime function . . . [was] parachuting into a country where there are a lot of friendly partisans and giving the friendly partisans a little help . . . Agent operations are more compatible with the CIA than with the military by a long shot."[46]

By the late fall of 1963, the White House momentum to expand the covert war had reached a crescendo that was sustained even after the assassination of President Kennedy. However, once President Johnson had a good look at what was involved in OPLAN 34A and how it might affect both his 1964 presidential campaign and his domestic political agenda, he quickly subdued those efforts to seriously escalate the secret war and opted for a more cautious approach.

President Johnson Takes Over—Trepidation Sets In

On November 22, 1963, at approximately 2:40 P.M. Central Standard Time, Lyndon Baines Johnson became president of the United States. In his memoir, he recalled the enormity of what he faced on that day: "I was catapulted without preparation into the most difficult job any mortal man can hold. My duties would not wait a week, or a day, or even an hour."[47] This was certainly true of the situation in South Vietnam, which in the aftermath of the assassination of President Diem was in the throes of a calamity.

Two days later, on November 24, Johnson was to learn the unvarnished facts about the failing U.S. war effort. The government of South Vietnam was in disarray—approaching anarchy—and the Viet Cong, backed and guided by Hanoi, was closing in. This is what Johnson heard

at his first Vietnam briefing as president. The news was delivered by McNamara, Rusk, Mac Bundy, McCone, and Lodge. Following the session, Johnson told his personal aide, Bill Moyers: "[Lodge] says it's going to hell in a hand basket out there. . . . If we don't do something, it'll go under—any day."[48]

Within a few weeks, LBJ faced the first of many difficult decisions over the need to do something about Vietnam. This time it had to do with the covert war against Hanoi. A critical juncture was approaching. The implementation of OPLAN 34A loomed on his agenda. With Mac Bundy, McNamara, and other top advisers behind it, 34A was ready—after its three-year incubation—to be set in motion. The question Johnson faced was not whether to execute the plan, but to what extent it should be implemented. He learned that it was an ambitious plan containing some risky operations and difficult decisions. Which of 34A's "total of 72 [categories of] actions . . . [containing] a total of 2,062 separate operations" should he select?[49]

During the November 24 briefing, Johnson is reported to have said: "I am not going to lose in Vietnam . . . I am not going to be the President who saw Southeast Asia go the way that China went."[50] It was classic bravado from the tough Texas politician who bullied everyone. However, it was not going to be that simple, and not just because of Hanoi's determination to win the war; Johnson's decisions on Vietnam would become hostage to his domestic agenda, especially the Great Society program, as Johnson would label his vision in a May 1964 speech. Since first elected to the Congress in 1936, Johnson's political interests had focused on domestic affairs, not foreign policy. Johnson saw himself carrying the legacy of the New Deal into the latter half of the twentieth century, following in the footsteps of his political hero, Franklin Roosevelt. His Great Society would build on and expand what FDR had started—lessening poverty; widening education; and expanding health care, housing, and voting rights.[51] But Johnson recognized from the start that fighting a major war could undermine progress toward the Great Society, and this limited his options on Vietnam.

Johnson found himself on the horns of a dilemma. On the one hand, to let Vietnam go down the tubes would open him to charges of being soft on communism. He believed that no Democratic president could survive such a label. He remembered that after the communists

took over in China, Harry Truman lost his effectiveness and was hounded by that mad dog, Joe McCarthy. On the other hand, if he was too aggressive in Vietnam, conservatives in Congress would use the cost of the war as an excuse to cut appropriations for the Great Society. World War II, after all, brought the New Deal to a halt.[52]

Johnson resolved to move cautiously, not getting too far in front, limiting U.S. involvement to keep the war from shattering his domestic agenda. How could he control the situation in Vietnam, while simultaneously pushing his Great Society legislation through Congress? The solution—graduated response—came from McNamara and the civilian strategists he had attracted to the Pentagon. They had new ideas about how to limit war and still prevail.

At the end of 1963, the clash between Vietnam and domestic priorities came to the fore. The 1964 presidential election was at stake. During the campaign, LBJ would go to great lengths to establish himself as tough but prudent on military matters, outflanking Barry Goldwater, whom he depicted as a fanatic. Decisions about 34A were made within this political setting.

Initially, McNamara recalled, the president told him that he "wanted the covert program strengthened." Like Kennedy, Johnson believed the small CIA effort was ineffective and was "grasping for a way to hurt North Vietnam without direct military action."[53] Expanding the covert war was the answer, along the lines hammered out at the Honolulu Conference on November 20, convened to review Vietnam policy and devise new options.

At Honolulu, McNamara had pushed for the implementation of 34A. According to declassified documents, he openly criticized the agency's performance against Hanoi: "The CIA program up to then and its projection into the foreseeable future did not appear to achieve the results desired. . . . A truly effective program would require the commitment of military assets."[54] Looking back on that meeting, McNamara acknowledged that he "supported the Pentagon takeover" of covert operations against Hanoi but contended that he "was not a great advocate of it at that time. It was one of the few options available for helping South Vietnam."[55] The records from the period disclose that McNamara's role in these matters was not merely one of acquiescence.

Following the Honolulu meeting, he returned to Washington intent on the Pentagon's taking over and escalating the covert war, as evi-

denced by steps he took to ensure that resources were available for 34A. In early December, he "directed that personnel and equipment . . . be arranged for immediately, and that DOD pay the costs. He wanted to achieve maximum readiness whether OPLAN 34A was approved or not and, in this regard, directed that personnel and equipment be moved to Saigon on a priority basis."[56]

The recommendations from the Honolulu meeting were incorporated into the National Security Action Memorandum (NSAM) 273, which framed the Johnson administration's initial Vietnam policy. LBJ approved the document on November 26. The inclusion of the Honolulu recommendations, according to Mac Bundy, broadened the policy actions contained in an earlier draft of NSAM 273. He recalled that this was the result of "directions by Johnson issued on Sunday, the 24th."[57]

NSAM 273 opened the door for the full implementation of 34A. This would significantly escalate the covert war against North Vietnam and put Johnson on the same course that Kennedy had charted. But that was not all.

NSAM 273 also revisited the issue of Laos. Those drafting 34A had given considerable attention to the Ho Chi Minh Trail. They believed that paramilitary operations in Laos should be included in the plan. Provision eight of the final version of NSAM 273 sought to give the Pentagon permission to operate in Laos. It stated: "[A] plan should be developed and submitted for approval by higher authority for military operations up to 50 kilometers inside Laos." In an oblique acknowledgment that this might conflict with the 1962 Geneva Accords, NSAM 273 added: "In addition, political plans should be developed for minimizing the international hazards of such an enterprise. . . . [O]perational responsibility for such undertakings should pass from CIA to MACV."[58]

Thus, the policy recommendations that Johnson received between late November and early December argued for a marked escalation of the covert war. The seeds Kennedy had sowed in 1961 appeared about to come to fruition, given Johnson's initial inclinations to increase the pressure on Hanoi by approving NSAM 273. However, in December, LBJ began to waver. He became apprehensive that this might thwart his domestic agenda and presidential aspirations. McNamara believed that "this caution reflected Johnson's general

cautiousness about Vietnam. Johnson wanted to avoid risky operations" and when he focused on 34A, "caution was a driving force. Avoid high risk."[59]

On December 21, McNamara and CIA Director John McCone met with Johnson to go over 34A. It was the pivotal meeting, the one in which the president's political reservation and timidity over covert operations clearly manifested itself. During the session, he decided on a course of action that would select from 34A only those operations "which promised the greatest return for the least risk."[60] Johnson then established the Krulak committee to reassess 34A in a manner consistent with his desire to avert risk.

The Krulak committee did just that. It reviewed "[t]he total array of feasible operations against NVN . . . from the viewpoint of achieving the greatest return at the least risk." Risk was measured in two ways. First, the committee assessed the extent to which "North Vietnam might retaliate by stepped-up activity against South Vietnam." Since the Saigon regime was already on the ropes, this could force its collapse "unless the United States intervened directly." This was precisely what Johnson believed he could not afford during the 1964 election year, a reality the Krulak committee was aware of. Second, it evaluated the degree to which executing different 34A missions might "evoke international reaction."[61] This too was to be avoided during the upcoming presidential sweepstakes.

The Krulak committee proposed a much reduced version of 34A. It advised executing only thirty-three of the seventy-two categories of actions contained in the plan, ones that satisfied the White House's "least risk" stipulation. It also came out against NSAM 273's recommendations concerning Laos. During December, Harriman and his protégés at the State Department were maneuvering to deny MACV the authority to operate against the trail. The Krulak committee concurred with Harriman's objections, arguing that "[t]he uneasy political and military balance in Laos could be upset" if NSAM 273 were implemented.[62]

In January 1964, Johnson approved the Krulak committee's recommendations. This was the crucial crossroads, where Kennedy administration aggressiveness gave way to Johnson administration trepidation over the use of covert operations against Hanoi. However, it was not only election-year jitters that led Johnson to adopt this cautious course of action, although that was a big part of it. He was also influenced by

the new ideas of the civilian strategists McNamara had working for him in the Pentagon.

McNamara had come to believe in the concept of graduated response. He had been convinced by his civilian strategists, or "whiz kids" as they were derisively referred to by the military, that there were new and more scientific ways to use force as an instrument of statecraft. Traditional military concepts were outdated. The whiz kids were proponents of the limited use of force to coerce an adversary to alter its behavior in ways consistent with U.S. interests. This was touted as innovative thinking that took full advantage of American military superiority. If an enemy did not comply, the pressure could be escalated. They linked graduated force with political bargaining and negotiations.

This new thinking was based on the assumption that if one started out slowly and then gradually increased the scope and intensity of military pressure as needed, the enemy would soon get the message and comply. If he did not, the pressure would increase to the point where rationality set in and he complied.

Johnson liked graduated response. He could have it both ways. Keep the communists at bay in Vietnam and, through graduated pressure, raise the heat on Hanoi until it was ready to negotiate; and best of all, keep the war from getting in the way of his agenda at home—the Great Society.

Graduated pressure is generally associated with how Johnson fought the Vietnam War after he was elected president. However, McNamara's concept also influenced decisions surrounding the execution of 34A. It was echoed by the Krulak committee, which proposed starting with a limited escalation of the covert war "to signal to the North Vietnamese leadership of the U.S. intention to continue damaging retaliatory actions of increasing magnitude unless and until their support of aggression in South Vietnam was halted."[63]

While Johnson found graduated pressure reassuring, how realistic was it? Did McNamara really believe it would work, or was it, as he suggested above, "one of the few options available for helping South Vietnam?"[64] McNamara's actions betray his later recollections about the promise of a covert war against the North. In his 1995 memoirs, he is unequivocal: "Long before the August [1964] events in the Tonkin Gulf, many of us who knew about 34A operations had con-

cluded they were essentially worthless. Most of the South Vietnamese agents sent into North Vietnam were either captured or killed, and the seaborne attacks amounted to little more than pinpricks."[65]

But it was early to draw such definitive conclusions. After all, the Gulf of Tonkin incident occurred in August 1964, when the execution of 34A would have been under way for only six months. Nevertheless, McNamara said again, when interviewed in 1998, that 34A "was not worth a damn. It was a stupid thing to do."[66] He believed the only reason the operation continued was that "the South Vietnamese government saw it as a relatively low-cost means of harassing North Vietnam in retaliation for Hanoi's support of the Viet Cong."[67]

Whatever doubts McNamara may have had about 34A in 1964, his actions at the time did not reflect them. He became the advocate for the Pentagon to take over the secret war from the CIA. Even before Johnson signed off on the truncated version of 34A, McNamara made sure in late 1963 that resources for 34A would be available in Vietnam. In 1964, when senior officials like Ambassador Lodge and Admiral Sharp expressed disappointment over 34A results, McNamara pressed on. SACSA action officers later recalled that in 1964 McNamara gave every appearance of being strongly behind the execution of 34A. Krulak, Hilsman, Colby, and Rostow also remembered him as an advocate of the covert war then.

It wasn't until 1965 that McNamara's interest in 34A faded, and then it faded precipitously. SACSA action officer Bill Murray saw the transformation firsthand. Once the bombing campaign began and U.S. ground forces entered the war, McNamara lost interest in 34A. Murray no longer took SOG action requests to him; he went instead to Cyrus Vance, the deputy secretary of defense.[68]

McNamara did confirm, however, that "after one year I gave up on 34A."[69] It had not produced the expected results. He wrote: "Looking back, it was an absurdly ambitious objective for such a trifling effort—it accomplished virtually nothing."[70] He had a point. What was executed in 1964 was an eviscerated version of 34A—a "trifling effort" indeed. McNamara was also correct in admitting he had expected entirely too much in the way of immediate results.

However, even if all the seventy-two categories of actions (2,062 separate operations) contained in the unabridged version of 34A had been executed, McNamara's goal of an instantaneous impact on

Hanoi would still have been out of reach. Covert campaigns do not work that way. They take time to establish. Only then are results attainable. McNamara did not grasp this subtlety. He was in a hurry, and when results were not immediately forthcoming, he lost interest in the covert war and sought other ways of coercing Hanoi. The White House followed suit.

The Impact of Trepidation on SOG Operations

President Johnson's cautious approach in executing OPLAN 34 in early 1964 had a profound and lasting impact on SOG. LBJ's guarded actions established a formula for evaluating and micromanaging all subsequent operations proposed by SOG's leadership. Consequently, a decision-making pattern emerged that lasted throughout SOG's entire existence: high-risk or politically explosive requests were either turned down or watered down.

The inhibiting impact of this authorization pattern on each of SOG's four operational divisions—agents and deception, psywar, marops, recon missions against the trail—was seen over and over again in the preceding pages. Whenever SOG proposed new operations that would escalate and intensify the secret war against Hanoi, it found itself in a senior-level interagency fight, and in this bureaucratic combat SOG almost always lost. The review process was stacked against it. The caution and restraint that LBJ imposed in December 1963 had a long-term crippling effect, constraining what SOG could and could not do against North Vietnam.

Recall the issue of stirring up a resistance movement inside North Vietnam. In 1963, the authors of OPLAN 34A believed "that the formation of resistance groups in North Vietnam would be fundamental to the success of the [overall covert] program."[71] At the time, McNamara was in strong agreement and said so in a memorandum to Secretary of State Rusk: "The North Vietnamese had enjoyed for some time relative immunity from any substantial penalty for its part in the insurgency in South Vietnam." It was time to make them "suffer serious reprisals for their continuing support of the insurgency." McNamara advised Rusk on the need for the "development of a Vietnamese national liberation movement which would be the ostensible sponsor of these operations [inside North Vietnam]."[72] In other

words, the secretary of defense believed the United States should foster an insurrection inside North Vietnam, just as Hanoi was doing in South Vietnam.

However, when the Krulak committee scrubbed 34A to make it consistent with LBJ's guidance to implement only those operations "which promised the greatest return for the least risk," the resistance concept was abandoned.[73] Following a 303 Committee review, a joint State-Defense-CIA message was sent to Pacific Command and the embassy in Saigon on January 16, 1964, stating that President Johnson had approved the recommendations of the Krulak committee. Absent was any reference to McNamara's recommendation to Rusk for "development of a Vietnamese national liberation movement." According to declassified documents, there was a "refusal, at the Washington level, to sanction the resistance movement concept."[74]

As was seen earlier, on three separate occasions, SOG appealed to the Johnson administration to change its mind. In March 1965, it requested authority "to recruit and support assets in the Democratic Republic of Vietnam for resistance, guerrilla warfare, and intelligence collection." When the request was reviewed at Pacific Command, care was taken to remove any reference to the "long-term objective to overthrow the government of the Democratic Republic of Vietnam."[75] Such language had to be expunged because it violated the administration's stated policy of not seeking to oust the Hanoi regime.

In spite of this clarification, the State Department, CIA, and the embassy in Laos all lined up against the SOG request by the time it arrived at the 303 Committee. The chances of approval were slim. Then, McNamara's representative on the 303 Committee, Deputy Secretary of Defense Cyrus Vance, administered the final blow. If anyone at the 303 Committee level was going to make the case for the resistance proposal, it should have been Vance.

However, when it came to covert action, Vance's views were paradoxical. As secretary of state in the Carter administration, he was a vociferous opponent of covert action.[76] But in 1965, Vance was not at all ardent in his opposition to covert operations. In fact, he was almost the opposite. Still, there were limits to how far he would go, according to SACSA action officers. Lieutenant Colonel Bob Rheault recalled that Vance almost always signed off on SOG requests that pertained to the Ho Chi Minh Trail in Laos. "It was usually very easy.

I would go in, I would explain it to him. By that time I had my ducks in line . . . The Joint Chiefs had already looked at it. So, my recollection is that it was pretty easy . . . I certainly don't recall any hassles."[77]

However, Vance drew the line when it came to the resistance movement request, according to Lieutenant Colonel George Maloney, another SACSA action officer. When asked why the 303 Committee rejected the three SOG appeals, he stated: "Well, Cy Vance was one of the reasons . . . [H]e did not want to take any risks. He said our public position is that we are in there to help the South Vietnamese. We're not in there to overthrow the North Vietnamese. We don't ever want the Chinese or the Russians to think that we are going to overthrow the North Vietnamese, and the minute we start arming or fomenting trouble in there, they're going to know it. So he was dead-set against any type of a resistance, any type of arming."[78] By the time the request reached the 303 Committee in mid–1965, it was a moot issue.

Other major operational proposals by SOG to intensify the secret war suffered the same fate. This was true, for example, of SOG's psywar efforts. Psychological operations can have several objectives in wartime. One is to encourage individuals inside your enemy's borders to commit acts of violence and sabotage against the regime. While SOG was proscribed from cultivating an organized resistance movement in North Vietnam, did this also preclude SOG's psywar section from encouraging individual acts of violence? The answer, as detailed earlier, was yes.

This was evident in the limitations Washington placed on SOG's psywar campaign in 1964. The purpose was to provide information to the North Vietnamese population about their government and the war in the hopes that it would lead them to express distrust, disaffection, and even mild forms of dissent. But that was as far as it could go. Washington would not allow SOG to exploit that disaffection and distrust. Encouraging members of the population to commit violent acts against the regime—killing North Vietnamese officials or sabotaging economic targets—was disallowed.

Colonel Albert Brownfield, who served as deputy SACSA in 1964–1966, recalled this restriction on psywar operations, noting that from the early days SOG was not permitted to encourage the population up North to take such action against the regime.[79] Lieutenant Colonel George Maloney, who served in SACSA from 1967 to 1969, stated that SOG's psywar specialists "were not to

encourage sabotage. I remember that very distinctly." The guidance from Washington was clear: "There was to be no sabotage, no overt act of violence by any of the North Vietnamese population against the North Vietnamese regime."[80]

Not only did SACSA action officers see these limitations as set in stone, but when special review panels established by the Joint Chiefs and Pacific Command to evaluate SOG's psychological operations proposed that the limitations be removed, the recommendations were never adopted. They were outside the boundaries established by the Johnson administration. To SOG's psywar specialists this entire approach seemed so contradictory. But it was the kind of contradiction that Richard Helms, who was CIA director from 1966 to 1973, saw frequently during his years of dealing with the White House. He recalled that policy makers were always enthusiastic about the use of covert action. However, "when you brought them the operational specifics," Helms noted, "they would raise concerns, throw up their hands and say, 'You want to do what?' . . . The policy makers were always tough—until they saw the specifics."[81]

Finally, SOG encountered stiff opposition at the senior levels of the Johnson administration when it sought authority to carry out covert reconnaissance operations against the Ho Chi Minh Trail. In Washington a powerful coalition formed to keep SOG out of Laos for nearly two years. Even after the White House authorized covert cross-border operations in Laos, interagency fights over the scope of these operations continued until SOG was disbanded.

It was not just these major operational requests that were rejected during the interagency review process. Washington also blocked many of the smaller operations SOG proposed. These included several discrete missions in the unabridged version of 34A. For example, different types of aerial attacks were to be carried out in black (unmarked) aircraft raids against easy targets inside North Vietnam. The operations were never authorized. OPLAN 34A also called for dropping unmarked mines into all of North Vietnam's major harbors. This too was rejected—too much political risk for the Johnson administration.

SOG proposed the use of counterfeit currency. Why not flood North Vietnam with it? Done properly, it could create stress on the economy. CIA had produced highly authentic replicas of North Vietnamese cur-

rency. However, only a very small amount was ever inserted. Washington had serious misgivings about going too far. It was a "political no-no," recalled former SOG chief Steve Cavanaugh.[82] Why? According to former CIA officer William Rydell, who directed SOG's psywar efforts in 1970, because "international regulations prevent you from doing it. . . . [We] couldn't do it because of the international cry that would arise for doing something like that."[83]

Another tactic was to dither with the North Vietnamese economy by interfering with its fishing fleets. As SOG chief Jack Singlaub recalled, "Making it unpleasant and hazardous for the fishermen to go out, not only did you deny food supply to the enemy, but you also denied the enemy a place to conceal its covert shipping." However, he explained that in Washington, "objections were raised over interference with the North Vietnamese fishing fleets. . . . [T]hey did not want us to do that because they did not recognize the economic component of war as valid."[84] Economic warfare was too politically sensitive and could result in a charge of immoral behavior.

Singlaub proposed other tactics that raised havoc in Washington. One was the previously discussed use of rice contaminants. SOG recon teams often found large caches of NVA rice stored in Laos. SOG teams could not carry the rice out because the caches were too large. Blowing up the caches simply scattered the rice. The North Vietnamese would just gather it up. So Singlaub proposed using a special contaminant known as "Bitrex, which would have been an easy way of ruining the rice. . . . [j]ust spread it on the rice, it would render it unsuitable for eating."[85] SOG's request was denied. Why? Because, according to Singlaub, "The State Department blocked my use of Bitrex." They saw it as laying the United States open to the charge of chemical warfare by Hanoi. Singlaub countered that it "was strictly for military consumption and to destroy it would place an added burden on their supply system."[86] Eventually, SOG received permission to use Bitrex, but only after months of intense bureaucratic fighting in Washington.

Another Singlaub request, which the State Department opposed, was the "use [of] incapacitating darts on ambushes to get a prisoner." One of OP 35's missions was to capture enemy personnel. The use of the darts would make it easier to accomplish. The State Department again raised the canard of chemical warfare against what in today's

parlance is called a nonlethal weapon. Its purpose is not to kill an enemy soldier but to help capture him. State was able to block the request for several months until the Joint Chiefs pressed for permission and received it.

Throughout its existence, SOG fought two formidable enemies—North Vietnam's leadership in Hanoi and America's leadership in Washington.

MISPLACED OPTIMISM OR MISSED OPPORTUNITY? THE SOG EXPERIENCE IN RETROSPECT

When President Kennedy said he wanted guerrillas to operate in North Vietnam, it was classic New Frontier bravado. If Hanoi could carry out subversive activities in the South, he would return the favor by fostering insurrection up North. While such hyperbole was a hallmark of the Kennedy administration, did it also reflect misplaced optimism on the part of the president with respect to what covert operations could accomplish?

In retrospect, the SOG experience suggests that there was an underlying logic to what JFK proposed. Nations engaged in war cannot afford instability and subversive activities taking place on the home front. It is not tolerable, because in war unity among the political leaders, military commanders, and the population is a sine qua non for winning. What Kennedy advanced was strategically sensible. Of course, by itself covert operations could not win the war. However, they could play an important role in an integrated strategy that sought to do so. Whether Kennedy realized this broader strategic reality is unknown.

Adding to the underlying logic of JFK's covert-action stratagem was the paranoid nature of the regime in Hanoi. Even in tranquil times, totalitarian states worry excessively about internal security matters. Wartime causes that apprehension to soar. The need for a secure home front was one of North Vietnam's strategic pressure points. Creating havoc there would affect Hanoi's capacity to foster the war in South Vietnam.

While this made sense, Kennedy faced a major hurdle—his own bureaucracy—in bringing his proposition to fruition. It took nearly three years before that bureaucracy produced a suitable covert-action

blueprint—OPLAN 34A. Finally, in the late fall of 1963, the covert war inside North Vietnam could be expanded and Hanoi would begin to feel the heat. In the midst of these events, Kennedy was assassinated.

Now Lyndon Johnson was president and Vietnam was his problem. His initial inclination was to play hardball with Hanoi. However, almost immediately, domestic political reality began to set in, and Johnson vacillated. He was not only president, he was de facto the Democratic Party's 1964 presidential candidate.

This complicated the rules of hardball. If the war became too visible to the American people, it could become a domestic political liability for LBJ. Bravado gave way to caution. This decision had both short- and long-term implications. In 1964 it meant that SOG would accomplish little because the White House watered down 34A. SOG's lack of success also had an unintended impact on the policy makers, most importantly McNamara. If SOG could not produce results, the administration would look for other ways to pressure Hanoi. This had, in turn, a long-term effect because it meant that SOG would have no patron at the top policy level in Washington. When SOG sought to expand its operations to do more against the North Vietnamese, it found itself outnumbered and outgunned in interagency battles.

Nevertheless, despite four years of Johnson administration timidity, Washington-imposed political constraints, SOG's own operational failures, and enemy countermeasures, by 1968 Hanoi was starting to show concern. Inside North Vietnam the regime evidenced growing fear of subversion and mounted a major counterespionage effort inside its borders to combat it. North Vietnamese newspapers, radio broadcasts, and other domestic security actions in 1968 revealed an increasing alarm over agents, spies, and espionage. Likewise, SOG's operations against the Ho Chi Minh Trail had North Vietnam's attention. Hanoi knew it could not sustain its conduct of the war in South Vietnam without unfettered use of the trail. It instituted a number of measures to secure the trail's use.

Thus, Hanoi did not take SOG lightly. The secret war against North Vietnam was beginning to have the impact that Kennedy had envisioned in 1961. But it had taken seven years to get to this point, and then U.S. domestic political reality struck again. In the aftermath of the 1968 Tet offensive, and with the encouragement of many of his senior advisers, Johnson looked for a way out of Vietnam. For the

remainder of his presidency, he sought to accelerate the Paris peace negotiations. As the basis for starting those talks, Hanoi irrevocably demanded cessation of U.S. bombing raids and all other acts of war directed inside North Vietnam, including SOG's covert operations. By the end of October 1968, believing he had no alternatives, LBJ succumbed to Hanoi's terms. He took a course of action that was forged in the aftermath of the trauma of Hanoi's Tet offensive.

The year 1968 was a watershed for MACVSOG. For its operations up North, Johnson's accession to Hanoi's demands turned out to be the endgame. Covert activities were shut down just as they were starting to have the intended impact. It was part of the price LBJ was willing to pay to persuade Hanoi to begin negotiations. Operations against the trail also suffered in 1968 as Hanoi's countermeasures started to take a toll on SOG's recon teams. By the end of the year, the NVA's defenses, particularly in Laos, had become increasingly effective. While this part of SOG—OP 35—fought on until the organization was dissolved, the opportunity to employ covert operations strategically had passed with this radical change in the Johnson administration's Vietnam policy.

While the Nixon administration continued SOG operations against the Ho Chi Minh Trail until 1972, there is no evidence in the declassified documents that it gave any consideration to restarting those covert operations inside North Vietnam that LBJ shut down in late 1968. Recall what President Nixon told his senior staff in early 1969: "I'm going to stop the [Vietnam] war. Fast."[87] Covert operations inside North Vietnam did not figure into his calculations of how to do so.

EPILOGUE

Covert action is not a magic bullet. In wartime even large covert operations do not win the war. However, they can contribute to winning when they adhere to the approach laid down by OSS chief Bill Donovan—in wartime, covert operations must be carried out under the auspices of the senior military leadership and integrated into the overall strategy for fighting the war.

In peacetime, covert action should be understood as an instrument of statecraft and not a substitute for it. Secret operations are not a last resort, an option exercised only when the alternatives are to do nothing or send in the marines. Consequently, covert action should be employed, in coordination with diplomacy and other instruments of statecraft, in support of foreign policy objectives.

There is a great deal to learn from MACVSOG about the capacity of the United States government to execute larger and more complex covert operations that applies to both wartime and peacetime. SOG experienced a number of obstacles and complications that limited the effectiveness of Washington's secret operations throughout the Vietnam War. Playing by Hanoi's rules proved to be much easier said than done.

The obstructions that plagued SOG's efforts are not an aberration, unique to the Vietnam case. Just the opposite. They can be found in

other Cold War examples where the United States sought to employ covert action. Furthermore, these limitations are likely to affect the capacity of the White House to use this instrument of statecraft in the future. An evaluation of the post–World War II history of American covert operations reveals the following recurring barriers to the effective use of it.

First, the derring-do nature of secret operations has had an enduring allure for the White House. However, while being drawn to the use of covert action in the belief that it will quickly resolve a difficult foreign policy problem, presidents have generally shown little understanding of what it can and cannot accomplish.

Second, presidents have also worried about employing clandestine methods, fearing the potential political fallout if the operations were exposed. This anxiety has led to uncertainty over the extent to which covert proposals should be carried out and has resulted in reduced efforts that then produced limited results.

Third, the effective use of covert action as an instrument of policy proved to be a persistent challenge for the White House during the Cold War. Presidents and their advisers were frequently inept in the coordination and integration of covert action with political, economic, military, and information warfare capabilities while simultaneously meeting political objectives. All too often, covert action was viewed as something detached from these other instruments of policy.

Fourth, organizing and managing complex covert programs has also been hard for the United States because it can involve the coordinated use of different tactics—agents, deception, psywar, sabotage, paramilitary actions—focused on a strategic aim or objective. The tactics used in these larger efforts were often poorly coordinated in Cold War covert operations.

Fifth, when more than one government agency is involved in a covert operation, the organizational and managerial challenges multiply. These situations have frequently been characterized by disputes, rather than cooperation, among the agencies involved, which undermines effectiveness. The coordination process becomes even more exacting when U.S. agencies have to establish working liaison arrangements with a foreign government or group to execute the covert program.

Sixth, employing different covert-action techniques, especially against denied areas and hard targets, presented the United States

with persistent operational-level challenges. Using these methods required creative planners knowledgeable about the target and operators capable of developing and executing specific projects and action programs. There was often a shortage of both.

Finally, the difficulty of developing tools to measure the impact of covert-operations programs was an impediment that plagued U.S. efforts in Cold War operations.

Many of the revelations about MACVSOG illustrate these seven enduring obstacles that impeded secret operations executed by Washington during the Cold War. Contrast MACVSOG's history with other covert actions initiated by the United States in which similar constraints hindered secret operations. These impediments appear endemic to the use of covert operations by presidents.

THE SOG EXPERIENCE AND COLD WAR SECRET OPERATIONS

• Throughout the Cold War almost every president, beginning with Harry Truman, was drawn to the use of covert action. Eisenhower saw it as an important instrument for fighting the Cold War and used it frequently to do so. While there are differences among presidents in terms of the extent to which they understood how and when to employ covert methods, each willingly operated in the shadows in an attempt to accomplish foreign policy objectives.

The allure of covert action was undoubtedly at play in 1961. From the very early days of his administration, President Kennedy embraced its use. It fit with his activist mentality. He made it clear to the National Security Council that if Hanoi could foster a guerrilla war in South Vietnam, he intended to do the same up North. Although Kennedy's stratagem had merit, his activism was not tempered by an understanding of the time needed to establish a complex covert operation. This has been true of other presidents as well. Nixon's ill-conceived attempt to steal the 1970 election in Chile is an outstanding example. He turned to covert action as a last resort to rescue a failed foreign policy.

• Several of Kennedy's senior advisers shared his interest in disrupting North Vietnam through covert operations. The most ardent was his brother, Attorney General Robert Kennedy. Others included

Robert McNamara, McGeorge Bundy, and Walt Rostow. Each mirrored JFK's approach to dealing with international challenges. Covert action was seen as an important means—real hardball—to be exploited. They were willing to play by Hanoi's rules. However, like the president, each of these advisers had, at best, a superficial knowledge of how to employ covert action.

Other presidents have selected senior advisers equally willing to play hardball and recommend the use of covert operations. Some have evidenced an understanding of the complexities involved in carrying it out, while others have not.

For example, Truman was persuaded by George Marshall in 1947 that the newly created CIA should be tasked with the responsibility for covert action. It was an instrument of foreign policy that the president needed. Marshall then demonstrated an understanding of how to use it in successful election operations in Western Europe in the late 1940s. During the Eisenhower administration, the Dulles brothers were keen proponents of secret operations. Ike did not shy away from their advice and readily adopted it as one means for fighting the Cold War. Operations in Iran in 1953 and Guatemala in 1954 proved successful. However, in denied areas the record was one of failure after failure. In the latter cases the administration showed little awareness of the internal political context inside communist dictatorships.

Paradoxically, while the Johnson administration was fumbling around with SOG, in northern Laos it ran an effective covert paramilitary operation under the direction of the CIA. This enabled Vang Pao, the Hmong military leader, to expand his forces and prevent the North Vietnamese Army from taking over Laos, at least until the United States abandoned Indochina.

Under President Nixon, it is well known that Henry Kissinger advised employing covert action in several instances. But in at least one major case—Chile—he exhibited insufficient understanding of how to do so. Finally, several of President Reagan's senior advisers, most notably CIA Director William Casey, sought to employ covert action as part of a strategy to fight Soviet expansion in the Third World. The two largest efforts were in Afghanistan and Nicaragua. While the operational record of each is muddled with missteps, the policy results must be judged as success stories.

• Covert operations against Hanoi were closely supervised by the White House. It was never a rogue operation. In the 1970s, and particularly at the time of the congressional investigations of the CIA headed by Senator Frank Church, the supposition that the agency had run operations without the knowledge of presidents was widely decreed.

In the case of North Vietnam, the rogue thesis cannot be sustained. Kennedy was behind the whole affair. His experience with the CIA was not one of dealing with a rogue elephant that operated wildly but more one of a stubborn mule that resisted what he wanted to do. He demanded action be taken but only under the supervision of the White House.

LBJ insisted on even more oversight and, consequently, SOG became a micromanaged organization during his presidency. Every mission was reviewed and authorized at the very top levels in Washington. An assessment of other Cold War covert operations, and particularly larger ones, likewise dispels the claim that agencies of the U.S. government ran secret operations without the knowledge and supervision of the White House. Just the opposite has been the case. Presidents have been the ones to authorize and oversee secret activities and have done so for two antithetical reasons.

On the one hand, most Cold War presidents have been eager to employ covert methods to accomplish specific policy objectives. On the other hand, they have been apprehensive over the trouble they could cause if exposed. This seeming incongruity is epitomized in the case of SOG. Pursuing what Kennedy had set in motion, LBJ charged the Pentagon with the task of intensifying the covert war inside North Vietnam and then fretted over the political, military, and international implications of doing so. The Johnson administration worried not only about failure but also about too much success. Consequently, interest turned to angst and resulted in a series of constraints and limitations on SOG operations that contributed to its ineffectiveness.

Since SOG, White House oversight has remained unchanged for the same disparate reasons—interest and caution. Some presidents have shown more interest—Reagan—and others more caution—Bush. But all have wanted control. What has changed is that it is no longer only the White House that insists on oversight of covert operations. Since the late 1970s, Congress has been an active participant in the authorization and execution process.

- To subvert Hanoi, Kennedy naturally turned to the CIA. After all, one of its missions was covert action. However, he quickly became disenchanted with the agency's inability to run larger covert operations. First, there was the Bay of Pigs implosion. Next, having tasked CIA to subvert Hanoi, he found that the agency had serious doubts that it could do so. This shocked Kennedy. He expected the spooks to be real swashbucklers.

Kennedy was not the only president to find restraint rather than derring-do at the agency. This proved especially true after two major political developments in the latter half of the 1970s. First was the congressional investigation of CIA wrongdoing. Second was the Carter administration's purge of the agency's covert-action specialists. These two events cowed the CIA when it came to larger covert programs and led one old hand in the early 1980s to lament that covert action was a dying art form. In fact, with a very few exceptions, those that were left in the CIA's covert-action division were hardly swashbucklers. This is what Reagan found in the early 1980s, when he sought to escalate covert paramilitary operations in Afghanistan and Nicaragua. Bureaucratic caution and conservatism had taken over at CIA headquarters. Getting the agency moving on these operations was not easy.

- Having given up on the CIA but still wanting to sabotage Hanoi, JFK directed the Pentagon to take over and escalate the covert war. The White House believed the military was up to the task. This proved not to be the case, and such reasoning led the administration to expect too much too quickly from SOG. The Special Forces did not possess critical and necessary skills, most importantly the know-how to establish and run agent networks and execute black psywar campaigns. This serves as yet another example of Washington policy makers' lack of understanding of the intricacies involved in executing covert operations.

In the 1980s the military's role in covert action again became an important policy issue in Washington. However, this time it was the Congress that sought to draw the Pentagon into these operations, not the White House, by establishing the U.S. Special Operations Command (SOCOM). One of the tasks of the new organization was to be prepared to execute specifically designated covert missions. Today, SOCOM's covert missions include countering terrorism and

proliferation of weapons of mass destruction, as well as unconventional warfare, strategic reconnaissance, and direct action. Much has changed since SOG was established. Special operations forces now have more of the kinds of capabilities SOG needed. Still, in certain esoteric areas like spies, agents, human collection, and black psywar, it is not clear that much has changed.

• A shortage of skills was not the only problem JFK encountered when he turned the covert war over to the military. The opposition of senior military leaders to this transfer presented an even bigger problem as the Joint Chiefs only grudgingly took on the mission. Not believing it could contribute much to the war effort, the brass refused to integrate SOG into U.S. war plans, such as they were. This was part of its contentious opposition to Kennedy's demand that the military develop special warfare capabilities. This attitude had a major impact on SOG. It quickly found itself persona non grata within the mainstream senior military leadership at MACV and Pacific Command and an orphan in the chain of command in the Pentagon.

This mainstream military outlook survived and flourished long after SOG was disbanded in 1972. Following the Vietnam War, it was instrumental in drastically reducing the size of special operations forces and removing any reference to special warfare in the basic military doctrine of the U.S. Army. This was at a time when the challenge of guerrilla insurgency, insurrection, international terrorism, and state support for these activities was on the rise internationally.

In the 1980s when Congress and some officials in the Reagan administration began to declare that these threats necessitated not less but more special operations forces and doctrine, an argument Kennedy had made two decades earlier, the mainstream military leadership once more rose in opposition. It was almost an exact replay of the early 1960s. When the Reagan administration became mired in debates over how to proceed, Congress acted. It legislated the creation of SOCOM, believing the United States needed to expand its capacity to address what was now called low-intensity conflict.

• Other factors impeded the execution of SOG's mission. First, the organizational challenge of having to depend on other U.S. gov-

ernment agencies—mainly the CIA—to provide certain skills and capabilities required cooperation and coordination between SOG and the agency. Second, the need to establish viable liaison arrangements with the South Vietnamese government to execute the covert program necessitated a high degree of trust.

When SOG was established in January 1964, its first chief assumed that he would receive the full support of the CIA. After all, this had been authorized under National Security Action Memorandum 57, which stated that when the military took over a larger covert operation, the agency was supposed to play a supporting role. At CIA headquarters, the leadership could hardly envision itself playing second fiddle to the Pentagon in covert operations. Consequently, it refused to provide an adequate degree of assistance, but rather sought to minimize its involvement. While the agency was happy about giving up operations against North Vietnam, it nevertheless saw covert operations as its responsibility and resented the idea that the military could replace it. SOG was an interloper to be resisted.

This CIA attitude toward military involvement in covert operations did not end when SOG was deactivated. The CIA continued to guard clandestine operations, including covert action, as its bailiwick. While the agency was willing to work with the military on joint operations, it believed it should always run the show. The military's role was to provide the necessary support. This did not work worth a hill of beans in Iran in 1980 when CIA had not one stay-behind agent to help with the Desert One rescue mission.

In other cases this approach worked, counterterrorism being the prime example. In the latter half of the 1980s a Counterterrorism Center was established at the CIA. Other government agencies, including the military, were to assist the agency in addressing the problem of terrorism. This has proved successful and other centers have been established to deal with the problems of international organized crime and proliferation of weapons of mass destruction.

In spite of these developments, professional tensions have continued to exist between the CIA and those parts of the military responsible for covert special operations. This has been especially true in the aftermath of the Cold War as specialists in and outside the U.S. government have argued that the Special Operations Command should be assigned the first line of responsibility for several new security

challenges requiring a covert approach. As with NSAM 57 in the early 1960s, such proposals do not foster interagency cooperation.

Establishing effective liaison arrangements with the South Vietnamese government also proved exceedingly hard because of SOG's fear that its counterpart was penetrated. The solution was to cut the Strategic Technical Directorate (STD) out of operations as much as possible. While SOG was able to do so, it was not without costs. It denied SOG the indigenous capabilities and expertise it needed to operate against North Vietnam. Furthermore, this approach raised the larger issue of the extent to which the United States can and should substitute itself for the host government.

Such liaison arrangements have remained delicate matters. Mirroring what the North Vietnamese did, other regimes have used the same countermeasures when threatened by a resistance movement. For example, when the Iraqi National Congress formed to challenge Saddam Hussein's reign after the Gulf War, it became a target for penetration and manipulation by Iraqi intelligence. To this end, the Iraqis adopted the same tactics as those employed successfully by North Vietnamese against the STD.

• SOG's record against Hanoi was mixed. It had some spectacular blunders, the most devastating being the failure of agent operations. SOG and CIA inserted approximately 500 agents into North Vietnam to establish spy networks. Hanoi caught every one and doubled several back for years. One reason for this disaster can be attributed to Washington's decisions over what the agents could do and not do. They were not allowed to destabilize or attempt to overthrow the Hanoi regime. Had the agent program been permitted to nurture a resistance or guerrilla movement for these purposes, the outcome might have been different. However, Washington perceived this to be too much of a political risk.

This was not the last time that the United States assisted resistance forces but subsequently refused to help them attempt to overthrow a despotic regime. An analogous situation occurred in 1981 when the Reagan administration decided to fund the Nicaraguan Contras, the guerrilla resistance movement fighting against the Sandinista regime. To do so the administration had to submit its plan to the Congress for review. The executive and legislative branches disagreed on the

Contras and their goals. This resulted in a compromise in which the United States provided certain kinds of assistance, but the CIA was proscribed from spending any money for the purpose of aiding the Contras to overthrow the Sandinista government.

A post–Cold War example took place in the aftermath of the Gulf War in 1991 when the enemies of Saddam Hussein gathered in northern Iraq to plot his demise. The leadership of this embryonic resistance movement requested help from the Bush administration, which at first appeared to be enthusiastic but quickly changed its position. To oust Saddam was seen as too politically destabilizing for Iraq and for the region. Only a modest sum was authorized by Washington for the Iraqi National Congress. The purpose of the assistance was not clear. The Clinton administration inherited the program but likewise was not willing to go very far in supporting it. The Iraqi resistance collapsed when Saddam Hussein decided to shut down the group's northern Iraq redoubt in 1996. The United States refused to provide air support to stop Saddam's armored columns, and the opposition was overrun.

• Despite White House timidity and Washington-imposed political constraints during 1968 SOG began to have the impact envisioned by Kennedy in 1961. Its accomplishments could have been greater had operations not been limited by jittery U.S. policy makers who were alarmed over the consequences of destabilizing Hanoi. They feared that it might bring the Chinese into the war or cause Moscow to react. Also, they fretted about the political humiliation these operations could generate if exposed. Such matters were more important to Washington than the difficulties SOG operations could cause Hanoi if expanded.

In the 1980s the Reagan administration faced a somewhat comparable situation. Following the Soviet invasion of Afghanistan, a Mujahideen resistance formed and began causing Moscow headaches, but it was not strong enough to drive the Soviets out. Air power held the resistance at bay. The administration was providing funds, but the Afghan guerrillas needed a weapon to neutralize the Soviet air force. The answer was the Stinger antiaircraft missile. However, to provide it to the Mujahideen would escalate the war. Possible Soviet reactions to such a step traumatized senior professionals at the CIA, and they

opposed providing the weapons. A debate raged over the matter for several months inside the Reagan administration. In the end, the decision was made to provide the Stingers, and they made an important contribution to the eventual Soviet defeat in Afghanistan.

• SOG had its share of successes, the extent of which was not understood because it paid insufficient attention to calculating the impact of its actions. The only method of evaluation used was counting the number of operations initiated. The lack of attention to such matters is not surprising because SOG was made up of operators who had little knowledge of methods and measurements of evaluation. That said, not being able to do so was costly in the long run. The difficulty of evaluating the kind of operations run by SOG is not unique to it. Lack of consistent evaluation has remained an endemic problem for the U.S. intelligence and special operations communities.

AFTERMATH

These broader policy lessons, as well as many other operational ones, were not culled from the MACVSOG experience in the years following the U.S. withdrawal from Vietnam. The SOG records were locked in the vaults to remain all but forgotten until the 1990s. The largest covert paramilitary operation conducted by the United States since World War II, with all that could be deduced from it, became one of the buried secrets of the war.

There also was no accurate accounting of the SOG men killed, missing in action, or captured by the NVA during recon missions. A precise figure has yet to be given by the Pentagon. Although the overall number and size of recon units was small, it is estimated that over 300 men were lost, one quarter of them missing in action.

These numbers are significant given that at its largest, OP 35's three detachments had a total of 110 officers and 615 enlisted personnel. But not all of them had crossed the fence. Each command-and-control detachment had thirty recon teams that carried out 95 percent of all operations against the trail. There were three Americans in each recon unit or approximately 270 Special Forces NCOs in any given year from 1966 until late 1971, at least on paper. In reality, because of high casualty rates, SOG was never at full strength. For example,

there were periods in 1968–1969 when fewer than half of the teams were combat ready.

Between February and April 1973 Hanoi finally released 591 American prisoners held in North Vietnam. No SOG men were among them. While many of those left behind had died during firefights with the NVA, as many as twenty were likely captured. What happened to them?

Men unaccounted for and lessons not learned. That became the legacy of SOG. The United States wanted to forget the Vietnam debacle, not learn from it in order to better prepare for future unconventional conflicts. Indeed, there was only one lesson learned from the Vietnam War—no more Vietnams.

This was especially true of an American military that finished the 1970s in disarray. Not only did it want to forget Vietnam but to expunge, as much as possible, the special warfare legacy of President Kennedy. As a result, Special Forces units were eviscerated. From a high of over 10,000, their size declined to approximately 3,600 by the mid–1970s. While this increased to three 1,400-man SF groups by the end of the decade, serious problems remained.

Major shortages existed in officers. It became exceedingly hard to attract them to Special Forces or keep them for a second or third SF assignment. The message from the military mainstream was unambiguous—a Special Forces assignment was a career stopper. Things were no better among NCOs. In the late 1970s, first-term enlisted personnel were filling NCO billets and many positions were staffed one or two grades below authorization. Skill and training levels had fallen well under those desired, and equipment, logistics, and command and control were in equally bad shape.

The brass had its revenge in other ways as well. War colleges and command and staff schools ignored special operations and no new doctrine was written for what came to be called low-intensity conflict.

Consequently, the men who commanded SOG and ran its operational divisions, with all of their hard-learned experience, moved on. There was no interest in what they knew about special warfare at the top echelons of the Pentagon. Some of these SOG men went on to great accomplishments in the military mainstream and civilian worlds. Others finished out their military service and quietly moved into tranquil civilian occupations.

Following his command as SOG chief, Don Blackburn finally was promoted to brigadier general in the late 1960s. His last assignment was as head of the SACSA in 1970, where he planned the remarkable Son Tay raid to free American POWs. While the raid was conducted in a near-flawless manner, the camp was empty and someone had to take the fall. One month after the foray Blackburn was reassigned to a research-and-development slot on the Army staff. The Headhunter's career was over and he retired eight months later.

Jack Singlaub, SOG's most creative commanding officer, returned to the military mainstream. In 1976, by then a major general, he was appointed chief of staff of the United Nations Command and U.S. Forces, Korea. This was just as newly elected President Jimmy Carter decided to act on his campaign promise to withdraw U.S. troops from South Korea. Singlaub inadvertently got caught up in the political brouhaha that ensued. His remarks to a reporter on the subject were distorted and Carter subsequently fired him in May 1977.

Singlaub was reassigned as U.S. Forces Command chief of staff. Carter had considered court-martial for his remarks about the withdrawal of U.S. troops but decided otherwise, probably because of the political firestorm that erupted over his dubious Korea policy and treatment of Singlaub. While he remained on active duty for one more year, Singlaub's career was over when Carter relieved him.

Bob Kingston left SOG at the end of 1967 after uncovering Hanoi's double cross of OP 34's agent operations and laying the basis for the diversionary program. For the next fifteen years he was promoted up the chain of command, with one foot in the conventional Army and the other in special operations.

In the late 1970s then–Major General Kingston commanded the Special Forces Center at Fort Bragg. Given his prior experience and a tour with the elite British Special Air Service, he was convinced that the United States had to resuscitate its special operations forces. Kingston was instrumental in creating Delta Force, America's elite counterterrorist unit. Having received his fourth star in the early 1980s, he completed an illustrious career as commander in chief of U.S. Central Command.

Mick Trainor went back to the Marine Corps after his stint in SOG's Naval Advisory Detachment, retiring in 1985 as a lieutenant general. His last assignment was deputy chief of staff for plans, poli-

cies, and operations at Marine Corps headquarters. Trainor next entered the world of journalism as a military correspondent for the *New York Times*.

From journalism Trainor moved to academe as director of the National Security Program at Harvard University's John F. Kennedy School of Government. In the aftermath of the 1991 Persian Gulf war, with Michael Gordon, chief Pentagon correspondent for the *New York Times*, he coauthored a highly controversial critique of the outcome of that conflict—*The General's War*.[1]

Like Trainor, Wesley "Duff" Rice went back to the corps after serving as the NAD's operations officer in 1967–1968. When asked how that tour contributed to his career, Rice was blunt: "I don't think as a professional Marine officer that it was of any value . . . [A]s far as making me a better Marine, a better commander, I don't think so."[2]

Ironically, Major General Rice would complete his military service back in the special operations business as the first director of the Joint Staff's Joint Special Operations Agency (JSOA) in 1984. The JCS established JSOA for the same wrongheaded reasons it had created the SACSA twenty years earlier. The chiefs hoped JSOA would sidetrack those calling for a revitalization and buildup of special operations forces. For Rice it was a frustrating end to his career. After it was over he stated: "I had many responsibilities, but I had little authority . . . As a two-star general I had little clout in a town of three- and four-star generals."[3]

For Ed Partain, the assignment to SOG as chief of agent operations in 1964 was a career aberration. He maintained long after it was over that "I did not want to go [to SOG], I was detailed to go." While he saw a place for Special Forces—"They were great fighters, great warriors, the kind of guys you . . . wish you could deep freeze on the last battlefield and thaw out on the battlefield of the next war"—he did not want to be part of them.[4] Partain returned to the conventional Army and stayed until he retired as a major general in 1985. In his last two assignments, he commanded the First and Fifth Infantry Divisions.

Less than a year after Bull Simons led the raid on Son Tay prison, he retired from the Army. Secretary of Defense Melvin Laird had tried to get him promoted to brigadier general. When Simons was not selected, Laird "appealed to [Army chief of staff] Westmoreland to

add Simons's name to the list. Westmoreland explained to him at great length that it was 'impossible'—the army had a rigid selection system." What possibly was missing from the record of one of the Army's greatest special operators and exceptional combat leader? It was the same nonsense that nearly kept Simons out of SOG in 1965 after Blackburn had selected him to initiate operations against the Ho Chi Minh Trail—he had not been "to one of the war colleges."[5]

Bull Simons led one more daring rescue mission—as a civilian. On December 31, 1978, he received a call from H. Ross Perot, CEO of Electronic Data Systems. Two of his employees had been jailed in Tehran during the chaos that followed the overthrow of the Shah and he could not get them out. Simons slipped into Iran and brought the two men home on February 19, 1979. The story of this daring rescue became the basis for Ken Follet's 1983 best-seller *On Wings of Eagles*.[6] Three months after he had put one over on the ayatollahs, Bull Simons died of heart failure. In November 1999 an eight-foot-tall monument in his memory was implanted in the Memorial Plaza of the John F. Kennedy Special Warfare Center and School at Fort Bragg.

Dick Meadows was one of the most extraordinary soldiers in the post–World War II United States Army. So impressive were his accomplishments in SOG running recon operations against the Ho Chi Minh Trail that Meadows received a direct commission to the rank of captain. At Son Tay he led the assault element after serving as the primary trainer for the entire raiding party. He later became one of the first four officers picked for Delta Force.

In 1980 the Carter administration decided to employ Delta to rescue the American hostages in Iran. Meadows slipped into Tehran using a false Irish passport and reconnoitered the embassy, surveyed Delta's route in and out of the city, and checked on the security of the warehouse where the CIA had stashed trucks and equipment for the rescue. After the mission aborted, he escaped through Turkey. During the 1980s he assisted the U.S. government in the war on drugs in Latin America. For his service as a private citizen, Dick Meadows was awarded the Presidential Citizen's Medal for Distinguished Service posthumously. A statue also stands in his memory at Fort Bragg.

Bob Andrews, who served in SOG's psywar section in 1968, retired from the Army in the early 1970s to pursue a highly successful career in the defense industry. He has held senior executive positions with

different aerospace corporations, most recently Boeing. However, he also put his experience in psywar and covert operations to good use and authored several spy thrillers, including *Last Spy Out* and *Death in a Promised Land*.[7]

John Hada was the deputy to three chiefs of OP 34. While he stayed in the military for a few more years after SOG, he decided to become an academic. Hada earned a Ph.D. in Japanese language and literature and was awarded a Fulbright scholarship for postdoctoral studies at the University of Tokyo. He then joined the faculty of the University of San Francisco as a member of the Department of Modern and Classical Languages.

After serving as the NAD's first chief of operations, Jim Munson returned to the Marine Corps but did not stay long. He retired in the early 1970s, completed graduate studies, and became a historian of the Commonwealth of Virginia.

Brute Krulak, the first chief of the SACSA, retired from the Marine Corps in 1968 as a lieutenant general. His views on the Vietnam conflict and military strategy, during his tour as SACSA in 1962–1964, were in the Pentagon mainstream. Later, as Commanding General Fleet Marine Force Pacific (FMFPAC), Krulak turned on the mainstream and began peppering McNamara with papers on why Westmoreland's attrition strategy was doomed to fail. It was to no avail and cost him the commandant's position.

After his retirement, Krulak earned a Ph.D. from the University of San Diego and joined the Copely Newspaper Corporation. He became president of its news service, as well as an author and columnist. In 1984 he published a well received book—*First to Fight: An Inside View of the U.S. Marine Corps*.[8]

SOG had saved Bob Rheault from the wrath of General Creighton Abrams, but his military career was effectively over in 1969. An account of what happened to him was published in that year's November issue of *Life* magazine. He could stay in the Army but would never receive another SF command assignment or promotion. A man of honor, Rheault decided to move on after twenty-six years of military service.

In 1971 he joined the Outward Bound School at Hurricane Island, Maine, and for the last twenty-seven years has served as an instructor there—and, on two occasions, as acting president of the school. Even

here Bob Rheault continued to serve his country. He developed special programs for returning Vietnam veterans who suffered from post-traumatic stress disorder. Working with the Veterans Administration, he helped many young men come to grips with Vietnam.

In 1989 he took fifteen Vietnam veterans on an Outward Bound trip to Uzbekistan, where they joined fifteen Soviet veterans of the Afghan war. When interviewed for this book, Bob Rheault was still at Hurricane Island, the oldest Outward Bound instructor in the world.

Finally, there are the survivors of the Vietnamese agent teams infiltrated into North Vietnam by the CIA and SOG. It was reasonably assumed in 1968 that most of the approximately 500 commandos that had been sent North were either killed in firefights or executed. Only a handful survived in prison, used by Hanoi as part of its double cross of OP 34. These men were written off as lost behind enemy lines. At the time of the signing of the Paris peace accords in January 1973, no mention was made of them by American negotiators.

Astonishingly, many survived years of torture, hard labor, and terrible living conditions in North Vietnamese dungeons. At the end of the 1970s, Hanoi began to slowly release those commandos who had endured captivity, some since as early as 1961–1962. By the end of the 1980s most had returned to their families in the South. In the 1990s they were allowed to leave Vietnam. Well over 150 came to America to start new lives.

Sadly, the U.S. government continued to forget these men. They had been recruited by the United States for highly dangerous missions in enemy territory but were ignored when they came to the country that had sent them North.

In 1995 these veterans of America's covert war filed a class-action suit in the U.S. Court of Federal Claims in Washington, D.C., for compensation—back pay in accordance with their contracts. The federal government decided to fight the case using shabby legal maneuvers. The commandos, Pentagon lawyers argued, had no contractual arrangement with the United States; they had signed agreements with SOG's South Vietnamese counterpart, the STD.

While technically correct, this legal machination was morally bankrupt and turned into a political embarrassment. In 1996, President Clinton signed a bill providing $20 million in compensation, about $40,000 apiece. However, the commandos continue to be

denied much-needed health benefits. Many suffer from years of brutal treatment in prison. Some are severely crippled from beatings and torture. In June 1998 they filed another class-action suit to receive health benefits as U.S. veterans. They certainly qualify.

Revitalization

In the aftermath of the failed attempt to rescue American hostages in Iran—Desert One—it was tragically apparent that the U.S. needed not less but more special operations forces (SOF) to respond to the challenges of low-intensity conflict (LIC). The post-Vietnam degradation of special warfare units was unambiguously clear.

In 1981, LIC was an important theme for the newly elected Reagan administration. It warned that terrorism and insurgency in the Third World posed serious problems. Even more worrisome was the assistance they received from the Soviet Union, members of the Warsaw Pact, and Cuba. Regimes in Iran, Libya, and Syria were doing the same.

The White House said it intended to develop an integrated strategy and special operations capabilities to respond. However, as in the Kennedy years, this proved hard to accomplish. Once again the senior military leadership rose in opposition. There was no need to expand SOF or to establish a centralized command for their employment. Some members of the Reagan administration concurred.

This led to a LIC policy that was disjointed and ad hoc. The administration did not produce a coherent political-military doctrine. While funding for SOF steadily increased, the lack of guidance from the White House undermined the development of a coherent organization, effective command and control, and interagency coordination.

In 1984, the administration attempted institutional restructuring but did so on Pentagon terms. A Joint Special Operations Agency (JSOA) was established by the Joint Chiefs to oversee all military preparation for low-intensity conflict. The brass labeled it a constructive step within the JCS command structure. It was anything but that. JSOA was isolated and its authority severely circumscribed. The Joint Chiefs used the same deceptive maneuvers their counterparts had used two decades earlier in establishing the SACSA.

This JCS opposition to SOF cannot be explained as a budget matter, the result of taking significant appropriations away from other

missions more important to the chiefs. The amount of funds involved was a pittance, especially in the huge defense budgets of the halcyon years of the Reagan administration. In 1987 SOF received $1.6 billion out of a defense budget in excess of $300 billion. The answer lies in the traditional American military approach to war and the experience in Vietnam. The mainstream military remained viscerally opposed to special operations.

In 1986, Congress intervened. It was convinced that low-intensity conflict was a serious problem, that the United States was unprepared to respond to the most likely form of future warfare, and that special operations forces offered the best answer. Senator William Cohen stated, "We are not well prepared for unconventional conflict . . . and it shows."[9] The administration had been floundering for five years. It was time to act. In November 1986, Congress took steps to remedy the situation. A reorganization plan sparkplugged by Senators Sam Nunn and Cohen was attached to the Defense Authorization Bill. It ordered the creation of a U.S. Special Operations Command (SOCOM) under the direction of a four-star general. The command has responsibility for doctrine, training, planning, readiness, acquisition of equipment and resources. The legislation also established an assistant secretary of defense for special operations and low-intensity conflict to focus policy deliberations on these important matters within the Pentagon.

It was one thing to create a new command, but quite another to convince the mainstream military to accept it. There was significant opposition from the Joint Chiefs and various regional commanders to SOCOM. By 1988 senior officers were still publicly expressing their indignation over this unwelcome appendage to their turf. One member of the JCS stated that the SOCOM was not a good idea and that the chiefs did not back it. Another senior JCS officer claimed that a small group of retired zealots had forced the legislation through Congress and that it was not necessary.[10]

In fact, several SOG veterans weighed in to influence Congress to revitalize special operations forces. Two served on the Secretary of Defense's Special Operations Policy Advisory Group (SOPAG)—Don Blackburn and Bob Kingston—a committee of retired flag and general officers with vast special operations experience. Other key members of the SOPAG were Sam Wilson, Dick Stilwell, Leroy Manor, Bill

Yarborough, and Shy Meyer. All were influential in urging Congress to act.

The creation of an assistant secretary of defense for special operations and low-intensity conflict also generated considerable enmity. One official in the Office of the Secretary of Defense stated that to support it was to be "disloyal to the Pentagon." The nomination of the first assistant secretary reflected this attitude. By proposing a series of unqualified and weak candidates over an eighteen-month period, a small group of civilians in the DOD stymied the selection process. The candidates they picked were rejected by Congress even before being formally nominated.

SOF revitalization turned into a dogfight reminiscent of the Kennedy administration's attempt to develop special warfare capabilities. However, this time things were different. The mainstream military tried once more to scuttle the buildup of SOF capabilities, but they were not successful.

By 1990 revitalization was a fact.[11] There were standing special operations units of significant size and stature. The skills of these forces had improved dramatically. Not only was a four-star general commanding SOCOM, but a brigadier general was in charge of every theater Special Operations Command—a huge change from SOG's place in the military hierarchy and a clear indication that SOF skills and assets finally were recognized for their import and potential impact.

COVERT ACTION AND THE POST–COLD WAR WORLD

One question remains to be addressed. In the aftermath of the Cold War, to what extent are the lessons from MACVSOG and revitalized SOF capabilities relevant to future presidents if they turn to covert operations in an effort or as a means of countering new threats and challenges?

Since the 1970s covert action has been a subject of intense public policy controversy. To what extent it should be employed by a democratic government has been widely debated. Many believe that it is inconsistent with American principles and, with rare exceptions, should be shunned. With the end of the Cold War those who hold this position have become increasingly outspoken. They believe that

covert action employs morally and ethically dubious means that violate America's democratic values. Others disagree and call for a more balanced approach.

Those who believe covert action is not consistent with U.S. ethics will be aghast at many of SOG's operations recounted in these pages. In several instances it played "real hardball," using tactics that today would raise moral qualms. Why? Because these methods not only manipulate but can result in physical harm—even death—of the individuals who are put into vulnerable circumstances. SOG exploited NVA prisoners of war by inserting them up North in highly perilous situations. North Vietnamese citizens kidnapped by SOG teams and indoctrinated were likewise exploited. Finally, SOG's booby-trap operations and some of its black psywar tactics, such as the poison pen letters, were fiendishly nasty. At the time, Washington policy makers did not object to these tactics on moral grounds because they saw themselves fighting a war, albeit an undeclared and limited one.

Should the U.S. employ such methods today? There is no easy answer, but any answer depends on the circumstances. A good starting point is whether it is wartime or peacetime. However, even in wartime, a democracy should consider the moral implications of the means it employs against enemies. But which ones? For example, what if, during the Gulf War, the United States had employed the SOG methods just discussed? Would we now be outraged on moral grounds, or would Americans accept their use as part of war? Would U.S. allies accept them? What if these measures were to be directed against a terrorist group willing to use weapons of mass destruction or a rogue state seeking to acquire nuclear weapons?

The story of SOG reveals that an array of covert measures is readily available and can have an impact. Is the post–Cold War world creating situations in which these methods may be needed to counter new threats? Given the emerging national security challenges that the United States will face as the twenty-first century approaches, the answer is yes.

At the top of the list is the acquisition of weapons of mass destruction by rogue states. Likewise, the disruptive policies of regimes like Iraq, Libya, Iran, and North Korea will be of continuing concern. Stability in the former Soviet republics and Russia itself requires close attention.

Terrorism is also on the list. The end of the Cold War did not bring an end to terrorism. Groups and movements motivated by transcendent religious ideals and ethnonationalist passions are more than willing to employ these tactics indiscriminately and may well escalate to a nuclear, chemical, or biological device. In fact, the terrorist cell that carried out the bombing of the World Trade Center in New York also attempted to use a chemical weapon. They failed because they lacked a basic understanding of scientific principles.

Ethnic and religious mayhem and its impact on regional stability also cannot be ignored, the internal war in Kosovo being a case in point. Once involved in the fighting, the United States and NATO faced the question of whether to arm and train the Kosovo Liberation Army (KLA). The KLA is a classic example of a resistance movement. The United States and NATO eventually provided the KLA with arms and training but did so clandestinely. After the war NATO had no choice but to recognize the KLA, in light of its political legitimacy with Kosovo's Albanian population.

The rise of transnational Islamic radicalism in the Middle East/Southwest Asia is another example. These groups are able to compete for political power through the use of violence, as well as other political and social measures. Radical religious movements and cults in India, Israel, and Japan have proven capable of similar violent actions. In the case of Japan, the religious cult Aum Shinri Kyo attacked the Tokyo subway in 1995 with sarin nerve gas. In the investigation that followed, the Japanese police found out that Aum had planned to ship sarin nerve agents to the United States for use against the White House or Pentagon. The cult is also reported to have conducted a "field test" of the biological agent botulinum toxin when it sprayed a U.S. military base in Yokosuka, Japan, in 1993. The test failed.

Organized criminal groups are also contributing to the declining ability of existing governments to govern in several key regions of the globe. In such a political environment, criminal organizations, many of which are ethnic based, flourish. They are able to threaten the stability of states, disrupt local economies, corrupt officials, and undermine financial institutions. The Andes region of South America is a glaring example. The linkages that exist between organized crime, ethnic and religious movements, and terrorist and insurgent groups compound the gravity of this challenge.

The United States will face each of these emerging international security challenges in the years ahead, and each will be difficult to counter. In developing policies and strategies to respond, all the instruments of statecraft should be considered, including special operations forces employed in covert-action missions. However, if presidents decide to select from among the operational measures employed by SOG, they will have to resolve the obstacles and complications that limited SOG's effectiveness during the Vietnam War. Given the fact that these impediments not only thwarted SOG but generally frustrated the use of covert operations by U.S. presidents throughout the Cold War, this will be a formidable challenge.

NOTES

CHAPTER ONE

1. *Foreign Relations of the United States, 1961–1963: Vietnam*, vol. 1 (Washington, D.C.: U.S. Government Printing Office, 1988), p. 16 (hereafter referred to as *FRUS, 1961–1963: Vietnam*, vol. 1). The quote is taken from a memorandum on the NSC meeting from the president's deputy special assistant for national security affairs, Walt Rostow, to the president's special assistant for national security affairs, McGeorge Bundy.

2. Ibid., pp. 5–6.

3. In May 1959 at the 15th plenum of the Central Committee, North Vietnam's leaders formally decided to escalate the insurgency in South Vietnam. Guerrilla and terrorist operations increased, as more cadres were infiltrated into the South by way of the Ho Chi Minh Trail. The CIA picked up evidence of large-scale infiltration during the latter half of 1959. Hanoi also decided at this time to improve the trail. General Bam and a 30,000-man workforce formed to undertake the task. Units assigned included the 559th Transportation Unit and the 70th NVA Battalion. On the development of the trail see Brigadier General Vo Bam, "Opening the Trail," *Vietnam Courier*, 22, no. 5 (May 1984), pp. 9–15. By fall, the escalation of operations that Lansdale reported was under way. For example, the VC ambushed two companies of South Vietnam's 23rd Division on September 26, 1959, and killed twelve soldiers. The attack made clear that the tempo of the armed struggle was on the rise.

4. The Counterinsurgency Plan had been worked on by the Country Team for most of 1960. It was approved at the January 28, 1961, NSC meeting without any serious disagreements. For a discussion of the plan see Senator Mike Gravel,

ed., *The Pentagon Papers: The Defense Department History of United States Decisionmaking on Vietnam* (Boston: Beacon Press, 1971), vol. 2, pp. 23–27, 137–38, 436–37.

5. *FRUS, 1961–1963: Vietnam*, vol. 1, p. 17.

6. Ibid.

7. Douglas Blaufarb, *The Counterinsurgency Era: U.S. Doctrine and Performance* (New York: Free Press, 1977).

8. John J. McCuen, *The Art of Counter-Revolutionary War* (Harrisburg, Pa.: Stackpole Press, 1966), p. 50.

9. "Cold War Terminology," *Army Information Digest* (June 1962), p. 53.

10. Ibid., p. 54.

11. John Foster Dulles, "The Evolution of Foreign Policy," *Department of State Bulletin* (January 25, 1954).

12. *Public Papers of the Presidents of the United States, Dwight D. Eisenhower* (Washington, D.C.: Office of the Federal Register, 1955), p. 332.

13. John F. Kennedy, *A Compilation of Speeches During His Service in the U.S. Senate and House of Representatives* (Washington, D.C.: U.S. Government Printing Office, 1964), pp. 1002–03.

14. Ibid., p. 91.

15. *Public Papers of the President, John F. Kennedy* (Washington, D.C.: U.S. Government Printing Office, 1962), pp. 232–36.

16. Ibid., p. 453.

17. Maxwell Taylor, *The Uncertain Trumpet* (New York: Harper and Row, 1959).

18. Maxwell Taylor, "Security Will Not Wait," *Foreign Affairs* (January 1961), p. 174–84.

19. David Halberstam, *The Best and the Brightest* (New York: Ballantine Books, 1992 edition), p. 56.

20. W. W. Rostow, *The Stages of Economic Growth* (Cambridge: Cambridge University Press, 1960).

21. John Dziak, a longtime specialist in Soviet political and military affairs, defines a counterintelligence state in the following manner. "Certain political systems display an overriding concern with 'enemies,' both internal and external. Security and the extirpation of real or presumed threats becomes the premier enterprise of such systems . . . The fixation with enemies and threats to the security of the state involves a very heavy commitment of state resources. Further, this fixation demands the creation of a state security service that penetrates and permeates all societal institutions (including the military), but not necessarily the claimant to monopoly power, usually a self-proclaimed 'revolutionary' party. This security service is the principal guardian of the party; the two constitute a permanent counterintelligence enterprise to which all other major political, social, and economic questions are subordinated . . . I would label such a system the counterintelligence state." This was the kind of political system the CIA had to operate against in denied areas, including North Vietnam. Dziak, *Chekisty: A History of the KGB* (Lexington, Mass.: Lexington Books, 1988), pp. 1–2.

22. Anthony Cave Brown, ed., *The Secret War Report of the OSS* (New York: Berkeley, 1976); for background on Donovan see Thomas Troy, *Donovan*

and the CIA (Frederick, Md.: University Publications of America, 1981). Donovan's position prevailed, although some theater commanders, most notably Douglas MacArthur, continued to oppose OSS operations.

23. John Ranelagh, *The Agency: The Rise and Decline of the CIA* (New York: Simon and Schuster, 1988), p. 88.

24. National Security Council Directive 10/2, June 18, 1948, Establishing the Office of Special Projects, reprinted in William Leary, *The Central Intelligence Agency: History and Documents* (University, Ala.: University of Alabama Press, 1984), pp. 131–33.

25. Ibid.

26. A fictionalized national best-seller was written about the Lansdale experience by William Lederer and Eugene Burdick, entitled *The Ugly American* (New York: W. W. Norton, 1958). In the volume, Lansdale is portrayed as the good Colonel Hillandale. Later, Graham Greene characterized Lansdale in a much less flattering light in his novel *The Quiet American* (New York: Viking Press, 1955). For Lansdale's own account see *In the Midst of Wars* (New York: Harper and Row, 1972). For a biography of Lansdale's life see *Edward Lansdale: The Unquiet American*, by Cecil Currey (Boston: Houghton Mifflin, 1988).

27. Roy Godson, *Dirty Tricks or Trump Cards* (Washington, D.C.: Brassey's, 1995), p. 42.

28. At the request of the interviewee, the identity of this individual is being withheld.

29. Godson, *Dirty Tricks or Trump Cards*, p. 47. At the time, the Albanian failure was attributed to Kim Philby, the Soviet spy who had knowledge of it due to his position in British intelligence. Consequently, the credibility of UW operations against other denied areas was not questioned. Godson reveals that there were several other reasons for the U.S.-British UW failure in Albania. These included communist agents in the exile community from which resistance fighters were being recruited; underestimation of the strength of counterintelligence and police controls in such communist states; little knowledge or firsthand experience in Albania; and no embassy or other unofficial base inside the country.

30. For the story of WIN, see Ranelagh, *The Agency*, pp. 127–28. The author's account is based on an interview with David Atlee Phillips, a senior CIA officer, who was part of the operation.

31. John K. Singlaub, *Hazardous Duty* (New York: Summit Books, 1991), p. 182.

32. Ibid.

33. John S. Bowman, ed., *The World Almanac of the Vietnam War* (New York: Pharos Books, 1985), p. 449.

34. Ibid., p. 451.

35. *FRUS, 1961–1963: Vietnam*, vol. 1, p. 12.

36. Oral history interview conducted by author with Herbert Weisshart. In *MACVSOG: Oral History Interviews with Officers Who Served in MACVSOG OP 39 (Psychological Operations)* (Medford, Mass.: Fletcher School of Law and Diplomacy, International Security Studies Program), p. 1.

37. Ibid., p. 5.

38. Ibid.

39. Kennedy, *A Compilation of Speeches*, p. 295.

40. Ibid., p. 333.

41. *United States-Vietnam Relations, 1945–1967,* 92nd Congress, 2nd Session (Washington, D.C.: U.S. Government Printing Office, 1972), book 4, p. 24.

42. Ibid., Book II, 18.

43. *FRUS, 1961–1963: Vietnam,* vol. 1, p. 74.

44. Ibid., pp. 93–94.

45. *Presidential Directives on National Security from Truman to Clinton* (Bethesda, Md.: University Publications of America, 1995), NSDDINDEX Record Number 180.

46. Oral history interview conducted by author with Herbert Weisshart. In *MACVSOG: Oral History Interviews with Officers Who Served in MACVSOG OP 39 (Psychological Operations),* pp. 3, 5.

47. Ibid., p. 4.

48. John F. Kennedy, "Speeches, Remarks, Press Conferences, and Statements, Aug. 1 through Nov. 7, 1960," in Freedom of Communications, Final Report of the Committee on Commerce, U.S. Senate, 87th Congress, First Session, Report 994, Part I (Washington, D.C.: U.S. Government Printing Office, 1961), pp. 510–11.

49. Ibid., p. 511.

50. NSAM 55 was signed by President Kennedy on June 28, 1961, along with NSAMs 56 and 57. Directed to the chairman of the Joint Chiefs of Staff, it opens with Kennedy stating, "I wish to inform the Joint Chiefs of Staff as follows with regard to my views on their relations to me in Cold War Operations." For the text see *Presidential Directives on National Security from Truman to Clinton,* NSDDINDEX Record Number 183, p. 1.

51. Ibid., NSDDINDEX Record Number 184.

52. See Lansdale's memorandum of October 23, 1961, to Maxwell Taylor, President Kennedy's military assistant. The subject of the memorandum is "Unconventional Warfare." Contained in *FRUS, 1961–1963: Vietnam,* vol. 1, pp. 421–22.

53. NSAM 57 was formally titled "Responsibility for Paramilitary Operations" and was directed by President Kennedy to the Secretary of State, Secretary of Defense, and Director of the CIA. It is contained in *Presidential Directives on National Security from Truman to Clinton,* NSDDINDEX Record Number 185.

54. *FRUS, 1961–1963: Vietnam,* vol. 2 (Washington, D.C.: U.S. Government Printing Office, 1990), p. 49.

55. A similar interagency organization, known as the 5412 Committee, existed during the Eisenhower administration. It grew out of the March 1955 "National Security Council Directive on Covert Operations," or NSC 5412. See *Presidential Directives on National Security from Truman to Clinton,* NSDDINDEX Record Number 1964. The 303 Committee replaced the 5412 Committee and took its name from the room at the Executive Office Building where it met.

56. Oral history interview with Roswell Gilpatric, John F. Kennedy Library (May 5, 1970), pp. 38–39.

57. Interview with General Victor Krulak in San Diego, Calif. (February 5, 1998), p. 7.

58. One historian of the period has noted that Taylor overlooked other experienced senior officers. These included Brigadier General William Yarborough, head of the Special Warfare Center at Fort Bragg; Colonel William Peers, who had experience

in guerrilla warfare in the OSS; and Brigadier General William Rossom, who became head of the Special Warfare Division of the Joint Chiefs of Staff. See Andrew Krepinevich, *The Army and Vietnam* (Baltimore: Johns Hopkins University Press, 1986), pp. 64–65.

59. To quote Clausewitz, "it is against these that our energies should be directed. If the enemy is thrown off balance, he must not be given a chance to recover. Blow after blow must be aimed in the same direction." See Carl von Clausewitz, *On War*, ed. and trans. by Michael Howard and Peter Paret (Princeton, N.J.: Princeton University Press, 1976), pp. 595–97.

60. John M. Collins, *Military Geography* (Washington, D.C.: Brassey's, 1998), p. 367.

61. Bam, "Opening the Trail," p. 9.

62. John F. Kennedy Library, National Security Files, Country File, Vietnam, Box 193. This information is in "CIA Field Report."

63. Ibid., NSF, Regional Security, Southeast Asia, Box 231A. See "Rostow-Taylor memo to JFK."

64. Quoted in Walter Isaacson and Evan Thomas, *The Wise Men: Six Friends and the World They Made* (New York: Simon and Schuster, 1986), p. 616.

65. Ibid., p. 618.

66. Cited in Halberstam, *The Best and the Brightest*, p. 189.

67. See Paul Langer and Joseph Zasloff, *North Vietnam and the Pathet Lao* (Cambridge, Mass.: Harvard University Press, 1970); Arthur Dommen, *Conflict in Laos* (New York: Praeger, 1971); and Zasloff and Leonard Unger, *Laos: Beyond the Revolution* (New York: St. Martin's Press, 1991).

68. Halberstam, *The Best and the Brightest*, p. 92.

69. John M. Newman, *JFK and Vietnam: Deception, Intrigue, and the Struggle for Power* (New York: Warner Books, 1992), p. 269.

70. Ibid., p. 14.

71. Oral history interview conducted by author with William Colby. In *MACVSOG: Oral History Interviews with Officers Who Served in MACVSOG OP 34 (Agent Operations Against North Vietnam)* (Medford, Mass.: Fletcher School of Law and Diplomacy, International Security Studies Program, July 1996), p. 7.

72. Joint Chiefs of Staff (hereafter cited as JCS), *U.S. Military Assistance, Command, Vietnam, Studies and Observation Group* (hereafter cited as MACVSOG) *Documentation Study* (July 1970), Appendix C/Annex B, "Airborne Operations," pp. 63–65.

73. Oral history interview conducted by author with William Colby. In *MACVSOG: Oral History Interviews with Officers Who Served in MACVSOG OP 34 (Agent Operations Against North Vietnam)*, p. 15.

74. Ibid., p. 10.

75. Oral history interview conducted by author with Herbert Weisshart. In *MACVSOG: Oral History Interviews with Officers Who Served in MACVSOG OP 39 (Psychological Operations)*, p. 7.

76. Gougelmann stayed involved in the war up to the very end, his last mission with the South Vietnamese Police Special Branch. For Tucker Gougelmann the end was a tragic one. During his long involvement in Vietnam, he adopted the children of the woman he was involved with. In 1975, after Saigon fell, Gougelmann secretly reentered the country to rescue his family and some orphans. He was arrested, impris-

oned, and died in captivity. After the return of his remains, an autopsy revealed that he had more than twenty broken bones. Reported in Sedgwick Tourison, *Secret Army Secret War* (Annapolis, Md.: Naval Institute Press, 1995) p. 343.

77. Edward Marolda and Oscar Fitzgerald, *The United States Navy and the Vietnam Conflict* (Washington, D.C.: Naval Historical Center, 1986), p. 203.

78. Oral history interview conducted by author with William Colby. In *MACVSOG: Oral History Interviews with Officers Who Served in MACVSOG OP 34 (Agent Operations Against North Vietnam)*, p. 13.

79. Oral history interview conducted by author with Herbert Weisshart. In *MACVSOG: Oral History Interviews with Officers Who Served in MACVSOG OP 39 (Psychological Operations)*, p. 5.

80. Cited in Editors of the Boston Publishing Company, *War in the Shadows* (Boston: Boston Publishing Company, 1988), p. 48.

81. "Record of the Sixth Secretary of Defense Conference, Camp Smith, Hawaii, July 23, 1962." Contained in *FRUS, 1961–1963: Vietnam*, vol. 2, p. 546.

82. Ibid., pp. 548–49.

83. "Paper prepared by the President's military representative (Taylor)," contained in Ibid., p. 660.

84. The most widely cited of these was Colonel John Paul Vann. See Neil Sheehan, *A Bright Shining Lie* (New York: Vintage Books, 1988).

85. *FRUS, 1961–1963: Vietnam*, vol. 3 (Washington, D.C.: U.S. Government Printing Office, 1991), p. 20.

86. "Memorandum from the Director of the Bureau of Intelligence and Research (Roger Hilsman) and Michael V. Forrestal of the National Security Council Staff to the President," contained in ibid., pp. 49–62.

87. "NIE 53–63, Prospects for Vietnam," contained in ibid., pp. 232–35.

88. Newman, *JFK and Vietnam*, p. 314.

89. Oral history interview conducted by author with William Colby. In *MACVSOG: Oral History Interviews with Officers Who Served in MACVSOG OP 34 (Agent Operations Against North Vietnam)*, p. 9.

90. Ibid.

91. "National Security Action Memorandum (NSAM) 273," contained in *FRUS, 1961–1963: Vietnam*, vol. 4 (Washington, D.C.: U.S. Government Printing Office, 1991), p. 637–40.

92. Newman, *JFK and Vietnam*, pp. 446–48.

93. Oral history interview conducted by author with Herbert Weisshart. In *MACVSOG: Oral History Interviews with Officers Who Served in MACVSOG OP 39 (Psychological Operations)*, pp. 5–6.

94. Gravel, ed., *The Pentagon Papers: The Defense Department History of United States Decisionmaking on Vietnam*, vol. 3, p. 149.

95. Ibid., p. 151.

96. JCS, *MACVSOG Documentation Study* (July 1970), Appendix A/Pt. IV, "Military Assistance Command Studies and Observation Group and the Strategic Technical Directorate: Inception, Organization, Evolution," p. 150.

97. Ibid., p. 151.

98. Ibid.

99. Gravel, ed., *The Pentagon Papers: The Defense Department History of United States Decisionmaking on Vietnam*, vol. 3, p. 151.

100. Ibid.

101. *Foreign Relations of the United States, 1964–1968: Vietnam* (Washington, D.C.: U.S. Government Printing Office, 1992), vol. 1, p. 5 (hereafter referred to as *FRUS, 1964–1968: Vietnam,* vol. 1).

102. JCS, *MACVSOG Documentation Study* (July 1970), Appendix A/Pt. IV, "Military Assistance Command Studies and Observation Group and the Strategic Technical Directorate: Inception, Organization, Evolution," p. 171.

CHAPTER TWO

1. Oral history interview conducted by author with Major General Edward Partain. In *MACVSOG: Oral History Interviews with Officers Who Served in MACVSOG OP 39 (Psychological Operations)* (Medford, Mass.: Fletcher School of Law and Diplomacy, International Security Studies Program, 1996), p. 18.

2. JCS, *MACVSOG Documentation Study* (July 1970), Appendix B/Annex K, "Comments on MACVSOG's Organizational Development," Tab B, p. 8.

3. Oral history interview conducted by author with Herbert Weisshart. In *MACVSOG: Oral History Interviews with Officers Who Served in MACVSOG OP 39 (Psychological Operations)* (Medford, Mass.: Fletcher School of Law and Diplomacy 1997), p.7.

4. JCS, *MACVSOG Documentation Study* (July 1970), Appendix B/Annex N, "Comments on MACVSOG's Operations and Intelligence," Tab A, p. 4.

5. JCS, *MACVSOG Documentation Study* (July 1970), Appendix A, "Summary of MACVSOG Documentation Study," p. 26.

6. JCS, *MACVSOG Documentation Study* (July 1970), Appendix B/Annex N, "Comments on MACVSOG's Operations and Intelligence," Tab A, p. 5.

7. Stanley Karnow, *Vietnam: A History* (New York: Penguin Books, 1984), pp. 331–34.

8. JCS, *MACVSOG Documentation Study* (July 1970), Appendix B/Annex N, "Comments on MACVSOG's Operations and Intelligence," Tab A, p. 6.

9. JCS, *MACVSOG Documentation Study* (July 1970), Appendix B/Annex K, "Comments on MACVSOG's Organizational Development," Tab F, p. 12.

10. JCS, *MACVSOG Documentation Study* (July 1970), Appendix B/Annex Q, "Comments on MACVSOG's Personnel and Training," Tab D, pp. 18–19.

11. Department of Defense, *United States-Vietnam Relations, 1945–1967,* vol. 11 (Washington, D.C.: U.S. Government Printing Office, 1971), p. 17.

12. JCS, *MACVSOG Documentation Study* (July 1970), Appendix B/Annex Q, "Comments on MACVSOG's Personnel and Training," Tab P, p. 47.

13. Ibid., p. 60.

14. Krepinevich, *The Army and Vietnam,* pp. 36–37.

15. JCS, *MACVSOG Documentation Study* (July 1970), Appendix B/Annex M, "Comments on MACVSOG's Command and Control," Tab A, p. 3.

16. Oral history interview conducted by author with Major General Edward Partain. In *MACVSOG: Oral History Interviews with Officers Who Served in MACVSOG OP 34 (Agent Operations Against North Vietnam),* p. 19.

17. Benjamin Schemmer, *The Raid* (New York: Avon Books, 1976), p. 46.

18. William Westmoreland, *A Soldier Reports* (Garden City, N.Y.: Doubleday, 1976), p. 108.

19. Oral history interview conducted by author with Major General John K. Singlaub. In *MACVSOG: Oral History Interviews with Chiefs of SOG* (Medford, Mass.: Fletcher School of Law and Diplomacy, International Security Studies Program, 1996), pp. 60–61.

20. John L. Plaster, *SOG: The Secret Wars of America's Commandos in Vietnam* (New York: Simon and Schuster, 1997). This quote by Westmoreland is taken from the cover of this book.

21. Westmoreland, *A Soldier Reports*, p. 106.

22. Oral history interview conducted by author with Brigadier General Donald Blackburn. In *MACVSOG: Oral History Interviews with Chiefs of SOG* (Medford, Mass.: Fletcher School of Law and Diplomacy, International Security Studies Program, 1996), p. 27.

23. Ibid., pp. 39–40.

24. Ibid., pp. 8, 13, 29.

25. JCS, *MACVSOG Documentation Study* (July 1970), Appendix C/Annex B, "Airborne Operations," p. 6.

26. Oral history interview conducted by author with Brigadier General George Gaspard. In *MACVSOG: Oral History Interviews with Officers Who Served in MACVSOG OP 34 (Agent Operations Against North Vietnam)*, p. 126.

27. Ibid., pp. 130, 132.

28. JCS, *MACVSOG Documentation Study* (July 1970), Appendix C/Annex B, "Airborne Operations," p. 85.

29. Ibid., p. 10.

30. Oral history interview conducted by author with Lieutenant Colonel James Munson. In *MACVSOG: Oral History Interviews with Officers Who Served in MACVSOG OP 37 (Maritime Operations Against North Vietnam)* (Medford, Mass.: Fletcher School of Law and Diplomacy, International Security Studies Program, 1997), p. 1.

31. Ibid., pp. 1, 12.

32. William Daugherty and Morris Janowitz, *A Psychological Warfare Casebook* (Baltimore: Johns Hopkins University Press, 1958), p. 779.

33. Cord Meyer, *Facing Reality* (New York: Harper and Row, 1980), p. 112.

34. Ibid., p. 114.

35. Oral history interview conducted by author with Herbert Weisshart. In *MACVSOG: Oral History Interviews with Officers Who Served in MACVSOG OP 39 (Psychological Operations)* (Medford, Mass.: Fletcher School of Law and Diplomacy, International Security Studies Program, 1997), p. 3.

36. Ibid., p. 14.

37. Ibid., pp. 12, 14.

38. Ibid., p. 12.

39. Ibid., p. 8.

40. Oral history interview conducted by author with Lieutenant Colonel John Harrell. In *MACVSOG: Oral History Interviews with Officers Who Served in MACVSOG OP 39 (Psychological Operations)* (Medford, Mass.: Fletcher School of Law and Diplomacy, International Security Studies Program, 1997), p. 1.

41. Ibid., p. 2.

42. JCS, *MACVSOG Documentation Study* (July 1970), Appendix D, "Cross-Border Operations in Laos," p. 4.

43. Ibid., p. 6.

44. Ibid., p. 7.

45. Ibid.

46. Ibid., p. 8.

47. Oral history interview conducted by author with Brigadier General Donald Blackburn. In *MACVSOG: Oral History Interviews with Chiefs of SOG*, p. 7.

48. Ibid., p. 37.

49. JCS, *MACVSOG Documentation Study* (July 1970), Appendix D, "Cross-Border Operations in Laos," p. 10.

50. Schemmer, *The Raid*, pp. 3, 76.

51. Ibid., p. 80.

52. Oral history interview conducted by author with Brigadier General Donald Blackburn. In *MACVSOG: Oral History Interviews with Chiefs of SOG*, pp. 16–17, 35.

53. Ibid., p. 18.

54. Oral history interview conducted by author with Major General John K. Singlaub. In *MACVSOG: Oral History Interviews with Chiefs of SOG*, p. 46.

55. Plaster, *SOG: The Secret Wars of America's Commandos in Vietnam*, pp. 77–78.

56. Oral history interview conducted by author with Major General John K. Singlaub. In *MACVSOG: Oral History Interviews with Chiefs of SOG*, p. 76.

57. Oral history interview conducted by author with Brigadier General Donald Blackburn. In *MACVSOG: Oral History Interviews with Chiefs of SOG*, p. 27.

58. Singlaub, *Hazardous Duty*, p. 293.

59. JCS, *MACVSOG Documentation Study* (July 1970), Appendix B/Annex M, "Comments on MACVSOG's Command and Control," Tab A, p. 3.

60. Ibid., p. 8.

61. Oral history interview conducted by author with Brigadier General Donald Blackburn. In *MACVSOG: Oral History Interviews with Chiefs of SOG*, p. 18.

62. Ibid., p. 30.

CHAPTER THREE

1. *Public Papers of the President, John F. Kennedy, 1961* (Washington, D.C.: U.S. Government Printing Office, 1962), p. 336.

2. See William Duiker, *The Communist Road to Power in Vietnam* (Boulder, Colo.: Westview, 1981).

3. "White Paper, 1961," in *The Vietnam Reader*, ed. by Marcus Raskin and Bernard Fall (New York: Vintage, 1965), pp. 123–24.

4. Frances Fitzgerald, *Fire in the Lake* (Boston: Little, Brown, 1972), p. 158–59.

5. Douglas Pike, *Viet Cong* (Cambridge, Mass.: MIT Press, 1966), p. ix.

6. James Olson, *Dictionary of the Vietnam War* (Westport, Conn.: Greenwood Press, 1988), p. 304.

7. Oral history interview conducted by author with William Colby. In *MACVSOG: Oral History Interviews with Officers Who Served in MACVSOG OP 34 (Agent Operations Against North Vietnam)*, pp. 9, 16.

8. Robert S. McNamara, *In Retrospect: The Tragedy and Lessons of Vietnam* (New York: Random House, 1995), p. 105.

9. Author's notes from a June 6, 1997, interview with Richard Helms at his home in Washington, D.C.

10. Oral history interview conducted by author with Major General Edward Partain. In *MACVSOG: Oral History Interviews with Officers Who Served in MACVSOG OP 34 (Agent Operations Against North Vietnam)*, p. 18.

11. Ibid., p. 22.

12. Ibid.

13. Oral history interview conducted by author with Lieutenant Colonel Ernest "Pete" Hayes. In *MACVSOG: Oral History Interviews with Officers Who Served in MACVSOG OP 35 (Clandestine Operations in Laos and Cambodia Against the Ho Chi Minh Trail)* (Medford, Mass.: Fletcher School of Law and Diplomacy, International Security Studies Program, 1997), p. 171.

14. Oral history interview conducted by author with Dr. John Hada. In *MACVSOG: Oral History Interviews with Officers Who Served in MACVSOG OP 34 (Agent Operations Against North Vietnam)*, p. 49.

15. Ibid.

16. U.S. Department of the Army, *FM31–21, Guerrilla Warfare* (Washington, D.C.: U.S. Government Printing Office, 1955); *FM31–21, Guerrilla Warfare and Special Forces Operations* (Washington, D.C.: U.S. Government Printing Office, 1958).

17. Oral history interview conducted by author with Dr. John Hada. In *MACVSOG: Oral History Interviews with Officers Who Served in MACVSOG OP 34 (Agent Operations Against North Vietnam)*, p. 38.

18. Oral history interview conducted by author with Lieutenant Colonel Ernest "Pete" Hayes. In *MACVSOG: Oral History Interviews with Officers Who Served in MACVSOG OP 35 (Clandestine Operations in Laos and Cambodia Against the Ho Chi Minh Trail)*, p. 172.

19. Oral history interview conducted by author with William Colby. In *MACVSOG: Oral History Interviews with Officers Who Served in MACVSOG OP 34 (Agent Operations Against North Vietnam)*, p. 10. These individuals had left the North in 1954, taking advantage of the 300-day population resettlement period that followed the signing of the Geneva Accords. Vietnamese in both the North and South were given the opportunity to relocate.

20. Ibid., p. 11.

21. Ibid.

22. JCS, *MACVSOG Documentation Study* (July 1970), Appendix C/Annex B, "Airborne Operations," p. 63.

23. Oral history interview conducted by author with William Colby. In *MACVSOG: Oral History Interviews with Officers Who Served in MACVSOG OP 34 (Agent Operations Against North Vietnam)*, p. 13.

24. Ibid., p. 16.

25. JCS, *MACVSOG Documentation Study* (July 1970), Appendix C/Annex B, "Airborne Operations," pp. 63–64.

26. Ibid., p. 1.

27. Ibid., pp. 64–65.

28. John Masterman, *The Double Cross System in the War of 1939 to 1945* (New York: Ballantine Books, 1982).

29. Reproduction drawn by J. Christian Hoffman.

30. MACVSOG, *Command History 1969*, Annex F, p. IX-B–4.

31. MACVSOG, *Command History 1968*, Annex F, p. III–4-C–2.

32. Ibid.

33. Ibid., p. III–4-C–4.

34. Oral history interview conducted by author with William Colby. In *MACVSOG: Oral History Interviews with Officers Who Served in MACVSOG OP 34 (Agent Operations Against North Vietnam)*, (1996), p. 16.

35. MACVSOG, *Command History 1968*, Annex F, p. III–4-C–4.

36. MACVSOG, *Command History 1969*, Annex F, p. IX-B–1.

37. Ibid.

38. Ibid.

39. MACVSOG, *Command History 1969*, Annex F, p. IX-B–1.

40. Ibid., p. IX-B–2.

41. MACVSOG, *Command History 1968*, Annex F, p. III–4-C–4.

42. Ibid.

43. MACVSOG, *Command History 1969*, Annex F, p. IX-B–2.

44. Ibid., p. IX-B–3.

45. Ibid.

46. Oral history interview conducted by author with Major General Edward Partain. In *MACVSOG: Oral History Interviews with Officers Who Served in MACVSOG OP 34 (Agent Operations Against North Vietnam)*, p. 29.

47. Ibid., p. 26.

48. Ibid., p. 28.

49. Oral history interview conducted by author with Dr. John Hada. In *MACVSOG: Oral History Interviews with Officers Who Served in OP 34 (Agent Operations Against North Vietnam)*, p. 46.

50. JCS, *MACVSOG Documentation Study* (July 1970), Appendix B/Annex N, "Comments on MACVSOG's Operations and Intelligence," Tab H, p. 39.

51. Oral history interview conducted by author with Dr. John Hada. In *MACVSOG: Oral History Interviews with Officers Who Served in MACVSOG OP 34 (Agent Operations Against North Vietnam)*, p. 46.

52. Oral history interview conducted by author with General Robert Kingston. In *MACVSOG: Oral History Interviews with Officers Who Served in MACVSOG OP 34 (Agent Operations Against North Vietnam)*, p. 53.

53. Ibid.

54. Ibid., p. 59.

55. Ibid., p. 63.

56. Ibid., p. 64.

57. Ibid., p. 63.

58. Ibid., p. 59.

59. Oral history interview conducted by author with Lieutenant Colonel Robert McKnight. In *MACVSOG: Oral History Interviews with Officers Who Served in MACVSOG OP 34 (Agent Operations Against North Vietnam)*, p. 102.

60. Ibid.

61. Masterman, *The Double Cross System in the War of 1939 to 1945*, p. 3.

62. Ibid., p. 8.

63. Ibid.

64. Ibid.

65. Barton Whaley, "Toward a General Theory of Deception," *Journal of Strategic Studies* (March 1982), p. 180. Whaley argues that "all deceptions occur inside the brain of the person deceived. They take place in the proverbial eye of the beholder; we are not deceived by others, we only deceive ourselves—the deceiver only intending and attempting to induce deception. He contrives and projects a false picture of reality; but to be deceived, we must both perceive this attempted portrayal and accept it in more-or-less the terms intended and projected." Donald Daniel and Katherine Herbig, "Propositions on Military Deception," *Journal of Strategic Studies* (March 1982), pp. 155–57. Daniel and Herbig explain that "deception is the deliberate misrepresentation of reality" by the deceiver "to gain a competitive advantage." To be successful, the deceiver must initiate a process that involves "decision makers, planners, and implementers." In developing and implementing a deception plan, three goals need to be met: "the immediate aim is to condition a target's beliefs; the intermediate aim is to influence his actions; and the ultimate aim is for the deceiver to benefit from the target's actions."

66. JCS, *MACVSOG Documentation Study* (July 1970), Appendix C/Annex B, "Airborne Operations," p. 3.

67. JCS, *MACVSOG Documentation Study* (July 1970), Appendix B/Annex N, "Comments on MACVSOG's Operations and Intelligence," Tab A, p. 5.

68. Richard Ulack and Gyula Pauer, *Atlas of Southeast Asia* (London: Macmillan, 1989), p. 132.

69. Oral history interview conducted by author with Major General Edward Partain. In *MACVSOG: Oral History Interviews with Officers Who Served in MACVSOG OP 34 (Agent Operations Against North Vietnam)*, pp. 23, 25.

70. Ibid., p. 25.

71. JCS, *MACVSOG Documentation Study* (July 1970), Appendix B/Annex N, "Comments on MACVSOG's Operations and Intelligence," Tab A, p. 7.

72. Ibid., Tab E, p. 22.

73. Ibid.

74. Ibid.

75. Ibid., p. 23.

76. Oral history interview conducted by author with Brigadier General Donald Blackburn. In *MACVSOG: Oral History Interviews with Chiefs of SOG* (Medford, Mass.: Fletcher School of Law and Diplomacy, International Security Studies Program, 1996), p. 11.

77. Ibid., pp. 10, 13.

78. JCS, *MACVSOG Documentation Study* (July 1970), Appendix C/Annex B, "Airborne Operations," p. 2.

79. Oral history interview conducted by author with Brigadier General Donald Blackburn. In *MACVSOG: Oral History Interviews with Chiefs of SOG*, p. 14.

80. Oral history interview conducted by author with Major General John K. Singlaub. In *MACVSOG: Oral History Interviews with Chiefs of SOG*, p. 44.

81. JCS, *MACVSOG Documentation Study* (July 1970), Appendix B/Annex N, "Comments on MACVSOG's Operations and Intelligence," Tab K, pp. 60–61.

82. Ibid., p. 64.

83. JCS, *MACVSOG Documentation Study* (July 1970), Appendix C/Annex A, "Psychological Operations," p. 137.

84. Oral history interview conducted by author with Major General John K. Singlaub. In *MACVSOG: Oral History Interviews with Chiefs of SOG*, p. 49.

85. JCS, *MACVSOG Documentation Study* (July 1970), Appendix C/Annex B, "Airborne Operations," p. 4.

86. Ibid., p. 4.

87. JCS, *MACVSOG Documentation Study* (July 1970), Appendix B/Annex N, "Comments on MACVSOG's Operations and Intelligence," Tab K, p. 65.

88. Oral history interview conducted by author with Dr. John Hada. In *MACVSOG: Oral History Interviews with Officers Who Served in MACVSOG OP 34 (Agent Operations Against North Vietnam)*, pp. 40, 48.

89. JCS, *MACVSOG Documentation Study* (July 1970), Appendix B/Annex N, "Comments on MACVSOG's Operations and Intelligence," Tab F, p. 32.

90. Ibid., Tab K, p. 54.

91. Ibid.

92. JCS, *MACVSOG Documentation Study* (July 1970), Appendix C, "MACVSOG Operations Against North Vietnam," p. 59.

93. JCS, *MACVSOG Documentation Study* (July 1970), Appendix B/Annex N, "Comments on MACVSOG's Operations and Intelligence," Tab J, p. 50.

94. Oral history interview conducted by author with Major General Edward Partain. In *MACVSOG: Oral History Interviews with Officers Who Served in MACVSOG OP 34 (Agent Operations Against North Vietnam)*, p. 25.

95. Ibid.

96. Oral history interview conducted by author with Lieutenant Colonel Ernest "Pete" Hayes. In *MACVSOG: Oral History Interviews with Officers Who Served in MACVSOG OP 35 (Clandestine Operations in Laos and Cambodia Against the Ho Chi Minh Trail)*, p. 171.

97. Ibid., p. 182.

98. Oral history interview conducted by author with Dr. John Hada. In *MACVSOG: Oral History Interviews with Officers Who Served in MACVSOG OP 34 (Agent Operations Against North Vietnam)*, p. 48.

99. Ibid., p. 40.

100. JCS, *MACVSOG Documentation Study* (July 1970), Appendix B/Annex N, "Comments on MACVSOG's Operations and Intelligence," Tab A, p. 8.

101. Ibid.

102. JCS, *MACVSOG Documentation Study* (July 1970), Appendix C/Annex B, "Airborne Operations," p. 15.

103. Oral history interview conducted by author with Major General Edward Partain. In *MACVSOG: Oral History Interviews with Officers Who Served in MACVSOG OP 34 (Agent Operations Against North Vietnam)*, p. 29.

104. Ibid., p. 34.

105. Ibid., pp. 24, 29.

106. Oral history interview conducted by author with Lieutenant Colonel Ernest "Pete" Hayes. In *MACVSOG: Oral History Interviews with Officers Who Served in MACVSOG OP 35 (Clandestine Operations in Laos and Cambodia Against the Ho Chi Minh Trail)*, p. 190.

107. JCS, *MACVSOG Documentation Study* (July 1970), Appendix C/Annex B, "Airborne Operations," p. 16.

108. Oral history interview conducted by author with Dr. John Hada. In *MACVSOG: Oral History Interviews with Officers Who Served in MACVSOG OP 34 (Agent Operations Against North Vietnam)*, p. 41.

109. Ibid., p. 42.

110. Ibid., p. 43.

111. Oral history interview conducted by author with General Robert Kingston. In *MACVSOG: Oral History Interviews with Officers Who Served in MACVSOG OP 34 (Agent Operations Against North Vietnam)*, p. 70.

112. Oral history interview conducted by author with Major General Edward Partain. In *MACVSOG: Oral History Interviews with Officers Who Served in MACVSOG OP 34 (Agent Operations Against North Vietnam)*, p. 30.

113. JCS, *MACVSOG Documentation Study* (July 1970), Appendix C/Annex B, "Airborne Operations," p. 28.

114. Ibid., p. 29.

115. Ibid.

116. Dziak, *Chekisty: A History of the KGB*, pp. 1–2.

117. Ibid., p. 3.

118. Ibid., p. 1.

119. Oral history interview conducted by author with William Colby. In *MACVSOG: Oral History Interviews with Officers Who Served in MACVSOG OP 34 (Agent Operations Against North Vietnam)*, p. 9.

120. Cited in *Area Handbook for North Vietnam* (Washington, D.C.: U.S. Government Printing Office, June 1967), p. 388.

121. JCS, *MACVSOG Documentation Study* (July 1970), Appendix C/Annex B, "Airborne Operations," p. 64.

122. JCS, *MACVSOG Documentation Study* (July 1970), Appendix C, "MACVSOG Operations Against North Vietnam," p. 63.

123. JCS, *MACVSOG Documentation Study* (July 1970), Appendix B/Annex N, "Comments on MACVSOG's Operations and Intelligence," Tab K, p. 69.

124. MACVSOG, *Command History 1969*, Annex F, p. IX–1.

125. JCS, *MACVSOG Documentation Study* (July 1970), Appendix C/Annex B, "Airborne Operations," p. 85.

126. Ibid.

127. Ibid., p. 7.

128. MACVSOG, *Command History 1969*, Annex F, pp. IX–1–2.

129. Oral history interview conducted by author with General Robert Kingston. In *MACVSOG: Oral History Interviews with Officers Who Served in MACVSOG OP 34 (Agent Operations Against North Vietnam)*, p. 58.

130. Ibid., pp. 68–69.

131. Oral history interview conducted by author with Lieutenant Colonel Robert McKnight. In *MACVSOG: Oral History Interviews with Officers Who Served in MACVSOG OP 34 (Agent Operations Against North Vietnam)*, p. 117.

132. Ibid., pp. 118–19.

133. Oral history interview conducted by author with Lieutenant Colonel Berton Spivy. In *MACVSOG: Oral History Interviews with Officers Who Served in MACVSOG OP 34 (Agent Operations Against North Vietnam)*, p. 162.

134. Ibid., p, 165.

135. MACVSOG, *Command History 1969*, Annex F, p. IX–4.

136. Oral history interview conducted by author with Lieutenant Colonel Berton Spivy. In *MACVSOG: Oral History Interviews with Officers Who Served in MACVSOG OP 34 (Agent Operations Against North Vietnam)*, p. 165.

137. Oral history interview conducted by author with Colonel Stephen E. Cavanaugh. In *MACVSOG: Oral History Interviews with Chiefs of SOG*, p. 95.

138. Oral history interview conducted by author with Lieutenant Colonel Berton Spivy. In *MACVSOG: Oral History Interviews with Officers Who Served in MACVSOG OP 34 (Agent Operations Against North Vietnam)*, p. 166.

139. Ibid.

140. MACVSOG, *Command History 1969*, Annex F, p. IX–3.

141. Plaster, *SOG: The Secret Wars of America's Commandos in Vietnam*, p. 228.

142. MACVSOG, *Command History 1969*, Annex F, p. IX–4.

143. Oral history interview conducted by author with Lieutenant Colonel C. P. Tamaraz. In *MACVSOG: Oral History Interviews with Officers Who Served in MACVSOG OP 34 (Agent Operations Against North Vietnam)*, pp. 153–54.

144. Oral history interview conducted by author with Lieutenant Colonel Berton Spivy. In *MACVSOG: Oral History Interviews with Officers Who Served in MACVSOG OP 34 (Agent Operations Against North Vietnam)*, p. 166.

145. JCS, *MACVSOG Documentation Study* (July 1970), Appendix C/Annex B, "Airborne Operations," p. 87.

146. Oral history interview conducted by author with Lieutenant Colonel Robert McKnight. In *MACVSOG: Oral History Interviews with Officers Who Served in MACVSOG OP 34 (Agent Operations Against North Vietnam)*, p. 116.

147. Ibid.

148. JCS, *MACVSOG Documentation Study* (July 1970), Appendix C/Annex B, "Airborne Operations," p. 84.

149. Oral history interview conducted by author with Lieutenant Colonel Berton Spivy. In *MACVSOG: Oral History Interviews with Officers Who Served in MACVSOG OP 34 (Agent Operations Against North Vietnam)*, p. 167.

150. MACVSOG, *Command History 1969*, Annex F, pp. IX–1–3.

151. Ibid.

152. MACVSOG, *Command History 1970*, Annex B, pp. IX–2.

153. JCS, *MACVSOG Documentation Study* (July 1970), Appendix C/Annex B, "Airborne Operations," p. 6.

154. Ibid.

155. This map was produced by John Plaster and provided to the author for use in this study.

156. Oral history interview conducted by author with Brigadier General George Gaspard. In *MACVSOG: Oral History Interviews with Officers Who Served in MACVSOG OP 34 (Agent Operations Against North Vietnam)*, p. 129.

157. Ibid., p. 125.

158. JCS, *MACVSOG Documentation Study* (July 1970), Appendix C/Annex B, "Airborne Operations," pp. 62–84.

159. Oral history interview conducted by author with Brigadier General George Gaspard. In *MACVSOG: Oral History Interviews with Officers Who Served in MACVSOG OP 34 (Agent Operations Against North Vietnam)*, p. 131.

160. Ibid.

161. Ibid.

162. JCS, *MACVSOG Documentation Study* (July 1970), Appendix C/Annex A, "Psychological Operations," p. 90.

163. Ibid.

164. Ibid.

165. Oral history interview conducted by author with Colonel Stephen E. Cavanaugh. In *MACVSOG: Oral History Interviews with Chiefs of SOG*, p. 89.

166. JCS, *MACVSOG Documentation Study* (July 1970), Appendix C/Annex A, "Psychological Operations," p. 110.

167. George C. Herring, *LBJ and Vietnam* (Austin, Texas: University of Texas Press, 1994), p. 172.

168. "Security Veterans Discuss Wartime Counterespionage," FBIS-EAS–95–177 (September 13, 1995), p. 70.

169. Not-for-attribution discussions with a security officer of the DRV in Hanoi (March 1997).

CHAPTER FOUR

1. Oral history interview conducted by author with William Colby in *MACVSOG: Oral History Interviews with Officers Who Served in MACVSOG OP 34 (Agent Operations Against North Vietnam)*, p. 9.

2. Ibid., p. 7.

3. Ibid., p. 13.

4. Ranelagh, *The Agency*, p. 216.

5. Oral history interview conducted by author with Herbert Weisshart. In *MACVSOG: Oral History Interviews with Officers Who Served in MACVSOG OP 39 (Psychological Operations)* (Medford, Mass.: Fletcher School of Law and Diplomacy, International Security Studies Program, July 1997), p. 10.

6. Ibid., p. 12.

7. Ibid., p. 15.

8. Oral history interview conducted by author with Lieutenant Colonel John Harrell. In *MACVSOG: Oral History Interviews with Officers Who Served in MACVSOG OP 39 (Psychological Operations)*, p. 39.

9. Oral history interview conducted by author with Lieutenant Colonel John Hardaway. In *MACVSOG: Oral History Interviews with Officers Who Served in MACVSOG OP 39 (Psychological Operations)*, pp. 66–67.

10. Ibid., p. 69.

11. JCS, *MACVSOG Documentation Study* (July 1970), Appendix B/Pt. V, "Military Assistance Command Studies and Observation Group and the Strategic Technical Directorate: Inception, Organization, Evolution," pp. 269–71.

12. Ibid., p. 272.

13. Interview with Ted Shackley at the Kenwood Country Club, Bethesda, Md., April 23, 1998.

14. Oral history interview conducted by author with Phil Adams. In *MACVSOG: Oral History Interviews with Officers Who Served in MACVSOG OP 39 (Psychological Operations)*, p. 106.

15. Oral history interview conducted by author with Herbert Weisshart. In *MACVSOG: Oral History Interviews with Officers Who Served in MACVSOG OP 39 (Psychological Operations)*, p. 9.

16. Author's notes from an interview with Lieutenant Colonel Al Mathwin in the Pentagon (July 1996).

17. Bowen retired from the Army in 1978 as a brigadier general, his last assignment being the chief of staff of the Sixth Army.

18. Oral history interview conducted by author with Lieutenant Colonel John Harrell. In *MACVSOG: Oral History Interviews with Officers Who Served in MACVSOG OP 39 (Psychological Operations)*, p. 41.

19. Ibid., p. 44.

20. Oral history interview conducted by author with Lieutenant Colonel John Hardaway. In *MACVSOG: Oral History Interviews with Officers Who Served in MACVSOG OP 39 (Psychological Operations)*, p. 63.

21. Oral history interview conducted by author with Phil Adams. In *MACVSOG: Oral History Interviews with Officers Who Served in MACVSOG OP 39 (Psychological Operations)*, p. 102.

22. Oral history interview conducted by author with Lieutenant Colonel Richard Holzheimer. In *MACVSOG: Oral History Interviews with Officers Who Served in MACVSOG OP 39 (Psychological Operations)*, p. 89.

23. Oral history interview conducted by author with Herbert Weisshart. In *MACVSOG: Oral History Interviews with Officers Who Served in MACVSOG OP 39 (Psychological Operations)*, p. 27.

24. Ibid.

25. Oscar Chapuis, *A History of Vietnam: From Hong Bang to Tu Duc* (Westport, Conn.: Greenwood Press, 1995), p. 101.

26. In the final showdown with the Chinese in 1427, he again proved innovative in warfare. This time, he employed elephants against Ming forces, who, although superior in number, could not maneuver because of the muddy conditions they found themselves in. The Chinese were not prepared to conduct operations in this setting. Having defeated the Chinese army, Le Loi allowed the Chinese generals to leave Vietnam while saving face.

27. JCS, *MACVSOG Documentation Study* (July 1970), Appendix C/Annex A, "Psychological Operations," pp. 14–20.

28. Ibid., p. 14.

29. Ibid., p. 15.

30. Ibid., p. 14.

31. MACVSOG, *Command History 1971–1972*, Annex B, p. B–13–10. The original document was photographed by John Plaster and provided to the author for use in this study.

32. Ibid.

33. This map was produced by John Plaster and provided to the author for use in this study.

34. Ibid., p. 77.

35. Oral history interview conducted by author with Lieutenant Colonel Roger McElroy. In *MACVSOG: Oral History Interviews with Officers Who Served in MACVSOG OP 39 (Psychological Operations)*, p. 150.

36. Ibid., p. 153.

37. Oral history interview conducted by author with Brigadier General Donald Blackburn. In *MACVSOG: Oral History Interviews with Chiefs of SOG* (Medford, Mass.: Fletcher School of Law and Diplomacy, International Security Studies Program, 1996), p. 12.

38. Ibid., p. 72.

39. Oral history interview conducted by author with Major General John K. Singlaub. In *MACVSOG: Oral History Interviews with Chiefs of SOG*, p. 52.

40. The number of detainees taken through the program during 1965–1968 are as follows: 1965, 126; 1966, 353; 1967, 328; and 1968, 185. JCS, *MACVSOG Documentation Study* (July 1970), Appendix C/Annex D, "Maritime Operations," p. 58.

41. JCS, *MACVSOG Documentation Study* (July 1970). Appendix C/Annex A, "Psychological Operations," p. 74.

42. Ibid., pp. 74–75. Another proposed manipulation of detainees was turned down. This involved "insertion of an NVN fisherman under controlled narcosis, into the mountain area of North Vietnam near the Laos border. This operation would create the illusion of SSPL secret zones existing in regions away from the coast."

43. Ibid., p. 18.

44. Ibid., p. 20.

45. Oral history interview conducted by author with Lieutenant Colonel Bob Andrews. In *MACVSOG: Oral History Interviews with Officers Who Served in MACVSOG OP 39 (Psychological Operations)*, p. 118.

46. Paradise Island was shut down in 1969, as a result of the concessions the Johnson administration made to Hanoi in order to start peace talks. Recall that these included accession to Hanoi's demand of unconditional cessation of the bombing and "all other acts of war" directed against the Democratic Republic of Vietnam. This included the demand that Washington end its covert operations inside the Democratic Republic of Vietnam. Johnson complied and halted all MACVSOG operations that involved physically crossing the North Vietnamese border.

47. Godson, *Dirty Tricks or Trump Cards*, p. 152.

48. MACVSOG, *Command History 1970*, Annex B, p. XI–1–3. In 1968, this included broadcasts in Vietnamese (7,300 hours), Cantonese (2,190 hours), Mandarin (730 hours), French (182.5 hours), and English (182.5 hours).

49. JCS, *MACVSOG Documentation Study* (July 1970), Appendix C/Annex A, "Psychological Operations," p. 65.

50. Oral history interview conducted by author with Phil Adams. In *MACVSOG: Oral History Interviews with Officers Who Served in MACVSOG OP 39 (Psychological Operations)*, p. 97.

51. Ibid., pp. 93–94.

52. Ibid., pp. 98–99.

53. JCS, *MACVSOG Documentation Study* (July 1970), Appendix C/Annex A, "Psychological Operations," p. 66.

54. Godson, *Dirty Tricks or Trump Cards*, p. 152.

55. JCS, *MACVSOG Documentation Study* (July 1970), Appendix C/Annex A, "Psychological Operations," p. 66.

56. Oral history interview conducted by author with Herbert Weisshart. In *MACVSOG: Oral History Interviews with Officers Who Served in MACVSOG OP 39 (Psychological Operations)*, p. 30.

57. Plaster, *SOG: The Secret Wars of America's Commandos in Vietnam*, chapter 7.

58. Godson, *Dirty Tricks or Trump Cards*, p. 152.

59. Photograph produced by John Plaster and provided to the author for use in this study.

60. MACVSOG, *Command History 1971–1972*, Annex B, p. B–3–14.

61. Oral history interview conducted by author with Herbert Weisshart. In *MACVSOG: Oral History Interviews with Officers Who Served in MACVSOG OP 39 (Psychological Operations)*, p. 19.

62. Ibid., pp. 22, 32.

63. MACVSOG, *Command History, 1971–1972*, Annex B, p. B–13–6. The original document was photographed by John Plaster and provided to the author for this study.

64. Oral history interview conducted by author with Lieutenant Colonel John Hardaway in *MACVSOG: Oral History Interviews with Officers Who Served in MACVSOG OP 39 (Psychological Operations)*, p. 65.

65. Oral history interview conducted by author with Herbert Weisshart. In *MACVSOG: Oral History Interviews with Officers Who Served in MACVSOG OP 39 (Psychological Operations)*, p. 19.

66. Plaster, *SOG: The Secret Wars of America's Commandos in Vietnam*, chapter 7.

67. Godson, *Dirty Tricks or Trump Cards*, p. 155.

68. MACVSOG, *Command History 1971–1972*, Annex B, p. B–13–7.

69. Ibid., p. B–13–6.

70. Ibid., p. B–13–7.

71. Ibid.

72. Oral history interview conducted by author with Lieutenant Colonel Bob Andrews. In *MACVSOG: Oral History Interviews with Officers Who Served in MACVSOG OP 39 (Psychological Operations)*, p. 121.

73. MACVSOG, *Command History 1971–1972, Annex B, p. B–13–7*.

74. Ibid., p. B–13–12.

75. Ibid.

76. Oral history interview conducted by author with Major General John K. Singlaub. In *MACVSOG: Oral History Interviews with Chiefs of SOG*, p. 55.

77. Photograph produced by John Plaster and provided to the author for use in this study.

78. Oral history interview conducted by author with Lieutenant Colonel Bob Andrews. In *MACVSOG: Oral History Interviews with Officers Who Served in MACVSOG OP 39 (Psychological Operations)*, p. 116.

79. Ibid.

80. Oral history interview conducted by author with William Rydell. In *MACVSOG: Oral History Interviews with Officers Who Served in MACVSOG OP 39 (Psychological Operations)*, p. 183.

81. MACVSOG, *Command History 1971–1972*, p. B–13–12.

82. Ibid., p. B–13–11. The original document was photographed by John Plaster and provided to the author for use in this study.

83. Oral history interview with Colonel Dan Schungel. In *MACVSOG: Oral History Interviews with Officers Who Served in MACVSOG OP 35 (Clandestine Operations in Laos and Cambodia Against the Ho Chi Minh Trail)* (Medford, Mass.: Fletcher School of Law and Diplomacy, International Security Studies Program, 1997), p. 212.

84. Plaster, *SOG: The Secret Wars of America's Commandos in Vietnam*, p. 130.

85. Oral history interview conducted by author with Lieutenant Colonel Bob Andrews. In *MACVSOG: Oral History Interviews with Officers Who Served in MACVSOG OP 39 (Psychological Operations)*, p. 122.

86. Oral history interview conducted by author with Brigadier General Donald Blackburn. In *MACVSOG: Oral History Interviews with Chiefs of SOG*, pp. 21–22.

87. JCS, *MACVSOG Documentation Study* (July 1970), Appendix C/Annex A, "Psychological Operations," pp. 112–36.

88. Ibid.

89. "Evaluation of SOG," the Report of the Ad Hoc Evaluation Group (February 1968), pp. 8–9.

90. Author's notes from an interview with Lieutenant Colonel Al Mathwin in the Pentagon (July 1996). Everyone interviewed who served in OP 39 told the same story. They were to disaffect the North Vietnamese population but not inspire it to commit acts of violence, let alone rebel.

91. Ranelagh, *The Agency*, pp. 302–09.

92. Oral history interview conducted by author with William Rydell. In *MACVSOG: Oral History Interviews with Officers Who Served in MACVSOG OP 39 (Psychological Operations)*, pp. 188–89, 194.

93. Ibid., p. 196.

94. Oral history interview conducted by author with Lieutenant Colonel Bob Andrews. In *MACVSOG: Oral History Interviews with Officers Who Served in MACVSOG OP 39 (Psychological Operations)*, p. 118.

95. Oral history interview conducted by author with Phil Adams. In *MACVSOG: Oral History Interviews with Officers Who Served in MACVSOG OP 39 (Psychological Operations)*, p. 97.

96. Ibid., p. 96.

97. Ibid., p. 101.

98. Oral history interview conducted by author with Lieutenant Colonel John Harrell. In *MACVSOG: Oral History Interviews with Officers Who Served in MACVSOG OP 39 (Psychological Operations)*, p. 52.

99. Oral history interview conducted by author with Lieutenant Colonel Richard Holzheimer. In *MACVSOG: Oral History Interviews with Officers Who Served in MACVSOG OP 39 (Psychological Operations)*, p. 90.

100. Oral history interview conducted by author with Lieutenant Colonel Derek Theissen. In *MACVSOG: Oral History Interviews with Officers Who Served in MACVSOG OP 39 (Psychological Operations)*, p. 177.

101. Oral history interview conducted by author with William Rydell. In *MACVSOG: Oral History Interviews with Officers Who Served in MACVSOG OP 39 (Psychological Operations)*, p. 196.

102. "Smash the American Imperialists' Psychological Warfare," *Nhan Dan* (September 7, 1965), trans. in *Joint Publications Research Service* (hereafter cites as *JPRS*), 32, 194, September 30, 1965, p. 1.

103. "Let Us Destroy the U.S. Imperialists' Espionage and Psychological Warfare," *Lao Dong* (September 14, 1965), trans. in *JPRS*, 32, 470, October 20, 1965, p. 1.

104. "Be Determined to Defeat U.S. Imperialists' Psychological Warfare," *Hoc Tap* (September 1967), trans. in *JPRS*, 43, 667, October 1967, p. 55.

105. "Defeat U.S. Intelligence Schemes," *Tuyen Huan* (April 1968), trans. in *JPRS*, 45, 522, p. 37.

106. "Be Determined to Defeat U.S. Imperialists' Psychological Warfare," p. 57.

107. "Enemy Commando Team Defeated on "Don Pu Peak," *Quan Doi Nhan Dan* (September 1968), trans. in *JPRS*, 47, 092, December 1968, p. 10.

108. "Enemy Spy Surrenders to NVN Authorities," *Nhan Dan* (August 24, 1968), trans. in *JPRS*, 46, 669, October 1968, p. 8.

109. "Educate the Masses to Defeat the Enemy's Psychological Warfare," *Tuyen Huan* (June 1968), trans. in *JPRS*, 42, 016, July 1968, p. 46.

110. "Understand and Carry Out the Laws on Punishing Counterrevolutionary Crimes," *Nhan Dan* (March 26, 1968), trans. in *JPRS*, 45, 296, May 1968, pp. 72–73.

111. "Decree on Counterrevolutionary Crimes," *Hoc Tap* (April 1968), trans. in *JPRS*, 45, 611, June 1968, pp. 103–10.

112. "Tighten the Socialist Legal Order Against Counter-Revolutionaries," *Nhan Dan* (March 24, 1968), trans. in *JPRS*, 45, 288, May 1968, p. 49.

113. Oral history interview conducted by author with Lieutenant Colonel Bob Andrews. In *MACVSOG: Oral History Interviews with Officers Who Served in MACVSOG OP 39 (Psychological Operations)*, p. 118.

CHAPTER FIVE

1. Marolda and Fitzgerald, *The United States Navy and the Vietnam Conflict*, p. 203.

2. Ibid., p. 201.

3. Ibid., p. 202.

4. JCS, *MACVSOG Documentation Study* (July 1970), Appendix C/Annex D, "Maritime Operations," p. 1.

5. Ibid.

6. Marolda and Fitzgerald, *The United States Navy and the Vietnam Conflict*, p. 203.

7. Interview with retired Navy Captain William Murray, New London, Conn. (October 5, 1997). During 1964–1966, Murray served in the Special Operations Division of the Office of the Special Assistant for Counterinsurgency and Special Activities (SACSA). As we will discuss in chapter Seven, the SACSA had oversight responsibility of MACVSOG for the Joint Chiefs of Staff. Murray handled SOG's marops at the Department of Defense level.

8. Marolda and Fitzgerald, *The United States Navy and the Vietnam Conflict*, p. 204.

9. Ibid.

10. Ibid., p. 205.

11. Ibid., p. 206.

12. McNamara, *In Retrospect: The Tragedy and Lessons of Vietnam*, p. 103.

13. Marolda and Fitzgerald, *The United States Navy and the Vietnam Conflict*, p. 337.

14. Ibid.

15. JCS, *MACVSOG Documentation Study* (July 1970), Appendix C/Annex D, "Maritime Operations," p. 3.

16. T. L. Bosiljevac, *SEAL: UDT/SEAL Operations in Vietnam* (Boulder, Colo.: Paladin Press, 1990), p. 40.

17. Ibid.

18. Oral history interview conducted by author with Lieutenant General Mick Trainor. In *MACVSOG: Oral History Interviews with Officers Who Served in MACVSOG OP 37 (Maritime Operations Against North Vietnam)* (Medford, Mass.: Fletcher School of Law and Diplomacy, International Security Studies Program, 1997), p. 39.

19. Oral history interview conducted by author with Captain Norman Olson. In *MACVSOG: Oral History Interviews with Officers Who Served in MACVSOG OP 37 (Maritime Operations Against North Vietnam)*, p. 127.

20. Oral history interview conducted by author with Commander Andrew Merget. In *MACVSOG: Oral History Interviews with Officers Who Served in MACVSOG OP 37 (Maritime Operations Against North Vietnam)*, p. 200.

21. Oral history interview conducted by author with Lieutenant General Mick Trainor. In *MACVSOG: Oral History Interviews with Officers Who Served in MACVSOG OP 37 (Maritime Operations Against North Vietnam)*, p. 39.

22. Oral history interview conducted by author with General Wesley Rice. In *MACVSOG: Oral History Interviews with Officers Who Served in MACVSOG OP 37 (Maritime Operations Against North Vietnam)*, p. 160.

23. JCS, *MACVSOG Documentation Study* (July 1970), Appendix C/Annex D, "Maritime Operations," p. 24.

24. Ibid., p. 13.

25. Marolda and Fitzgerald, *The United States Navy and the Vietnam Conflict*, p. 439. Photo courtesy of the Naval Historical Center.

26. Ibid., p. 21.

27. Ibid., p. 16.

28. Ibid., p. 16.

29. Ibid., p. 17.

30. Ibid., p. 22.

31. Ibid., p. 25.

32. Oral history interview conducted by author with Lieutenant Colonel James Munson. In *MACVSOG: Oral History Interviews with Officers Who Served in MACVSOG OP 37 (Maritime Operations Against North Vietnam)*, p. 20.

33. Ibid., p. 18.

34. Oral history interview conducted by author with Lieutenant General Mick Trainor. In *MACVSOG: Oral History Interviews with Officers Who Served in MACVSOG OP 37 (Maritime Operations Against North Vietnam)*, p. 48.

35. Oral history interview conducted by author with Captain Norman Olson.

In *MACVSOG: Oral History Interviews with Officers Who Served in MACVSOG OP 37 (Maritime Operations Against North Vietnam)*, p. 138.

36. JCS, *MACVSOG Documentation Study* (July 1970), Appendix C/Annex D, "Maritime Operations," p. 26.

37. Ibid., p. 27.

38. Ibid., p. 7.

39. Ibid., p. 8.

40. Ibid., p. 10.

41. Ibid., p. 35.

42. Marolda and Fitzgerald, *The United States Navy and the Vietnam Conflict*, p. 341.

43. JCS, *MACVSOG Documentation Study* (July 1970), Appendix C/Annex D, "Maritime Operations," p. 36.

44. Marolda and Fitzgerald, *The United States Navy and the Vietnam Conflict*, p. 342.

45. Oral history interview conducted by author with Lieutenant Colonel James Munson. In *MACVSOG: Oral History Interviews with Officers Who Served in MACVSOG OP 37 (Maritime Operations Against North Vietnam)*, p. 28.

46. Ibid.

47. JCS, *MACVSOG Documentation Study* (July 1970), Appendix C/Annex D, "Maritime Operations," p. 37.

48. Marolda and Fitzgerald, *The United States Navy and the Vietnam Conflict*, p. 395.

49. Ibid., p. 398.

50. Ibid., p. 407.

51. JCS, *MACVSOG Documentation Study* (July 1970), Appendix C/Annex D, "Maritime Operations," p. 37.

52. Marolda and Fitzgerald, *The United States Navy and the Vietnam Conflict*, p. 409.

53. Ibid., p. 38.

54. JCS, *MACVSOG Documentation Study* (July 1970), Appendix C/Annex D, "Maritime Operations," p. 38.

55. Ibid.

56. Ibid.

57. Ibid., p. 39.

58. Ibid., p. 42.

59. Oral history interview conducted by author with Lieutenant General Mick Trainor. In *MACVSOG: Oral History Interviews with Officers Who Served in MACVSOG OP 37 (Maritime Operations Against North Vietnam)*, pp. 51–2, 57.

60. Ibid., p. 54.

61. Ibid., p. 56.

62. JCS, *MACVSOG Documentation Study* (July 1970), Appendix C/Annex D, "Maritime Operations," p. 44.

63. MACVSOG, *Command History 1966*, Annex M, p. 34.

64. Ibid., p. 32.

65. JCS, *MACVSOG Documentation Study* (July 1970), Appendix C/Annex D, "Maritime Operations," p. 46.

66. Ibid., p. 44.

67. Ibid.

68. Oral history interview conducted by author with Lieutenant General Mick Trainor. In *MACVSOG: Oral History Interviews with Officers Who Served in MACVSOG OP 37 (Maritime Operations Against North Vietnam)*, p. 47.

69. Oral history interview conducted by author with Lieutenant Colonel Pat Carothers. In *MACVSOG: Oral History Interviews with Officers Who Served in MACVSOG OP 37 (Maritime Operations Against North Vietnam)*, p. 85.

70. Ibid., p. 98.

71. Oral history interview conducted by author with Commander Bob Terry. In *MACVSOG: Oral History Interviews with Officers Who Served in MACVSOG OP 37 (Maritime Operations Against North Vietnam)*, p. 104.

72. Ibid., pp. 106–07.

73. Ibid., p. 116.

74. JCS, *MACVSOG Documentation Study* (July 1970), Appendix C/Annex D, "Maritime Operations," p. 47.

75. MACVSOG, *Command History 1967*, Annex G, p. III–1–2.

76. As noted earlier, Olson was the "real deal" in terms of the kind of experience and leadership the NAD should have had all along in its commanding officer. He had the right background. Following Vietnam, Olson stayed in the special warfare business and finished his Navy career as the first chief of staff of Joint Special Operations Command (Delta Force), which was formed after the ill-fated mission to rescue U.S. hostages in Iran in 1980. JSOC became the Department of Defense's elite counterterrorist force. Olson played a central role in its development.

77. Oral history interview conducted by author with Captain Norman Olson. In *MACVSOG: Oral History Interviews with Officers Who Served in MACVSOG OP 37 (Maritime Operations Against North Vietnam)*, p. 150.

78. Ibid., p. 133.

79. Oral history interview conducted by author with Lieutenant Colonel Pat Carothers. In *MACVSOG: Oral History Interviews with Officers Who Served in MACVSOG OP 37 (Maritime Operations Against North Vietnam)*, p. 97.

80. Oral history interview conducted by author with Captain Norman Olson. In *MACVSOG: Oral History Interviews with Officers Who Served in MACVSOG OP 37 (Maritime Operations Against North Vietnam)*, p. 156.

81. JCS, *MACVSOG Documentation Study* (July 1970), Appendix C/Annex D, "Maritime Operations," p. 52.

82. MACVSOG, *Command History 1968*, Annex F, p. F–III–1–A–1.

83. Oral history interview conducted by author with Captain Norman Olson. In *MACVSOG: Oral History Interviews with Officers Who Served in MACVSOG OP 37 (Maritime Operations Against North Vietnam)*, p. 128.

84. Ibid., pp. 128–29.

85. Ibid., p. 18.

86. Ibid.

87. Ibid., p. 5.

88. Ibid., p. 3.

89. MACVSOG, *Command History 1968*, Annex F, p. F-III–1–5.

90. Ibid.

91. Ibid., p. F-III-E–1.

92. See William Colby, *Lost Victory* (New York: Contemporary Books, 1968) and Dale Andrade, *Ashes to Ashes: The Phoenix Program and the Vietnam War* (Lexington, Mass.: Lexington Books, 1990).

93. MACVSOG, *Command History 1968*, Annex F, p. F-III–1–2.

94. Ibid., p. F-III–1–3.

95. MACVSOG, *Command History 1969*, Annex F, p. F-III–1–2.

96. Ibid., p. F-III–1-A/B/C–1.

97. MACVSOG, *Command History 1970*, Annex B, p. B-III–7.

Chapter Six

1. Lieutenant General Harold G. Moore and Joseph L. Galloway, *We Were Soldiers Once . . . And Young* (New York: Random House, 1992), p. xvii.

2. "How North Vietnam Won the War," *Wall Street Journal* (August 3, 1995).

3. Bam, "Opening the Trail," p. 15.

4. Bowman, ed., *The World Almanac of the Vietnam War*, p. 454.

5. JCS, *MACVSOG Documentation Study* (July 1970), Appendix D, "Cross-Border Operations in Laos," p. 2.

6. Newman, *JFK and Vietnam*, pp. 275–76.

7. JCS, *MACVSOG Documentation Study* (July 1970), Appendix B/Pt. I–IV, "Military Assistance Command Studies and Observation Group and the Strategic Technical Directorate: Inception, Organization, Evolution," p. 146.

8. *Foreign Relations of the United States, 1961–1963; Vietnam* (Washington, D.C.: U.S. Government Printing Office, 1991), vol. 4, pp. 699–700.

9. Ibid., p. 701.

10. Ibid., p. 741.

11. *FRUS, 1964–1968: Vietnam*, vol. 1, p. 867.

12. JCS, *MACVSOG Documentation Study* (July 1970), Appendix D, "Cross-Border Operations in Laos," p. 4.

13. Ibid.

14. *FRUS, 1964–1968: Vietnam*, vol. 1, p. 276.

15. JCS, *MACVSOG Documentation Study* (July 1970), Appendix D, "Cross-Border Operations in Laos," p. 6.

16. *FRUS, 1964–1968: Vietnam*, vol. 1, p. 215.

17. This map is drawn from Plaster, *SOG: The Secret Wars of America's Commandos in Vietnam*, p. 13.

18. JCS, *MACVSOG Documentation Study* (July 1970), Appendix D, "Cross-Border Operations in Laos," pp. 6–7.

19. Ibid., p. 8.

20. *FRUS, 1964–1968: Vietnam*, vol. 1, p. 872.

21. Cited in Karnow, *Vietnam: A History*, p. 395.

22. Oral history interview conducted by author with Lieutenant Colonel Raymond Call. In *MACVSOG: Oral History Interviews with Officers Who Served in MACVSOG OP 35 (Clandestine Operations in Laos and Cambodia Against the Ho Chi Minh Trail)*, pp. 8–9.

23. Halberstam, *The Best and the Brightest*, p. 512.

24. JCS, *MACVSOG Documentation Study* (July 1970), Appendix D, "Cross-Border Operations in Laos," p. 10.

25. Cited in Newman, *JFK and Vietnam*, p. 95.

26. JCS, *MACVSOG Documentation Study* (July 1970), Appendix D, "Cross-Border Operations in Laos," p. 12.

27. MACVSOG, *Command History 1966*, Annex M, p. 97.

28. Cited in Schemmer, *The Raid*, p. 80.

29. Oral history interview conducted by author with Lieutenant Colonel Raymond Call. In *MACVSOG: Oral History Interviews with Officers Who Served in MACVSOG OP 35 (Clandestine Operations in Laos and Cambodia Against the Ho Chi Minh Trail)*, pp. 26, 28.

30. Schemmer, *The Raid*, p. 48.

31. Oral history interview conducted by author with Lieutenant Colonel Raymond Call. In *MACVSOG: Oral History Interviews with Officers Who Served in MACVSOG OP 35 (Clandestine Operations in Laos and Cambodia Against the Ho Chi Minh Trail)*, pp. 9–10.

32. Ibid., p. 25.

33. Ibid., p. 6.

34. Ibid.

35. Ibid.

36. Oral history interview conducted by author with Major Charles Norton. In *MACVSOG: Oral History Interviews with Officers Who Served in MACVSOG OP 35 (Clandestine Operations in Laos and Cambodia Against the Ho Chi Minh Trail)*, p. 36.

37. Plaster, *SOG: The Secret Wars of America's Commandos in Vietnam*, p. 339.

38. The traditional tribal pattern of social organization characterized the Nung minority. Based on a highly patriarchal family system, tribal elements lived in closely knit territorial units.

39. Kevin Generous, "Irregular Forces in Vietnam," in Bowman, ed., *The World Almanac of the Vietnam War*, p. 445.

40. Oral history interview conducted by author with Lieutenant Colonel Raymond Call. In *MACVSOG: Oral History Interviews with Officers Who Served in MACVSOG OP 35 (Clandestine Operations in Laos and Cambodia Against the Ho Chi Minh Trail)*, p. 20.

41. The Montagnards consisted of several distinct tribal elements including the Jarai, Rhade, Sedang, and Bru. Each of these tribes had its own homeland region. For example, the Bru were located in the area just south of the 17th parallel. The Sedang lived south and east of Da Nang, while the Jarai and Rhade were located right in the central region of South Vietnam.

42. Quoted in Daniel S. Rogers, *The Montagnards and the Hmong: America's Ethnic Warriors in Indochina* (unpublished master's thesis, Fletcher School of Law and Diplomacy, Tufts University, 1997). This study has been very helpful for information on the Montagnards.

43. JCS, *MACVSOG Documentation Study* (July 1970), Appendix B/Pt. V, "Military Assistance Command Studies and Observation Group and the Strategic Technical Directorate: Inception, Organization, Evolution," p. 213.

44. The FOBs "were charged with providing administrative support, conduct-

ing advanced unit training, briefing, staging, infiltrating, exfiltrating and debriefing of reconnaissance teams and exploitation forces." Ibid.

45. According to SOG documents, each of these three detachments was "organized along battalion lines and consisted of: a headquarters element, a reconnaissance company, two reaction or exploitation companies, and a security company. The reconnaissance company is authorized 30 teams, each generally composed of three U.S. and nine indigenous personnel." Ibid., p. 211.

46. Ibid., pp. 211–12.

47. OP 35 established a training program for recon teams at Camp Long Thanh, which had been in operation for some time supporting the training needs of other divisions of SOG. According to the records, "When the concept for cross-border operations was approved, training techniques were initiated and facilities of the camp were modified or established as necessary to support training of reconnaissance teams and exploitation [reaction] forces." This two-month course of instruction included patrolling behind enemy lines, movement through jungle areas, radio communications, Morse code with the AN/GRC–109 radio, and survival training. Ibid., p. 212.

48. JCS, *MACVSOG Documentation Study* (July 1970), Appendix D, "Cross-Border Operations in Laos," p. 11.

49. Oral history interview conducted by author with Brigadier General Donald Blackburn. In *MACVSOG: Oral History Interviews with Chiefs of SOG*, pp. 16–17.

50. Ibid., p. 35.

51. Ibid., p. 17.

52. Ibid., p. 18.

53. Oral history interview conducted by author with Lieutenant Colonel Raymond Call. In *MACVSOG: Oral History Interviews with Officers Who Served in MACVSOG OP 35 (Clandestine Operations in Laos and Cambodia Against the Ho Chi Minh Trail)*, p. 10.

54. Ibid., pp. 13, 21.

55. MACVSOG, *Command History 1966*, Annex M, pp. 104–5.

56. George J. Veith, *Code-Name Bright Light: The Untold Story of U.S. POW Rescue Efforts During the Vietnam War* (New York: Free Press, 1998).

57. Oral history interview conducted by author with Brigadier General Donald Blackburn. In *MACVSOG: Oral History Interviews with Chiefs of SOG*, p. 31.

58. Oral history interview conducted by author with Major General John K. Singlaub. In *MACVSOG: Oral History Interviews with Chiefs of SOG*, p. 48.

59. Oral history interview conducted by author with Colonel Stephen E. Cavanaugh. In *MACVSOG: Oral History Interviews with Chiefs of SOG*, p. 88.

60. Ibid., p. 101.

61. Oral history interview conducted by author with Lieutenant Colonel Raymond Call. In *MACVSOG: Oral History Interviews with Officers Who Served in MACVSOG OP 35 (Clandestine Operations in Laos and Cambodia Against the Ho Chi Minh Trail)*, p. 14.

62. Ibid., p. 17.

63. Ibid., p. 18.

64. Ibid., p. 25.

65. JCS, *MACVSOG Documentation Study* (July 1970), Appendix D, "Cross-Border Operations in Laos," p. 16.

66. Quoted in *War in the Shadows* (Boston: Boston Publishing Company, 1988), p. 87.

67. JCS, *MACVSOG Documentation Study* (July 1970), Appendix D, "Cross-Border Operations in Laos," p. 17.

68. Ibid.

69. Oral history interview conducted by author with Lieutenant Colonel Raymond Call. In *MACVSOG: Oral History Interviews with Officers Who Served in MACVSOG OP 35 (Clandestine Operations in Laos and Cambodia Against the Ho Chi Minh Trail)*, p. 15.

70. JCS, *MACVSOG Documentation Study* (July 1970), Appendix D, "Cross-Border Operations in Laos," p. 18.

71. Ibid., p. 18.

72. MACVSOG, *Command History 1966*, Annex M, p. 97.

73. JCS, *MACVSOG Documentation Study* (July 1970), Appendix D, "Cross-Border Operations in Laos," p. 18.

74. Ibid., p. 19.

75. MACVSOG, *Command History 1966*, Annex M, p. 97.

76. Oral history interview conducted by author with Major Charles Norton. In *MACVSOG: Oral History Interviews with Officers Who Served in MACVSOG OP 35 (Clandestine Operations in Laos and Cambodia Against the Ho Chi Minh Trail)*, p. 56.

77. Ibid.

78. MACVSOG, *Command History 1966*, Annex M, p. 98.

79. This account was told to the author during one of the innumerable discussions the author had with John Plaster during the research and writing of this book.

80. JCS, *MACVSOG Documentation Study* (July 1970), Appendix D, "Cross-Border Operations in Laos," p. 24.

81. According to Ray Call, most of these larger operations "established a perimeter defense to secure a target while our people were putting charges in to destroy it" or "to secure landing zones to extract a team if we had to." Unlike the recon teams, which might stay in Laos for up to five days, Call noted, at no time did he ever have an exploitation force "on-site more than three or four hours. It was go in, get the job done and get out." Oral history interview conducted by author with Lieutenant Colonel Raymond Call. In *MACVSOG: Oral History Interviews with Officers Who Served in MACVSOG OP 35 (Clandestine Operations in Laos and Cambodia Against the Ho Chi Minh Trail)*, p. 30.

82. Ibid., p. 24.

83. JCS, *MACVSOG Documentation Study* (July 1970), Appendix D, "Cross-Border Operations in Laos," p. 26.

84. Ibid., p. 34.

85. Oral history interview conducted by author with Major Charles Norton. In *MACVSOG: Oral History Interviews with Officers Who Served in MACVSOG OP 35 (Clandestine Operations in Laos and Cambodia Against the Ho Chi Minh Trail)*, p. 50.

86. JCS, *MACVSOG Documentation Study* (July 1970), Appendix D, "Cross-Border Operations in Laos," p. 28.

87. MACVSOG, *Command History 1967*, Annex G, p. G-IV–1.

88. Ibid., p. G-IV–1.

89. Oral history interview conducted by author with Lieutenant Colonel

Jonathan Carney. In *MACVSOG: Oral History Interviews with Officers Who Served in MACVSOG OP 34 (Agent Operations Against North Vietnam)*, p. 85.

90. MACVSOG, *Command History 1967*, p. G-IV-5.

91. JCS, *MACVSOG Documentation Study* (July 1970), Appendix E, "Cross-Border Operations in Cambodia," p. 3.

92. Ibid., pp. 3–4.

93. Ibid., p. 1.

94. Ibid.

95. This map is drawn from Harry Summers, *Vietnam War Almanac* (New York: Facts on File Publications, 1985), p. 105.

96. JCS, *MACVSOG Documentation Study* (July 1970), Appendix E, "Cross-Border Operations in Cambodia," p. 10.

97. Ibid., p. 12.

98. Ibid., p. 13.

99. MACVSOG, *Command History 1967*, Annex G, p. G-IV-4.

100. JCS, *MACVSOG Documentation Study* (July 1970), Appendix D, "Cross-Border Operations in Laos," p. 39. According to this document, the number of wounded increased markedly. Indigenous casualties were escalating as well. Operations were also costly, according to one evaluation, in terms of the number of "air assets committed . . . particularly in helicopters where 20 have been lost [in 1967] and at least 51 damaged."

101. For full account of this mission see Plaster, *SOG: The Secret Wars of America's Commandos in Vietnam*, pp. 78–79.

102. The MACV report is contained in JCS, *MACVSOG Documentation Study* (July 1970), Appendix D, "Cross-Border Operations in Laos," pp. 38–39.

103. Cited in Philip Davidson, *Vietnam at War: The History, 1946–1975* (Novato, Calif.: Presidio Press, 1991), p. 486.

104. Plaster, *SOG: The Secret Wars of America's Commandos in Vietnam*, p. 80.

105. Oral history interview conducted by author with Lieutenant Colonel Raymond Call. In *MACVSOG: Oral History Interviews with Officers Who Served in MACVSOG OP 35 (Clandestine Operations in Laos and Cambodia Against the Ho Chi Minh Trail)*, p. 26.

106. Ibid.

107. Oral history interview conducted by author with Major Charles Norton. In *MACVSOG: Oral History Interviews with Officers Who Served in MACVSOG OP 35 (Clandestine Operations in Laos and Cambodia Against the Ho Chi Minh Trail)*, p. 50.

108. Oral history interview conducted by author with Major General John K. Singlaub. In *MACVSOG: Oral History Interviews with Chiefs of SOG*, p. 69.

109. This map was produced by John Plaster and provided to the author for use in this study.

110. Plaster, *SOG: The Secret Wars of America's Commandos in Vietnam*, p. 83.

111. Oral history interview conducted by author with Colonel Stephen E. Cavanaugh. In *MACVSOG: Oral History Interviews with Chiefs of SOG*, p. 99.

112. Douglas Pike, *PAVN: People's Army of Vietnam* (Novato, Calif.: Presidio Press, 1968), pp. 108–09.

113. Plaster, *SOG: The Secret Wars of America's Commandos in Vietnam*, p. 85.

114. Ibid., pp. 90–94.

115. Oral history interview conducted by author with Lieutenant Colonel Lawrence Trapp. In *MACVSOG: Oral History Interviews with Officers Who Served in MACVSOG OP 35 (Clandestine Operations in Laos and Cambodia Against the Ho Chi Minh Trail)*, p. 130.

116. Oral history interview conducted by author with Major General John K. Singlaub. In *MACVSOG: Oral History Interviews with Chiefs of SOG*, p. 70.

117. Oral history interview conducted by author with Lieutenant Colonel Lauren Overby. In *MACVSOG: Oral History Interviews with Officers Who Served in MACVSOG OP 35 (Clandestine Operations in Laos and Cambodia Against the Ho Chi Minh Trail)*, p. 110.

118. Ibid.

119. Ibid., p. 103.

120. Interview with Colonel Pat Lang (November 1997).

121. Ibid.

122. Oral history interview conducted by author with Lieutenant Colonel Ernest "Pete" Hayes. In *MACVSOG: Oral History Interviews with Officers Who Served in MACVSOG OP 34 (Agent Operations Against North Vietnam)*, pp. 189–90.

123. MACVSOG, *Command History 1968*, Annex F, p. IV–6.

124. Ibid., p. IV–7.

125. Ibid.

126. Ibid., p. IV–7.

127. Ibid.

128. Oral history interview conducted by author with Lieutenant Colonel Lawrence Trapp. In *MACVSOG: Oral History Interviews with Officers Who Served in MACVSOG OP 35 (Clandestine Operations in Laos and Cambodia Against the Ho Chi Minh Trail)*, p. 128.

129. Oral history interview conducted by author with Lieutenant Colonel Lauren Overby. In *MACVSOG: Oral History Interviews with Officers Who Served in MACVSOG OP 35 (Clandestine Operations in Laos and Cambodia Against the Ho Chi Minh Trail)*, p. 110.

130. MACVSOG, *Command History 1968*, Annex F, p. IV–A–1.

131. MACVSOG, *Command History 1969*, Annex F, p. III–4–7.

132. Ibid., p. 9.

133. Ibid., pp. 8–9.

134. Ibid.

135. Ibid., p. 9.

136. Oral history interview conducted by author with Colonel Jack Isler. In *MACVSOG: Oral History Interviews with Officers Who Served in MACVSOG OP 35 (Clandestine Operations in Laos and Cambodia Against the Ho Chi Minh Trail)*, p. 144.

137. Ibid., p. 146.

138. Ibid., pp. 150, 155.

139. Ibid., p. 156.

140. Ibid., p. 150.

141. MACVSOG, *Command History 1969*, Annex F, p. III–4–8.

142. JCS, *MACVSOG Documentation Study* (July 1970), Appendix B/Pt. V, "Military Assistance Command Studies and Observation Group and the Strategic Technical Directorate: Inception, Organization, Evolution," pp. 211–12.

143. MACVSOG, *Command History 1969*, Annex F, p. 10.

144. JCS, *MACVSOG Documentation Study* (July 1970), Appendix E, "Cross-Border Operations in Cambodia," p. 29.

145. Ibid., p. 30.

146. JCS, *MACVSOG Documentation Study* (July 1970), Appendix E, "Cross-Border Operations in Cambodia," p. 29.

147. H. R. Haldeman, *The Ends of Power* (New York: Times Books, 1978), p. 219.

148. Robert Shaplen, *Road from War* (New York: Harper and Row, 1970), p. 301.

149. Richard M. Nixon, *RN: The Memoirs of Richard Nixon* (New York: Grosset and Dunlap, 1978), p. 397.

150. George Herring, *America's Longest War: The United States and Vietnam, 1950–1975* (New York: Wiley & Sons, 1979), p. 223.

151. Ibid., p. 225.

152. The United States sent "a million M–16 rifles, 12,000 M–60 machine guns, 40,000 M–79 grenade launchers, and 2,000 heavy mortars and howitzers." The South Vietnamese military was also given "ships, planes, [and] helicopters," and their military schools were expanded, promotion system professionalized, pay scales raised, and veterans benefits increased. Ibid., p. 226.

153. Oral history interview with Colonel Daniel Schungel. In *MACVSOG: Oral History Interviews with Officers Who Served in MACVSOG OP 35 (Clandestine Operations in Laos and Cambodia Against the Ho Chi Minh Trail)*, pp. 208–09.

154. MACVSOG, *Command History 1970*, Annex B, p. B-III-36.

155. Oral history interview conducted by author with Lieutenant Colonel Ernest "Pete" Hayes. In *MACVSOG: Oral History Interviews with Officers Who Served in MACVSOG OP 34 (Agent Operations Against North Vietnam)*, p. 197.

156. Oral history interview with Colonel Daniel Schungel. In *MACVSOG: Oral History Interviews with Officers Who Served in MACVSOG OP 35 (Clandestine Operations in Laos and Cambodia Against the Ho Chi Minh Trail)*, p. 208.

157. Oral history interview conducted by author with Lieutenant Colonel Ernest "Pete" Hayes. In *MACVSOG: Oral History Interviews with Officers Who Served in MACVSOG OP 34 (Agent Operations Against North Vietnam)*, p. 195.

158. MACVSOG, *Command History 1970*, Annex B, p. B–19.

159. Plaster, *SOG: The Secret Wars of America's Commandos in Vietnam*, p. 316.

160. MACVSOG, *Command History 1970*, Annex B, p. B-III-32.

161. Ibid., p. B-III-33.

162. Ibid., p. B-II-4.

163. Ibid., p. B-III-41.

164. Quoted in Plaster, *SOG: The Secret Wars of America's Commandos in Vietnam*, p. 318.

165. Sarah Bottoms, "Pulling Boat #13 is a Fitting Memorial," *The Challenge: Hurricane Island Outward Bound School* (undated publication), p. 8.

166. Ibid., p. 9.

167. I learned of the story of David Mixter when I went to interview Colonel Bob Rheault. After he left Special Forces and resigned from the Army and following his reinstatement by the Secretary of the Army (see chapter Seven for the details), Rheault joined the staff of the Hurricane Island Outward Bound School.

He is still there twenty-seven years later. On two occasions he has served as acting president of the school.

168. Plaster, *SOG: The Secret Wars of America's Commandos in Vietnam*, p. 318.

169. Karnow, *Vietnam: A History*, p. 630.

170. MACVSOG, *Command History 1971–72*, Annex B, p. B–3–21.

171. Plaster, *SOG: The Secret Wars of America's Commandos in Vietnam*, p. 337.

172. Oral history interview conducted by author with Colonel Roger Pezzelle. In *MACVSOG: Oral History Interviews with Officers Who Served in MACVSOG OP 35 (Clandestine Operations in Laos and Cambodia Against the Ho Chi Minh Trail)*, p. 222.

173. Ibid., p. 224.

174. Ibid., pp. 232, 240.

175. Ibid., pp. 235, 241.

176. Ibid., pp. 237, 241.

177. Ibid., p. 241.

178. Ibid.

179. Ibid., p. 247.

180. Ibid., p. 239.

181. Herring, *America's Longest War: The United States and Vietnam, 1950–1975*, p. 240.

CHAPTER SEVEN

1. A hero in World War I, Donovan received the Medal of Honor. Following the war, he established a Wall Street firm and built it into a powerful business. While this made Donovan wealthy and helped him move in the highest circles of influence, he was primarily concerned with America's role in the increasingly dangerous world of the 1930s.

2. Oral history interview conducted by author with Brigadier General Donald Blackburn. In *MACVSOG: Oral History Interviews with Chiefs of SOG*, pp. 36–37.

3. Ibid., p. 38.

4. Ibid., p. 37.

5. Ibid., pp. 38–39.

6. Oral history interview conducted by author with Major General John K. Singlaub. In *MACVSOG: Oral History Interviews with Chiefs of SOG*, p. 75.

7. Ibid.

8. Ibid., p. 60.

9. Oral history interview conducted by author with Colonel Stephen E. Cavanaugh. In *MACVSOG: Oral History Interviews with Chiefs of SOG*, p. 114.

10. Ibid., p. 112.

11. *Public Papers of the Presidents of the United States, John F. Kennedy* (Washington, D.C.: U.S. Government Printing Office, 1962), p. 453.

12. Quoted in Krepinevich, *The Army and Vietnam*, p. 35.

13. Ibid., p. 31.

14. Ibid., p. 37.

15. Ibid.

16. Ibid.

17. Cited in Ranelagh, *The Agency*, p. 379.

18. Ibid.

19. *Inspector General's Survey of the Cuban Operation and Associated Documents* (Washington, D.C.: National Security Archive, 1998), pp. 143, 145–46.

20. JCS, *MACVSOG Documentation Study* (July 1970), Appendix B/Pt. I–IV, "Military Assistance Command Studies and Observation Group and the Strategic Technical Directorate: Inception, Organization, Evolution," p. 96.

21. Ibid.

22. Ibid., pp. 96–97.

23. Oral history interview conducted by author with Brigadier General Donald Blackburn. In *MACVSOG: Oral History Interviews with Chiefs of SOG*, pp. 36–38.

24. JCS, *MACVSOG Documentation Study* (July 1970), Appendix B/Pt. I–IV, "Military Assistance Command Studies and Observation Group and the Strategic Technical Directorate: Inception, Organization, Evolution," p. 216.

25. Interview with General William Westmoreland at his home in Charleston, S.C. (October 3, 1997), p. 1.

26. Ibid., pp. 1–2.

27. Ibid., p. 3.

28. Ibid., pp. 3–4.

29. Ibid., p. 5.

30. Ibid., pp. 10–11.

31. Ibid., p. 10.

32. Ibid., p. 20.

33. Ibid., p. 3.

34. Ibid., p. 19.

35. Ibid., pp. 15–16.

36. Ibid., p. 17.

37. Ibid., p. 15.

38. Interview with Captain William Murray, pp. 1–2.

39. Ibid., p. 36.

40. Currey, *Edward Lansdale: The Unquiet American*, p. 227.

41. William Lederer and Eugene Burdick, *The Ugly American* (New York: Norton, 1958).

42. Currey, *Edward Lansdale: The Unquiet American*, p. 228.

43. Excerpts from the memorandum are contained in ibid., p. 229.

44. JCS, *MACVSOG Documentation Study* (July 1970), Appendix B/Pt. I–IV, "Military Assistance Command Studies and Observation Group and the Strategic Technical Directorate: Inception, Organization, Evolution," p. 49.

45. Ibid.

46. Ibid.

47. Ibid., p. 50.

48. Ibid., p. 51.

49. Ibid.

50. Ibid., p. 54.

51. Ibid.

52. Ibid.

53. Ibid., pp. 54–55.

54. Cited in Krepinevich, *The Army and Vietnam*, p. 31.

55. *Presidential Directives on National Security from Truman to Clinton*, NSDDINDEX Record Number 185.

56. JCS, *MACVSOG Documentation Study* (July 1970), Appendix A, "Summary of MACVSOG Documentation Study," p. 49.

57. Olson, *Dictionary of the Vietnam War*, p. 244.

58. Halberstam, *The Best and the Brightest*, p. 276.

59. Perhaps the best example of this is the story of John Paul Vann and his experience with Krulak. See Sheehan, *A Bright Shining Lie*, book four.

60. Interview with General Victor Krulak, pp. 1–2.

61. Currey, *Edward Lansdale: The Unquiet American*, p. 255.

62. JCS, *MACVSOG Documentation Study* (July 1970), Appendix B/Pt. I–IV, "Military Assistance Command Studies and Observation Group and the Strategic Technical Directorate: Inception, Organization, Evolution," p. 56.

63. Interview with General Victor Krulak, p. 3.

64. Ibid., p. 19.

65. Ibid., pp. 10–11.

66. Ibid., p. 14.

67. Ibid., p. 8.

68. Written commentary by Captain William Murray provided to the author during an interview at his home in Groton, Conn. (October 13, 1997).

69. Interview with Lieutenant Colonel Harold Bentz by telephone (October 16, 1997), p. 3.

70. Written commentary by Captain William Murray.

71. Interview with Captain William Murray, p. 7.

72. JCS, *MACVSOG Documentation Study* (July 1970), Appendix B/Pt. V, "Military Assistance Command Studies and Observation Group and the Strategic Technical Directorate: Inception, Organization, Evolution." Insert between pp. 280–81 is graphically reproduced by Freda Kilgallen.

73. Written commentary by Captain William Murray.

74. Interview with Captain William Murray, p. 10.

75. Written commentary by Captain William Murray.

76. Interview with Captain William Murray, pp. 10, 26.

77. Written commentary by Captain William Murray.

78. Ibid.

79. Interview with Captain William Murray, p. 17.

80. Written commentary by Captain William Murray.

81. This memorandum was posted on the Web site http://www.historians.org.

82. Interview with Brigadier General Albert Brownfield by telephone (October 23, 1997), pp. 2–3.

83. Interview with Captain William Murray, p. 17.

84. Interview with Captain Bruce Dunning at his studio in Washington, D.C. (September 19, 1997), p. 20.

85. Ibid.

86. *Changing the Army: An Oral History of General William E. Depuy* (Washington, D.C.: United States Army Center of Military History, 1988), p. 169.

87. Interview with Brigadier General Albert Brownfield, p. 11.

88. Interview with Captain Bruce Dunning, p. 8.

89. Interview with Colonel Robert Rheault in Rockland, Maine (September 11, 1997), p. 4.

90. Ibid.

91. Ibid., p. 6.

92. Ibid., p. 9.

93. Ibid., p. 13.

94. Homer Bigart, "How the Green Beret Affair Unfolded," *New York Times* (October 6, 1969), p. 1. Also see Shelby Stanton, *Green Berets at War* (Novato, Calif.: Presidio Press, 1985), pp. 189–93.

95. Plaster, *SOG: The Secret Wars of America's Commandos in Vietnam*, p. 243.

96. Interview with Captain William Murray, pp. 19–20.

97. Interview with Lieutenant Colonel George Maloney in Washington, D.C. (September 19, 1997), p. 5.

98. Ibid., pp. 7–8.

99. JCS, *MACVSOG Documentation Study* (July 1970), Appendix B/Pt. I–IV, "Military Assistance Command Studies and Observation Group and the Strategic Technical Directorate: Inception, Organization, Evolution," p. 152.

100. Ibid., p. 157.

101. Interview with General Victor Krulak, pp. 17, 20.

102. Ibid., pp. 21, 23.

103. JCS, *MACVSOG Documentation Study* (July 1970), Appendix B/Pt. V, "Military Assistance Command Studies and Observation Group and the Strategic Technical Directorate: Inception, Organization, Evolution," p. 236.

104. JCS, *MACVSOG Documentation Study* (July 1970), Appendix B/Pt. I–IV, "Military Assistance Command Studies and Observation Group and the Strategic Technical Directorate: Inception, Organization, Evolution," p. 169.

105. Ibid., p. 158.

106. Interview with Brigadier General Albert Brownfield, p. 7.

107. Interview with Colonel Robert Rheault, p. 2.

108. Ibid., p. 27.

109. Interview with Lieutenant Colonel George Maloney, pp. 15–16.

110. Ibid., p. 6.

111. JCS, *MACVSOG Documentation Study* (July 1970), Appendix B/Pt. V, "Military Assistance Command Studies and Observation Group and the Strategic Technical Directorate: Inception, Organization, Evolution," p. 270.

112. Ibid.

113. Ibid., pp. 270–71.

114. Ibid., p. 266.

115. Ibid., p. 271.

116. Ibid., p. 234.

117. Ibid., p. 264.

CHAPTER EIGHT

1. Plaster, *SOG: The Secret Wars of America's Commandos in Vietnam*.
2. April Oliver and Peter Arnett, "Did the U.S. Drop Nerve Gas?" *Time* (June 15, 1998), pp. 37–39.
3. Ibid., p. 38.
4. Ibid.
5. Ibid., p. 37.
6. Ibid., p. 39.
7. Jeff Greenfield introduced it on the CNN broadcast. His cohost was Bernard Shaw. Also involved was CNN's senior producer Jack Smith. Providing perspective in the segment was Pulitzer Prize–winning journalist Arnett, who along with Oliver published the account in *Time* magazine.
8. While repeating the same story to *Newsweek*, Robert Van Buskirk also volunteered that "he had forgotten it entirely for 24 years. . . . He had repressed the memory on Easter Sunday 1974." How did that occur? CNN's main source explained, "[U]ntil he had a vision of Christ on that Easter morning, he had been drinking heavily and was haunted by nightmares." Apparently, CNN producer Oliver's "five-hour interview" with him brought those repressed memories rushing back. Evan Thomas and Gregory Vistica, "What's the Truth About Tailwind?" *Newsweek* (June 22, 1998), pp. 32–33.
9. Van Buskirk told the *New York Times* that "He had not confirmed that a gas dropped on the area by American aircraft during the raid was sarin." Furthermore, "he said he did not tell CNN that a soldier he killed during that raid . . . was definitely an American defector." Lawrie Mifflin, "An Ex-Officer in CNN's Nerve-Gas Report Disputes Part of It," *New York Times* (June 27, 1998), p. A13.
10. One of them, Jay Graves, released a statement saying, "I did not participate in Operation Tailwind in an advance recon or in any other way during September 1970 in Laos." Rowan Scarborough, "Commando Groups Demand Retraction from CNN-Time: Display Files of Source Showing He Was Not in the Operation," *Washington Times* (June 17, 1998), p. A2. The other, James Cathy, identified by Oliver and Arnett as an "Air Force rat-pack commando," turned out to have been an air traffic control supervisor at a U.S. air base in South Vietnam. He claimed "he was picked for the deepest U.S. penetration of Laos while on furlough from his duty station." There is no evidence in all of the declassified SOG documents of a recon team member with this kind of background ever being selected in this fashion. Scarborough, "Retired Airman Making Tailwind Claim Won't ID Others," *Washington Times* (June 30, 1998), p. A3.
11. Oliver and Arnett, "Did the U.S. Drop Nerve Gas?," pp. 38–39.
12. Robert Caldwell, "CNN's Dubious Tale of Nerve Gas and Defectors," *San Diego Times-Union* (June 21, 1998), p. G–1.
13. Thomas and Vistica, "What's the Truth About Tailwind?," p. 32.
14. Eugene McCarley, who led the Tailwind mission on the ground in Laos, went on the record as having told CNN's Oliver "a thousand times that poison gas was not used. I told them over and over that it's just preposterous." He was quoted in the piece only as saying that it was his understanding "these gases,

these lethal gases, are an Air Force ordnance in their arsenal." While true, how was it relevant? Cited in Eric Felton, "CNN and Time's Poisonous Smear," *Weekly Standard* (June 29, 1998), p. 21.

15. For example, one of the Air Force pilots who dropped the gas, Art Bishop, stated he told Oliver "repeatedly that it was tear gas." Ibid., p. 21. The Army medic on Tailwind, Gary Rose, also "told a CNN producer on at least three occasions the Air Force used non-lethal tear gas to suppress the enemy." Rowan Scarborough, "Ex-Army Medic Rebuts CNN," *Washington Times* (June 24, 1998), p. A3.

16. CNN brought in attorney Floyd Abrams to conduct an independent review of the broadcast. His report, which CNN posted on its Web site, is a devastating refutation of the story and the investigative reporting that led up to it.

17. Lloyd C. Gardner, *Pay Any Price: Lyndon Johnson and the Wars of Vietnam* (Chicago: Ivan R. Dee, 1995), p. 32.

18. Ibid., p. 66.

19. Halberstam, *The Best and the Brightest*, p. 43.

20. Interview with W. W. Rostow at the Fletcher School of Law and Diplomacy, Tufts University, Medford, Mass. (April 2, 1998), p. 1.

21. U.S. Congress, Senate Select Committee to Study Governmental Operations with Respect to Intelligence Activities, *Alleged Assassination Plots Involving Foreign Leaders*, 94th Congress, 1st Session (Washington, D.C.: U.S. Government Printing Office, 1975), p. 334.

22. Richard Bissell, *Reflections of a Cold Warrior* (New Haven, Conn.: Yale University Press, 1996), p. 201.

23. *Alleged Assassination Plots Involving Foreign Leaders*, p. 334.

24. Ibid.

25. Ibid.

26. Author's notes from a June 6, 1997, interview with Richard Helms.

27. Oral history interview conducted by author with William Colby in *MACVSOG: Oral History Interviews with Officers Who Served in MACVSOG OP 34 (Agent Operations Against North Vietnam)*, pp. 9–10.

28. Interview with Captain William Murray, pp. 21, 24.

29. Interview with Ambassador William Sullivan at the Fletcher School of Law and Diplomacy, Tufts University, Medford, Mass. (September 27, 1997), p. 5.

30. JCS, *MACVSOG Documentation Study* (July 1970), Appendix C/Annex D, "Maritime Operations," p. 1.

31. Oral history interview conducted by author with William Colby in *MACVSOG: Oral History Interviews with Officers Who Served in MACVSOG OP 34 (Agent Operations Against North Vietnam)*, pp. 7–8.

32. JCS, *MACVSOG Documentation Study* (July 1970), Appendix B/Pt. I–IV, "Military Assistance Command Studies and Observation Group and the Strategic Technical Directorate: Inception, Organization, Evolution," p. 88.

33. Ibid.

34. Ibid.

35. Ibid., pp. 64–65.

36. Interview with W. W. Rostow, p. 2.

37. Author's notes from a June 6, 1997, interview with Richard Helms.

38. McNamara, *In Retrospect: The Tragedy and Lessons of Vietnam*, p. 14.

39. Ibid., p. 15.

40. Correspondence with Roger Hilsman (August 1, 1997), p. 1.

41. Roger Hilsman, *To Move a Nation* (New York: Delta Books, 1967), p. 44.

42. Interview with W. W. Rostow, p. 2.

43. Interview with General Victor Krulak, p. 1.

44. Correspondence with Roger Hilsman, p. 2.

45. Author's notes from a June 6, 1997, interview with Richard Helms.

46. Interview with General Victor Krulak, p. 5.

47. Lyndon Baines Johnson, *The Vantage Point* (New York: Holt, Rinehart and Winston, 1971), p. 12.

48. Bill Moyers, "Flashback," *Newsweek* (February 10, 1975).

49. JCS, *MACVSOG Documentation Study* (July 1970), Appendix B/Pt. I–IV, "Military Assistance Command Studies and Observation Group and the Strategic Technical Directorate: Inception, Organization, Evolution," p. 171.

50. Newman, *JFK and Vietnam*, p. 442.

51. Deborah Shapley, *Promise and Power* (Boston: Little, Brown, 1993), p. 281.

52. For an interesting discussion on these issues see Doris Kearns, *Lyndon Johnson and the American Dream* (New York: Harper and Row, 1976), chapters 8–9.

53. McNamara, *In Retrospect: The Tragedy and Lessons of Vietnam*, p. 103.

54. JCS, *MACVSOG Documentation Study* (July 1970), Appendix B/Pt. I–IV, "Military Assistance Command Studies and Observation Group and the Strategic Technical Directorate: Inception, Organization, Evolution," p. 111.

55. Author's notes from a June 30, 1998, interview with Robert S. McNamara by telephone.

56. JCS, *MACVSOG Documentation Study* (July 1970), Appendix B/Pt. I–IV, "Military Assistance Command Studies and Observation Group and the Strategic Technical Directorate: Inception, Organization, Evolution," p. 153.

57. Newman, *JFK and Vietnam*, p. 448.

58. JCS, *MACVSOG Documentation Study* (July 1970), Appendix B/Pt. I–IV, "Military Assistance Command Studies and Observation Group and the Strategic Technical Directorate: Inception, Organization, Evolution," p. 21.

59. Author's notes from a June 30, 1998, interview with Robert S. McNamara.

60. JCS, *MACVSOG Documentation Study* (July 1970), Appendix B/Pt. I–IV, "Military Assistance Command Studies and Observation Group and the Strategic Technical Directorate: Inception, Organization, Evolution," p. 157.

61. Ibid., p. 159.

62. Ibid., p. 158.

63. Ibid., p. 159.

64. Author's notes from a June 30, 1998, interview with Robert S. McNamara.

65. McNamara, *In Retrospect: The Tragedy and Lessons of Vietnam*, p. 130.

66. Author's notes from a June 30, 1998, interview with Robert S. McNamara.

67. McNamara, *In Retrospect: The Tragedy and Lessons of Vietnam*, p. 130.

68. Interview with Captain William Murray, p. 24.

69. Author's notes from a June 30, 1998, interview with Robert S. McNamara.

70. McNamara, *In Retrospect: The Tragedy and Lessons of Vietnam*, p. 105.

71. JCS, *MACVSOG Documentation Study* (July 1970), Appendix C/Annex A, "Psychological Operations," p. 7.

72. JCS, *MACVSOG Documentation Study* (July 1970), Appendix C, "MACVSOG Operations Against North Vietnam," p. 3.

73. Anxiety over how far to go in escalating the covert war against North Vietnam also led the administration to task the CIA's Board of National Estimates to assess 34A in terms of "probable reactions to various courses of action with respect to North Vietnam." Specifically, the board was asked to review the watered-down version of 34A that had come out of the Krulak committee review. "The[se] operations," the board concluded, "would not be likely to lead to appreciably increased Chinese Communist involvement . . . [nor] would the operations lead the Soviets to believe that the United States had made a significant change in its policies." JCS, *MACVSOG Documentation Study* (July 1970), Appendix B/Pt. I–IV, "Military Assistance Command Studies and Observation Group and the Strategic Technical Directorate: Inception, Organization, Evolution," p. 168.

74. JCS, *MACVSOG Documentation Study* (July 1970), Appendix C/Annex A, "Psychological Operations," p. 7.

75. Ibid.

76. In 1975, he told a congressional committee investigating intelligence matters that covert action should be used only when doing so was "absolutely essential to the national security" of the United States and as a "last resort." Under this standard, Vance declared, "the number of covert actions would be very, very small." U.S. Congress, Hearings Before the Senate Select Committee to Study Governmental Operations With Respect to Intelligence Activities, *Covert Action*, 94th Congress, 1st Session (Washington, D.C.: U.S. Government Printing Office, 1975), vol. 7, p. 54.

77. Interview with Colonel Robert Rheault, pp. 21–22.

78. Interview with Lieutenant Colonel George Maloney, pp. 9–10.

79. Interview with Brigadier General Albert Brownfield, p. 10.

80. Interview with Lieutenant Colonel George Maloney, pp. 24–25.

81. Author's notes from a June 6, 1997, interview with Richard Helms.

82. Oral history interview conducted by author with Colonel Stephen E. Cavanaugh. In *MACVSOG: Oral History Interviews with Chiefs of SOG*, p. 105.

83. Oral history interview conducted by author with William Rydell. In *MACVSOG: Oral History Interviews with Officers Who Served in MACVSOG OP 39 (Psychological Operations)*, p. 193.

84. Oral history interview conducted by author with Major General John K. Singlaub. In *MACVSOG: Oral History Interviews with Chiefs of SOG*, p. 77.

85. Ibid., p. 46.

86. Ibid.

87. Haldeman, *The Ends of Power*, p. 219.

EPILOGUE

1. Michael Gordon and Bernard Trainor, *The General's War* (Boston: Little, Brown, 1994).

2. Oral history interview conducted by author with General Wesley Rice. In *MACVSOG: Oral History Interviews with Officers Who Served in MACVSOG OP 37 (Maritime Operations Against North Vietnam)*, p. 173.

3. Richard Shultz, "Discriminate Deterrence and Low Intensity Conflict," *Conflict* (no. 1, 1989), p. 30.

4. Oral history interview conducted by author with General Edward Partain. In *MACVSOG: Oral History Interviews with Officers Who Served in MACVSOG OP 34 (Agent Operations Against North Vietnam)*, p. 19.

5. Schemmer, *The Raid*, p. 287.

6. Ken Follet, *On Wings of Eagles* (New York: Morrow, 1983).

7. Robert Andrews, *Last Spy Out* (New York: Bantam Books, 1991); and *Death in a Promised Land* (New York: Pocket Books, 1994).

8. Victor Krulak, *First to Fight: An Inside View of the U.S. Marine Corps* (Annapolis, Md.: Naval Institute Press, 1984).

9. Richard Shultz, "Low Intensity Conflict: Future Challenges and Lessons From the Reagan Years," *Survival* (July/August 1989), p. 367.

10. Ibid., p. 368.

11. Susan Marquis, *Unconventional Warfare: Rebuilding U.S. Special Operations Forces* (Washington, D.C.: Brookings, 1997).

ACKNOWLEDGMENTS

❖

It would have not been possible to research and write this book without a great deal of assistance and encouragement from all those acknowledged below. Individually and collectively they made important contributions to *The Secret War Against Hanoi*.

The idea of doing a study about MACVSOG was first suggested to me by Sam Blake, a Ph.D. student at the Fletcher School in the latter half of the 1980s. At that time it was not possible to do such a study, as SOG records were still buried deep in Pentagon vaults. However, the idea stuck with me.

In the early 1990s, some SOG documents were declassified, but they were so sanitized that much more was kept classified in these records than was released. I tried under the Freedom of Information Act (FOIA) to have the rest of the material reconsidered for declassification, but had no luck. Consequently, the story of MACVSOG remained a mystery.

In 1994 my luck began to change. During that academic year I was the Olin Distinguished Professor of National Security Studies at the United States Military Academy (USMA). In September I was requested to go to the U.S. Army Special Operations Command (USASOC) at Fort Bragg as the Haiti crisis escalated. General Gordon Sullivan, the chief of staff of the Army, asked Lieutenant

General Terry Scott, the commanding general of USASOC, to answer several questions he had about possible low-intensity conflict threats that might arise after the United States intervened. I took part in this effort and while doing so had several conversations with General Scott. As we were finishing, he asked what kinds of studies USASOC should focus on to draw lessons from Cold War special operations. I proposed MACVSOG. We discussed why this was important and under what arrangements I would undertake the study for him.

I returned to West Point and over the next several months worked on a research proposal. I owe a great debt of gratitude to Colonel Dan Kaufman, chair of the Social Sciences Department at USMA and to Lieutenant Colonel Jay Parker, a member of the faculty, for their advice and reading of the proposal. In drafting it, I suggested, with their strong encouragement, that the study be done at the unclassified level and be published by a commercial publisher. For such a work to be credible, the author had to be able to let the chips fall where they might.

General Scott agreed and in August of 1995 I began working. There are no words to express how greatly I have valued Terry Scott's support and friendship during the completion of *The Secret War Against Hanoi*. As USASOC commanding general, he helped me find the documents and have them declassified. He also opened the door to all the SOG veterans I interviewed for the book. Without a letter from him, and a point of contact on his staff to call and check things out, I doubt I would have had the opportunity to meet with these men. Terry Scott established my bona fides with them. After retiring from the Army and assuming his current position as director of the National Security Program at the John F. Kennedy School of Government at Harvard University, he continued to assist me in numerous ways. Thank you Terry, you are a wonderful friend.

Lieutenant General Pete Schoomaker replaced Terry Scott at USASOC. Like Terry, Pete always took my calls and did all he could to help. Now the commanding general of the U.S. Special Operations Command, Pete Schoomaker is one of the finest general officers I have had the pleasure to work with in over two decades of working with the military. The third ASOCSOC commanding general that supported the project was Bill Tangney. Like Terry and Pete, Bill was always there when I needed assistance. How fortunate I've been to have the assistance of these three splendid soldiers.

The commanding general of the U.S. Special Operations Command in 1995, Wayne Downing, also encouraged me to write the book and supported my efforts to do so. Even after he retired, Wayne did all he could to facilitate the declassification of SOG records. In my quest to locate the SOG documents in the Pentagon, I also owe a debt of thanks to Colonel Jeff Jones, chief of the Special Operations Division of the Joint Staff. On his staff, Vanessa Lanham was also of great assistance in many ways.

There is no way I can express my gratitude to the SOG veterans and members of the SACSA interviewed for this book. I traveled all over the United States to interview most of them face-to-face. They took my project with the utmost seriousness, and to a man believed it was time to tell the full story of SOG. They welcomed me into their homes and gave me all the time I needed. In short, they were gracious in every way. Especially helpful was my friend John Plaster.

Once the research was completed, the project entered the writing stage. I had the good fortune to receive a grant from the Smith Richardson Foundation to support this period of the project. At the foundation, Dr. Marin Strmecki, vice president and director of programs, was instrumental in helping me submit a successful proposal. Marin also took great interest in the substance of the study and encouraged all my efforts. I value his professional advice and friendship.

I would still be working on this book if it were not for Freda Kilgallen, program manager of the International Security Studies Program at the Fletcher School. Freda transcribed all of the interviews, which amounted to hundreds of hours of taped discussions. Every minute of it was turned into text that I could use. It was a first-class effort. After the manuscript was in draft form, Freda took over and managed a review process that saw each chapter pass through several iterations. Her sharp eye and sensitivity to every detail were invaluable in moving the manuscript to completion. I am extremely fortunate to have her assistance. Freda made this book much better.

Also from the International Security Studies Program at the Fletcher School, I must thank Roberta Breen, my staff assistant. She handled the correspondence for the project, arranged all research trips, maintained my schedule, and kept the records in order. Roberta did a terrific job under the most adverse conditions. In the midst of

the project, she had to beat back a bout with cancer. She not only prevailed, but also did so without missing a beat in the office. What an amazing individual.

The manuscript also reflects the professional editorial scrutiny of Elissa Rabellino. She read every word and fixed many things. Two very talented Ph.D. students at the Fletcher School who were research associates of the International Security Studies program, Ruth Citrin and Rhoda Margesson, likewise critiqued and edited several chapters. Their ability and skill improved the final product. In close to twenty years at the Fletcher School, I've worked with many outstanding graduate students, but none better than Ruth and Rhoda.

To market the study I needed an agent. I could not have found a more suitable one than Ben Schemmer. A West Point graduate, career soldier, editor of important journals, and an outstanding author: Ben is a great agent. He never stops working on your behalf, and does so with enthusiasm and care. He also read the entire manuscript and executed an editorial review that any author would treasure. He greatly improved every chapter. In what can only be described as a "take no prisoners" approach, Ben attacked every line. I came to refer to this as "having been Schemmered." Thanks, Ben, you showed me how to write.

At HarperCollins I had the good fortune to work with Paul McCarthy, senior editor. His experience, knowledge of military affairs, and seasoned eye was a wonderful asset to be able to take advantage of. Paul knows the business and is a class act. So is his assistant, Alice Herrin. Alice can really manage and keep everything on schedule. These are real talents that I came to appreciate.

I also want to thank my colleague and close friend at the Fletcher School, Bob Pfaltzgraff, for his encouragement and advice. One of the two reasons I came to Fletcher in 1983 was to work with Bob, and he has always been there for me. The Fletcher School dean, Jack Galvin, the former Supreme Allied Commander Europe, likewise was a terrific supporter throughout this project. I am deeply grateful to each of these fine men.

I wish to dedicate this book to my wife, Casey, and my son, Nicholas. I love them both so much and think both are just great.

INDEX

❖